In Search of Admiration and Respect

China Understandings Today

Series Editors: Mary Gallagher and Emily Wilcox

China Understandings Today is dedicated to the study of contemporary China and seeks to present the latest and most innovative scholarship in social sciences and the humanities to the academic community as well as the general public. The series is sponsored by the Lieberthal-Rogel Center for Chinese Studies at the University of Michigan.

A complete list of titles in the series can be found at www.press.umich.edu

IN SEARCH OF ADMIRATION
AND RESPECT

*Chinese Cultural Diplomacy in the
United States, 1875–1974*

Yanqiu Zheng

University of Michigan Press
Ann Arbor

For questions or permissions, please contact um.press.perms@umich.edu

Published in the United States of America by the
University of Michigan Press
Manufactured in the United States of America
Printed on acid-free paper
First published September 2024

A CIP catalog record for this book is available from the British Library.

Library of Congress Cataloging-in-Publication Data

Names: Zheng, Yanqiu., author. | Michigan Publishing (University of Michigan),
 publisher.
Title: In search of admiration and respect : Chinese cultural diplomacy in the United
 States, 1875–1974 / Yanqui Zheng.
Other titles: China understandings today.
Description: Ann Arbor : University of Michigan Press, 2024. | Series: China
 understandings today | Glossary in English and Chinese (pages 205–209). |
 Includes bibliographical references (pages 211–236) and index.
Identifiers: LCCN 2024016825 (print) | LCCN 2024016826 (ebook) |
 ISBN 9780472076802 (hardcover) | ISBN 9780472056804 (paperback) |
 ISBN 9780472904471 (ebook other)
Subjects: LCSH: Cultural diplomacy—China—History—19th century. | Cultural
 diplomacy—China—History—20th century. | China—Relations—United
 States. | United States—Relations—China.
Classification: LCC DS775.8 .Z45 2024 (print) | LCC DS775.8 (ebook) |
 DDC 327.51009/034—dc23/eng/20240501
LC record available at https://lccn.loc.gov/2024016825
LC ebook record available at https://lccn.loc.gov/2024016826

DOI: https://doi.org/10.3998/mpub.12739543

Open access funding for this publication was provided by the Lieberthal-Rogel Center for
Chinese Studies (LRCCS) and the Weatherhead East Asian Institute.

The University of Michigan Press's open access publishing program is made possible
thanks to additional funding from the University of Michigan Office of the Provost and the
generous support of contributing libraries.

Cover photograph: Li Lincan at the Chinese Art Treasures exhibition at the National
Gallery of Art, May 26, 1961. Courtesy of the National Gallery of Art Archives.

献给我的父母
王健梅 *(1957–1999)* 郑家骅 张世平

In solidarity with all academic workers
who labor under precarious conditions

Studies of the Weatherhead East Asian Institute, Columbia University

The Studies of the Weatherhead East Asian Institute of Columbia University were inaugurated in 1962 to bring to a wider public the results of significant new research on modern and contemporary East Asia.

Contents

Digital materials related to this title can be found on
the Fulcrum platform via the following citable URL:
https://doi.org/10.3998/mpub.12739543

Figures

Tables

Acknowledgments

In the hasty acknowledgments section of my PhD dissertation, I promised to offer my proper thanks to those who had helped me when the dissertation turned into a monograph "in a few years." A few jobs and a global pandemic later, the intervening time, indeed technically a few years, feels a lot longer and much less straightforward.

My heart is still filled with gratitude to so many teachers who fostered my intellectual growth. Researching the history of Chinese cultural diplomacy in the United States reflects my ongoing interest in broadly defined education and intercultural encounters. As an uncommitted philosophy major at Peking University, I found values in studying education through the encouragement of Tian Ling. Du Xiaozhen indulged my dabbling in Rousseau's *Emile* despite my limited grasp of the Enlightenment icon and French. At the Graduate School of Education, Ma Wanhua and Shi Xiaoguang broadened my horizon to international higher education. The joint certificate program in human rights between Peking University Law School and Lund University's Raoul Wallenberg Institute allowed me to practice English as a working language and study abroad for the first time in southern Sweden. I was also able to savor Taiwan's multicultural legacies thanks to Chou Chuing's support of my stay at National Chengchi University as a visiting student.

This book also grows out of my own experiences of being Chinese in a country where I choose to have spent the majority of my adulthood. Without Don Warren, I would not be able to enroll in the PhD program in education at Indiana University Bloomington on a fellowship. In that

cosmopolitan college town, Andrea Walton and Dionne Danns ignited my enthusiasm for archives, where I first learned about the China Institute in America. Luise McCarty generously shared her own trans-Atlantic experiences. The late Heidi Ross and Bill Monahan hosted cheerful gatherings for sojourners like me many times in their storied home. Pamela Walters taught me to treat history as a rigorous methodology in social inquiries. Sara Friedman led me to critical reflections on the state. Klaus Mühlhahn's classes affirmed my determination in studying Chinese history from transnational perspectives.

If my intellectual journey until Bloomington gave me a good mix of multidisciplinary exposure, my PhD training at Northwestern University defined who I am as a scholar. The Department of History took a chance on me, who had only taken a few history courses here and there, and turned me into a historian of China in the world. Together with the Chabraja Center, it offered not only the funding but also a collegial intellectual environment where many faculty cared about mentoring. As my advisor, Melissa Macauley beamed her native Southern California warmth despite being a long-term resident of Chicagoland. While preparing her ambitious reinterpretation of modern China's experience with colonialism, Melissa endured too many of my half-baked ideas. Yet she always had the patience and talent of helping me develop those ideas as my own. Thanks to her, I also learned very early on that much more than good ideas, the academic career entailed navigating the larger institutional matrix. Peter Carroll and Daniel Immerwahr generously shared their respective knowledge of Chinese and U.S. history, and helped me cope with the ups and downs of research with their unique sense of sarcasm and humor. Besides these three exemplary scholar-teachers, Sarah Fraser in art history first introduced me to the multiple evacuations of the National Palace Museum collections. Laura Hein and Amy Stanley taught me to see Japan in both national and transnational lights. Rajeev Kinra opened my eyes to the larger significance of the Islamic world. Deborah Cohen changed the way I understood archives. Michael Allen showed me the international repercussions of the plural Vietnam Wars. Jeon Yuh walked me through the basics of oral history. I never summoned the courage to take Sarah Maza's legendary cultural history seminar at Northwestern, but she did not hesitate at all to guest lecture in my undergraduate course on historiography during the pandemic.

I also owed a lot of my history training to the renowned Institute of Modern History at Academia Sinica in Taipei. A powerhouse in the broadly defined history of modern China, the Institute generously hosted me four times, despite my lack of any history degree in the Sinophone world. I had

the privilege of learning from Chang Li, Lien Ling-ling, Wang Cheng-hua, Wu Jen-shu, Wu Zhe, Yu Chien-ming, Yu Miin-ling, Peter Zarrow, Zhu Marlon, the late Chang Peng-yuan, and the late Yang Tsui-hua. Lin Hsiu-chuan and other administrative staff skillfully took care of my entry permit each time, a confounding process only fit for the most knowledgeable and dedicated.

As difficult as it is to swallow the negative feedback in academia—I have certainly had my share of rejections and being ignored—I have been blessed with generous advice from many others during the research and writing process. Quite a few initial encounters have turned into ongoing correspondence and friendship. To the best of my knowledge, I benefited from the insights of Jessamyn Abel, Tomoko Akami, Mohammed Al-Sudairi, Nicole Barnes, Jen Black, Annalisa Bolin, Timothy Brook, Charlotte Brooks, Kara Carmack, Gordon Chang, Chen Fanghao, Chen Hongmin, Huaiyu Chen, Chen Kuan-Jen, Chen Zhongchun, Reed Chervin, Chou Fang-mei, Brian Cwiek, Anatoly Detwyler, Duan Xin, Thomas DuBois, Shuhua Fan, Xin Fan and Yan He, Feng Xiaocai, Tom Finger, Zach Fredman, Jane Gaines, Matt Galway, Gao Yunxiang, Molly Geidel, Geng Youquan, Jessica Gienow-Hecht, Chuck Hayford, Derek Heng, Yong Ho, Hsu Feng-yuan, Yih-Jye Hwang, Jen Tien-hao, Jiang Wenjun, Ryan Kashanipour, Ron Kassimir, Judd Kinzley, Sam Kling, Jonathan Kuiken, Kung Chien-wen, Barak Kushner, Ulug Kuzuoglu, Jeff Kyong-McClain, Jeremy LaBuff, Terry Lautz, Joseph Lee, Li Peichen, Li Shan, Teng Li, Lin Guo-Sian, James Lin, Liou Wei-Chih, Ma Lin, Nan Ma, Zhao Ma, Benjamin Martin, Nate Mathews, Covell Meyskens, Minami Kazushi, Adam Nelson, Jack Neubauer, Ngoei Wen-Qing, Federico Pachetti, Ying Qian, Qiao Zhaohong, Chris Reed, Ke Ren, Ren Yue, Giles Scott-Smith, George Shea, Akira Shimizu, Ian Shin, Melody Shum, Amy Sopcak-Joseph, Su ShiYu, Syu Siou-meng, Philip Thai, Tsai Wei-chieh, Tseng Pin-Tsang, Hans van de Ven, Wang Yi, Wang Yu, Yuanchong Wang, Rachel Wallner, Ryan Watson, Shuge Wei, Wei Bingbing, Ssu Weng, Emily Wilcox, Hugh Wilford, Glenn Willis, Wu Jingping, Xu Ang, Xue Yiqun, Wen-hsin Yeh, Shaoqian Zhang, Zhao Yanjie, Zhou Huimei, the late Richard Hsu, the late Huang Li-an, and the late Wango Weng. Generous funding from the Kuo Ping Wen Symposium in New York in 2014, the Culture, Propaganda, and Intelligence in Foreign Relations Summer Institute in Leiden in 2016, the Sights and Sounds of the Cold War in the Sinophone World Conference in St. Louis in 2017, the China in a Global World War II Summer Institute in Cambridge, United Kingdom, in 2017, the Culture and International History VI Conference in Berlin in 2019, and the Uneasy Allies Conference

in Kunshan in 2019 and online in 2020 enabled me to tap the collective wisdom of many fellow participants. The transnational scholarly network I drew on belies the myth of a single-author monograph.

Researching and publishing a history book requires an extensive support infrastructure I no longer take for granted. Tal Nadan at the New York Public Library, for example, answered many of my questions from textual files to photo negatives. Wang Mei-ling at Academia Historica in suburban Taipei generously lent me a spare stainless-steel lunchbox so that I could heat my lunch in the staff steamer instead of waiting for lukewarm delivery in the cold and damp winter. Many other librarians and archivists helped me navigate various research collections. Embarrassingly, I do not remember the names of most of these unsung heroes in historical research. I would not be able to go to the libraries and archives across the United States and the Taiwan Strait without the financial support from Northwestern University, including the Department of History, the Graduate School, and the Buffett Institute for Global Affairs, Doris G. Quinn Foundation, and the California-based China Times Cultural Foundation. Only after graduating from Northwestern did I realize that access to a research library with relevant print and digital collections was a privilege. Thanks to Columbia University's Modern China Seminar, I have not only found an intellectual community but also gained access to a world-class library system. I am forever grateful to Alice Newton of the University Seminar Office, and Jim Cheng and Chengzhi Wang of Starr Library for their ongoing support. The Social Science Research Council (SSRC) offered me more generous professional development support than what my previous faculty jobs did. These funds and the subvention from the First Book Award of Columbia University's Weatherhead East Asian Institute paid for image reproduction and the superb index prepared by Malcolm Thompson. The open-access publishing is made possible by both the Weatherhead subvention and support from the University of Michigan's Lieberthal-Rogel Center for Chinese Studies. The Johns Hopkins University Press allowed me to reuse part of my article published in *Twentieth-Century China* in chapter 5. Part of chapter 3 will appear as a contributing chapter in a forthcoming edited volume on Sino-U.S. relations between 1937 and 1949 by Cambridge University Press. Ariana King at the Weatherhead Institute and Sara Cohen, Annie Carter, Kevin Rennells, and their team at the University of Michigan Press patiently guided me through the publishing process as a first-time author. My book's Columbia and Michigan imprint is, respectively, a fitting tribute to the Columbia alumni in the pages and acknowledgment of my own decade-long sojourn in the Midwest. Following my curiosity

comes with a huge price tag, yet not every deserving scholar can afford to see their ideas in print. I could never overestimate my sheer luck in acquiring the cumulative trust and goodwill of so many people.

The completion of this book was also intertwined with much larger structural challenges beyond my anticipation or control, but I never ran out of help even during my moment of need. While the restrictions of Sino-American academic exchange and archival access in mainland China even before the pandemic are well-known, similar practices have also grown entrenched in Taiwan where certain repositories are off limit to scholars traveling on a Chinese (including Hong Kong and Macau) passport. Chou Tong-yi and Tsai Jung-ju helped locate essential sources. When the elimination of my tenure-track job amid institutional retrenchment, something I had naïvely considered impossible, threatened my legal residency in the United States during the pandemic, Melissa Macauley, Deborah Cohen, Chris Stevens, Washington State University's Department of History, and College of the Holy Cross's Department of History all stepped up on my behalf, and Patrick Danner hosted a cathartic bonfire before I moved from Pennsylvania. Despite the lack of media interest, the American Historical Association provided me a platform in *Perspectives on History* to publicize the travails of noncitizen scholars. Beholden to the ebb and flow of external funding, the SSRC nevertheless allowed me to contribute to knowledge production in a different way. I can never thank enough those I had the privilege of working closely with, including Francisca Aguayo, Anna Bruckner, Tatiana Carayannis, Eric Deng, Amira Elsherif, and Alejandra Gutierrez.

As much as I tend to define myself in terms of work, I would not be able to endure my pursuit without the encouragement and hospitality of dear friends and their family, including Cao Xing, Chen Bodong, Keith Clark, Ding Yuhan, Dong Li, Du Wei and Ran Tian, Michael Falcone, Fei Yang, Fu Bo, Geng Xun, Goh Liangzhou, Guo Hsiao-Jing, Hao Liang, He Jhih-Wei, Jake Hardesty, Scott Hofer and Dahye Lee, Hong Hao, Hou Jinfang, Hou Wenjun, Jiang Longzhi, Kao Yu-Tien, Kevin Lam, Li Xiaobao and Rafael Guerra, Lu Jiao, Lu Xun, Michael Nguyen, Qi Wen, Brian Seyfried, Shen Wei Ting, Blake Smith, Song Tao, Terrel Sykes, Gino Vlanovou, Wang Shih Cheng, Sylvia Wang, Wang Xiaochun, Wang Zhu, Xu Nan, Luke Williams and Isabel Chen, Yang Guangshuo, Yao Yoshiyasu, Yin Wei, Yin Xiaosong, Sarah Yu, Yu Yun, Zhang Hantian, Zhang Hui, Zhang Lu and Mark Zhuang, Zhang Wei, Zhao Wanxia, and Zhu Benjun. Special thanks go to Carolyn Hsu, great grandniece of the founding director of the China Institute. Carolyn hosted me countless times at her and René

Balcert's book-filled apartment in Manhattan, shared her fascinating family history, and introduced me to quite a few witnesses of modern Chinese history. She is an elegant embodiment of cosmopolitan China. Knowing her and some other friends for so long makes them feel like family.

Speaking of family, my blended one is still in Taixing, a lesser-known city in China's otherwise well-studied lower Yangzi region where I was born and raised. My mom had long passed away before I had any clue of writing a book. Yet her pictures, on my desk and in my wallet, have traveled with me to many places I am sure she would love to visit. Growing up during the Cultural Revolution when the rich and powerful could fall at any moment, she told me repeatedly that only knowledge was the ultimate wealth that no one could take away. I experienced the unanticipated changes in my career around the similar age when she was laid off from a small collective work unit and picked up embroidery piecework from a new Sino-Japanese trading firm. I do not know whether I handled everything with her level of grace and determination, but I hope this book proves that I am trying to heed her advice and example. The Cultural Revolution also cost my dad many career opportunities, including one in diplomacy. Understandably dubious of my quixotic life choice, he nevertheless tolerates that in the depth of his affections. Even though I only got to know my stepmom after leaving for college, she has become an inseparable part of my dad's life and my own. She is the kind of mom who was determined to bring Taixing's delicacies wrapped in layers of plastic to me in Chicago despite my warnings about the customs inspection. To none other than my parents, past and present, I dedicate this book in the language they can read. Although I grew up as the only child, my stepbrother has given me the next best thing of having a sibling as an adult. Spending time with him, my sister-in-law, and my nephew during my regrettably short home visits has always been a joy.

Like it or not, such a project is no longer feasible for me today. The completion of this book has been shadowed by the growing challenges of China studies, the demoralizing chasm between the intellectual calling and insecurity of academic labor, and the frustrating if not borderline cruel U.S. immigration system. But these adversities are really trivial compared to the more immediate existential threats of various kinds endured by too many in the world. Publishing the book now gives myself closure on more than a decade's work and allows me to thank as many as I can remember—there must be omissions—who have helped me along a winding yet rewarding journey and taught me to remain humble and resilient. I am of course solely responsible for all the errors.

Notes on the Chinese Language

For important Chinese terms, the book provides *pinyin* in the chapters and a glossary of characters in the end. Depending on the provenance of the terms, the glossary uses simplified scripts for those from post-1949 mainland China and traditional scripts for others.

The treatment of Chinese names is generally the same with two exceptions. The non-*pinyin* transliteration of well-known figures such as Chiang Kai-shek and T. V. Song is retained. For the sake of consistency, the bibliography of Chinese sources is listed according to the alphabetical order of names in *pinyin*, regardless of which transliteration is used in the book. The non-*pinyin* transliteration of the author's name, if known, is included in the parenthesis.

The translation of Chinese words and phrases, unless otherwise noted, is mine.

"The Self-Strengthening in China needs many people knowledge-able about the foreign situations, and academies where foreigners are employed to teach those who are interested in Western learning. It is also necessary to establish Chinese academies in Britain, France, and Germany where learned Chinese could teach foreign students who appreciate Chinese learning. Over time they will be agreeable to our manners and understand our subtleties, which is secretly ben-eficial to us."

Zeng Jize
diary on the fifth day of fourth moon, fifth year of the Guangxu reign (May 25, 1879)

"The Chinese nation (*Zhonghua minzu*) generates only fear in the world, not admiration . . . [This] is not the Chinese nation's true glory today."

Tang Junyi
lecture at New Asia College, Hong Kong, 1972

Introduction

Whose China

A few months after the immensely popular novel *The Good Earth* garnered Pearl S. Buck (1892–1973) a Pulitzer Prize in 1932, the *New York Times* reprinted a stinging critique by a male Chinese reviewer and also published Buck's spirited rejoinder. Jiang Kanghu (Kiang Kang-hu, 1883–1954) was an early proponent of socialism in China and then the first professor of Chinese studies at McGill University in Canada. He assailed Buck's perceived misunderstandings of China as a foreigner with superficial knowledge of his native country. "Chinese coolies and amahs" in Buck's writings, Jiang declared, "may form the majority of the Chinese population, but they are certainly not representative of the Chinese people." In her response, Buck was unapologetic about her affective and ethnographic authority on the Chinese masses. She only depicted the Chinese "as he [was] to me" and it was her duty "[f]or truth's sake" to speak out against Jiang's "cruel" elitism and the "small, indifferent aristocracy of intellectuals" he represented.[1]

This heated exchange laid bare the contested authority in representing China internationally. Even at a time when Buck's success supposedly ushered in more two-way cultural interactions between China and the United States, the struggle over such discursive power was not far from the surface.[2] Personal politics aside, Jiang's distrust of the accuracy and legitimacy of foreign representation of China was far from unique among peers.[3] In a more nuanced review of *The Good Earth*, Chen Hengzhe (Sophia Chen Zen, 1890–1976), a Vassar graduate and the first female professor at Peking

University, also lamented Buck's "lack of any intimate association of minds and hearts" despite her "abundant sympathy" toward the Chinese and "long residence" in China as a foreign writer.[4]

Who had the right to tell China's stories abroad and whose stories were most heard? Between the country's initial posting of diplomats in the West in the 1870s and the consolidation of its international representation by the People's Republic of China (PRC) in the 1970s, more and more Chinese with international experiences championed their responsibility in doing so. They saw it as their class and civic duty to disabuse international public opinions of the negative stereotypes of China supposedly perpetuated by lower-class Chinese immigrants and misinformed foreigners. As ongoing sociopolitical turmoil limited the Chinese state's ability in projecting a uniformly desirably image of China, those determined Chinese tried to co-opt and compete with diverse narrations of their home country. This crowded field where the educated Chinese sought competitive advantage underscores the unequal power relations embedded in the intercultural encounters between China and the outside world.[5] Even a much more powerful PRC in the early twenty-first century still believes that the Confucius Institute (*Kongzi xueyuan*), its signature initiative in promoting Chinese language and culture overseas, plays an essential role in correcting perceived "misreading" and "misunderstanding" of China in "Western discursive dominance" (*xifang huayu quan*).[6]

Before his criticism of Buck, Jiang had already started pondering why China ceded the authority in representing itself internationally. Never successful in China's ferocious partisan politics in the early twentieth century, Jiang was the first instructor of Chinese studies at two prestigious North American universities: University of California, Berkeley in most of the 1910s and McGill in the early 1930s.[7] In an article titled "Chinese Studies" for the *McGill News* in 1931, Jiang wrote,

> [T]he Chinese have never been a nation or a race proficient in advertisement. China has long been isolated and always self-sufficient and self-contented, except for a few ambitious rulers who sought intercourse abroad, and who, for this very ambition, have always been hated and disowned by their own people. The Chinese cared little to know others and to let themselves be known to others. Many things Chinese have been introduced to the West by Westerners without any intelligent selection or authentic interpretation. Still more have been exported through China's clever neighbor, Japan, who assumes the credit of their origin, and monopolizes the profit of their supply.

> The Chinese national character is more exclusive and retiring than even that of India, from which country the first religious missionaries were dispatched, though there has been no *missionary* [emphasis added] work done by China.[8]

The last sentence bears an uncanny resemblance to the opinions of two other very different observers of Chinese culture. Intellectual historian Joseph Levenson (1920–1969) at Berkeley maintained in a posthumous publication that pre-Communist China had no sense of "*mission*" (emphasis original).[9] Reflecting on his cross-country trip in the United States in 1960, the renowned Chinese scholar Qian Mu (1895–1990) also believed that China "hosted those who came to learn but did not dispatch those who went out to teach" (*you lai xue wu wang jiao*).[10]

While Jiang's isolationist interpretation of China is debatable, his assessment of foreign dominance in the international narration of China largely rings true during the late imperial period. As the country generally assumed the emulation *and* dissemination of its civilizational superiority, it was mainly foreigners rather than Chinese themselves who promoted and reinterpreted Chinese culture overseas. There were few Chinese equivalents of the successive Japanese embassies between the seventh and ninth centuries, Marco Polo (1254?–1324) during the Mongol period, or the Jesuit missionaries between the late sixteenth and early eighteenth centuries. One exception of active extraterritorial projection of Chinese culture was the occasional imperial investiture envoys to anoint new rulers of the tributary states such as Korea, Liuqiu (Ryukyu), and Vietnam.[11] Following elaborate protocols, these envoys were supposed to be the living symbol and conveyer of the superior Chinese civilization to those in the outskirts of the Sinitic world. Rather than regurgitate narrow Sinocentrism, this point actually acknowledges the agency of foreigners in appropriating Chinese culture on their own terms instead of simply accepting China's superiority.[12]

From Individual Icons to Institutional Actors

As this book will demonstrate, China's lack of missionary spirit became an increasingly untenable thesis after the collapse of the Sinitic international order in the late nineteenth century. The precipitous fall of the country's reputation in a world order dominated by Western imperial powers galvanized intensifying Chinese efforts in projecting China's cultural refine-

ment and achievements. Just a little after Jiang's writing in the 1930s, some Chinese icons of such cultural projection made their successful debut. In the United States and Britain, respectively, Lin Yutang (1895–1976) and Chiang Yee (Jiang Yi, 1903–1977) became the popular spokesman of Chinese cultural wisdom through their bestsellers in English and helped generate more sympathy toward China during the Second Sino-Japanese War (1937–45).[13]

Less studied than iconic individuals but arguably even more important in the lasting impact of cultural projection are institutions for the cause.[14] In fact, emerging institutions under significant Chinese leadership started to support cultural diplomacy, essentially a long-term pedagogical project that taught China's cultural refinement to the West. This book focuses on the institutionalization of Chinese cultural diplomacy mainly in the United States, where such Chinese aspirations for a uniform message of refinement had to contend with China's fragmented and often negative representations. In this crowded field, Jiang acknowledged that the significant role of foreign institutions in shaping the "international understanding and friendship between China and the West," such as the Freer Gallery of Art and the Harvard-Yenching Institute in the United States and the North-China Branch of the Royal Asiatic Society in semicolonial Shanghai.[15] But he also conceded the contributions by a then young institution still in operation today, the New York-based China Institute in America (*Hua Mei xiejinshe*). Founded in 1926, the Institute was the brainchild of cosmopolitan intellectuals from both China and the United States amid the post–World War I surge in "cultural internationalism."[16] In its first fifty years, the directors in charge of daily operations were mostly American-educated Chinese intellectuals, who strove to promote the broader understandings of China as an inherently valuable cause through an offshore organization.

Far from a lone institution, the China Institute was part of a larger story of Chinese cultural diplomacy that involved a transnational network of government and nongovernmental actors. Before the Institute's founding, two generations of cosmopolitan Chinese intellectuals in the late Qing dynasty (1644–1912) had contemplated the promotion of what they considered the best of Chinese culture among Western powers. Steeped in traditional learning but also aware of the gap between China and the West, they put forward a modern vision of Chinese statecraft that sought not only wealth and power but also admiration and respect. The Institute channeled such efforts onto a more institutionalized platform in the United States. And it was soon joined by the Nationalist government, which started to realize the pragmatic values of cultural diplomacy under the intensifying Japanese

threat in the 1930s and the PRC's challenges during the Cold War. Despite their different rationales, the China Institute's persistent financial troubles and the Nationalist government's ongoing existential crises necessitated their collaboration and the bifurcated structure of Chinese cultural diplomacy in the United States through the mid-1970s. Although the PRC did not engage in mainstream cultural diplomacy in the United States until the 1970s, its actual use of Chinese culture in its international engagement elsewhere provides a particularly illuminating foil in understanding the two institutional actors in later chapters.

In Search of Admiration and Respect fuses international history and cultural analysis, and draws upon previously untapped primary sources, which include government records, institutional and personal papers, and oral history interviews in the United States, Taiwan, and mainland China. Cultural diplomacy, systematic attempts in narrating China's enduring cultural achievements in order to win international, mainly American, goodwill, fundamentally reconstituted modern Chinese statecraft. In the Westphalian international order, Chinese cultural and political elites realized that the assumption of foreign appreciation and emulation of China's cultural splendor was no longer tenable. Rather, China as a precarious member in the family of nations had to actively prove its civilized status to the international community, particularly the Western powers. Far more than a short-term policy, cultural diplomacy was intimately tied to the soul-searching over modern China's cultural identity and its dramatically shifted position in the world. This underscores the "externalization of the goals of the state" (*guojia mubiao de waiqing*) by transnational actors when the Chinese state alone was unable to carry out cultural diplomacy or coordinate related efforts.[17]

My relatively long temporal coverage spans common watersheds in modern Chinese historiography such as 1911 and 1949 and marks a century of fragmented international representations of China. Such fragmentation motivated concerned Chinese cultural and political elites in upending what they considered unjust international branding of China by ignorant foreigners and lower-class Chinese immigrants.[18] Rather than reifying their idealization of China's refinement, this book dissects it as a nationalist and gendered project by mostly Chinese men with privileged status. Due to the availability of sources, the bulk of this book focuses on the China Institute and Nationalist government in the middle half of the twentieth century. During this period the United States as a rising global power also became the primary target of the Chinese endeavors. The two major institutional actors do not constitute an exhaustive history of Chinese cultural diplo-

macy. They had to engage at different points transnational business interests from China to Chinatown, American philanthropies and scholarship, and the PRC diplomatic initiatives, all of which introduced alternative visions of Chinese culture to Americans. I take seriously these interlocutors and competitors in order to highlight their more consistent investment in the cause and the importance of the institutional approach to cultural diplomacy.

Despite their shared desire of asserting the sovereign definition of China, the China Institute and the Nationalist government adopted distinctive pedagogies. Directed by cosmopolitan Chinese intellectuals, the Institute carried out modest long-term programming through a mix of lectures, publications, curricular development, and loan exhibitions. Before the Cold War, its eclectic definition of Chinese culture embraced both venerable traditions and modern developments. While highlighting Chinese understandings of this living culture, the Institute also incorporated friendly foreign perspectives. Such eclecticism continued in the Cold War as it increasingly showcased antiquities to avoid political controversies, a strategy similarly adopted by Chinese American communities in publicly celebrating traditional festivals such as the Chinese New Year.[19] In contrast, the Nationalist government's cultural diplomacy was decisively self-Orientalist from its inception, and fixated on periodic exhibitions and performances of antiquarian legacies, with the storied former imperial art collections as a major tool. As the government boasted of painstaking stewardship of China's unique cultural patrimony against the menace of Imperial Japan and later the PRC, it tried to teach an exclusivist lesson on Chinese culture and claim its sole legitimacy in representing China. But the grand spectacle was often too evanescent to achieve lasting goals of cultural diplomacy without an institutional infrastructure.[20]

The result of such bifurcated cultural diplomacy was mixed. It gave Chinese cultural and political elites a voice in sharing their understandings of China on the international stage. But their endeavors teetered between the modest programming of a perennially underfunded cultural organization and fleeting spectacles of a government often fighting for survival and relevance. Chinese cultural diplomacy allowed limited circulation of Chinese understandings of China but faltered in continuously and effectively projecting such understandings due to the two institutional actors' financial and political constraints. Nevertheless, its checkered development in the United States left a rich legacy to the PRC as it gradually shook off the revolutionary excesses since the mid-1970s and increasingly resorted to traditional Chinese culture in engaging the outside world.

Terminology

Cultural diplomacy is gaining currency in both scholarly and policy circles but remains a loaded term. Some define it narrowly as "an actor's attempt to manage the international environment through making its cultural resources and achievements known overseas and/or facilitating cultural transmission abroad." It is one component of the broader public diplomacy, the efforts "to accomplish the goals of . . . foreign policy by engaging with foreign publics."[21] The contributors to an edited volume titled *Searching for a Cultural Diplomacy* take a more expansive view and generalize the term as "a tool and a way of interacting with the outside world" that intends to win the foreign affection. It is thus not dissimilar to public diplomacy, or Joseph Nye's concept of soft power.[22] However, it remains imperative not to assume the equivalency of concepts between its theoretical origin often in the West and the Chinese context.[23]

This book uses cultural diplomacy in order to elevate its explanatory power in China's quest for modernity and to further extend such explanation to peripheral polities in general. The existing usage of the term often results in a descriptive conglomerate of different kinds of noncoercive international engagement. What the China Institute and the Nationalist government tried to achieve was not just the *production* of what they considered Chinese culture but also *projection* of their intended messaging to the targeted audience. Given what they were running up against, the long-term effect of Chinese cultural diplomacy depended on a coherent infrastructure of persuasion. This goes beyond the mere content and specifically highlights the importance of projection, i.e., the channels through which packaged information is disseminated and contested. Compared to institution, infrastructure emphasizes material connectivity as a necessary precondition for persuasion of cultural appeals to work.[24] Such conceptualization interrogates cultural diplomacy as part and parcel of the inherent power dynamics of unequal intercultural encounters and offers meaningful comparison between the Chinese case and those of other more established contemporary powers, the focus of existing studies on the history of cultural diplomacy. The efforts by the China Institute and the Nationalist government confirm that modern China enjoyed limited agency in self-narration in such encounters where it was no longer the assumed center. Investigating the workings of the infrastructure of persuasion embeds cultural diplomacy in transnational nation-building and opens new analytic horizon for the concept in the Chinese context and beyond.

During China's tumultuous transition from a multiethnic empire to

nation-state, cultural diplomacy became a practice *avant la lettre*. *Wen-hua waijiao*, the literal Chinese translation, did not became a proper term among the Chinese reading public until the 1930s following the alarming reactions to Japan's vigorous cultural outreach on the world stage. And it did not stick until the early 1970s when the rapprochement between the PRC and the United States compelled the Nationalist government in Taiwan to openly champion it as an alternative to the increasingly difficult conventional diplomacy. The lack of lexical self-awareness did not prevent the earlier efforts by different Chinese to practice what the term entails.

Guomin waijiao, often translated as public diplomacy, was the most popular Chinese term since the early twentieth century to describe alternative international engagement beyond official diplomacy. But it does not fully account for the collaboration between the undertakings by the China Institute and the Nationalist government. Similar to many other Chinese neologisms at the turn of the twentieth century, it emerged through the translingual practice.[25] As the Japanese drew on classical Chinese to translate *diplomatie nationale* in contrast to *diplomatie bureaucratique*, they settled on *kokumin gaikō*. The same Chinese characters reentered modern Chinese as *guomin waijiao* through the massive Chinese translation of Japanese publications. The disintegrating central government in early twentieth-century China provided a conducive environment for the emergence and flourishing of *guomin waijiao*. It invited civic participation in international engagement but still shadowed official diplomacy in its focus on politics and economy.[26] While the efforts to seek sovereign control in defining China's cultural refinement also became imperative when the Chinese state lacked the capacity in doing so, *guomin waijiao* is not specific enough in highlighting such efforts.

Another useful Chinese term *xuanchuan* is bedeviled by its lack of a precise English equivalent. Literally meaning "to announce and publicize," it appeared sporadically in classical texts. In the mid-nineteenth century, foreign missionaries and their Chinese collaborators used the word to translate propaganda, which since the seventeenth century meant the active spread of the Christian faith. The Japanese incorporated the two-character word as *senden* and later used it to translate the politicized meaning of propaganda in the beginning of the twentieth century. *Xuanchuan* was then exported back to China and mistakenly acquired the status of a neologism. But the equivalence between *xuanchuan* and propaganda in their modern iterations is problematic. Unlike propaganda, which acquired negative connotations as the sinister manipulation of public opinions especially after World War I, *xuanchuan* does not always have the same baggage. The

two Leninist parties in China—the Chinese Nationalist Party and the Chinese Communist Party (CCP)—popularized the term in the 1920s as the political vanguard's legitimate communications in awakening the masses.[27] It has become a household word in modern Chinese, and the Nationalists sometimes described their cultural diplomacy as *wenhua xuanchuan*. English-language scholarship has also started to mainstream propaganda as a key strategy in information management by governments and corporations in various historical contexts.[28] To avoid the baggage of *xuanchuan* or propaganda, this study uses cultural diplomacy as a more neutral term.

Significance

This is the first scholarly monograph that examines modern China's outward cultural projection in the United States from its inception in the age of high imperialism to the eve of the PRC's ascendance as its predominant practitioner. The case study of China is also a more general inquiry into a peripheral polity's quest for cultural sovereignty in the unequal international order. This China-in-the-world approach intervenes in two broad bodies of literature: the historiography of modern China and its diaspora, and the histories and theorizing of intercultural encounters. China's engagement with the international order has long been a defining focus in modern Chinese history. But the study of Chinese modernity largely treats the country as a student, however innovative and sophisticated, in learning foreign technologies and ideas amid longstanding domestic traditions in order to achieve material wealth and power.[29] This book, while cognizant of the importance of such learning, demonstrates that the deepening encounter with the world since the late nineteenth century also fueled Chinese aspirations in teaching foreigners what they considered the best of their national culture. The understanding of Chinese modernity will be incomplete without the equal consideration of the quest for cultural admiration and respect.

The entangled relationship between the China Institute and the Nationalist government extends the well-trodden theme of Chinese state-society interactions from the domestic to transnational context. The weakening of the central Chinese government unleashed extensive civic activism in local governance at the turn of the twentieth century.[30] At roughly the same time, cosmopolitan intellectuals took the lead in articulating the need to project the refined image of China in order to win international recognition, which culminated in the founding of the China Institute in a

foreign country increasingly central to China's international standing. As a latecomer to cultural diplomacy, the Nationalist government had to collaborate with the Institute but was unable to fully co-opt it. Such a persistent bifurcated structure reflected the active negotiations between those intellectuals and the state, not to mention their transnational competitors, over the international narration of what Chinese culture was and should be. In this sense, Chinese cultural diplomacy should be understood in relation to the literature on the contemporary domestic debate over the meanings of Chineseness.[31] Though not at exactly the same pace, they were two sides of Chinese nation-building. As within territorial China, this project's unfolding in the United States exposed class exclusion among its proponents, who generally kept distance from ordinary Chinatown residents. Though not a history of Chinese Americans per se, this book offers a unique class-conscious perspective of particular segments of Chinese America.

More specifically, this book reevaluates the Nationalist government across the 1949 divide and critically compares the Cold War international outreach of two competing Chinese states, namely the Republic of China (ROC) on Taiwan and the PRC on the mainland. Scholars have come a long way from a narrow focus on its corruption and failure to a more fine-tuned perspective on its limited success in state-building. With few exceptions, however, such reevaluation focuses squarely on the pre-1949 period and seldom looks at the governments in mainland China and Taiwan in a continuous light.[32] The evolving cultural diplomacy from the 1930s to the 1970s highlights the Nationalist resilience despite ongoing sociopolitical turmoil. It also brings a cultural dimension to the growing literature in English that takes seriously the ROC's multifaceted international engagement even when its international legitimacy was facing serious challenges.[33] Treating the PRC's similar efforts as an important foil, this study sheds light on the differential deployment of Chineseness by rival Chinese states. If Maoism was the PRC's most iconic international brand through the 1970s, the ROC pushed, though not always successfully, to make the former imperial art collections under its care the enduring symbols of a different China.[34] The comparison between the two competing Chinese governments also strengthens the cultural dimension of the study of the Cold War international competition between divided nations in general.[35]

Chinese cultural diplomacy demonstrates the limited agency of a peripheral polity in self-representation in the unequal intercultural encounters. Focusing on the Chinese case helps fill the lacuna in the existing histories and theorizing of such encounters. The historiography of cultural diplo-

macy is skewed heavily toward short-term programs by more established powers in the twentieth century not facing immediate existential crises.[36] Internal debates over the definition and mission of national culture not-withstanding, these states were better equipped to coordinate a stable infrastructure of persuasion.[37] Such conceptualization of cultural diplo-macy, however, is not helpful in understanding polities not in the position of power. Successive sociopolitical upheavals in much of the nineteenth and twentieth centuries forced China to come to terms with its changing position in the world. As neither cosmopolitan Chinese nor the National-ist government alone could sustain what they strove to do, studying the Chinese case compels us to confront a different kind of rationale and infrastructure of cultural diplomacy. It is a bifurcated structure informed by dramatically shifted national identity and intimately tied to the state's struggle for legitimacy. Similar connections among cultural heritage, national identity, and state legitimacy also matter in the postcolonial and postconflict contexts. Former colonies in the Global South showed lim-ited agency in negotiating with former colonial powers about the return of indigenous artifacts, and both sides (re)constructed their national identities around these evocative objects.[38] Restoring the heritage site after armed conflicts could allow the victorious side to boast its legitimacy to both the domestic and international audience through such acts of benevolence and responsibility while meting out the victor's justice.[39]

My attention to the infrastructure of persuasion resonates with the historical scholarship on global communications and opens up another avenue in examining the significance of the Chinese case in broader lights. Scholars generally differentiate between content and network industries. In a similar vein, the infrastructure of persuasion functions as the network, which exerts enormous control over information flow in both the physical and discursive sense.[40] Additionally, the underlying yearnings for a more sovereign definition of China in Chinese cultural diplomacy were not dis-similar to the call for information or cultural sovereignty among select Global South countries in the 1950s and 1960s. It was a time when they aspired to upend the Western media dominance in both content and net-works and radically change the international communications infrastruc-ture through the UN framework.[41] Those similar feelings, however, were rooted in very different politics: Chinese cultural diplomacy in the period of my study never intended to challenge the privileged position the United States occupied in intercultural encounters. In lieu of fundamentally reshaping the power dynamics of such encounters, a bifurcated structure

was the best concerned Chinese elites could achieve against continuous sociopolitical upheavals.

Focusing on the United States in this study is due to both the availability of sources and the country's growing importance to China's international standing. Additionally, it critically engages the United States in the world as a burgeoning field and its methodology. The rich studies on the outward U.S. influence in winning hearts and minds, particularly during the Cold War, partly reflect the country's strenuous efforts in warding off international cultural influence in the mid-twentieth century.[42] But not adequately accounting for the world in the United States beyond immigration and ethnic formation inadvertently reinforces American exceptionalism and isolates the country from the actually multidirectional intercultural encounters. This book challenges the U.S. insularity by joining similar yet still scattered studies that foreground foreign actors' conscientious shaping of Americans' perception of outside cultures.[43] It situates the United States squarely in the cultural crosscurrents without losing sight of power politics.

Last but not least, this study revisits Edward Said's influential theorizing of Orientalism and its utility in understanding the politics of intercultural encounters. Based on modern European literary texts on the Middle East, Said offers a trenchant critique of the patronizing Western perceptions of the Orient as the exotic and backward other in need of imperial and colonial tutelage.[44] Since Said's initial exposition of such Western discursive violence and domination, scholars have been expanding the geographical contour of Orientalism to other theaters of unequal intercultural encounters, such as the United States and East Asia.[45] Effective in underlying the Western discursive power in constructing the imageries of the Other, the Saidian framework is however less articulate on how such construction also depends on the active participation of those who seem to be the powerless object of Western domination. Despite the call to reframe Orientalism as a more interactive process in the field of Chinese history in the 1990s, white Americans remain the predominant focus in scholarly writings on the construction of the imageries of China in the United States.[46] This book highlights the limited Chinese agency in curating sometimes self-Orientalist images in order to reorient Orientalism toward admiration and respect of China's longstanding cultural refinement, and by extension, support for the country itself. Steeped in unequal power relations, Orientalism is nevertheless not a one-way imposition by the West but rather a contested process over the cultural definition of the Other.

Outline

Besides the introduction and epilogue, the book consists of five substantive chapters. The first two begin with the early ideas of modern Chinese cultural diplomacy dating back to late Qing diplomats to the West. This paved the way for the respective emergence of the China Institute and the Nationalist government as two institutional actors in the 1920s and 1930s, which embraced distinctive visions and pedagogies under different circumstances. Treating international understandings of China as a worthy cause in and of itself, the Institute taught more inclusive lessons of ancient *and* modern China's cultural achievements through modest but ongoing lectures, exhibitions, and teacher education. Under waves of existential crises, the Nationalist government sought to stake an exclusive claim on China's orthodox cultural heritage through showcasing former imperial art collections and exploit their political utilities. The Sino-Japanese War ultimately forced the government to abandon its plan to exhibit such collections at the 1939 New York World's Fair. Instead diverse entrepreneurs and American philanthropists promoted Orientalist imageries of China for their commercial and charitable causes, which signaled the competition facing the messaging of China's cultural achievements. While the Nationalist government's foray into cultural diplomacy was not too far behind that of major powers', its limited resources and reliance on the spectacle in the United States, whose rules were largely set by Americans, bespoke the lack of its own infrastructure of persuasion.

The next three chapters examine the rise and fall of the contingent partnership between the China Institute and the Nationalist government from the mid-1940s to mid-1970s. The Institute's transpacific fundraising in the 1940s and 1950s scrambled the relationships among its donors from the major patron Henry Luce (1898–1967) to the Rockefeller family and the Nationalist government, and transformed the political economy of Chinese cultural diplomacy in the United States. While the Nationalist government was fighting for survival on the mainland and Taiwan, the contingent partnership between the hitherto two separate actors of Chinese cultural diplomacy did not erase their fundamental differences. This explains why the government separately staged two major spectacles of Chinese antiquities in the 1961–62 Chinese Art Treasures exhibition and the 1964 New York World's Fair, once its security under the U.S. military umbrella improved. But even at the height of its cultural diplomacy in the United States, the government still did not control its own infrastructure

of persuasion and continued to face competition by professionally trained American curators and diverse entrepreneurs of Orientalism. The PRC's international ascendance since the late 1960s, and particularly its rapprochement with the United States in the 1970s, ultimately unsettled the bifurcated Chinese cultural diplomacy between the China Institute and the Nationalist government. As the Institute hedged its position in the fluid situation, the Nationalist government reluctantly maintained ties but also dispatched its own troupe to give touring performances of Peking Opera, allegedly destroyed by the Cultural Revolution on the mainland. Rather than a helpless victim in the inevitable rapprochement between Beijing and Washington, Taipei shrewdly exploited the PRC's weakness and presented a different China increasingly rooted in Taiwan itself.

The book ends with a reflection upon the contemporary controversy surrounding Chinese cultural diplomacy. Despite the PRC's current hegemony in representing China, the resilience of Taiwan and more recent insurgence of Falungong, the banned spiritual movement since the late 1990s, continue to contest the international definition of Chineseness. Also, the PRC's tight grip over the Confucius Institute often turns counterproductive. The earlier history of Chinese cultural diplomacy where different institutional actors tackled similar issues of competing voices and infrastructure of persuasion thus remains relevant.

Slow Institutionalization

1875–1940

"The aim of the China Institute is to promote a closer cultural and educational relationship between China and America."
Brochure of the China Institute in America, 1926

Inchoate ideas of cultural diplomacy began to percolate among cosmopolitan Chinese intellectuals in the last quarter of the nineteenth century, when the Qing government started to dispatch regular diplomats to the West. Improvements in global communications quickened the circulation of China's negative imageries and increasingly challenged Chinese cultural confidence. As foreigners wrote contemptuously of various Chinese vices and Chinese immigrant laborers encountered virulent xenophobia, some educated Chinese saw it as their duty to wrestle the sovereign control of their native country's international branding away from those they considered condescending outsiders and lower-class compatriots. From its inception, Chinese cultural diplomacy was intimately tied to the painful acknowledgment and strenuous defense of China's cultural standing in the Westphalian system, a sea change from the international order China had been accustomed to since the fifteenth century. It heralded an unchartered direction in Chinese statecraft, and was both nationalist and elitist as different practitioners sought to project the best of China, its refinement and sophistication, to an international and largely Western audience,

whose opinions mattered a great deal in determining a particular country's standing in the family of nations. The need for cultural diplomacy thus presented new opportunities for some cosmopolitan Chinese who could not necessarily advance on the established career route such as the civil service examination. They aspired to be China's spokesperson and claimed new cultural authority through diplomatic service, diasporic upbringing, or study abroad. As the Chinese state struggled to stand on its feet between the late Qing and early Republic, such intellectual tides continued through the early twentieth century and culminated in the founding of the China Institute in America in 1926.

This chapter tracks how ideas of Chinese cultural diplomacy got gradually institutionalized from the late nineteenth century to the early years of the China Institute. There are at least three dimensions of this story. First, this transnational pedagogical project morphed from something hypothetical in the mind of cosmopolitan Chinese unable to engage the foreign public directly to the actual promotion of the best of China by those in good command of foreign languages. Due to linguistic barriers, some early Qing diplomats only had private musings of cultural diplomacy. At the turn of the twentieth century, it took those linguistically capable, many of whom were beyond the diplomatic ranks, to communicate their understandings of Chinese culture in foreign press and put the earlier musings into action.

Second, Chinese cultural diplomacy gradually transitioned from individual to institutional actors as represented by the China Institute. Despite the intense emotional investment in this project by generations of cosmopolitan intellectuals since the late Qing, many of them moved on to other callings in their life. It was not until the 1920s when a broad consensus emerged on the necessity of coordinating hitherto haphazard efforts through a more permanent organization. It was to be staffed by dedicated individuals who would make a career of Chinese cultural diplomacy. The China Institute was the institutional pioneer in that direction.

Third, the rising international stature of the United States gradually made it the primary target in Chinese cultural diplomacy. Early discussions of Chinese cultural diplomacy in the late nineteenth century aimed at Western powers in general and did not have a clear national focus. As the United States attracted more Chinese students by the early twentieth century, college campuses initiated these students into the American style associational life.[1] The founding and early operation of the China Institute were made possible by American-educated Chinese students, and pushed the United States to the forefront of institutionalized Chinese cultural diplomacy.

The institutionalization of China's international cultural outreach through the 1920s took place largely without the help from the Chinese state. The late Qing and early Republican government was too preoccupied with perennial external threats and domestic strife to maintain meaningful investment in teaching foreigners the best of China. When international publicity was on the agenda at all, the embattled government often outsourced it to foreigners at the Imperial Maritime Customs or Chinese merchants. The lag of state leadership sets the Chinese case apart from contemporary foreign powers that actively supported their national cultural diplomacy agencies. It testifies to the transnational reach of China's civic vitality, which, far beyond treaty revision and international trade as emphasized in existing scholarship, also encompasses cultural outreach.[2]

The rest of this chapter largely follows the chronological order and traces the deepening understandings of Chinese cultural diplomacy in the late nineteenth and early twentieth centuries. It begins with a brief recount of the late imperial Chinese thinking on cultural projection between roughly the fifteenth and eighteenth centuries. In a time when China prided itself as the center of civilization under heaven, Chinese assumption of the foreign emulation of their culture did not incentivize self-promotion. But such confidence began to crack since the country's humiliating encounter with the West in the mid-nineteenth century. This chapter then moves to the early Chinese scholar-officials posted in the West, who, despite being diplomatic representatives of the state, started to voice opinions of cultural diplomacy about which the state had little clue. Without much support from the state, Chinese cultural diplomacy deepened in the early twentieth century as more cosmopolitan Chinese beyond the diplomatic ranks began to share similar concerns and take actions. This chapter eventually turns to the founding and early operation of the China Institute, which represented the epitome in the slow institutionalization of disseminating Chinese cultural influence undertaken by cosmopolitan intellectuals.

From Cultural Superiority to Cultural Diplomacy

Ideas of modern Chinese cultural diplomacy gradually developed at the end of the nineteenth century, and it was a painfully slow process. A few hundred years before when Song China (960–1279) confronted the harsh reality of different steppe polities' control of parts of former Chinese territories, the elites channeled their bruised cultural ego into precocious nationalism instead of actively spreading it outward.[3] Late imperial rulers

of China in the Ming (1368–1644) and Qing dynasties held elaborate spectacles to impress foreigners with the grandeur of the Celestial Empire.[4] But as the introduction demonstrates, it was based on a dramatically different logic of China's cultural superiority and, by extension, lesser need of extraterritorial projection of Chinese culture. Even what educated Chinese perceived to be the "greatest change in three millennia" in late Qing did not immediately dislodge the belief in such superiority nor trigger actions to address the new reality. The Qing state's crushing defeat in the Opium Wars (1839–42, 1856–60) as well as its protracted civil war (1851–64) with the Taiping rebels provided momentum to the Self-Strengthening Movement, promoted mostly by forward-looking provincial officials between the 1860s and 1890s.[5] Under slogans such as "subdue the enemies by learning from their strong points" (*shi yi chang ji yi zhi yi*) and "Chinese learning as essence, Western learning as practical use" (*zhongxue wei ti xixue wei yong*), this movement conceded the practical yet still auxiliary value of Western learning in building up China's national defense. But the Self-Strengtheners, steeped in traditional education, retained their fundamental belief in the values of Chinese culture itself and never considered the promotion of such culture among foreigners a particularly urgent project to raise China's perilous international standing.

In the West it was still foreigners, particularly missionaries, who had broader contact with Chinese beyond treaty ports and dominated the representation of Chinese culture since the late nineteenth century. Unlike the accommodating Jesuits, who had fraternized with the mandarins and painted China generally in a positive light, the new wave of Protestant missionaries, many hailing from Britain and the United States, further contributed to the negative turn of China's international image since Montesquieu's thesis of oriental despotism in the mid-eighteenth century.[6] A select few, such as Samuel Wells Williams (1812–1884), grew more fond of Chinese cultural traditions and later became early sinologists in Western universities. But in general, long residence in remote areas and interactions with the downtrodden did not give Protestant missionaries the most positive impressions of Chinese culture. Against the benchmark of modern Christian civilization, they highlighted Chinese vices such as superstition, opium, and foot binding and sought to change China in that direction. *Chinese Characteristics* by the American Congregational missionary Arthur Henderson Smith (1845–1932), first published in 1890, is a popular example in this genre.[7] Local gentry, whose cultural authority eroded after the missionary penetration of China's hinterland, vehemently opposed Christianity as early as the 1860s.[8] But direct challenges of the missionary char-

acterization of China to assert the Chinese voice still awaited deepening Chinese nationalism and, by extension, cultural diplomacy.

The transnational career of Wang Tao (1828–1897), including a stint in introducing Chinese classics to the international audience, confirms the limited Chinese enthusiasm in taking control of China's international image in the mid-nineteenth century. With a lower degree from the civil service examinations and little prospect in officialdom, Wang learned English while working at the London Missionary Society Press in Shanghai in the 1840s. Wang first demonstrated his bicultural competence by assisting the new Chinese translation of the Bible. When Wang sought refuge in the British colony of Hong Kong in 1862 due to his involvement in the Taiping Rebellion, he met James Legge (1815–1897), a Scottish missionary interested in Chinese learning. During the 1860s Wang played an essential role in Legge's massive English translation of Confucian classics.[9] Although Wang later became a leading advocate for China's political and economic reform, he never seemed to include his own earlier experience in publicizing the Chinese classics as part of the reform agenda.

It was the overseas posting of diplomats, a novel practice in Chinese foreign relations that became routine since 1875, that gradually sharpened the Chinese recognition of the necessity of cultural diplomacy. Unlike the diaspora of Chinese labor to Southeast Asia and the Americas, diplomatic posting in the West marks the unprecedented foreign sojourn of well-educated Chinese in China's encounter with the outside world. As they sought new avenues toward career advancement through extended overseas stay, the early diplomats took note of the huge differences between their native and host countries. Even without active prodding from the Chinese government, they were keen on expressing cultural pride steeped in their belief in China's longstanding preeminence. For example, Bin Chun (1804–1871), the first Qing envoy to the West in 1866, used stylized prose and poetry to depict foreign admiration of China's cultural refinement. Zhang Deyi (1847–1918), an English translator in several early missions who later rose on diplomatic ranks, defended the superiority of Confucianism in front of European acquaintances and Japanese visitors.[10] Xue Fucheng (1838–1894), the Qing minister to various European powers in the early 1890s, elaborated on the popular theory of Chinese origins of Western learning in order to justify more reforms, and proclaimed in his diary that "the teaching of Jesus is going to decline, and the teaching of Confucius is going westward."[11]

If these expressions still reflected some residual sense of cultural superiority, Zeng Jize (1839–1890) first articulated the rationale of cultural diplo-

macy for China in a drastically different world order. Son of Zeng Guofan
(1811–1872), the famous scholar-general whose provincial army helped
the ailing Qing suppress the Taiping Rebellion, Jize was the Qing minister
to Britain and France in the late 1870s and to Russia in the first half of the
1880s. In his diary entry in late May 1879, shortly after the beginning of
his tenure, Zeng the junior shared with Halliday Macartney (1833–1906),
the British translator in the Chinese legation, his vision of establishing
"Chinese academies" in Western Europe. Teaching foreign students who
"appreciate Chinese learning" would over time make them "agreeable to
our manners and understand our subtleties," a cause that would be "secretly
beneficial" to China. Zeng pointed to the unprecedented Chinese *teach-
ing* in the West in relation to Chinese *learning* from the West, which had
been in practice for over a decade. Zeng's cultural diplomacy was rooted in
his balanced international outlook that neither deified nor demonized the
West. His solid classical education and first-hand experience of Western
powers thus gave him a multicultural mentality. Yet under severe budgetary
strains, Zeng knew that his vision was simply "idle talk" (*kongyan*).[12]

With rudimentary knowledge of English and French, Zeng only
speculated on cultural diplomacy in his diary in Chinese. Another late
Qing diplomat Chen Jitong (1851–1907), however, directly presented the
image of "a rational and 'harmonious' Chinese civilization" with his fluent
French. Raised in the vibrant literati culture in Fuzhou, Chen attended
the Navy Yard after his family fortune declined and mastered French in
this prominent new institution of Western learning established during the
Self-Strengthening Movement. As the secretary and military attaché of the
Qing legations in Berlin and Paris in the 1880s and early 1890s, the cos-
mopolitan Chen fashioned himself as a *lettré chinois* well versed in French
culture, and he strove to disabuse the French public of China's negative
stereotypes in his extensive publications in the popular press and presenta-
tions on China in Parisian learned societies.[13] In one of his most famous
books, *Les chinois peints par eux-mêmes*, which had immediate English and
German translations after its initial publication in 1884, Chen defended
the Chinese "title to throw his modicum of marvelous inventions into the
universal balance where the services rendered to humanity are weighed."
He also pleaded readers to understand "the least known" country "as it is,"
rather than, according to popular tales, simply a place where people "were
accustomed to eat dogs."[14]

As China's defeat in the first Sino-Japanese War (1894–95) dashed the
high hopes of the Self-Strengthening Movement, the deepening sense of
national crisis galvanized a more spirited defense of the sovereign control

of China's international image. Starting from the early twentieth century, more educated Chinese beyond diplomats went abroad, an experience that heightened their cultural nationalism. Though often labeled conservative, they were not so much advocating blind preservation of the status quo as affirming the broader values of Chinese culture in a time of seemingly undisputed Western dominance.[15] The more linguistically capable among them also took such messages directly to the foreign public and contributed to the further development of Chinese cultural diplomacy.

The influential national essence (*guocui*) school in the opening decade of the twentieth century is one such example. Taking inspirations from their sojourn in Japan, this group advocated anti-Manchu nationalism and conscientious preservation of the best of Han Chinese culture against the perceived Western cultural encroachment through their flagship journal *Guocui xuebao*. Compared to the Self-Strengthening Movement, the national essence activists were more determined to address the existential anxiety of China's cultural identity.[16] Based on his mastery of Chinese classics and reading of Chinese translations of Western thought, Zhang Taiyan (1869–1936), a high-profile *guocui* advocate, argued for a multicultural vision in which the Chinese and Western cultures, with separate but equal values, should be treated in their own right.[17] Despite the lack of direct communications with the foreign public, Zhang's vision fortified the intellectual foundation of Chinese cultural diplomacy, namely the inherent values of Chinese culture in the age of high imperialism.

The coinciding new wave of studying abroad further enabled a younger generation of cosmopolitan and bilingual Chinese to directly challenge the representations of China by foreigners, particularly the missionaries. Zhang Shizhao (1881–1973), a future critic of the New Culture Movement (1915–20), attempted to assert the Chinese representation of China while studying at the University of Aberdeen. After having read Arthur Smith's famous *Chinese Characteristics*, Zhang wrote a critical response to the popular magazine *The Spectator* and his letter was published in mid-August, 1910. Based on his own bona fide classical education, Zhang sharply questioned foreign missionaries' knowledge of China given their own education and association with lower-class Chinese converts and compradors. Zhang's determination in establishing the orthodoxy of cultural refinement in understanding China among the British public elicited further interests from the magazine's readers as well as Smith himself, who happened to be in Britain for a conference then. Their replies, in moderate or confrontational tones, defended the missionaries' sympathy to China compared to other foreigners and the value of Christianity in modernizing China.

In a second letter to the magazine, Zhang recounted the moral influence of Confucianism and China's other cultural achievements dating back to the Hundred Schools of Thought between 600 and 200 BCE, long before the birth of Christianity. But in the eyes of his interlocutors, such cultural traditions, however longstanding, were still far from comparable to what Christianity could offer to China.[18] This episode reinforced Zhang's belief in the Western misunderstandings of China, and it motivated his future defense of Confucianism among what he believed was the Western-inspired onslaught of China's cultural essence.[19]

Wu Tingfang (1842–1922), the former Qing minister to the United States and the Republic's first minister of justice, published *America through the Spectacles of an Oriental Diplomat* in the United States in 1914. Unlike classically trained Chinese intellectuals seeking new opportunities through diplomatic service or study abroad, Wu's cosmopolitanism stemmed from his birth to Chinese parents in Malacca, then part of the British Straits Settlements, and family and career connections spanning China, Britain, the British colony of Hong Kong, and the United States. An early detailed comparison between American and Chinese societies aimed at the foreign public written by a Chinese author, Wu's book affirmed the relative merits of both nations. But in his chapter on American versus Chinese civilization, Wu, well aware of the deep-seated Western prejudice against China, still exhorted "the white races . . . to learn from their colored brethren."[20] This was in essence a renewed call of what Chen Jitong had tried to achieve three decades earlier in Paris.

The outbreak of World War I in 1914 and the ensuing industrial scale carnage heightened Chinese intellectuals' concerns about the perversion of Western culture. It also boosted renewed appreciation of the universal values of their native culture and provided further impetus of Chinese cultural diplomacy. Despite the iconoclastic impact of the New Culture Movement, contemporary Chinese intellectual tide also featured somber yet no less influential cultural criticisms such as *Ouyou xinying lu* (Impressions of a European Tour) by Liang Qichao (1873–1929) and *Dongxi wenhua jiqi zhexue* (Eastern and Western Cultures and Their Philosophies) by Liang Shuming (1893–1988).[21] Juxtaposing what appeared to be the materialistic and aggressive West and the spiritual and peaceful East, these authors believed that China possessed the cure to the Western malaise. Informed by his tour of the post–World War I Europe, Liang explicitly exhorted the Chinese youth to respect and "synthesize" (*zonghe*) their national culture with Western research methods and "spread outward" (*wang wai kuochong*) such amalgamated new Chinese culture for the benefit of all humankind.[22]

The celebrity publicist for Chinese culture on the international stage following the outbreak of World War I was the eccentric and interracial Gu Hongming (1857–1928). Similar to Wu's diasporic and colonial entry into Chinese officialdom, Gu was born in British Penang and educated in Scotland and continental Europe in the 1870s before serving in the Qing government from the 1880s. After the 1911 Revolution, he proudly kept his queue and remained a staunch monarchist and defender of Confucianism. Unsatisfied with what he considered stiff translations by James Legge (without acknowledging Wang Tao's critical assistance), Gu had been retranslating Confucian classics, such as the *Analects* and the *Great Mean*, into English since the late nineteenth century. These works were soon followed by his English-language essays on contemporary Chinese politics from the early twentieth century.[23]

Gu's most celebrated work was *The Spirit of the Chinese People*, an English-language treatise originally published in Beijing in 1915. Amidst the raging war in Europe, Gu finished the first comprehensive exposition on Chinese culture in English by a self-claimed Chinese author, which was soon translated into other languages. Taking exception to what he considered incorrect foreign depictions of China, Gu opined that the depth, broadness, simplicity, and delicacy of the Chinese civilization were beyond the Europeans and Americans because of their respective deficiency in these traits. Under criticism once again was Arthur Smith, who in Gu's opinion unjustifiably faulted the Chinese want of exactness due to his lack of understanding of the Chinese "life of the heart." The British diplomat and sinologist Herbert Allen Giles (1845–1935) in his view was a man who could "translate Chinese sentences" but could not "interpret and understand Chinese thought."[24] Similar to Chen Jitong's *Les chinois peints par eux-mêmes*, *The Spirit of the Chinese People* attempted to lay out universal values of refined Chinese culture. But unlike Chen's dashing literary flair, Gu's vision focused squarely on what he thought Confucianism entailed.[25]

As radical critiques of Confucianism and traditional China in the 1910s morphed into *zhengli guogu* (reorganization of heritage) in the 1920s, the moderation of the New Culture Movement triggered a new scholastic dimension of Chinese cultural diplomacy.[26] This new intellectual development emphasized a scientific and systematic reevaluation of China's traditions, not just Confucianism but also other schools.[27] Moreover, it aspired to outcompete foreign sinologists on a more organized basis and make Chinese scholarship on China the defining interpretation in international sinology. Despite some methodological differences, Chinese scholars had the shared exasperation: "why can we not disseminate our culture ourselves

but have to wait for others to interpret it?"[28] Such sentiments of academic nationalism were steeped in the flourishing cultural internationalism in the early twentieth century. Despite the brief hiatus during World War I, scholarly exchange became increasingly prominent in international relations.[29] This enabled Chinese scholars of different political persuasions to keep abreast of the contemporary sinology abroad, particularly in France and Japan, where Édouard Chavannes (1865–1918), Paul Pelliot (1878–1945), Shirotori Kurakichi (1865–1942), and Naitō Konan (1866–1934) won international acclaim for their philological, archaeological, and historical examinations of Chinese borderlands and frontiers. Considering these achievements China's national disgrace, Chinese scholars were motivated to write comprehensive studies of China from the perspective of its heartland and bring back the global center of China studies from Paris and Kyoto to Beijing.[30]

The 1920s witnessed unprecedented institutionalization of such ambitions thanks to the incorporation of *guoxue* (national learning) in Chinese higher education. While there had been periodic individual gestures and publications in earlier decades, institutional coordination was almost nonexistent. In 1902, for example, those representing China at the first International Congress of Far-Eastern Studies in Hanoi, a special International Congress of Orientalists promoted by the French colonial authorities in Vietnam, were from the French mission to China and the British controlled Imperial Maritime Customs and the North China Branch of the Royal Asiatic Society.[31] By the 1920s, several national, private, and missionary universities established their institutes of national learning.[32] Such institutional synergy enabled the new generation of cosmopolitan Chinese intellectuals to envision a collective goal to make Chinese scholarship on China the defining interpretation among the international sinological community.

An Unprecedented Platform

Since the first regular overseas posting of Chinese diplomats in 1875, several generations of intellectuals came to realize the importance of projecting China's favorable international image on Chinese terms. But few made it their committed career choice, which deprived Chinese cultural diplomacy of its institutional foundation. The founding of the China Institute in America in New York in 1926 changed much of that. It was the culmination of the slow institutionalization of disparate strands of Chi-

nese cultural diplomacy since the late nineteenth century. Previously, Chinese intellectuals' occasional cultural diplomacy gestures such as foreign language publications and media appearances entailed little control over the informational platform itself. The Institute, however, emerged as an infrastructure of persuasion based in the foremost American metropolis with broad support from both cosmopolitan Chinese and Americans. It was thus different from organizations with similar goals of promoting public understandings of China abroad but without meaningful Chinese leadership, such as the China Society founded in Britain in 1906, and the China Society of America founded in New York in 1911. By the late 1950s, the latter was housed on the premises of the China Institute and even considered a merger, an indication of its decline.[33] Particularly significant to Chinese cultural diplomacy were the Institute's first two directors, Guo Bingwen (Kuo Ping Wen, 1880–1969), the founding director through 1930, and Meng Zhi (Paul Meng, 1900–1990), Guo's associate and successor who retired in 1967. Both Chinese Christians and graduates of American universities, Guo and especially Meng made a career out of publicizing China's cultural achievements.

The early history of the China Institute was intricately tied to the China Foundation for the Promotion of Education and Culture (*Zhonghua jiaoyu wenhua jijin dongshihui*), another important entity in the history of cultural relations between China and the United States. In 1908 the U.S. government remitted the first batch of the surplus Boxer Indemnity as the earmarked funding for the establishment of the Tsinghua School, a preparatory institution for Chinese students to continue their higher education in the United States.[34] The Indemnity was part of the Boxer Protocol of 1901, signed by the Qing government and various foreign powers to conclude their occupation of Beijing following the Boxer Rebellion (1898–1900). Many cosmopolitan Chinese intellectuals hailed from this school, including Meng Zhi and Cheng Qibao (1895–1975), important future staff at the Institute. Proposals for another remission to support Chinese education and culture surfaced after China joined the Allied powers during World War I, and were finally approved by Congress and President Calvin Coolidge in May 1924, a global moment of resurging interest in intercultural exchange. Four months later, the China Foundation was established in the warlord government's capital Beijing with ten Chinese and five Americans on its board. The chief mission of this joint body was to administer the second batch of the Boxer Indemnity remission for broadly defined educational and cultural projects in China.[35]

While the major programming focus of the China Foundation was

within China, two visionary trustees, Paul Monroe (1869–1947) and Guo Bingwen, persuaded the board to set up an organization in the United States to promote public understandings of China. Monroe, vice chairman of the board and professor of educational history and administration at Columbia University's Teachers College, frequently visited China and colonial Philippines in the 1920s on lecture and research tours.[36] A former student of Monroe, Guo was the first Chinese to receive a doctorate from Teachers College in 1914 and the founding president of the famed National Southeast University, the first national university south of the Yangzi River, in the early 1920s. After having resigned his presidency in 1925 due to political controversy, Guo went on a lecture tour in the United States to increase the public understandings of China.[37] As concurred by Monroe, Guo sensed the need of a more organized approach in promoting such understandings in the United States. It was Guo who drafted the proposal for the China Institute, which Monroe presented to the board of the China Foundation.[38] It was approved in February 1926 and the China Institute was formally founded in New York in May. With Guo elected as the founding director, the Institute aimed to "promote a closer cultural and educational relationship between China and America." To get it started, the Foundation also provided the initial three-year funding of over $50,000.[39]

Existing accounts on the founding of the China Institute often highlight the role of John Dewey (1859–1952) and his Chinese student Hu Shi (1891–1962).[40] Despite the lack of direct documentation, available evidence does not support such purported role of Dewey or Hu. To be sure, Dewey and Hu were influential figures in the history of Sino-U.S. cultural exchange. At the invitation of Hu, Dewey spent two years in China between 1919 and 1921, and his numerous lectures made him an icon for new education.[41] Both would welcome the founding of the Institute, yet neither of them was actively involved in the China Foundation in early 1926 when it approved Guo's proposal to establish the Institute. Dewey, although an early trustee of the Foundation, had already vacated his position. In the same year, Hu was busy accompanying a British delegation in China to discuss the details about setting up an organization similar to the China Foundation to administer the British remission of the Boxer Indemnity.[42]

Furthermore, unlike Guo, Dewey and Hu had no established track record as seasoned administrators in educational and cultural institutions, despite their influence as inspirational intellectuals. Coming from a Christian family in Shanghai, Guo had already had extensive work experiences at modern institutions such as the publishing house before furthering his education at the College of Wooster and Teachers College. During his stu-

dent days in the United States, he actively participated in extracurricu-
lar activities and helped organize the national Chinese Student Christian
Association in North America and later Chinese Students' Alliance. Guo's
impressive leadership continued at the National Southeast University after
his return to China. It was the combination of intellectual vision *and* prac-
tical know-how that made Guo and Monroe the more convincing founders
of the first Chinese cultural diplomacy organization abroad.[43]

The China Institute's entanglement in China's partisan politics despite
its professed "non-political" nature is another aspect of its early history
that is often missing in existing studies. The mid-1920s witnessed China's
chaotic political transition from the warlord to Nationalist government
and Guo's career in the warlord era had long raised red flags among the
Nationalist circles. As president of a prospering university in the early
1920s, the pragmatic Guo sought patronage from the provincial warlord
and limited radical politics on campus. Yet on its faculty was Yang Xingfo
(1893–1933), an outspoken professor of business administration and engi-
neering who was not only a Nationalist veteran but also became sympa-
thetic to communism. Yang's risky politics led to his dismissal in 1924.
Supported by the Nationalist machination in Shanghai, Yang accused Guo
of colluding with the warlord government in the newspapers and incited
student protests that ultimately forced Guo's resignation in 1925.[44] While
the surviving historical records in China today are often favorable to Yang
because of his communist sympathies, it is important to acknowledge the
masqueraded partisan maneuvers in the name of mass politics in the 1920s
from both the left and right.[45]

Guo's earlier distaste of radical politics continued to bedevil his ten-
ure at the China Institute. Backed by Roger Greene (1881–1947), a like-
minded trustee of the China Foundation, Guo tried to continue his prag-
matic leadership in New York. But to Guo's dismay, at a time of imminent
regime change in China, "people were not so much interested in state-
ments regarding normal activities, like education," and "political subjects
[were] . . . most in demand."[46] When the Institute was founded in May
1926, the Guangzhou-based Nationalist government was preparing the
Northern Expedition (1926–28) to unify the country. As the victorious
Nationalist troops reached the rich Yangzi River delta in early April 1927,
Greene received three similar letters from Chinese students in the United
States demanding a change of leadership at the Institute. They claimed
that Guo's return to China, which was actually not true, at a critical time
in Sino-U.S. relations warranted the immediate appointment of an act-
ing director. This new acting director should help "destitute" students and

combat "sinister" and "malicious propaganda," probably referring to the hostile U.S. media reaction following the Chinese troops' violence against foreign residents in Nanjing in late March.[47] The actual motivation behind these letters are hard to ascertain, but it is very probable that they were from the pro-Nationalist activists.[48] Except for one letter by an individual student with no mention of affiliation, the other two were from representatives of the Chinese Students' Alliance and the Chinese Student Christian Association, two big organizations of Chinese students in the United States where Guo had been involved before. This suggests an organized opposition to Guo's tenure at the China Institute. During his conversation with Greene in mid-April, Guo speculated without further elaboration that these letters were incited by "a particular individual who wants the job." In Greene's opinion, the student groups were unhappy with Guo because "he [did] not engage in propaganda for the Nationalist Party directly."[49] Greene's assessment confirms that the political controversy surrounding Guo followed him from China to the United States.

Guo did not cave in to the immediate pressure as two years ago.[50] But his whereabouts soon motivated the radical wing of the Nanjing-based Nationalist government to attempt another move against him and the organizations he was affiliated with. As the main funder of the China Institute, the China Foundation was supposed to function as an autonomous entity to promote educational and cultural projects in China. Under the lingering influence of revolutionary diplomacy (*geming waijiao*), the radical Nationalist slogan for the immediate end of foreign privileges in the 1920s, the Foundation became a political target.[51] In 1928, there was rumor of Guo's appointment as the new commissioner of the Ministry of Foreign Affairs in Beiping (Beijing). His previous dealings with the warlord government and deep connections to the China Foundation—as trustee and director of the Foundation-supported China Institute—incited more scrutiny of the Foundation. Yang Xingfo, the professor fired by Guo, seized the opportunity to advocate a government reorganization of the Foundation. Then deputy head of the University Council (*Daxue yuan*), equivalent of Ministry of Education, Yang used Guo's connections to the former warlords to justify the government appointment of new trustees for the Foundation, which according to its constitution should be self-perpetuating. Although the Nationalist government initially approved Yang's bold proposal, it raised alarms among the trustees and even led to the U.S. embassy's threat of the suspension of the Boxer Indemnity remission, which was the financial lifeline of the China Foundation and, by extension, the China Institute.

A complicated maneuver in the composition of the board, which included Guo's resignation, finally reached a compromise satisfactory to all parties in 1929, and the attempted reorganization of the Foundation stopped short of drastically changing the status quo.[52]

While the China Foundation survived the proposed government reorganization, this incident resulted in important changes to the China Institute and ultimately Meng Zhi's directorship. Existing accounts treat the changes at the Foundation and the Institute in the late 1920s as separate events. But given the Foundation's critical importance in supporting the Institute, the potential government takeover of the Foundation was unlikely not to have a significant impact on the nascent Institute. The uncertainty of the Foundation's fate resulted in its decision to terminate funding for the Institute by 1929. Guo's efforts to turn the China Institute into a more self-sufficient membership organization were roughly simultaneous, but for unknown reasons his plan was rejected by the Foundation's board in June 1929, which means that the Institute could fold its operations by the end of that year.[53] Meng, who had started working at the Institute as honorary secretary in 1928, initiated another attempt of reorganizing. In early 1930, the China Institute finally assembled an independent board of trustees with Monroe as its president and Meng became the new deputy director. When Guo went back to China later that year to head the Nationalist government's foreign trade bureau, Meng assumed the directorship and remained in the position for almost four decades.[54]

Twenty years Guo's junior, Meng came to the China Institute with less political baggage from the warlord era and more experiences with Chinese students in the United States. Scion of a forward-looking gentry family, he attended modern schools such as Nankai in Tianjin and Tsinghua in Beijing, and participated in the famous 1919 student protest against the transfer of the German lease on Chinese territories to Japan during the Paris Peace Conference. In Beijing, he also became a Christian and befriended U.S. missionaries who, as chapter 3 will demonstrate, would be useful in his later career at the Institute. Supported by the Boxer Indemnity Scholarship, Meng went to Davidson College and Columbia University, where he further honed his organizing skills. Upon graduation he served as the YMCA student secretary and traveled extensively in the United States, China, and Europe before joining the China Institute. An active member of the Chinese student community, Meng was also the Chinese Student Christian Association's general secretary when the Association asked for Guo Bingwen's replacement together with some other Chinese students.

Whether and to what extent Meng was involved in the complaint against Guo was unclear, but his appointment elicited no opposition from the Nationalist circles.[55]

Because of the unparalleled details in Meng's memoir, existing studies tend to rely on it to reconstruct the early history of the China Institute. But it is important to cross-examine Meng's accounts with contemporaneous archival sources when possible. The Institute's independence following Meng's reorganization, for example, was nominal at best. In fact, the Institute was never able to acquire an endowment to secure its operations even through the 1970s. The China Foundation, after having survived the controversy of the attempted Nationalist takeover, began to pump money again to the financially challenged Institute later in 1930. The Institute's financial dependence on the Foundation did not really change compared to the late 1920s. According to available data, over 60 percent of the Institute's operating budget still came from the Foundation through the late 1940s.[56] As chapter 3 will demonstrate, the Institute was not compelled to break away from such dependency until the early 1940s when a more threatening Nationalist proposal to abolish the Foundation altogether forced the Institute to begin an extensive fundraising campaign.

Despite their apparent differences, Guo and Meng together turned the China Institute into the embodiment of institutionalized efforts to promote broader understandings of China. Similar to earlier proponents of the cause, the Institute's first two directors were cosmopolitan and patriotic Chinese who supported what they believed to be an inherently valuable undertaking. What distinguished them was their dedication to the cause for years or decades, rather than occasional dabbling, and their shepherding of it through an unprecedented organizational platform. As will be made clear, both favored an eclectic approach to Chinese culture and tried to keep partisan politics at arm's length. Their efforts helped keep Chinese cultural diplomacy, mostly an ideal among earlier generations, going when the Chinese state was unable to.

The founding of the China Institute also signaled the increasing focus of the previously untargeted ideas of Chinese cultural diplomacy on a particular country that was becoming a global hegemon and would play a disproportionate role in China's international engagement. Despite the utter disappointment in the Wilsonian doctrine among educated Chinese after the Paris Peace Conference in 1919, the United States still enjoyed a more favorable reputation than the European powers and Japan due to its lack of apparent territorial ambitions in China.[57] And Sino-U.S. relations in the early twentieth century were particularly deep in cultural and educational

exchange. American missionaries ran the largest number of Christian educational institutions in China, and the United States was also a top destination of an increasing number of Chinese students studying abroad.[58] Coming of age at a time of fermenting Chinese nationalism, these students were yearning for, in the words of one of them, "better means and facilities . . . to bring Chinese news and views uncolored and unprejudiced before the world."[59] As it turned out, the United States was increasingly the "world" for Chinese cultural diplomacy. Based in its foremost metropolis, the Institute would be one of the key "means and facilities" in reaching Americans.

Modest Yet Persistent Programming

As an organization that aspired to foster "a closer cultural and educational relationship between China and America," the China Institute first served as China's de facto educational liaison agency.[60] In the 1870s the Qing government dispatched an official envoy to accompany more than one hundred boys sent to study in the United States in the Chinese Educational Mission.[61] By the 1920s, the Chinese government was simply too preoccupied with domestic turbulence to maintain a similar office. The Institute represented the warlord government's Ministry of Education as well as the National Association for the Advancement of Education (*Zhonghua jiaoyu gaijin she*)—a professional organization established in 1921 with Guo as one of the founding trustees—at the fiftieth anniversary conference of the American Library Association in Philadelphia and Atlantic City in 1926.[62] At a time when hundreds of new Chinese students came to study in the United States every year, the Institute also provided essential advising. In 1933 the president of Tsinghua appointed Meng Zhi, an alumnus, honorary director of the Chinese Educational Mission to supervise Tsinghua students and make general recommendations about Chinese students in the United States.[63] In collaboration with Chinese host institutions, the Institute also facilitated the visit of diverse American intellectuals, such as William Heard Kilpatrick (1871–1965), professor of educational philosophy at Columbia University Teachers College, in early 1927, and W. E. B. Du Bois (1868–1963), the leading African American thinker, in late 1936.[64]

But it was in "the stimulation of general interest in America in the study of Chinese culture" that the China Institute made unprecedented contributions.[65] Unlike the uncoordinated efforts by earlier visionaries, the Institute forged a more organized approach to teaching refined Chinese culture through an institutional platform. Its debut appearance was at the

Sesquicentennial Exposition in Philadelphia in 1926 where it organized an exhibition of the historical evolution of Chinese education on behalf of the National Association for the Advancement of Education and the China Foundation. Since the mid-nineteenth century, such expositions had become a prime space for showcasing economic and cultural achievements of different nations.[66] This undertaking bore the personal influence of the Institute's founding director Guo as he served as trustee in both organizations. Additionally, his PhD dissertation at Teachers College was a comprehensive study of the Chinese educational system from ancient times until the early twentieth century. Guo and his associates managed to collect more than one thousand items from several provinces and commissioned some of the future well-known Chinese architects then studying at the University of Pennsylvania to design the 1,100 square feet of exhibition space in the Palace of Education and Social Economy in traditional Chinese style. In the prize-winning exhibit, visitors could see "the fruits of an educational system 5,000 years old," from the ancient literacy primers to the development of modern universities in China.[67]

In 1930 Mei Lanfang (1894–1961), China's foremost Peking Opera actor of young female (*dan*) roles, staged a critically acclaimed U.S. tour in New York, Chicago, San Francisco, Los Angeles, and Honolulu. Recent Chinese studies are paying more attention to the China Institute's role in this large spectacle of Chinese cultural diplomacy, as it appears to be the only surviving institution that helped orchestrate Mei's tour.[68] The Institute undoubtedly provided logistical support for Mei's presence in New York, but it is important not to exaggerate the Institute's significance as its precarious finance made it unlikely to play any substantive role outside the New York metropolitan region. In fact, existing evidence suggests a separate entity managed at least Mei's tour in California.[69] In the 1920s, the warlord government periodically contracted Mei's performances at his private residence in Beijing to impress foreign visitors. Encouraged by such success, the enterprising Mei was eager to extend his influence further afield, which could in turn boost his domestic box office. It took the encouragement of Paul Reinsch (1869–1923), the departing U.S. minister to China, and the painstaking fundraising and preparations by Mei's team in China before he set sail from Shanghai in late 1929. Assisting Mei were Qi Rushan (1875–1962), a leading theorist of Peking Opera, and Zhang Pengchun (1892–1957), a Tsinghua and Columbia graduate and proponent of the new spoken drama.[70] A Peking Opera aficionado himself, Meng Zhi had also been in conversation with Mei's team, particularly Zhang because of their shared educational background, about the best way to perform in

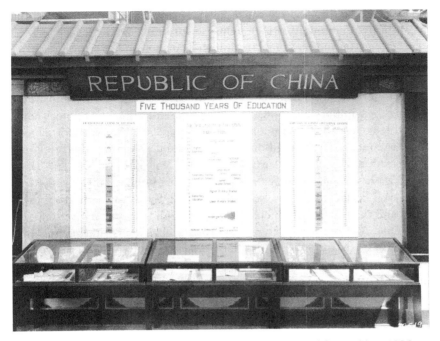

Fig. 1. China Institute exhibit at the Philadelphia Sesquicentennial Exposition, 1926. (Courtesy of PhillyHistory.org, a project of the Philadelphia Department of Records.)

the United States even before officially joining the Institute.[71] Assuming the inability of ordinary Americans to appreciate "the more subtle acting techniques," the planners settled on "tactical orientalism" in the form of the spectacle of dramatic choreography and colorful costume in order to impress.[72] Mei's performance opened with great fanfare in New York in mid-February and continued to dazzle audiences and the press throughout the country. The Hawaiian-born Chinese American actress Soo Yong (Yang Xiu, 1903–1984) provided brief explanations in English before each scene, which was informative for the uninitiated.[73] To give the audience more background knowledge of this unfamiliar genre, the Institute also issued a brochure that included, among other things, essays by Hu Shi and Qi Rushan and explanatory notes of all the acts in the repertoire.[74]

While Mei's glamor garnered widespread critical acclaim for himself and China's cultural sophistication, the spectacle as cultural diplomacy only achieved ephemeral effects. A revealing contrast is the renowned Russian actor Konstantin Stanislavski (1863–1938), who toured the United States in 1923 and 1924, a few years before Mei. Following the initial fanfare,

Stanislavski and his associates maintained ongoing conversations with the local theater community, which helped institutionalize the legacy of Russian acting. Mei and the China Institute fell far short in this critical regard.[75] After the flurries of media attention to elegant Chinese theater tapered off, the evanescent spectacle of Mei's tour did not achieve much long-term impact, nor did it advance substantive new knowledge about China. Following their initial shock and awe, American critics resorted to more composed language to reflect upon the actual impact of Mei's performances, a change rarely commented on in existing studies. Despite their ongoing appreciation of his graceful artistry, the critics for both the *New York Times* and *New York Herald Tribune* flatly declared that unlike Stanislavski's Moscow Art Theatre, there was "scarcely anything for us to 'learn' from these plays and their players," which could "hardly influence the native stage."[76]

While Mei's tour challenged the existing Orientalist imaginaries of a backward China, presenting the allure of a supposedly authentic and exotic China artificially froze the Other in time, another key Orientalist logic. In his essay, Hu Shi called Chinese opera "historically an arrested development," which essentially served as an archaeological wonder for those interested in studying "the irrevocably lost steps in the slow evolution of the dramatic art."[77] At roughly the same time when American critics hailed Mei's refinement and sophistication, they eviscerated the performances of a Japanese *kabuki* troupe in New York exactly because of its perceived modern pretensions and defiance of such Orientalist logic.[78] But even the popular demand for exotic China had a saturation point. Despite Meng's fond memory in his memoir, a Chinese classical music concert at the New School organized by the China Institute two years after Mei's tour received a much more reserved review for being "interesting" because of its "strangeness."[79] This once again emphasizes the importance of evaluating Meng's claim against other available sources lest we exaggerate the impact of the Institute.[80] As will be seen in later chapters, the spectacular approach to cultural diplomacy, often favored by the Nationalist government, continued to suffer from similar weaknesses in the decades ahead.

The China Institute's more sustaining contribution to Chinese cultural diplomacy resided in its much less spectacular programming that introduced a living Chinese culture to the public. Not long after its founding, the Institute started to invite prominent speakers, both Chinese and foreigners (mostly Americans), to give public lectures in its office on various aspects of Chinese life in the past and present. Unfortunately, Meng's memoir offers no details on the exact timing or content of these lectures. But even a partial list of distinguished speakers between roughly the late

TABLE 1. Partial List of Speakers at the China Institute around the late 1920s and 1930s

Name	Profession
Taixu (Tai Hsü)	Founder of Chinese Buddhist Society
Mei Lanfang	Peking Opera icon
J. J. L. Duyvendak	Professor of Chinese, Leiden University
Sidney Gamble	YMCA worker and sociologist
Berthold Laufer	Curator of Anthropology, Field Museum
Chu Minyi	Nationalist official and promoter of Taichi
Zhao Yuanren (Y. R. Chao)	Professor of Linguistics, Tsinghua University
Paul Monroe	Professor of Education, Teachers College
Carleton Washburne	Progressive educator
Henry K. Murphy	Architect
Chen Hengzhe (Sophia Chen)	Professor of History, Peking University
Jiang Kanghu (Kiang Kang-hu)	Professor of Chinese, McGill University
Liu Zhan'en (Herman C. E. Liu)	President, University of Shanghai
Ding Wenjiang (V. K. Ting)	Geologist and Secretary General, Academia Sinica
Wu Youxun (Y. H. Woo)	Professor of Physics, Tsinghua University
Wu Yifang	President, Ginling College
Hu Shi (Hu Shih)	Professor of Chinese, Peking University
Sophia Han	Professor of Music, Peiping University
Tao Xingzhi (Tao Heng-chih)	Progressive educator
Wei Zhuomin (Francis Wei)	Philosopher and President, Huazhong University
Xu Shilian (Leonard S. L. Hsu)	Professor of Sociology, Yenching University
Ji Chaoding (Chi Chao-ting)	Economist and lecturer at New School for Social Research

Note: Chinese name in *pinyin* provided in parentheses if identified and different from Meng's transliteration.

1920s and 1930s, based on their estimated presence in the United States, hints at the breadth of topics the Institute brought to the public, particularly from different Chinese perspectives. The Chinese speakers were mostly scholars and educators but also included those from art, religious, and government circles. Their politics ran across the spectrum, including an undercover communist spy (Ji Chaoding), future collaborationists with Japan (Chu Minyi and Jiang Kanghu), those who would stay in the PRC (such as Chen Hengzhe) after 1949, and those who would settle in the United States (such as Zhao Yuanren) or Taiwan (such as Hu Shi).[81] Existing studies find some tentative connections between the Institute and the literary circles originated in Beijing.[82] What should not be overlooked is the Institute's networking through Columbia University and Christianity, as its first two Chinese directors were deeply enmeshed in both circles. Besides the aforementioned Monroe and Hu, Laufer taught at Columbia, and Liu, Tao, and Ji studied there. Liu, Wu, Tao, Wei, and Hu were either Chinese Christians or worked at missionary universities.

Meng also extended the China Institute's promotion of broad under-standings of China from public lectures to American schools. Already in 1923, Liu Tingfang (1891–1947), dean of Yenching University's Faculty of Theology, lamented the lack of proper textbook coverage on China for schoolchildren in the United States.[83] Meng's extensive life experience in the United States further confirmed such a lack of "basic information and survey courses" on China in public schools. And he actually decided to develop two such survey courses on Chinese history and culture for school teachers in the city of New York. After a son of the well-known Chinese American pastor Huie Kin (1854–1934) introduced Meng to the new mayor Fiorello La Guardia (1882–1947), the Institute soon got the city's approval of these courses as in-service credit courses for teachers. In Meng's opinion, the China Institute was soon recognized as "the nation's first and largest school of Chinese studies for non-specialist teachers."[84]

Compared to public lectures and teacher training programs, both of which were more likely to serve those already in metropolitan New York, the China Institute's known reference publications on China in the 1920s and 1930s carried cultural diplomacy further afield. Interested readers everywhere could find expanding lists of theses and dissertations written by Chinese students in American universities, many of which were on China. They could also read recommended monographs in English on the coun-try by both Chinese and foreign authors. Those with the Chinese language capability could follow the guide on the learned societies and leading peri-odicals in China.[85] Similar to many contemporary Chinese intellectuals, the Institute wanted to present China "at her best" to an international audience.[86] But instead of simply criticizing foreigners for their "unsys-tematic study, unbalanced knowledge, and unauthorized interpretation of Chinese culture and life," the Institute tried to amplify the voice of Chinese authors in its recommended titles.[87] The hitherto dominance of foreigners in representing China abroad meant that the vast majority of the relevant English language publications in the recommended reading lists were still written by non-Chinese. As an organization directed by cosmopoli-tan Chinese intellectuals, the Institute embraced these perspectives. But as the recommended lists gradually dropped dated English language titles by missionary authors such as Samuel Wells Williams's *The Middle Kingdom*, first published in 1848, they increased the percentage of Chinese authors from under a quarter to well over a third. Such representation was sig-nificantly greater than that in the suggested readings in contemporaneous syllabi on the survey of Chinese civilization and culture edited by American scholars.[88]

TABLE 2. Breakdown of the China Institute's Recommended Books on China

Category	Bulletin 5 Number of titles	Bulletin 6 Number of titles	Loo Number of titles	*China* (1939) Number of titles
General Works	20 (3.5)	19 (2.5)	8 (4)	4 (4)
History			6 (0)	N/A
Biography			10 (6)	N/A
His. & Bio. combined	11 (1)	10 (1)		
Geography & Travel	N/A	N/A	11 (1)	N/A
History & Geography	N/A	N/A	N/A	7 (0)
Government & Foreign/ International Relations	22 (11)	24 (11)	13 (6)	N/A
Economy			8 (0)	N/A
Social Life			11 (3)	N/A
Econ. & Soc. Life combined	11 (2)	12 (2)		
Education	6 (5)	5 (4)	4 (3)	N/A
Arts (& Crafts)			26 (1)	
Literature			18 (13)	
Arts & Lit. combined	13 (0)	13 (0)		28 (15)
Industrial Arts & Customs	N/A	N/A	N/A	9 (0)
Philosophy & Religion	17 (2)	17 (2)	12 (6)	N/A
Bibliography	N/A	N/A	5 (1)	N/A
Modern Political Changes	N/A	N/A	9 (7)	N/A
Modern Intellectual & Social Changes	N/A	N/A	6 (4)	N/A
China Today	N/A	N/A	N/A	10 (2)
Additional Magazines, Films, and Charts	N/A	N/A	N/A	*miscellaneous, authorship unclear*
Total	100 (24.5)	100 (22.5)	147 (55)	58 (21)
Chinese Authors (%)	24.5%	22.5%	37.4%	36.2%

Note: The number of those by Chinese authors are in parentheses, with fractions due to a joint publication between a Chinese and Japanese author.

TABLE 3. Breakdown of China Society Syllabi on History of Chinese Civilization and Culture

	Syllabus 1929	Syllabus 1934	Syllabus 1941
Number of titles	170 (17.5)	191 (27)	226 (37)
Chinese authors (%)	10.3%	14.1%	16.4%

Note: The syllabi followed the temporal order from prehistory to the time of publication with different headings for different periods. The thematic categories are thus not directly comparable to those in China Institute publications. The number of those by Chinese authors are in parentheses, with fractions due to a joint publication between a Chinese and Japanese author.

A closer look at the China Institute's publications also reveals an eclectic perspective on Chinese culture that showed no particular preference between the past and present, or among different political persuasions. The increase of Chinese authors in the reading lists came mainly from those of classical literature *and* of contemporary development in China. The Institute aspired to introduce to the American public an encompassing Chinese culture that was not just ancient but also, in the words of the editor of the 1935 list, "living, vital, and adjusting itself to changing conditions."[89] The 1939 list, moreover, included the translation of diverse contemporary authors such as Lu Xun (1881–1936), Guo Moruo (1892–1978), and Shen Congwen (1902–1988). Lu and Guo were celebrated icons in the leftist canon, and Shen received critical acclaims for his writings on the idyllic countryside. Edgar Snow (1905–1972), the leftist American journalist, appeared twice with an edited collection of translated modern Chinese short stories and his 1937 bestseller *Red Star Over China* under the heading "China Today."[90] In the Institute's bulletin of October 1938, a research associate introduced some of the most important intellectual debates in modern China from the New Culture Movement in the 1910s to the competing understandings of feudalism among Marxist historians at the turn of 1930.[91] Such attention to leftist themes, among other things, was in line with the zeitgeist of the Cultural Front in the United States.[92] As will be seen in the following chapters, the Institute's early presentation of Chinese culture would be very different from that of the Nationalist government, which often dwelled on the proprietary and exclusivist claims on ancient objects and performances. The Institute's own approach would also change significantly during the Cold War.

But the China Institute's vision was by no means all inclusive. Similar to earlier visionaries of Chinese cultural diplomacy, the Institute was continuing an elitist project that sought to shift the American understandings of China away from the lower-class Chinese immigrants to China's refined cultures. To be sure, such understandings were in flux in the late 1920s and 1930s due to China's political transitions, and the publication of Pearl Buck's *The Good Earth* in 1931 in particular generated a new wave of public sympathy toward China.[93] But the book was not so much directed toward the country's masses, let alone cultural refinement, as universal suffering amid the global depression. Compared to Jiang Kanghu's blatant condescension toward lower-class Chinese in representing national culture, the Institute was less overt in its class prejudice. Yet its Chinese directors were from similarly privileged intellectual backgrounds, who strove to present genteel programming on China to a respectable middle-class

audience. Just like Mei Lanfang's performances aimed to write off ordinary Cantonese-speaking Chinatown residents in defining "Chinese" drama in the United States, the Institute would also like its audience to look away from Chinatowns in understanding China's cultural achievements.[94]

Besides systematic efforts in promoting public understandings of Chinese culture, the China Institute also issued direct political commentaries particularly on the escalating Sino-Japanese conflict throughout the 1930s. Those commentaries were similar in spirit to the impulse of Chinese cultural diplomacy, namely to get the Chinese opinions regarding China heard in the United States. They often came in occasional pamphlets following major Japanese advances in China.[95] After the Japanese siege of Shanghai in early 1932, for example, Macmillan Publishing solicited both Meng Zhi and Kawakami Kiyoshi (1873–1949), a Japanese journalist, to write about the developing conflict between the two countries. The resulting publications gave Americans a unique opportunity to observe direct polemics between the two countries' Anglophone intellectuals when the U.S. government was reluctant to go beyond the nonrecognition policy with regard to Japan's territorial expansion in China.[96] It was unclear whether and to what extent the Nationalist government was behind such commentaries. But as anti-Japanese sentiments became a common denominator between the government and many liberals who would otherwise keep their distance, the Institute's critique of Japan did not necessarily entail its partisan alignment with the Nationalists. The Chinese minister to the United States Yan Huiqing (W. W. Yen, 1877–1950) wrote the introduction of Meng's book in 1932, and the Japanese prime minister Inukai Tsuyoshi (1855–1932) did the same for Kawakami's book. Another 1938 pamphlet was compiled by a staffer at the Institute and published by the Trans-Pacific News Service, a New York-based news outlet founded by a former American journalist in China named Bruno Shaw (1894–1984, also known as Bruno Schwartz). This organization did have ties to the Nationalist government and later developed into the official Chinese News Service in the early 1940s.[97] Despite these indirect connections, there was no evidence on the Nationalist government's direct influence on the Institute. Its official newspaper *Zhongyang ribao*, for example, carried no report on the Institute during this period. As later chapters will demonstrate, the increasing Nationalist patronage starting from the mid-1940s certainly affected the popular perception of the Institute but never eliminated its autonomy in charting its own cultural diplomacy.

From an institutional perspective, the China Institute's early cultural diplomacy was made possible by not only its location in a well-connected

world city but also the fortuitous timing. Before the mid-twentieth century, there was hardly any organized expertise in the United States capable of engaging the public on relevant subjects besides a handful of missionary-turned-scholars. The incorporation of Chinese studies in college curriculum dated back to the 1870s but remained quite limited on isolated campuses through the 1920s. In 1931, L. Carrington Goodrich (1894–1986), a lifelong faculty member at Columbia, opined that "competent teachers can be counted on the fingers of two hands."[98] Such a structural lacuna allowed the Institute, technically a nonscholarly organization, to offer an important popular education on China through its own platform. Such unique value of the Institute's early work is duly noted by contemporary and later scholars like Jiang Kanghu; Earl H. Pritchard (1907–1995), president of the Association for Asian Studies in the early 1960s; and Tsuen-Hsuin Tsien (Qian Cunxun, 1910–2015), librarian of University of Chicago's East Asian collections.[99] But as the field of China studies slowly professionalized in the United States, the Institute would face more competitions in shaping the public understandings of China. In the late 1920s, more established and better financed organizations such as the American Oriental Society (founded in 1843), American Council of Learned Societies (founded in 1919), Harvard-Yenching Institute (founded in 1928), and Rockefeller Foundation (founded in 1913) began to jointly push for the expansion and professionalization of the scholarly study of China and East Asia in general.[100] As university professors increasingly claimed more authority to the public in the following decades, the Institute's role would be gradually eclipsed.

Conclusion

This chapter recounts the intellectual and institutional underpinnings of early Chinese cultural diplomacy. The deepening interests of cosmopolitan Chinese in teaching China's cultural refinement to foreigners began with the visionary thinking of China's first regular diplomats in the late nineteenth century. They culminated in the founding of the China Institute as the first institution under significant Chinese influence to promote public understandings of China in the United States. Increasingly uneasy about their home country's negative international images, a new breed of cosmopolitan Chinese intellectuals was determined to become the sovereign spokesperson of China's cultural refinement over the pigtails, bound feet, opium dens, and chop suey. Propelled by strong nationalist sentiments

to reclaim the country's rightful position in the pantheon of respectable national cultures, this project treated the international dissemination of Chinese culture as an inherently valuable cause beyond immediate political goals.

But as the unprecedented institutional platform of Chinese cultural diplomacy, the China Institute ultimately rested on shaky ground. Without its own endowment, the Institute was financially dependent on the China Foundation and thus susceptible to any changes to this single source of funding. The Institute's financial challenges mostly limited its operations to the New York metropolitan area, despite its name that suggested a national operation. Without the systematic support of the state, Chinese cultural diplomacy initiated by cosmopolitan intellectuals ultimately paled in comparison to similar projects by more established powers. With the emergence of the Nationalist government in the late 1920s, would the Chinese state step into a field that had been hitherto dominated by cosmopolitan Chinese intellectuals? How exactly would the Nationalist state compare to the more experienced foreign powers in its cultural diplomacy initiatives? It is to these questions that the following chapter will turn.

Government Learning

1905–1940

"At present, the Japanese take Chinese culture as their own to publicize to the whole world, and act as though they represent Eastern (*dongyang*) culture. This has improved their international standing and greatly helped their diplomacy. We need to be very concerned."

Tang Zhong, "On Cultural Diplomacy," 1933

"The exhibition of antiquities showcases a nation's ancient civilizations, and that of contemporary art does the same for its current achievements. Both are a means of increasing international cultural understandings, which is very helpful to diplomacy."

Chang Renxia, "Cultural Diplomats and Cultural Diplomacy," 1940

The history of Chinese cultural diplomacy leading up to the founding of the China Institute in America took place largely without the help of the otherwise preoccupied Chinese state. But this started to change after the establishment of the Chinese Nationalist government in Nanjing in the late 1920s. Operating on a nationalist platform, the government regained tariff autonomy in 1928 and continued its efforts in repealing extraterritoriality, the exemption of select foreign nationals from Chinese law. In addition to restoring economic and political sovereignty, the Nationalist government also started to see sovereign implications in China's international branding. The escalating Japanese threat from Manchuria down to the rest of China

spurred the government to start consolidating a labyrinth of bilateral initiatives in cultural exchange with a number of foreign countries into more coherent cultural diplomacy. Another signature government initiative in response to such threat was the multiple evacuations of the former imperial art collections dating back to the eleventh century. The odyssey of these precious objects decisively raised their nationalist stakes as the evocative symbol of an enduring and elegant civilization despite grave challenges. Showcasing these objects abroad, particularly in the United States, became the ultimate ambition of official Chinese cultural diplomacy. The Nationalist government earnestly planned a grand exhibition of those antiquarian cultural symbols at the 1939 New York World's Fair in anticipation of pragmatic benefits, such as economic and military aid from China's most critical ally.

In familiar terms, the world in the 1930s was gripped by economic depression, political unrest, and military conflicts. But on the cultural front, the decade also witnessed deepening intercultural encounters in several ways. All the major powers across the North Atlantic and Eurasia had sensed the critical importance of cultural projection in an increasingly volatile world order and established their dedicated national agencies by 1940. While the Nationalist government was a latecomer, its awakening to Chinese cultural diplomacy was in fact timely. Also given the steady rise of the United States in international affairs, China was far from alone trying to exploit the growing influence of a new hegemon to its own advantage. France, for example, did similar things in order to win the American goodwill to fight their battles against Nazi Germany.[1]

Japanese military advance in China ultimately foiled the Nationalist government's planned exhibition in New York. But many other challenges confronted the government as it learned to practice Chinese cultural diplomacy in the 1930s. In a decade of supposedly more sympathetic understandings of China after the publication of *The Good Earth*, Orientalist stereotypes did not simply fade. Anna May Wong (1905–1961), the most famous Chinese American actress in Hollywood, continued to be typecast as cunning and sexualized roles in films from *Daughter of the Dragon* (1931) to *Dangerous to Know* (1938). The lead female role in the film adaptation of Buck's enormously popular novel also ultimately eluded her.[2] Moreover, those stereotypes continued to outcompete the intended messaging of China's cultural refinement and sophistication. As the Nationalist government failed to engage the American public in the "exhibitionary order" steeped in unequal representations of the Other, Orientalist imageries with dubious geographical grounding in China proliferated at the New York

fair.[3] A lot of them specifically invoked China's former imperial frontiers, most of which had fallen under contested jurisdiction by the 1930s. In the absence of institutional actors of Chinese cultural diplomacy in this raucous space, commercial and philanthropic interests of different constituents dominated the projection of China, however vaguely defined.

The rest of the chapter follows a rough chronological order and is divided into two broad sections. It first recounts how the Chinese state for a long time remained lukewarm toward cultural diplomacy despite the groundswell among cosmopolitan intellectuals. That changed with the Nationalist government's deepening recognition of the necessity of asserting its sovereign definition of Chinese culture under Japan's growing threats, and its gradual but incomplete centralization of Chinese cultural diplomacy. The chapter then moves to the New York fair, where the Nationalist government's planned debut of the former imperial art collections did not materialize because of its deepening war with Japan. Such absence facilitated the cacophonous voices speaking on behalf of China. Whenever possible, this chapter draws upon the experiences of regular fairgoers and underscores the uneven receptions of a fleeting multitude of China-related imageries at a mass exhibition, a format very different from the China Institute's smaller scale genteel programming. It ultimately questions the long-term efficacy of spectacle as a means for cultural diplomacy, a problem the Nationalist government would continue to confront in the 1960s and 1970s.

The Trailing State

As demonstrated in the previous chapter, early ideas of Chinese cultural diplomacy started to develop in the late nineteenth century without direct support of the Chinese state. A myriad of domestic and international challenges weakened the political authority of the central government. Although it became increasingly aware of the importance of new communication technology in affecting the international opinions of China, cultural diplomacy was far from an official priority for the country's survival in the imperialist world order.[4] Even initiatives bearing the appearance of official Chinese cultural diplomacy turned out to have no substantial Chinese input. The first major acquisition of the Library of Congress' Asian Division, for example, is a collection of almost one thousand Chinese volumes on Confucian classics and works of some scientific subjects, which bore the imprint "presented to the Government of the U.S.A. by

His Majesty the Emperor of China, June 1869." It was actually a hesitant response from *Zongli yamen*, the de facto foreign office, to the Smithsonian Institution's request of exchange of government publications and other U.S. government agencies' need of Chinese census and revenue data.[5] Chinese language classes at Harvard University began around 1880 when the university invited a Chinese scholar without official credentials to teach there, and Columbia University's curriculum began in the early twentieth century with financial contributions from a trustee and his former loyal Chinese valet.[6]

The Chinese state's lagging interest in cultural diplomacy also explains why it essentially outsourced the international representation of China at the international exposition. Since the mid-nineteenth century, such expositions became a prominent venue to showcase the economic, scientific, and cultural achievements of different nations, henceforth a critical platform for cultural diplomacy. Up until the early twentieth century, the Qing government entrusted China's participation in these events to the Imperial Maritime Customs, a government agency founded in the 1850s but led and staffed mainly by foreign employees. In other words, the preoccupied Chinese government ceded its involvement in this infrastructure of persuasion, which was critical to the production and projection of China's international image. The rising tide of Chinese nationalism made such arrangement increasingly unacceptable. More and more Chinese were offended by what they considered the Customs' arrogance and its disgraceful exhibits on China, such as the opium paraphernalia and foot-binding, and demanded the Qing government's direct leadership in representing China at such exhibitions. In this context the Qing government sent its own first official delegation to the St. Louis World's Fair in 1904, though still under the supervision of the Customs, and finally terminated the Customs' involvement in 1905.[7]

However, the Qing government's debut in St. Louis revealed not so much its coherent approach to cultural diplomacy as the ambivalent meanings of China. And it fell far short of Japan's success in representing Asia on the international stage. Following the debacle of the Boxer Rebellion, the Dowager Empress Cixi (1835–1908) was eager to repair relations with the West amid the New Policies reform and dispatched a royal prince as head of the official Qing delegation. She also commissioned the exhibition of her own oil portrait by the U.S. painter Katharine A. Karl (1865–1938), an unprecedented public display of a living monarch's image to demonstrate her personal goodwill. The large number of exhibits from various provinces mainly featured highly ornate furniture and carvings with delicate crafts-

manship. But the cluttered display gave viewers more of an impression of Oriental curios rather than dignified display of Chinese culture. The elaborate China pavilion itself was modeled after the prince's private residence and projected more of the Manchu royal family, which was at increasing odds with the fermenting Han Chinese nationalism.[8] In contrast, Japan had been actively participating in international exhibitions since the end of the Tokugawa period (1600–1868) to showcase its cultural traditions and, later, industrial progress.[9] It staged a critically acclaimed exhibition in St. Louis that highlighted its national cultural legacies and particularly the "beautiful women" (*bijin*) icon. In the spirit of imperially inflected Pan-Asianism, the Japanese exhibition overshadowed that of the Qing and was considered "the sole guardians of the art inheritance of Asia."[10]

The Republican Revolution in 1911 toppled the monarchy but did not immediately enhance the Chinese government's role in cultural diplomacy. Although operating on a more self-consciously nationalist platform, the Republican government largely ceded the handling of such international publicity to commercial interests. The first major international exhibition Republican China officially participated in was the 1915 Panama-Pacific International Exposition in San Francisco. But similar to 1904, this international debut did not amount to any coherent messaging on China. The main Chinese pavilion was modeled after the Hall of Supreme Harmony (*Tai he dian*) in the Forbidden City. Within this evocative space, the predominant focus was to increase the country's standard export of tea, silk, and handicraft. A private Shanghai collector provided old paintings, which were on display at the separate Palace of Fine Arts.[11] In comparison, the Japanese exhibition was more balanced in showcasing the country's economic achievements and cultural legacies. It once again commanded widespread appreciation as the leading Asian nation that successfully blended the past and present.[12]

Over a decade later at the 1926 Philadelphia Sesquicentennial Exposition, the fractured representations of China and the competitive advantage of Japan remained little changed. The previous chapter alludes to the China Institute's education exhibit at the Palace of Education and Social Economy in Philadelphia right after its founding. But the disorganized presentation of China at the same exposition's Palace of Agriculture and Foreign Exhibits diluted the efforts by the Institute. Busy with thwarting the Northern Expedition from the south, the internationally recognized warlord government in Beijing did not participate. Only at the urge of some Shanghai businesses did the warlord in control of five southeastern provinces allocate a meager sum of $7,000 for China's "official" participa-

tion, which was actually dominated by the commercial interests in China and Chinatowns in the United States.[13] Due to the late acceptance, there was no Chinese national pavilion. The exhibits from China, ranging from raw materials to handicrafts, were crammed into a narrow lot. Several Chinese and Chinese American merchants displayed similar commodities in the concession of Chinese Village at the Gladway. These disparate objects made no concerted efforts of projecting an admirable national Chinese culture to impress the American audience. In contrast, the national exhibition coordinated by the Japanese government made a meticulous presentation of Japanese art and manufactures at not only its national pavilion but also a spacious lot at the Palace of Agriculture and Foreign Exhibits.[14]

In the wake of World War I, the Chinese government entertained the idea of cosponsoring a new Institut des hautes études chinoises in Paris with its French counterpart. If successful, it would have actually gone beyond the international exhibitions and turned Zeng Jize's "idle talk" of establishing Chinese academies in the West into reality. But the budget shortage in China meant that the Institut, founded in 1920, survived mainly with the French remission of the Boxer Indemnity and meager subsidies from the French government. Besides funding, the Institut was mostly administered by the French personnel, despite a token Chinese government representative. The vast majority of its seminars were taught by French scholars because of the lack of Chinese scholars well-versed in French. In essence, it became another foreign institution of higher learning on China.[15]

Ambitions and Frustrations

The hitherto lukewarm government interest in Chinese cultural diplomacy started to change under the Nationalists. As a critical pillar of cultural diplomacy, Chinese nationalism informed the new party-state's vision in augmenting China's international voice on various matters. The government gradually built up its international propaganda apparatus in response to Japan's intensifying threat.[16] Moreover, it became increasingly invested in projecting China's cultural achievements, which required even longer-term commitment. An early example was China's participation in the League of Nations' international cultural exchange program. It was championed by Li Shizeng (1881–1973), scion of a high-ranking Qing official and a Nationalist veteran with deep connections in France. In 1922 the League established the International Committee on Intellectual Cooperation in Geneva, an advisory body to promote cultural exchange as a means to safeguard international

peace. With further support from France, the International Committee set up an executive body, the International Institute of Intellectual Cooperation, in Paris in 1926.[17] A member state of the League, China under the warlord government participated in neither the International Committee nor International Institute in the 1920s.[18] This changed in the early 1930s when the Nationalist government at the behest of Li sent representatives to the Geneva-based International Committee. Li himself led an official Chinese delegation to the International Committee in 1932 and founded the Chinese National Committee of Intellectual Cooperation in Shanghai in 1933.[19] In the meantime, he also donated personal collections to establish the Bibliothèque Sino-Internationale on the premises of the Chinese delegation in Geneva. In late 1934, this library reportedly hosted a small art exhibition of Chinese art to showcase refined Chinese culture.[20]

Besides the multinational organization, the Nationalist interest in cultural diplomacy also appeared in a plethora of bilateral cultural organizations. The involved foreign countries included not just major powers (e.g., Britain and Germany) and other sovereign nations (e.g., Poland and Siam) but also colonies aspiring for national independence (e.g., India and Burma). Despite the appearance of private organizations, these organizations were often led by ranking Chinese officials with foreign ties, who sought subsidies from the Nationalist government and used culture as a convenient cover to advocate for China's closer relationship with relevant foreign countries.[21] They functioned more as personal projects of select officials with vested international interests than the coordinated measures of cultural diplomacy by the central government.

The Sino-Soviet Cultural Association, one of the most studied among such organizations, was founded in 1935 by Sun Ke (Sun Fo, 1891–1973).[22] Son of the late Nationalist leader Sun Yat-sen (1866–1925) and head of the Legislative Yuan, Sun Ke was adept in promoting cultural exchange in order to enhance his own political standing. With tacit government support, Sun was already one of the main patrons of two acclaimed English-language magazines edited by Chinese intellectuals: *The China Critic* (1928–45) and *T'ien Hsia Monthly* (1935–41). These short-lived publications showcased, among other things, a cosmopolitan China and its cultural refinement.[23] At a time when the Nationalist government was scrambling to resist the rising Japanese threat, Sun pushed for pragmatic Sino-Soviet cooperation. Besides supporting cultural exchange with the Soviet Union that the left had long engaged in, his association also spearheaded the exhibition of part of the evacuated former imperial art collections in Moscow and Leningrad between 1940 and 1941 as a goodwill gesture.[24]

TABLE 4. Bilateral Cultural Organizations in China in the 1930s and 1940s

Founding	Organization	Location
1933	Zhong Ying wenhua xiehui (Anglo-Chinese Cultural Association)	Nanjing
	Zhong Bo wenhua xiehui (Sino-Polish Cultural Association)	Nanjing
	Zhong Yin xuehui (Sino-Indian Cultural Society)	Nanjing; Santiniketan, India (1934)[a]
1934	Zhong Yi wenhua xiehui (Sino-Italian Cultural Association)	Shanghai
	Zhong Nan wenhua xiehui (China-South Sea Cultural Association)	Shanghai
1935	Zhong De wenhua xiehui (Chinesisch-Deutscher Kulturverband)	Nanjing
	Zhong Wai wenhua xiehui (China and Foreign Cultural Association)	Shanghai
	Zhong Su wenhua xiehui (Sino-Soviet Cultural Association)	Nanjing
1937	Zhong Xian wenhua xiehui (Sino-Siamese Cultural Association)	Nanjing and Bangkok
1939	Zhong Fa Bi Rui wenhua xiehui (Sino-French, Belgian, and Swiss Cultural Association)	Chongqing
	Zhong Mian wenhua xiehui (Sino-Burmese Cultural Association)	Chongqing
	Zhong Mei wenhua xiehui (Chinese-American Institute of Cultural Relations)	Chongqing
1940	Zhong Ri wenhua xiehui (Sino-Japanese Cultural Association)	Nanjing (collaboration government)
	Zhong Yue wenhua gongzuo tongzhihui (Sino-Vietnamese Cultural Association)	Guilin
1941	Zhong Ma wenhua xiehui (Sino-Malayan Cultural Association)	Malaya
1942	Zhong Han wenhua xiehui (Sino-Korean Cultural Association)	Chongqing

Note: All the English translations of organizations are mine except for those listed in Lin, *A Guide to Chinese Learned Societies and Research Institutes*, 7–8.

[a] This organization had two branches founded at different points. The one in India was founded in 1934.

Despite the political nature of these cultural organizations, their establishment in roughly one decade testifies to the increasing importance of culture in how the Nationalist government envisioned China's foreign relations. In the 1920s, when the Institut des hautes études chinoises in Paris and the China Institute in New York strove to promote public understandings of China, the warlord government in Beijing was generally indifferent to the cause of cultural diplomacy due to a myriad of domestic and international challenges. While such challenges hardly went away in

the 1930s, culture became a much more serious diplomatic toolkit for the Nationalists.

However, the sheer number of these bilateral organizations also underlines the disorganized nature of the nascent Nationalist cultural diplomacy. No foreign country seemed to command central attention, which was uncannily similar to the "segmented, regionally specific" management of multiple frontiers by a coterie of local officials during the high Qing in the eighteenth century before the emergence of a coordinated national foreign policy.[25] The lack of coordination becomes more glaring from a comparative perspective. Almost all the major powers by the 1930s had recognized the strategic importance of cultural diplomacy in an increasingly perilous world order. More importantly, each of them had established at least one official or semi-official agency to coordinate their efforts and carry out continuous programming.[26] Even small states such as Hungary operated its own cultural institutes in strategic Western European capitals such as Paris and Rome since the 1920s.[27] Nationalist China never had the resources nor vision to create such a unitary agency as the infrastructure of persuasion for its cultural diplomacy. As will be seen later, this problem would continue to bedevil the Nationalist government in the decades ahead.

The intensifying Japanese military threat throughout the 1930s ironically spurred the Nationalist government to consolidate its cultural diplomacy in a different way. One of the first signs was the growing centrality of the former imperial art collections in the Nationalist understanding and projection of Chinese culture. As the Japanese advance in early 1933 endangered Beiping (Beijing), where the collections were held, the government evacuated almost twenty thousand crates of antiquities southward to Shanghai's international concession. The vast majority of these objects, from painting and calligraphy to bronze and porcelain, came from the recently established National Palace Museum (*Guoli gugong bowuyuan*, NPM). In the late Qing, radical Han Chinese nationalists started to challenge the Manchu imperial family's proprietary hold on what they considered China's national treasures. The rampant outflow of these precious objects into the domestic and foreign art markets in the early twentieth century added a further sense of urgency among China's political and cultural elites in establishing a national museum to safeguard and display the country's cultural patrimony. In 1914, the Institute for Exhibiting Antiquities (*Guwu chenliesuo*) opened within the Forbidden City and displayed collections from the old Qing palace in Manchuria and summer resort in Chengde.[28] Over a decade later in 1925, the eviction of the abdicated Qing emperor from the Forbidden City resulted in the founding of the NPM

TABLE 5. Major Powers' Cultural Diplomacy Agencies by 1940

Founding	Agency	Country
1883	Alliance française	France
1889	Dante Alighieri Society	Italy
1907	Institut français	France
1920s	Istituto Italiano di Cultura	Italy
1923	Ministry of Foreign Affairs China Cultural Affairs Bureau	Japan
1925	Deutsche Akademie	Germany
	All-Union Society for Cultural Relations with Foreign Countries (VOKS)	Soviet Union
1934	British Council	Britain
	Kokusai bunka shinkōkai (KBS)	Japan
1940	Department of State Office for Coordination of Commercial and Cultural Relations between the American Republics	United States

with a significantly larger cumulative collection, which dated back to the eleventh century.[29] The outbreak of the full-scale Sino-Japanese War in 1937 sent the evacuated objects further into China's hinterland. The multiple evacuations raised the nationalist stakes of such objects, which the government learned to leverage as a proprietary symbol of an enduring Chinese culture at a time of national crisis.[30]

The 1935 International Exhibition of Chinese Art at the Royal Academy of Arts in London also quickly taught the Nationalists the pragmatic benefits of antiquarian self-fashioning. This exhibition followed precedents of national shows at the same venue, such as the Flemish and Belgian, Dutch, Italian, Persian, and French art in the previous decade, and solicited exhibits from multiple suppliers, including private collectors, dealers, and museums. Prominent exhibitors included Sir Percival David (1892–1964), the foremost British collector of Chinese porcelain and one of the original planners, and C. T. Loo (Lu Qinzhai, 1880–1957), a leading Chinese art dealer from China with businesses in France and the United States. Despite the mounting Japanese threat and some domestic oppositions to exhibiting invaluable national treasures overseas, the Nationalist government decided to participate because of the perceived prestige of this exhibition hosted by the leading colonial power. As the largest contributor, it amassed more than one thousand diverse objects in China from porcelain and bronze to calligraphy and painting. Of these, more than seven hundred came from the evacuated NPM collection. With the British and Chinese heads of state as patrons, the international debut of the NPM collection not only generated renewed enthusiasm for Chinese art and culture

but also created enormous goodwill as China was about to face the brunt of a full-scale Japanese invasion.[31] The glowing reception of the London show solidified the Nationalist government's belief in the grand spectacle of China's antiquarian culture as the preferred approach of cultural diplomacy. Different from the China Institute's eclectic lessons on Chinese culture that embraced perspectives past and present, Chinese and foreign, the Nationalist government was more interested in teaching with proprietary ancient objects that highlighted exclusive guardianship and legitimated its own rule.

But as one of the many invited participants in this international exhibition, Nationalist China still struggled to assert Chinese cultural refinement on its own terms. In such an event organized and dominated by the British, the Nationalist government as a junior partner did not have much control over the final presentation of its exhibits, let alone the overall infrastructure of persuasion. The British members of the joint preparatory committee often had the final say in determining the objects to be sent to London and overemphasized their own preference, such as imperial porcelain. The Royal Academy's final catalogue not only dismissed the English-language labels drafted in China but also imposed British opinions over the disputed attributions of certain items without consulting the Chinese. During the exhibition, the Academy dispersed and crammed what the Chinese considered invaluable national treasures, particularly those from the NPM, with numerous other objects into ten rooms, on average more than three hundred items per room. In the end, the ambitious Nationalist plan struck an unwanted resemblance to the cluttered presentation of Chinese objects as Oriental curios at the St. Louis fair in 1904. During the exhibition, it was also the British and other foreigners who delivered most of the public talks on Chinese art and culture at various cultural and educational institutions in London.[32] As will be shown in later chapters, such unequal intercultural encounters where the Chinese lacked the final agenda-setting power continued to haunt the Nationalist spectacles in the United States in the 1960s and 1970s.

In addition to both positive and negative international development, China's domestic cultural politics in the 1930s also facilitated the antiquarian focus in the Nationalist self-fashioning. Far from the monopoly of China, different states such as France also employed a traditionalist approach to shore up national identities in this volatile decade.[33] The Nationalist government's the New Life Movement tried to mold Chinese culture inflected through neo-Confucian ethics with Christian evangelism

and Fascist-inspired organizing techniques in order to strengthen its tenuous rule under the threat of Japan and the communist rebels.[34] The government also tacitly supported ten professors' Declaration on the Building of China-Based Culture (*Zhongguo benwei de wenhua jianshe xuanyan*) in 1935, which advocated a more conscientious national culture against "total Westernization" (*quanpan xihua*).[35] These signified the government's continuing anxieties over the preservation of China's cultural identity, and its determination to use culture as a tool of legitimation.[36] Such a pragmatic use of national culture was in agreement with its cultural diplomacy, which intended to showcase former imperial collections in order to win more sympathy and support for its looming showdown with Japan.

It is in the same decade when cultural diplomacy (*wenhua waijiao*) began to appear as a neologism among Chinese intellectuals in reference to Japan's progress vis-à-vis China's inadequacies. Following its widely criticized occupation of Manchuria, Japan withdrew from what it considered the biased League of Nations in 1933. But this seemingly isolationist disengagement from the world was mitigated by an increasing emphasis on cultural exchange among Japan's internationalist elites. Chinese commentators on foreign affairs soon started to use *wenhua waijiao* to describe the new Japanese strategy. Although the authors unanimously condemned what they considered Japanese ruse with imperial ambitions, some also pondered over the possibility of Chinese cultural diplomacy itself. The author of a 1933 commentary called upon his compatriots to take cues from not only the recent Japanese but also the longstanding French example of cultural diplomacy in order to establish China's rightful position in representing the Eastern culture in the world. Chang Renxia (1904–1996), a historian of Indian and Japanese art, echoed these points in another commentary in 1940.[37] Yet similar to what the earlier generations of cosmopolitan intellectuals had advocated before the founding of the China Institute, these discussions were strong on the sentiments but short on the organizational specifics. This became even more apparent in comparison to the contemporary Japanese approach.[38] The founding of the semi-official Society for International Cultural Relations (KBS) in 1934 was a strong testament to the Japanese government's organized approach to its cultural outreach. As the central command in Japanese cultural diplomacy, the KBS staged, among other things, a critically acclaimed loan exhibition of twelve centuries of Japanese art at the Museum of Fine Arts in Boston in 1936, an accomplishment the Nationalist government could only achieve in the early 1960s.[39]

Abandoned Plans

Not yet a clear target of the official Chinese cultural diplomacy in the early 1930s, the United States nevertheless emerged by the end of the decade as its primary focus. This was in tandem with the country's increasing importance in the overall Nationalist assessment of China's international positioning under the mounting threat from Japan, despite the apparent U.S. neutrality in the Sino-Japanese conflict.[40] Drawing upon the precedent in London, the Nationalist government first endeavored to stage another exhibition of Chinese antiquities at the Metropolitan Museum of Art in New York. The lukewarm U.S. response frustrated the Chinese plan, but the undeterred government proposed something even more ambitious: showcasing Chinese antiquities at the incoming world's fair in New York, which would move Chinese cultural diplomacy from venerated museum galleries to more raucous fairgrounds.[41] The World of Tomorrow exhibition in 1939 and 1940, held in Flushing Meadows Park converted from a dumping ground, offered tens of millions of visitors the wonderland of future technology against the harsh reality of worldwide economic depression and political unrest. Far from the only iconic world's fair in the United States in the 1930s, the New York fair nevertheless offered the Nationalist government an unprecedented international stage, which had been out of reach in the 1933–34 Century of Progress exhibition in Chicago because Japan's military threat derailed the government's plan to participate.[42] The Golden Gate International Exposition in San Francisco, held in the same year as the New York fair, did not quite justify the government's limited resources during wartime.

The Nationalist government started planning its participation in the New York fair in late 1937, including the U.S. debut of some evacuated NPM collections in order to win more public support for China's war efforts against Japan. Instead of characterizing the 1930s world's fairs as a purely modernist fantasy, scholars have been paying more attention to the prominent display of antiquarian cultural elements from old master paintings to kimono-clad women.[43] What the Nationalists tried to achieve was not dissimiliar to the British projection of "traditional" values at the same venue.[44] Unfortunately, the growing intensity of the Japanese attack once again forced the Nationalist government to abandon its participation in a major world's fair in late 1938. Even the Chinese merchants were unable to participate due to challenging wartime logistics. Taking advantage of such a vacuum were not only entrepreneurs trying to profit from the exotic

imageries of China and its contested borderland but also philanthropists determined to use a similar Orientalist logic to solicit donations for a war-torn country.

While the early correspondence between the fair corporation and individual Chinese exhibitors dated back to 1936, the Nationalist government did not make an immediate commitment after receiving the official invitation in 1937 due to Japan's military threat.[45] Given the logistic difficulties, the Ministry of Industries reiterated the five year moratorium on China's participation in any international exhibition, introduced soon after the Chicago fair.[46] More cognizant of the positive publicity of such participation, the Ministry of Foreign Affairs decided not to decline the U.S. invitation outright. In his letter to the U.S. ambassador to China Nelson T. Johnson (1887–1954) in late July, two weeks after the Marco Polo Bridge Incident, the minister of foreign affairs Wang Chonghui (1881–1958) expressed China's interest in participation but requested financial assistance from the fair and friends of China in the United States.[47] However, Japan's subsequent attack on Nationalist China's political and economic center in the lower Yangzi region and the chaotic Nationalist retreat soon overshadowed the tentative acceptance.

After a high-profile lobby in 1938, the anxious fair corporation finally secured China's formal commitment. It solicited the service of John Foster Dulles (1888–1959), the future secretary of state who was then prominent in the religious peace movement, and George W. Shepherd (1895–1980), a U.S. missionary in China and advisor to Chiang Kai-shek, to persuade top Chinese officials.[48] Besides, prominent American women also approached their Chinese counterparts to encourage China's participation, including Mrs. Theodore Roosevelt Jr. (née Eleanor Butler Alexander, 1888–1960), whose husband was then national chairman of the United Council for Civilian Relief in China, and Mrs. W. Murray Crane (née Josephine Porter Boardman, 1873–1972), a dedicated supporter of the China Institute since the early 1930s. They sent respective telegrams to Madame Chiang Kai-shek (1897–2003) and Madame H. H. Kung (1888–1973), the two Song sisters married to the top Nationalist leaders.[49] Under such intensive persuasion, the Executive Yuan finally accepted the U.S. invitation in principle in mid-May 1938, just one year before the fair's opening.[50]

A preparatory committee led by the Ministries of Economic Affairs and Education soon started planning in earnest. The goal of the Chinese participation was to showcase China's recent and wartime achievements and promote Chinese products and foreign trade. Also explicit among the major goals was to "publicize the spirit and characteristics of our national

culture and art . . . in order to facilitate Sino-U.S. cultural cooperation."[51] This reflected the government's awakening to the pragmatic values of cultural outreach in the United States and coordination of its previously unfocused cultural diplomacy initiatives under trying conditions. As the U.S. support for China's protracted war with Japan became ever more critical, the world's fair in its largest city provided a perfect launching ground of the fledgling Nationalist cultural diplomacy. Given the ongoing Japanese threat to evacuated collections, an exhibition of Chinese antiquities at the New York fair could also lead to subsequent safekeeping of these precious objects. To facilitate this, the preparatory committee set up a subcommittee on art, including cultural bureaucrats and directors of major museums such as the NPM, to oversee the selection of national treasures for the New York fair. Following the precedent of a comprehensive display of China in London, the exhibits would come from several contributing institutions, including the NPM and the Institute for Exhibiting Antiquities, and mostly from the vast imperial collections of the former Qing ruling house.[52]

Yet such a clear intention was muddled by the preparatory committee's conceptual confusion over how to categorize the exhibits to represent China's "national culture and art." In the detailed regulations on selecting exhibits, eligible items were actually scattered across quite different categories. *Guwu* (ancient objects), a twentieth-century term of curated antiquities for scientific study and modern museums, was colisted with *gongyi meishupin* (objects of applied art) under the heading *yishu* (art). But *gongyi meishupin* contained various subcategories, such as sculpture, carving, and embroidery, which, if made in the past, could pass as *guwu*. The Nationalist exhibits at the London exhibition included exactly such ancient *gongyi meishupin* as *guwu* to represent the splendor of the Chinese civilization. Also curious was the inclusion of *guwan* (ancient playthings) under *gongyi meishupin*.[53] Compared to *guwu*, which was imbued with nationalist connotations during the Republican era, *guwan* as a term dating back at least to the eighteenth century often referred to similar objects in private collections and art markets among literati connoisseurs and dealers. In the 1930s, while *guwan* and *guwu* referred to more or less the same objects, the former was inadequate to convey the nationalist significance of antiquities because of its association with play (*wan*) and individual actors.[54] But the preparatory committee's regulations betrayed the cultural resilience of this seemingly dated term vis-à-vis its modern rival. Other conceptual challenges to *guwu* in the same document included rare books under the category of education, and *gutong* (ancient bronzes) under domestic manufactures.

The continuing Japanese assault ultimately thwarted the first National-

ist cultural diplomacy initiative in the United States. The lukewarm U.S. reception to the Chinese plan did not help, either. When the Nationalist government finally decided to participate in the New York fair in May 1938, it was headquartered precariously in the mid-Yangzi city of Wuhan after evacuating from the capital Nanjing in the end of 1937. As the Japanese military continued to make relentless attacks on China's major cities, including Wuhan, and communication lines in 1938, the government began to withdraw further upriver to the wartime capital Chongqing. With Wuhan falling in late October, the Nationalist plan for the New York fair, including the exhibition, also collapsed. Moreover, the Nationalist government, following what Britain had offered for the London exhibition in 1935, insisted on U.S. naval transport of the priceless exhibits. Yet the U.S. government declined to make the promise for fear of provoking Japan.[55] Such a turn of events barely half a year before the fair's formal opening forced the Nationalist government to call off China's official participation, including the NPM's U.S. debut.[56]

The heightened logistic challenges during wartime also prevented the Chinese merchants from representing China in New York. Immediately following the suspension of the official participation, the Nationalist government vowed to support merchant groups to send their own exhibits. The Chinese Exhibitors' Association, representing a motley group of commercial interests, indeed sought the government authorization and subsidy to officially represent China in New York. Then based in the British colony Hong Kong after the Japanese attack of Shanghai, the Association combined wartime patriotism and international trade in justifying its proposal. According to its optimistic estimate, the first batch of the handicraft exhibits such as the paper umbrella and lacquerware could depart Hong Kong in late May 1939 and arrive in New York in mid-June, leaving enough time for the Chinese exhibition's opening in mid-July. Despite the fleeting reference to "the propagation of our nation's graceful culture," the main emphasis was on the economic benefits to the government and, implicitly, its own members. The government initially approved a subsidy of one hundred thousand Chinese yuan in May 1939 but reversed course in early June. Citing wartime budgetary shortfalls and logistical challenges, the government not only scrapped the funding but also requested the Association to suspend its participation in the New York fair.[57] The Association thus decided to sponsor charity sales of already collected exhibits overseas and the government later allocated twenty thousand Chinese yuan to compensate for its loss in early 1940.[58]

Entrepreneurs and Philanthropists

With both the Chinese government and merchants out of the picture, the New York fair provided a wide opening for actors inside and outside the fairground to exploit the imageries of varying connections to China for commercial and philanthropic purposes. Instead of the Nationalist government's intended messaging of the refined culture of a unified China, the fractured representations of China in New York often focused on different borderlands with ambiguous connections to China's political center but beyond its effective control. They included both the contiguous former imperial frontiers as the latest Orientalist fad and the Chinatown in the United States.

Within the fair, the Lama Temple, a life-size replica of the eighteenth-century original in China, failed to generate the anticipated excitement. The original temple was of a Sino-Tibetan fusion style in the Qing imperial summer resort, itself a replica of the Potala Palace in Lhasa. The enormous exhibit (over 28,000 numbered parts) was first commissioned by a Chicago-based merchant for the Chicago World's Fair in 1933 after the Chinese government denied his request to disassemble the original structure and reassemble it in the United States. But the replica still achieved great success in Chicago.[59] The New York fair corporation began to negotiate the shipping of this exhibit to the East Coast as early as 1937. In addition to the Chicago-based owner, the Temple in New York was also under the local sponsorship of Frank Reilly, an electrical contractor of J. Livingston & Company. Reilly formed the Lama Temple Sponsors, Ltd., and acted as the local co-concessionaire of the "Chinese Lama Temple." It was installed in the amusement midway, where the profit-driven display of the exotic ran supreme.[60] But the surprisingly low attendance made Reilly's business venture an utter disappointment in the 1939 season. In a complaint to the fair, Reilly claimed that the main reason for the lackluster attendance at his concession was that the "educational" exhibit could not attract the majority of the midway visitors, who usually came in the evening and were "more interested in strip-tease than in the Ming Dynasty."[61] The muddled chronology aside, Reilly was completely unaware of his exhibit's implications in the layered Qing ethnic politics, which could not be reduced to a single "Chinese" label.[62] In another telegram, Reilly made a casual racist joke of using "plaster o' Paris to fill up the Chinks" and hoped this "authentic Chinese mausoleum on the cemetery circuit" would draw visitors.[63] What he really cared about was not so much the exhibit's edu-

cational as its pecuniary effect. Yet as the fair noticed, *Strange as It Seems*, an animated show of exotic places around the world based on the popular comic strips of John Hix (1907–44), continued to draw visitors away from the Temple exhibit. Even lowering the price for admission did not help. As of mid-1940, Reilly was still unable to pay back the loan of $26,000 the fair had extended to him in 1939.[64]

In anticipation of the increased volume of visitors during the fair, the local Chinese American community also actively promoted the Chinatown in lower Manhattan as another exotic attraction. In 1938, an enterprising Henin Chin (Chen Tian'en) published the *Official Chinatown Guide Book for Visitors & New Yorkers*. But due to trademark issues, it could not be advertised as the World's Fair edition. The extensive advertisements, the vast majority from various Chinatown businesses from restaurants to retailers, revealed the booklet's main purpose: to get more patrons for these businesses during the fair.[65] Despite its focus on the imperial art collections in its planning of Chinese cultural diplomacy in the United States, the Nationalist government endorsed this commercially oriented publication at a time when it was unable to participate in the New York fair. In addition to the president of the fair corporation, top Chinese diplomatic representatives, including the ambassador Wang Zhengting (1882–1961) and the consul general in New York Yu Junji (1900–1968) graced pages of the *Guide Book* with their felicitations. Although Chinese Americans had long been an important target of the Nationalist political canvassing, they had been largely excluded from Chinese cultural diplomacy since its inception because of their perceived low socioeconomic status and detrimental impact on American understandings of China. But at a time when something was better than nothing, the Nationalist government had to tap into this group in order to make itself somewhat heard during the fair.[66]

As a self-Orientalist exposé of Chinatown, Chin's *Guide Book* ultimately served a very different purpose from the intended Nationalist messaging. Its coverage of Chinese culture, including China's long history and the lasting legacy of Confucius, was crammed into a few nonprominent pages in the middle of the booklet. A somewhat informative dynastic chronology was mixed with mythic early rulers and legendary stories of Confucius.[67] The presentation of such a quaint culture emphasized its nonthreatening nature to the body politic of the modern United States, which, rather than jeopardize the assimilability of Chinese immigrants, would hopefully increase the appeal of ethnic businesses. Despite dwelling upon a seemingly antiquarian motif, Chin and his fellow Chinese Americans had little intention to impress Americans with the sophistication of Chinese culture

as the Nationalists would. Instead, they turned it into a commodity in order to carve out their precarious position in a country that still legally barred most of Chinese immigration.

In midtown Manhattan, the Arden Gallery also attempted to take advantage of the New York fair with a planned exhibition of purported imperial art treasures from China. Located at 460 Park Avenue, Arden had already organized two loan exhibitions since the outbreak of the Sino-Japanese War in 1937 in collaboration with prominent New York dealers and women's relief organizations in the United States for China's civilian refugees. Focusing respectively on Chinese bronze and jade, these two exhibitions showcased objects from various private collections in the United States.[68] What Arden proposed in early 1939 in conjunction with the incoming fair was a more ambitious charity exhibition no longer confined to particular kinds of objects. Among the high-profile sponsors it sought was Henry Luce, the China-born son of missionaries, the influential publisher of *Time* and *Fortune*, a staunch supporter of the Nationalist government, and the future patron saint of the China Institute.[69]

Arden seemed to envision a more comprehensive exhibition of objects from the Forbidden City, which on the surface could substitute the Nationalist government's aborted cultural diplomacy. Despite the reference to the rarefied palace ground, the underlying commercial interests made the proposed Arden exhibition more akin to the aspirations of the aforementioned Chinatown entrepreneurs than the Nationalist cultural diplomacy. Besides Luce's known support of the Nationalist government, one of the major reasons why Arden solicited him in the first place was to leverage Luce's network to underwrite the estimated cost of $20,000. Based on its optimistic projection of the "quite large profits," Arden was fairly confident that there would be "no possibility of loss to the underwriters," who would merely provide "working capital."[70] Luce indeed tirelessly canvassed the New York high society—among his targets Abigail Aldrich Rockefeller (1874–1948), Marshal Field III (1893–1956), and the Thomas J. Watson (1874–1956) couple—and finally helped Arden raise enough money for the exhibition. But similar to Frank Reilly, the overly confident co-concessionaire of the Lama Temple exhibit, Arden did not foresee the exhibition's disappointing attendance, which the gallery also blamed on the underattended 1939 fair. In the end it could only ask underwriters like Luce to wait indefinitely for the potential return of their original investment.[71]

Upon close examination of its catalogue, the Arden exhibition of "Imperial Art Treasures from Peking's Forbidden City" betrayed its marketing gimmick based on a haphazard amalgamation of objects rather than

their veritable imperial provenance. Except for the ormolu and rock monastery clocks the Yongzheng Emperor (reign 1723–35) ordered from London and three of the eighteen-piece desk set for the Qianlong Emperor (reign 1735–96), most of the exhibits did not have any clear connection to a particular monarch or the palace complex.[72] Two Ming dynasty brocade temple hangings reportedly came from the Lama temple by the lake Nanhai within the imperial city. But as the catalogue's editor conceded in his introductory remarks, Nanhai, to the west of the main palaces, was not part of the Forbidden City itself.[73] The so-called imperial millefleur jar was a popular porcelain style during the Qianlong reign not necessarily restricted to the imperial house. The exhibits without the imperial designation at all, such as a cloisonné censer, were likely to be generic objects off the market.[74] Even more curious was Madame Chiang Kai-shek's gift of a small silver dragon boat to Mrs. Theodore Roosevelt Jr. in 1927.[75] The disparate objects thus did not cohere under the claimed imperial pedigree.

Furthermore, the Arden exhibits exposed a weak Chinese state's inability to safeguard its cultural patrimony rather than represent a refined China as the Nationalists would have expected of the NPM collections. The Qianlong desk set probably came from liquidated collaterals for the last Qing emperor's defaulted loans in the 1920s.[76] Additional suppliers included C. T. Loo and Tonying, two leading dealerships of Chinese art in Europe and the United States also involved in earlier Arden exhibitions.[77] They were headed respectively by C. T. Loo and C. F. Yau (Yao Shulai, 1884–1963), well-connected antique merchants from China and, as the following chapter will demonstrate, important supporters of the China Institute's initiative in exhibiting Chinese art in the 1940s. The two dealerships took advantage of the increasing demand for Chinese art in European and U.S. markets in the early twentieth century as well as the contemporary political instability in China, and conducted sometimes questionable acquisitions that were borderline looting and smuggling.[78] The two English-made clocks, for example, might be spoils from foreign troops' sacks of Qing palaces in 1860 or 1900, which showed up subsequently in the market through the burgeoning international trade of Chinese art.[79] In the end, the Arden exhibition revealed the global dispersal of Chinese art under imperialism and capitalism more than Chinese cultural diplomacy.

The fair's lackluster attendance in 1939 did not deter other Americans from showcasing the exotic China/Orient in order to generate commerce or compassion in the 1940 season. Harrison Forman (1904–1978), for example, was determined to revive the Orientalist aura of the troubled Lama Temple exhibit as the new operator. An intrepid explorer of Tibet

and wartime reporter in China, Forman was already famous from his 1935 travelogue *Through Forbidden Tibet*. He was also the technical director in Frank Capra's 1937 epic film *Lost Horizon*, based on a 1933 bestseller about the mythic Shangri-La.[80] Eager to continue exploiting the perceived popular fascination with China's former imperial frontiers in Central Asia at the New York fair, Forman tasked a personal representative, Robert R. Hansen, to make the pitch as he was still in China. Their June 1938 proposal emphasized Tibet as the "very last remaining great expanse of 'frontier'" and its "primitive mysticism, weird rituals, Oriental occultism, strange peoples."[81] In another telegram to the fair corporation's president in early 1939, Hansen promised, among other things, "sensational . . . devil dancers" and "seductive temple dances" that would be "eye filling and gasp producing" and boasted a handsome net profit of $180,000. Ignoring the Lama Temple exhibit earlier in Chicago, Hansen concluded by pleading the fair to "introduce for the first time in the history of fairs the never before exhibited land of Tibet."[82] While the fair was doubtful of the financial prospect of this proposal in 1939, it finally approved Harrison Forman, Inc. to sublease the Lama Temple and run its own Forbidden Tibet exhibition in 1940.[83]

Similar to earlier operators, Forman selectively amplified and distorted the original temple's Manchu, Chinese, and Tibetan legacies in the layered Qing ethnopolitics. Heeding the fair's suggestion of creating lively shows within "an authentic architecture" and eager to boost the number of fee-paying visitors, Forman, Inc. removed the interior furnishings of various Tibetan Buddhist artifacts—prompting a local collector to attempt a bid on those removed objects—and added a show of female "bally" (presumably belly) dancers with provocative body movements.[84] Trying to peddle the mystic appeals of a generic East, Forman's associates never justified the relevance to Tibet of a predominantly Egyptian form of choreography dating back to the pre-Islamic times.[85]

Such a drastic change to the exhibit raised its public profile but also drew vocal criticisms of the allegedly indecent show from different quarters. Besides the local Protestant and Catholic churches, Frank Reilly's Lama Temple Sponsors, the 1939 operator of the concession and still its official lease holder, also expressed concerns about such bad publicity.[86] A nationalistic L. K. Wong blasted a "most obscene lecture" in front of the "Chinese temple" and a "most disgraceful show" as a "disgrace" to China's cultural refinement.[87] Proponents of Chinese cultural diplomacy would have shared such sentiments. Probably out of its self-interest to keep a concessionaire, the fair corporation first defended Forman's efforts in

"prov[ing] the authenticity of his Tibetan dancers and reproductions on the inside of 'Lama Temple'" and dismissed Wong's criticism as a politically motivated "under-current" against Forman. Although conceding that "the real Tibetan ceremonies could not be reproduced in this Country," it believed that Forman was simply displaying "the lighter and more presentable parts" of Tibetan culture.[88] But the ongoing public outcry finally compelled the fair corporation to demand a change from the concession.[89] Such obsession with indecency means that neither the critics nor the fair questioned the Orientalist conflation of Middle Eastern dancing with the Qing Empire's ethnopolitics.

Yet even the fanfare of bally dance did not improve the concession's dire financial situation. In early June, less than a month after the opening of the 1940 season, the temple exhibit once again changed hands from Harrison Forman, Inc. to a new entity called Tibet, Inc. Sandra Carlyle (1907–1996), Forman's wife but seldom identified as Mrs. Forman, replaced Hansen as Forman's new representative.[90] Forman probably wanted to shake up the business with someone he trusted. But the concession continued to suffer from huge financial losses and took more loans from the fair just to stay open. Even drastic measures such as discounted admission and reduced payment to the fair did not make much of a difference.[91] On the other hand, the concession's lax security, which resulted in the respective stealing of cash and furnishings by an employee and a visitor, further highlighted its mismanagement.[92] As the 1940 season drew to a close, the fair was stuck with a gigantic structure, over whose demolition and storage its various stakeholders had no consensus.[93] A spectacular exhibit that the fair had expected to bring enormous Orientalist appeals and huge profits ended up as a financial and logistical liability.

Besides this disappointing business venture, some "American friends" of China also attempted to "sponsor a Chinese exhibit for the American people" in order to raise public sympathy toward China's wartime plight in 1940.[94] Bruno Schwartz (Shaw), a former journalist in China, was the driving force behind these efforts. In the late 1930s, Schwartz was simultaneously the national campaign manager of the United Council for Civilian Relief in China and director of the Trans-Pacific News Service, the Nationalist government's de facto official news agency in the United States.[95] Although the United Council orchestrated the China Day on October 10, China's national day, during the 1939 fair, Schwartz was contemplating a more ambitious program for 1940. In his letter to the fair corporation in late 1939, Schwartz proposed a China Exhibits, Inc. to be organized by the United Council. The proposed venue was the Dutch pavilion from

the 1939 season, which would be vacant in 1940 because of the intensifying warfare in Europe. With the United Council's pro-China position and the preliminary support of Hu Shi, the leading Chinese liberal intellectual and then Chinese ambassador to the United States, Schwartz was confident that his proposal would also get the approval of the Nationalist government.[96]

Although Schwartz's philanthropic representation of China envisioned the display of ancient Chinese art and culture, his plan upon close examination also differed from the aborted Nationalist cultural diplomacy. Among the proposed exhibits were "ancient and valuable Chinese arts and crafts," which would give Americans "the opportunity to benefit from the cultural and inspirational value to be derived from the achievements of China's ancient civilization."[97] Despite a similarly lofty rhetoric, the arts and crafts label betrayed a quite different understanding of China's cultural traditions. As a popular decorative style aspiring to use simple forms in Western Europe and North America at the turn of the twentieth century, the arts and crafts movement drew upon earlier and foreign, particularly Japanese, aesthetics and fashioned itself against the industrial society.[98] Using such a label to characterize China's cultural achievements unintentionally locked Chinese culture at a charming but folk level and reinforced the Orientalist condescension. Foreclosed were its appeals of refinement and sophistication the Nationalist government had planned to project in New York.

Yet Schwartz's plan never appeared to have materialized, and the shakeup of the Nationalist government's top diplomatic representative in the United States might offer some clue. In 1938, Chiang Kai-shek appointed Hu Shi as ambassador in the hope that this well-connected liberal scholar would secure an abundance of the much-needed U.S. aid. But as of 1940, Chiang did not consider Hu's achievement impressive. In June, T. V. Soong (1894–1971), a top financial official and Madame Chiang's brother, arrived in Washington as Chiang's personal envoy and superseded Hu's authority. Unlike Hu, Soong was a pragmatic bureaucrat who focused squarely on aggressive negotiations on military and economic aid with the U.S. government.[99] Schwartz's plan was thus much less likely to receive his blessing. To Schwartz's relief, the American Bureau for Medical Aid to China managed to organize a small exhibition on China. According to the brief press release, the exhibition publicized the Bureau's work with "the color and atmosphere of a street in a Chinese city" provided by Chinatown performers. Still implicit in the exhibit was the U.S. benevolence toward an exotic and needy China.[100]

Conclusion

Unlike its predecessors in China at the turn of the twentieth century, the Nationalist government rushed to an awakening to Chinese cultural diplomacy and particularly its importance in the United States during the 1930s. The intensifying Japanese threats served as a catalyst for the battered government to tighten its hitherto scattered bilateral initiatives in cultural outreach into a more focused cultural diplomacy program. It centered on the international spectacle of the former imperial art collections as an enduring symbol of China's cultural elegance. On the other hand, such threats also nullified the Nationalist efforts in its planned cultural diplomacy debut in the United States at the New York World's Fair. Instead, commercial and philanthropic interests vied to represent China and its ambiguous borderlands in Central Asia and diasporic enclaves in the United States in the carnivalesque space. These cacophonic Orientalist imageries at the fair maintained an entrenched epistemological advantage and continued to tune out the intended messaging of Chinese cultural diplomacy. All these underline the challenges the Nationalist government faced in its international cultural outreach. Under trying conditions, the government simply did not have the means nor time to establish, as other powers had done, a central command in charge of cultural diplomacy. Without such an effective infrastructure of persuasion to generate continuous programming, the Nationalists tried to break into the inherently unequal exhibitionary order to get its message across. But the unexpected debacle of the Lama Temple exhibit in New York highlighted the fickle and fleeting popular taste, as well as the risks in such a strategy of cultural diplomacy. As the following chapter will demonstrate, the Nationalist government in the early 1940s soon found a neglected partner in advancing its stalled cultural diplomacy.

Contingent Confluence

1943–1958

"[The China Institute] will continue to be important to the increasing friendship between our two peoples. Especially due to President Luce's consistent support of our country in public opinions, their fundraising request of $100,000 should be approved."

Nationalist government internal memo, late 1947

"This has added greatly to my feeling of inadequacy in telling you of all people anything at all helpful about China Institute, or what we finally came to call 'the Cause of China' . . . it would be very difficult if not impossible to find any place where your charitable dollars could have more impact."

Anonymous memo by aide of Henry Luce, July 19, 1958

The China Institute and the Nationalist government had developed their separate visions and strategies of cultural diplomacy in the United States by the late 1930s. Grown out of the post-World War I surge in cultural internationalism, the Institute under the leadership of cosmopolitan Chinese intellectuals promoted public understandings of eclectically defined Chinese culture on a modest organizational basis. It treated such cultural projection as a worthy cause in and of itself when there was no unified Chinese state to do the same. In contrast, the Nationalists only began to consider staging spectacles of antiquarian Chinese culture in the 1930s as a pragmatic means of getting more U.S. support in order to confront the

escalating Japanese threat. But chaotic wartime logistics disrupted the government's ambitious plan to display the former imperial art collections at the 1939 New York World's Fair.

This chapter focuses on how these two almost parallel tracks of Chinese cultural diplomacy became entangled in the 1940s and 1950s. Bookended by the height of mutual goodwill between China and the United States during World War II, and the stabilization of tense military standoff across the Taiwan Strait, this period witnessed dramatic shifts in both countries' domestic politics and their bilateral relations. The Nationalist government survived the Japanese invasion, lost the Chinese Civil War, and retreated to Taiwan in 1949. In the same year, the PRC was founded on the mainland, and the nascent state soon fought a brutal three-year war with the United States on the Korean Peninsula. These momentous ruptures aside, attention to the modus operandi of Chinese cultural diplomacy in the United States, particularly its evolving philanthropic support base and programming, sheds light on obscured continuities and pragmatic considerations behind partisan posturing.

The China Institute's financial problems and the government's struggles with legitimacy across the 1949 divide triggered the government's support of the Institute via the perceived political influence of Henry Luce. Son of a China missionary, media magnate, and staunch Nationalist supporter, Luce was an essential catalyst, though far from the only one, in the entanglement between the China Institute and the Nationalist government. But Luce's involvement in his "Cause of China" was much more nuanced than his well-documented political support of the Nationalists. Such a mutually convenient arrangement gradually took on more politicized meanings as China became an increasingly fraught topic in U.S. politics. The Institute's fundraising and programming was the bellwether of reshuffling political and economic interests that would continue to influence the infrastructure of persuasion for Chinese cultural diplomacy in the United States. The support from Luce and the Nationalist government kept the Institute afloat. But it also alienated other donors, such as the Rockefellers, and brought the long-term reputational baggage of the Institute's perceived partisanship. In the uneasy engagement between China and the United States in the mid-twentieth century, the Institute was a nodal point, active participant, strategic beneficiary, and collateral damage all in one.

The limited existing studies on the China Institute focus on the pre-1949 period and rely mostly on published sources. Such an approach is not as well equipped to understand the multilayered transnational context in which the Institute operated across the 1949 divide. It can also inadver-

tently underestimate the uncertainties in the Institute's changing relationships with diverse constituents and reinforce the conceptual stranglehold of the partisan Luce-Nationalist nexus on an actually fluid moment.[1] Drawing upon different archival records, the Institute's own publications, and oral history, this chapter argues that the convergence of two institutional actors of Chinese cultural diplomacy is better understood through their involvement in an intricate web of mutual (mis)calculations with American philanthropists such as Luce and the Rockefellers. These (mis)calculations led to an unexpected "philanthropic Cold War," the political and economic realignment among the Institute and its benefactors marked by competing interests and personal rivalries. It not only transformed the political economy of Chinese cultural diplomacy in the United States but also facilitated a decisive antiquarian turn in its content. To be sure, the Chinese Nationalist government had tried to stake an exclusivist claim to China's ancient and unbroken cultural pedigree centered on the former imperial art collections since its foray into cultural diplomacy in the 1930s. The Institute, however, had embraced a more eclectic approach that incorporated both past achievements and contemporary developments, and both Chinese and non-Chinese perspectives. The intensifying partisan finger-pointing in the 1940s and 1950s made the antiquarian focus a much safer way to talk about China in the United States. But structurally and discursively, the Institute never abandoned its more inclusive vision.

What follows is divided into three substantive sections. It begins with the China Institute's pragmatic campaign for its own office space in 1943 and 1944, which brought together diverse stakeholders and uncovered their different calculations. The following section, in a rough chronological order, focuses on how the intensifying Cold War and volatile relationship between China and the United States politicized the Institute's fundraising. Despite the Institute's attempt to continue earlier pragmatism, and Luce's predominantly cultural logic in supporting the Institute, the Nationalist government continued to see the Institute as a political lever in effecting favorable U.S. policies during the raging Chinese Civil War and beyond. The increasingly partisan connotations of the Institute's connections to Luce and the Nationalists, together with Luce's perceived lack of interest in the new Rockefeller philanthropies, drove the Rockefellers further away from the Institute. This philanthropic Cold War on China sustained itself on the stakeholders' persistent mutual misperceptions. The chapter then turns to the Institute's programming in the midst of such philanthropic turbulence to demonstrate that its unmistakable embrace of Chinese antiquities still maintained subtle distance from the Nationalist

government. The entanglement between the two institutional actors of Chinese cultural diplomacy around the mid-twentieth century underscores a contingent confluence of shifting political and economic interests that undergirded public understandings of China in the United States. But the two actors' fundamental differences, as the next two chapters will show, did not disappear and would resurface in the 1960s.

Convergent and Divergent Interests in China House

More than five years into the Sino-Japanese War, China saw an auspicious beginning in 1943. The United States, which joined the war after Pearl Harbor, agreed to relinquish extraterritoriality together with the United Kingdom.[2] A flurry of optimism regarding the long overdue fulfillment of national independence ensued among Chinese of different political persuasions.[3] Such legal privilege exempted nationals of Western powers (later also Japan) from Chinese law as early as the 1840s, a stipulation Qing China agreed to in the unequal treaties after its defeat in the First Opium War. Though not immediately seen as an infringement on sovereignty in light of the existing Qing legal pluralism, the practice later became a symbol of national humiliation and its abolition a rallying cry for Chinese nationalism.[4] Due to their extensive interests in China, the United States and United Kingdom were among the last foreign powers to abrogate this privilege. But by then, they had already lost their semicolonial concessions on China's coast to Japan, and considered the abrogation a symbolic morale-boosting measure to their Chinese ally.[5]

Yet halfway across the globe in New York, the widely applauded new treaty imperiled the survival of the China Institute. Without a stable endowment, the Institute had mostly survived on the annual funding from the China Foundation for the Promotion of Education and Culture. A generally autonomous steward of the second batch of the Boxer Indemnity remission founded in Beijing in 1924, the Foundation was ultimately financed by the Chinese government's Indemnity payment. But under the dual existential threats from both Imperial Japan and the CCP, the Nationalist government had never directly subsidized the Institute nor considered it a political asset. The 1943 treaty, however, would terminate the Boxer Protocol of 1901, which could jeopardize operations of the Indemnity-supported China Foundation and, by extension, the Institute. Chen Lifu (1900–2001), the Nationalist Minister of Education, called for the government takeover of the remaining Boxer Indemnity remission and abolition

of all organizations previously supported by such funds.[6] As Roger Greene, a long-term trustee of the China Foundation, wrote, it was not possible "to forecast what part the China Foundation [would] be able or willing to play in the maintenance of the China Institute in America in the future."[7]

Facing the dire prospect in 1943, the China Institute's director Meng Zhi proposed an office building and student center, named China House, as the opening gambit in a fundraising campaign that aimed to woo major philanthropists in the United States.[8] The Chinese government was not under serious consideration, nor were "small gifts from the 'Cantonese laundrymen,'" a condescending reference to working-class Chinese immigrants in internal correspondence.[9] In Meng's opinion, the Institute, stuck in a small rented office in midtown Manhattan, could attract donors beyond the China Foundation with improved facility.[10]

The China Institute first turned to John D. Rockefeller Jr. (1874–1960) in April, patriarch of a prominent family that had shown deep philanthropic interests in China. Rockefeller bankrolled the founding of the prestigious Peking Union Medical College in 1917. On the eve of the Sino-Japanese War, the Rockefeller Foundation sponsored some of the most respected natural and social science programs in various Chinese universities.[11] The Institute had appealed to Rockefeller once in 1931, supported by trustee members jointly working for Rockefeller-funded organizations such as the Council on Foreign Relations and Institute of Pacific Relations (IPR). Rockefeller's advisor Arthur W. Packard (1901–1953) declined the request due to the Institute's perceived narrow national focus.[12] Given the family's continuing interest in China, the Institute tried again in 1943, represented by its trustee Stephen Duggan (1870–1950), also director of the Institute of International Education, an advocacy organization for student exchange supported by the Rockefeller Foundation. But Packard still believed that the China Institute, a worthy cause notwithstanding, was too narrow compared to Rockefeller projects such as the International House, residential buildings and social centers for students of all nationalities in New York, Berkeley, Chicago, and Paris dating back to the 1920s and 1930s.[13] An established philanthropic enterprise, the Rockefeller team found the Institute's proposal wanting in its routine merit-based evaluation.

Later, Meng successfully persuaded Luce with personal connections. Back in his student days in Beijing in the late 1910s, Meng befriended a few missionary educators, including Henry W. Luce (1868–1941), father of the future media tycoon. After his involvement in the YMCA, Meng converted to Christianity and Luce Sr. gave Meng his Christian name Paul. Following the China Institute's failed pitch to Rockefeller, the indefatigable Meng

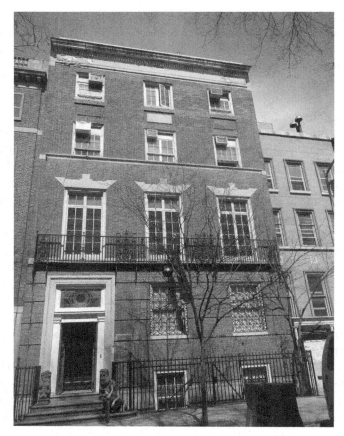

Fig. 2. China House, 2013. (Photograph by Jim Henderson, courtesy of Wikimedia Commons.)

turned to Luce Jr., whom he had known since an IPR meeting in Canada in 1933, in the fall of 1943.[14] By this time, Luce Sr. had passed away and the foundation in his honor established by his son in 1936 was trying to establish itself in philanthropic circles. In his final proposal in mid-November, Meng asked for a sum total close to $100,000, which included the initial purchase of property, furnishings, and five-year maintenance and programming. The Luce Foundation originally only considered the purchase of the house plus guaranteed maintenance funds of one year. But one day before the formal offer, Roger Greene suggested an extension of the guaranteed maintenance to two years.[15] The Foundation informed the Institute thusly in early 1944. The Institute, as later concurred by the China Foundation's

special wartime committee in the United States, promptly accepted the gift of a Neo-Georgian townhouse at 125 East 65th Street in Manhattan, where it remained until 2014.[16] Between its founding in 1936 and the end of World War II, the Luce Foundation made most of its grants to Asian affairs, of which the vast majority went to the Institute.[17]

But unknown to Meng, Luce had already envisioned an organization to promote public understandings of Chinese culture in the United States before the pitch. As a missionary son born and raised in China, Luce maintained a romantic connection to the country even though he lived a mostly segregated life away from ordinary Chinese.[18] With his business at a comfortable height by the early 1940s, Luce was eager to translate his passion for China, something not uncommon among Americans of similar upbringings, into philanthropy where he did not bear the burden of legacy as the Rockefellers.[19] According to an internal memo by his personal aide Wesley Bailey (1911–1990), Luce in early 1943 was already contemplating a new Pacific House "for the dissemination of Chinese culture and Sino-American understanding," a cause the China Institute had been trying to fulfill under tight budget. To act on this vision, Bailey had a lunch discussion with an unidentified Chinese living in the United States. His interlocutor, who seemed sympathetic to the Nationalist government but not in its employ, suggested that the house be named China House. This would recognize China as an important U.S. ally during World War II and also avoid the apparent connection to the IPR, too left-leaning to the Nationalists. Bailey agreed that the United States had been "pretty slovenly" in its China aid, and that Luce's support of a China House would be another overdue gesture to shore up Chinese morale.[20] Meng's fundraising success was therefore fortuitous because the China Institute was the only viable organization in the United States in broad alignment with Luce's vision.

The Luce Foundation knew about the China Institute's chronic dependence on a single revenue source, but it offered mixed signals about what to do. On the one hand, the Foundation did not want the Institute to continue the status quo. The guaranteed funding for the maintenance of the China House would only last two years, rather than the five-year package Meng had asked for. While the Foundation gave a more generous estimate of the House's annual maintenance at $12,000 (Meng's was a little over $10,500), it would only pay $7,000, thus leaving a sizeable fundraising job to the Institute "to broaden the interest among both Chinese and Americans in the Institute and its work."[21] This was exactly what the Institute had been unable to do in the previous two decades.

On the other hand, the Luce Foundation, as concurred by Luce him-

self, was doubtful of the China Institute's ability to ever get financially self-sufficient. It actually insisted upon the China Foundation's continuous funding as a prerequisite for the gift, despite the Foundation's survival crisis between 1943 and 1944. In a memo to Luce in mid-November 1944, Charles L. Stillman (1904–1986), president of the Luce Foundation, put it plainly that the China Institute "was the creature of the [China] Foundation and dependent upon the continued support of the [China] Foundation."[22] Just days before the China House's formal opening on December 1, Stillman not only threatened to rescind the gift should such funding discontinue, but he also used personal connections with Secretary of State Edward R. Stettinius Jr. (1900–1949) to reiterate the Luce Foundation's opposition to the proposed abolition of the China Foundation. Stettinius was sympathetic to Stillman's position and told the Nationalist government that the China Foundation's autonomy was a tacit prerequisite of the U.S. relinquishment of extraterritoriality.[23] Trustees of the China Foundation also lobbied pro-American officials to keep their organization intact. Such a chorus of opposition finally worked as a new interim cabinet under T. V. Soong called off the abolition plan in late 1944.[24]

While the Nationalist government was not unaware of the China Institute before 1943, it had shown little political interest in this humble cultural organization. Meng's memoir mentions the Institute's involvement in administering some government scholarships for Chinese students in the United States starting in the 1930s, as well as his own participation in the Committee on Wartime Planning for Chinese Students in the United States (*Liu Mei Zhongguo xuesheng zhanshi xueshu jihua weiyuanhui*) led by Soong in the early 1940s.[25] Despite great ambitions in quality control, the government's study abroad policy suffered from funding shortage and uneven implementation due to more pressing concerns especially after the outbreak of the Sino-Japanese War.[26] To enlist the Institute's assistance made sense, but the level of such assistance is questionable because neither Meng nor the Institute features prominently in the existing research in Chinese, if at all. Another piece of confounding evidence is the lack of relevant reporting in the official newspaper *Zhongyang ribao* prior to Luce's gift. This is corroborated by Meng's own acknowledgment that he did not enjoy the government's full trust, particularly among the more conservative factions.[27] Meng's incomplete biographical sketches in the government's "temporary" (*linshi*) and "supplementary" (*buchong*) personnel files around the mid-1940s and even mid-1950s also demonstrate the Institute's auxiliary rather than essential value.[28]

The China House quickly transformed a hitherto *working* relationship

into high-profile *political* patronage. In early February 1944, less than a month after the gift, China's wartime chief finance officer H. H. Kung wrote a letter of appreciation to Luce. Luce's gesture, Kung penned, "[would] go a long way in further strengthening the cordial ties of our two peoples." He also personally donated $10,000 to the China Institute for furnishing the House.[29] In late August, Kung, now the Institute's honorary president, formally accepted Luce's gift at New York City Hall. There he also officiated at the ceremony of the 2495th birthday of Confucius (551–479 BCE) as a descendant of the sage teacher. Both the *New York Times* and *Zhongyang ribao* covered Kung's glowing remarks of Luce's generosity and the Institute's achievements in promoting Sino-U.S. educational and cultural exchange. Kung, according to the *Times*, also presented to the Luce Foundation a handwritten calligraphy scroll from Chiang, where the four main characters read "the way is one and the winds blow together" (*dao yi feng tong*).[30]

Given its timing, the Nationalist government's conspicuous patronage of the China Institute since 1944 was more likely a gamble on Luce's perceived influence in U.S. politics in exchange for favorable policies. To begin, in the inscription to the right of the four characters, Chiang dedicated his felicitations to the opening of the meeting facility of *Zhongguo xiehui*.[31] Apparently, neither Chiang nor his aides bothered to check the actual Chinese name (*Hua Mei xiejinshe*) of the China Institute. Facing existential threats from Imperial Japan and the CCP, the Nationalist government needed to marshal more international goodwill particularly from its most powerful ally. Luce's high-profile visits to China in 1932 and 1941 had already put him on the Nationalist radar as a potential booster in the United States. The widespread influence of *Time* and *Life* further confirmed the Nationalist belief in his influence.[32] Luce's signature philanthropic project could, the government believed, serve as a new opening to garner support, both moral and material, in the United States. This was especially critical as the Nationalist reputation started to slip after Madame Chiang's celebrated 1943 tour of the United States due to increasing reports of corruption and incompetence.[33]

Kung championed the China Institute possibly for his own benefit. Bedeviled by the widespread corruption accusations of his tenure as the wartime minister of finance, Kung needed a reputable cultural cause to embellish his political career.[34] In 1939 he became the founding president of a nebulous Sino-American Cultural Society (*Zhong Mei wenhua xiehui*), which facilitated exclusive gatherings of Chinese and Americans in Chongqing under the banner of cultural exchange.[35] Kung's involve-

ment in the Institute continued this pattern. After his initial personal gift of $10,000 in 1944, Kung made several more donations of over $30,000 in combined value in the 1940s. These were often through the organizations he controlled, such as the Society and the Bank of China, where he was chairman of the board. With no explicit mention of the Nationalist government, these contributions enhanced Kung's personal prestige.[36]

Reactions to Meng's 1943 fundraising underscore the (potential) donors' distinct visions of harnessing China's cultural resonance before Cold War politics set in. A more seasoned philanthropist, Rockefeller insisted on reviewing the Institute's missions in the context of his overall charitable giving. Much less experienced despite his upbringing in China, Luce was a more spontaneous novice taken by a proposal that more or less spoke his mind, and his name attracted the Nationalist attention. With the incoming political maelstrom, these early decisions would acquire more political meanings.

Philanthropic Cold War in Different Directions

The China House gift, far more than Luce's cursory interest in the China Institute, was the opening gambit in his longstanding "Cause of China" when the Chinese state lacked the capacity to support such an endeavor. Despite his pressing schedule, Luce accepted the invitation to join the Institute's board of trustees in late May 1944.[37] Luce was elected president in 1947 and remained chairman of the board, a position created for him, from 1951 until his death in 1967.[38] In the meantime, the Luce Foundation generously funded the Institute's general operations and building maintenance through the 1970s, with an annual average around $27,000 between 1944 and 1966 (including the China House).[39]

Luce's deepening involvement in the China Institute in the late 1940s did not fundamentally change the Institute's relationship with other benefactors in the short term. The China Foundation made a generous donation of $50,000 in 1945 to help finance the Institute's budget for the following five years.[40] Even the differences between Meng and the Luce circle regarding the Institute's priority right after Luce's gift gradually disappeared. In late 1944, the Luce Foundation president Charles Stillman privately criticized Meng for diverting resources from Luce's main goal of promoting Chinese culture in the United States, and dismissed Meng's putatively student-centered programming as only "effective in a small way." He even contemplated the Foundation's repossession of the property with

the tacit support of Luce and more explicit encouragement of his sister Elisabeth Luce Moore (1903–2002), longtime trustee at both the Foundation and Institute, and her brother's personal deputy overseeing their daily operations.[41] The CCP's battle victories raised the strategic values of Chinese students and eventually made such differences moot.

The same advisor of the Rockefeller family philanthropy also persuaded John D. Rockefeller III (1906–1978), then newly at the helm, to make small donations contingent on the China Institute's "diligent efforts" in seeking different philanthropic contributions.[42] Although Luce and his associates had similar concerns, the Rockefeller team actually made the Institute's fundraising performance a key prerequisite for its continuing support. For 1944 and 1945, for example, Rockefeller III only promised $4,000 and $1,000 respectively toward the Luce Foundation's estimated annual operating budget of $12,000 for the China House, should the Institute be able to demonstrate a diverse support base.[43] As the Institute failed such a requirement in 1944, Rockefeller III's associates only released the promised $4,000 after Christmas on the ground of "friendly relations between Chinese and American people" and the Institute's "useful purpose," but did not relent on the original condition for $1,000 for 1945.[44] Although the family advisor suggested giving $1,000 for 1945 to show goodwill toward Luce's project, Rockefeller III did not appear to have followed through. The similar gesture of one-time sympathy funding of $5,000 also occurred in 1947 and 1950 respectively for the Institute's (overly) ambitious fundraising campaigns of $550,000 and $150,000, and the 1947 contribution was even "an altogether pleasant surprise" to the Institute.[45]

In China, the Nationalist government continued to see the China Institute as a potential political lever to deliver more U.S. aid to fight the CCP after 1945. But due to the controversy of China in post–World War II U.S. politics, the government's contributions often came in disguise. In late 1946, Minister of Finance Yu Hongjun (1898–1960) reported to Chiang Kai-shek that per his order, Premier T. V. Soong had asked the Central Bank to wire $25,000 to the Institute, the first documented official contribution.[46] While Chiang's motivations were unmentioned, Luce's perceived influence on U.S. policies toward China should be a key factor. As the donation reached the Institute, however, creative accounting completely changed its nature. An October 1947 tally of fundraising accomplished in the year registered a personal gift of $25,000 from Soong and the record continued in a 1949 tally of the Institute's annual income since its founding.[47]

The Nationalist government's political interests in the China Institute

became more evident in late 1947, when CCP troops gradually gained the upper hand in the civil war. In early December, the government received a telegram addressed to Chiang from Luce, which asked for a donation of $100,000 at a time when the Institute was unable to secure sufficient funds because of "a number of political and economic factors unfavorable to China."[48] Contemporary opinion polls confirmed Americans' reluctance to get involved in China's domestic strife, which probably explained the Institute's difficulty in fundraising.[49] In fact, the telegram was composed in the name of Luce by his sister Elisabeth Luce Moore, Meng Zhi, and another unnamed employee when Luce was out of office. In their internal deliberation presented to Chiang, ranking Nationalist officials treated the letter with utmost seriousness. While cognizant of the Institute's work in administering government scholarships during the Sino-Japanese War, they focused on Luce's unwavering support of the Nationalist government and his potential in effecting more U.S. aid. This request, as they reasoned, was "of paramount importance to the prospect of our bilateral relations," and Chiang apparently concurred.[50] By the end of the month the requested contribution, an enormous sum for a struggling government in an excruciating civil war and a hyperinflationary economy, was already in the Institute's account. Except in a required filing to the Justice Department in 1948, the Institute probably did not disclose this donation to other potential donors. Even the otherwise diligent Rockefeller team in 1949 did not seem to be aware of this hitherto single largest contribution to the Institute, surpassing even the value of the China House.[51]

It was the fallout from the Chinese Civil War and Korean War that scrambled the China Institute's relationship with different donors. The intensifying Cold War redefined the meanings of its fundraising and ultimately reshaped public perceptions of the Institute. As hyperinflation in China in the late 1940s inflicted heavy investment losses, the China Foundation ultimately abandoned some assets on the mainland and retreated to Taiwan in 1949.[52] Its funding to the Institute, the most significant prior to Luce's patronage, dried up quickly afterwards. It gave $5,000 in 1950 in response to an original request of $100,000, and another $2,000 in 1951, the last recorded donation, followed by an unanswered appeal in 1954.[53] This put further pressure on the Institute's anemic fundraising. Even Luce was only able to wring one-time contributions out of his business acquaintances, for example Thomas J. Watson Jr. (1914–1993), executive vice-president of IBM in 1949, and DeWitt Wallace (1889–1981) and his Reader's Digest Foundation in 1955, to defray the annual budget.[54] In the vivid language of Luce's associates, these contributions were often "only shaken

from the tree . . . by [Luce's] shaking," and materialized after Luce "put the bite on people for whose gifts [he] was personally responsible." The Institute, in their opinion, was doing "an excellent job except for money-raising." These individual contributions therefore did not translate into the "oncoming flood" that would "find adequate entrances" to "all doors and windows."[55] In other words, they were far from the Institute's much-needed broader philanthropic base.

Despite Luce's political support of the Nationalist government, his commitment to the China Institute became increasingly rooted in a cultural justification irrespective of its financial outlook as the Cold War deepened. As a missionary son, Luce harbored a zeal to promote his own vision of traditional Chinese culture in the United States. This made him more of a kindred spirit to cosmopolitan Chinese like Meng, who saw such promotion first and foremost as a worthy cause in and of itself.[56] Despite the Nationalist government's repeated proclamations to the contrary, it had little realistic opportunity of reinvading mainland China from Taiwan after 1949. That only reinforced Luce's determination in preserving what he feared was a disappearing China. Although still openly invoking the Cold War rhetoric of fighting for Free China in justifying his support of the Institute, Luce was actually more concerned about Chinese culture as he understood it than the political fate of the Nationalists. Reflecting upon his support of the Institute in 1957, Luce wrote in a private memo that "the more pessimistic one is about the *political* future, the more enthusiastic one should be in supporting anything that can perpetuate its *cultural* fact [emphases added]." In spite of the political impasse across the Taiwan Strait, Luce reaffirmed his sense of mission because for him "surely this is not the moment to lose what has been so painfully savaged from a 3000-year old culture."[57]

When Rockefeller III made another sympathy contribution of $5,000 to the China Institute in 1952, Cold War controversies surrounding China weighted heavily on his decision. The Rockefeller family was willing to cooperate with the victorious CCP in the end of the 1940s in order to preserve its extensive philanthropic presence in China, the largest in all foreign countries in terms of the dollar amount.[58] But the subsequent outbreak of hostilities on the Korean Peninsula shattered that possibility. Rising McCarthyism in the United States also prompted the family to shed various philanthropic liabilities, including the IPR.[59] Unaware of Luce's cultural logic in supporting the Institute, Rockefeller III's advisors scrutinized not only its financial prospect but also its perceived partisan affinity with the Nationalist government in Taiwan through Luce. Although the

advisors conceded that the Institute had been trying to "maintain a more neutral and objective position," they suggested Rockefeller III not allow his name to "rank too prominently" among its supporters.[60] Prematurely hopeful about returning to China in the near future in 1957, these advisors wanted Rockefeller III to "remain uncommitted" to the Institute and "retain maximum freedom of action" in a time of "the two Chinas problem" because "the situation in the Far East may change in the next few years."[61] In a letter to the Luce team, one advisor warned that the Institute would not "be able to talk to the Chinese people after the present political mess clarifies itself."[62]

As the Cold War finger-pointing over the "loss" of China became increasingly toxic in the United States, Rockefeller III made Japan and Asia in general the safer focus of his international philanthropy. He hoped in vain that another small donation to the China Institute would invite Luce's reciprocal support of his philanthropic cause.[63] Rockefeller III's interest in Japan developed at the same time as China during his first trip to East Asia in 1929.[64] It deepened after he served in a diplomatic mission to Japan in 1950 to negotiate a peace treaty following World War II. Similar to Luce's dedication to the China Institute, Rockefeller III revived the Japan Society, founded in 1907 by Americans with business ties to Japan but suspended during World War II, and served continuously as its president and chairman of the board from 1952 until his unexpected death in a traffic accident in 1978.[65] In 1955, Rockefeller III also founded an ecumenical Asia Society to promote Asian culture in the United States. After having declined the Institute's appeals three times in 1955 and 1956 on the ground of limited programmatic focus, Rockefeller III was prepared for a peace offering.[66] But by the time of the last recorded goodwill donation of $5,000 in 1958, even his advisors were warning the futility of "a little back scratching operation" because of Luce's apparent indifference to his philanthropic projects with no direct connections to China. Before making the contribution, Rockefeller III confided in an aide that his reluctance to support the Institute was due to its "rather limited nature" and "the fact that Mr. Luce and his publications have been so negative in their reaction to approaches from the Japan and Asia Societies."[67] Rockefeller III even explained why he had declined the Institute's earlier requests in his offer letter without mentioning Luce's name: "[T]hose who had contributed so generously to China program so seldom seemed to have an interest in similar programs for other parts of Asia. This fact still disturbs me very much."[68]

Although Rockefeller III had hoped in late 1949 that his cautious contributions to the China Institute would deliberately make "the door be left

open a crack," political clashes and personal differences ultimately stood in the way.[69] In late 1960, some advisors flatly dismissed the Institute as a political liability not worthy of the Rockefeller money.[70] But others proposed a meeting between Rockefeller III, Luce, Elisabeth Luce Moore, and Dean Rusk (1909–1994), then president of the Rockefeller Foundation, to reset relations. The meeting had to be postponed to 1961 because of Luce's absence from New York during the New Year, and Rockefeller III told his team to wait for Luce's lead.[71] There is no documentation of any follow-up. The proposed reconciliation came fifteen years later between the remaining family members of the two rival philanthropists as Luce had already passed away. In 1976, Luce's son Henry Luce III (1925–2005) became the Institute's chairman of the board, and Rockefeller III's brother and vice president, Nelson Rockefeller (1908–1979), was invited to host the Institute's fiftieth anniversary dinner.[72]

Across the Pacific in Taiwan, the recuperated Nationalist government was still interested in using the China Institute as an unofficial diplomatic channel and a potential intelligence source after 1949. In late May 1952, Edwin N. Clark (1902–1982), the Institute's president, Eisenhower's former aide, and brigadier general during World War II, visited Taiwan for one week to discuss the possibility of establishing a branch there. Luce and Meng did not travel with Clark to avoid inciting further speculations about the relationship between the Institute and the Nationalists.[73] For the ostensible purpose of his travel, Clark simply spent one morning meeting with relevant scholars and government officials in Taipei.[74] But Chiang Kai-shek met with Clark three times during this seemingly ordinary business trip. In their conversations, Chiang asked little about the Institute itself but was very keen on ascertaining then presidential candidate Eisenhower's views on fighting communism and the Nationalist plan of reinvading mainland China. Even the Ministry of Foreign Affairs officials who accompanied Clark paid close attention to his every comment and gesture and tried to decipher in their report his and Eisenhower's position on China.[75] The government's intense interest reflected its anxiety about the stalemate of the Korean War and an important election year in the United States that could upend the two-decade long Democratic hold on the presidency and return Congress back to Republican control.

The Nationalist government also resumed funding for the China Institute in the mid-1950s, but unlike the no-strings-attached pre-1949 donations, these gifts were earmarked for programs Taipei wished to spearhead with the Institute's assistance. One major example is the Chinese Advisory Committee on Cultural Relations in America (*Jiaoyubu zai Mei jiaoyu wen-*

hua shiye guwen weiyuanhui), established by the Ministry of Education in 1954 and housed at the Institute. Comprised mostly of Chinese intellectuals residing in the United States, including the Institute's founding director Guo Bingwen, the Advisory Committee shared the Institute's goals of promoting Chinese culture and assisting Chinese students.[76] It indicated the government's growing ambition but still limited capacity in carrying out these goals through its own organizational platform. The Institute's logistical support was therefore still essential.

At its inaugural meeting in late 1954, the Advisory Committee offered $1,000 to the Institute to organize a conference on Sino-American cultural relations to counter what Taipei considered the biased influence of established professional associations such as the Association for Asian Studies (AAS).[77] As China House was too small to hold a big conference, the Institute contacted University of Maryland in suburban Washington upon Luce's suggestion. Another fortuitous connection was that a professor of German literature there had taught at Tsinghua, the alma mater of the Institute's key Chinese staff members such as Meng Zhi and Cheng Qibao.[78] Cheng worked in educational administration in China and represented Nationalist China at the United Nations Education, Scientific and Cultural Organization before joining the Institute in the early 1950s. Between 1955 and 1965, University of Maryland and the Institute cohosted the annual conference on Sino-American cultural relations with discreet Nationalist funding for a decade, and Cheng was the key liaison among the different parties.[79] Besides the Nationalist diplomats and pro-Nationalist Chinese scholars, sympathetic American officials and scholars were also regular attendees. The conference focused on the value and future of traditional Chinese culture during the global Cold War, the need for more school curriculum on Chinese culture in the United States, and the ongoing educational exchange between Taiwan and the United States.[80] The Sino-American Cultural Relations conference would not have been possible without the Nationalist's government's targeted project funding for the Institute.

Noncontroversial China

Unlike the criticisms by some key members of the Luce circle, the China Institute did not overlook its mission in disseminating Chinese culture in the United States in the 1940s and 1950s. But growing political tensions and their philanthropic manifestation did nudge the Institute in new

directions in highlighting noncontroversial aspects of Chinese culture. Compared to its earlier balance between the past and present, there was a noticeable antiquarian turn in the Institute's approach as contemporary situations in China became too politically inconvenient to cover. This resulted in a discursive convergence with the Nationalist government's cultural diplomacy. But the Institute still maintained a more eclectic approach to Chinese antiquities that incorporated more diverse perspectives beyond the former imperial collections.[81]

The China House gift enabled the China Institute to set up a dedicated gallery for ongoing exhibitions focusing on ancient Chinese art. Additionally, the Institute also drew on transnational Chinese talents among others to support the professional study of Chinese art history in the United States. As the collecting of Chinese art flourished in the United States since the turn of the twentieth century, the occasional museum exhibitions of Chinese art were mostly limited to the select few major institutions.[82] The improved facility allowed the Institute to arrange a small yet regular annual loan exhibition on varying aspects of traditional Chinese art. Since its founding in 1945, the Chinese Art Society of America was affiliated with the Institute and coordinated the exhibitions. These achievements, according to Meng's memoir, relied on the indispensable service of C. T. Loo and C. F. Yau, both internationally recognized veteran Chinese art dealers. They were founding members of the Society, trustees of the Institute, and the latter served as a long-term vice president.[83] Both had engaged in often murky and questionable acquisitions. As the CCP's expanding control over China gradually shut down the once brisk art market, the Society provided them a respectable cause to contribute their experience, knowledge, and wealth. The list of known exhibitions at the Institute in the 1940s and 1950s demonstrates that despite their focus on ancient Chinese art, they were not dictated by the imperial taste as in the Nationalist case, nor were they exclusively on ancient China. In the late 1940s, there was one exhibition of painted Chinese antiques by Wilma Prezzi, an American female artist once in the employ of Loo and the Institute, and another one dedicated to Yun Gee (Zhu Yuanzhi, 1906–1963), a prominent Chinese American modernist painter.[84] In the latter half of the 1950s, there were also exhibitions on Indian and Japanese art. Besides exhibitions, the Society started publishing since its founding *Archives of the Chinese Art Society of America*, the first scholarly journal dedicated to Chinese art history in the West. There had been a few existing academic journals on broadly defined Asian art in Western Europe and the United States, such as *Ars Asiatica* (France, 1914–35), *Transactions of the Oriental Ceramic Society* (Britain,

TABLE 6. Partial List of Exhibitions Held at the China Institute, Mid-1940s to Late-1950s

Date	Catalogue
December 3, 1945–January 15, 1946	*Animals and Birds in Ancient Chinese Bronze*
January 16–February 28, 1947	*Exhibition of Paintings by Wilma Prezzi*
April 28–May 31, 1947	*Ivory and Bone Carvings from 1200 B.C. to 18th Century*
August 5–September 15, 1947	*Exhibition of Paintings by Yun Gee*
October 10–November 15, 1949	*A Study of Chinese Civilization through the Arts: Shang, Chou, and Han Dynasties*
April 28–May 27, no year (c. 1940s)	*Cloisonné Enamels: 15th, 16th, 17th and 18th Centuries*
December 1–January 10, no year (c. 1940s)	*Ancient Chinese Textiles*
May 12–June 12, 1950	*Chinese Art of the Sung and Yuan Dynasties*
October 10–November 10, 1950	*Art of the Ming and Ch'ing Dynasties*
February 2–April 3, 1951	*Chinese Mirrors*
May 21–June 21, 1951	*Ancient Chinese Silver*
October 10–November 30, 1951	*Chinese Blue and White Porcelain: Objects of Art of K'ang-hsi, Yung-cheng and Ch'ien-lung*
March 18–May 7, 1952	*Art of Late Eastern Chou*
February 22, 1953	*Art of the Tang Dynasty* (no catalogue, report in *New York Times*)
December 1, 1952–January 31, 1953	*Chinese Snuff Bottles of the 17th and 18th Centuries*
February 19–April 17, 1954	*Small Sculptures: Shang through Sung Dynasties*
March 17–April 16, 1955	*Kung Hsien and the Nanking School: Some Chinese Paintings of the Seventeenth Century*
May 3–25, 1956	*Indian Paintings: 11th to 20th Century*
November 29, 1956–January 10, 1957	*18th Century Marked Imperial Porcelain in Sung Tradition*
March 21–April 19, 1957	*Ch'ang-Sha: The Art of the Peoples of Ch'u, 5th–3rd Centuries B.C.*
April 1–30, 1958	*Japanese Paintings*
May 5–31, 1959	*Chinese Buddhist Bronzes*

Source: Data from Brooklyn Museum Library and Worldcat.

1923–), *Revue des Arts Asiatiques* (France, 1924–39), *Arbitus Asiae* (Germany, 1925–), *Eastern Art* (United States, 1928–31). None of these, however, was under meaningful Chinese leadership. The *Archives* broke new grounds in a field where Chinese voices, whether in organizing or scholarship, had not yet been heard much internationally.

The China Institute's antiquarian turn was also intertwined with its exploration of educational film as the mass media technology of the day.

Shortly before the outbreak of the Sino-Japanese War, the Institute's director Meng Zhi produced a documentary titled *Glimpses of Modern China* with the support of the Harmon Foundation, an important institution in promoting the technology and African American art. Despite shots of the exterior of the National Palace Museum, Meng's focus was on China's modern development, particularly American-educated national leaders.[85] In the early 1940s, Meng further recruited young talents to train with Harmon and produce educational films on behalf of the Institute. One of the recruits was Wango Weng (Weng Wange, 1918–2020), descendant of a prominent scholar-official family in the late Qing and pioneer of Chinese educational film in the United States.[86] Weng attended Purdue University in 1938 to escape the war in China and continue his study in engineering, but the artistically-inclined Weng did not quite enjoy his major. Thanks to Meng's introduction, Weng was able to blend his artistic pursuit and engineering training in producing educational films in full color.[87] One of Weng's earliest surviving works was *Out of a Chinese Painting Brush* (1945), a documentary of the brush techniques of Zhang Shuqi (Chang Shu-chi, 1900–1957).[88] One of the celebrated modern Chinese painters, Zhang toured the United States and Canada in the early 1940s as the Nationalist government's unofficial artistic ambassador to solicit more aid for China.[89] Zhang successfully blended contemporary Western oil and Japanese brush painting techniques with Chinese bird and flower painting traditions in creating a glittering and colorful new style. But through a self-Orientalist twist, Weng's documentary obscured the transnational origins of modern "Chinese" painting and made Zhang a pure Chinese artist who wielded a simple brush, the quintessential and timeless Chinese painting implement, with dynamic ease and magic elegance.[90]

In the charged political atmosphere, the emphasis on noncontroversial China not just defined the China Institute's new art programming but also seeped into its existing work. The public lectures stopped discussing contemporary China and turned to topics such as Chinese literature, art, and religion.[91] Following the Institute's 1944 incorporation as an educational institution chartered under the University of the State of New York, the state regulator of education, its service courses for school teachers in New York city, which Meng Zhi had started in the 1930s, further expanded. Similar courses were offered to interested adult learners in the New York metropolitan area, and summer teacher workshops started in New Jersey, Indiana, and even the West Coast. Due to the higher percentage of female school teachers, many students in these classes were also women.[92] By the end of the 1950s, elite private and public universities in the United States

were yet to systematically build China studies, as the field was still reeling from the political fallout of the "loss" of China.[93] As they were still too preoccupied to teach the public about China, the Institute continued to fill the niche and critical gap. These courses also emphasized traditional art and literature and were taught by accomplished scholars and artists such as Chiang Yee.[94] Students often expressed deep gratitude for getting to know real "Chinese" beyond their previous "Chinese American" acquaintance. Some even claimed that the Institute's courses were more interesting than those offered at Columbia University or that they were even better than a field trip to China because a visitor would not meet as many bilingually capable scholars.[95] While affirming the value of popular education on China, such feedback also reinforced the Institute's condescension toward lower-class Chinese immigrants in defining things Chinese and the privileged position of the United States in intercultural encounters.

But these courses did not just stick to China's venerable past taught by professional men to amateur women. In the adult classes, the China Institute also pioneered the teaching of Chinese cooking beyond the typical Chinatown fare, taught by educated Chinese women who had recently arrived in the United States. This gendered and culinary dimension of the Institute's cultural diplomacy coincided with the slowly changing public perceptions of Chinese food and allowed some safe discussions of China's living culture. While the influx of Chinese immigrants from the Pearl River delta region had introduced their foodways to the United States since the mid-nineteenth century, Chinese food was not always associated with fine dining.[96] By the mid-twentieth century, it was chop suey and fortune cookies that largely defined Chinese food.[97] *How to Cook and Eat in Chinese* (1945) by Yang Buwei (1889–1981), medical doctor by training and wife of the famous Chinese linguist Zhao Yuanren (1892–1982), became the first Chinese cookbook published in the United States and written by educated Chinese to introduce Chinese cooking from beyond the Pearl River delta.[98] As more educated Chinese women, usually from more developed areas along China's east coast, escaped the chaos in China and settled in the United States, teaching lessons of authentic Chinese food became one of the few options for them to earn much-needed income to support their family. The Institute was the first known organization to hire these women to teach such lessons no later than 1955.[99] It launched the culinary career of Grace Chu (Xie Wenqiu, 1899–1999) and Florence Lin (Shen Pengxia, 1920–2017), two Zhejiang natives who would become celebrity promoters of authentic Chinese food in the United States.[100]

Similar to the student profile in the China Institute's teacher educa-

tion courses, most in these lessons were women. Judging from the saluta-
tion (Mrs. v. Ms.) and last name in the available roster from Chu's classes,
many were probably married white or Jewish women.[101] The references to
such lessons in widely circulated magazines also testified to their popular-
ity among women. A female reporter of home economics for the *New York
Herald Tribune* relayed her coverage of the lessons in the *New Yorker* in
1958. A decade later, public perceptions of these classes took a more playful
turn. A 1968 article in the women's magazine *Cosmopolitan* encouraged its
readers to learn something "dramatic and new" in Lin's class at the Insti-
tute as a good way to overcome breakup or boredom.[102]

Besides broader understandings of China through school curricu-
lum and adult classes, the China Institute also sought to achieve a lasting
knowledge infrastructure at the postsecondary level. The main liaison of
the aforementioned Sino-American Cultural Relations conference, Cheng
Qibao was not satisfied with the temporary nature of such gatherings and
endeavored to spearhead a "permanent cultural cause" (*yongjiu wenhua
shiye*). According to Cheng's recollection, he and other like-minded Ameri-
can academics such as David N. Rowe (1905–1985), professor of Chinese
politics at Yale, had long been interested in founding a scholarly organiza-
tion to promote the study of China and counter the perceived political
bias of the AAS. At the 1958 annual cultural relations conference at the
University of Maryland, the American Association of Teachers of Chinese
Language and Culture was established for those purposes with Cheng as its
executive secretary. The organization was later renamed American Associa-
tion for Chinese Studies, which still exists today. It brought together China
scholars sympathetic to the Nationalist government and offered them a
friendly and stable platform to exchange and disseminate ideas. Cheng's
great pride in this achievement testifies to his recognition of the impor-
tance of the infrastructure of persuasion in sustaining the promotion of
Chinese culture in the United States.[103]

Under the aegis of the aforementioned Chinese Advisory Committee
on Cultural Relations in America, supported by the Ministry of Education
in Taiwan but housed at the China Institute, Cheng also led a compre-
hensive survey on the teaching of China in American higher education
between 1955 and 1956. Questionnaires were sent to six hundred four-year
colleges, close to half the number of such institutions in the United States
then, with a reply rate of almost 50 percent. Among 220 institutions that
offered courses related to China, the survey found that the overwhelming
majority of them put China in a larger geographical framework, such as
Far East and Asia, and that only thirty were able to offer more than five

relevant courses. In Cheng's opinion, the state of the field was "far from satisfactory" and called for much more intensive courses focusing specifically on China, given the importance of China to the United States.[104] This survey was eclipsed by the far more influential contemporary one funded by the Ford Foundation, which was to become a major supporter of Chinese studies in select public and private research universities in the United States. As the growth of university-based knowledge centers of China studies would become the new norm throughout the educational system and across society in general, the heyday of the Institute's role as a public educator of China was coming to an end. Its last known and also most extensive annotated bibliography on China for school teachers, including 180 book entries, 37 educational films, and a preliminary critical analysis of the stereotypes and oversimplifications of China in American textbooks, came out in 1956 in partnership with the Chinese Advisory Committee.[105]

Conclusion

Much more than a single cultural organization's realignment, the China Institute's fundraising and programming in the turbulent 1940s and 1950s indexed the shifting political and philanthropic foundations of public discussions of China in mid-twentieth century United States. Far from a radical organization prior to the 1940s, the Institute had nevertheless not shunned away from what it would later avoid, such as leftist writers W. E. B. Du Bois and Lu Xun, or the May Fourth Movement. The Institute did retreat from that to a politically safer rendition of China, which was geared toward a white middle-class audience without references to racial or revolutionary solidarity. But that did not mean a total reversal of its politics, nor did it necessarily make the Institute a partisan of the nebulous right-wing China Lobby. To be sure, the evidence of the Institute's seeming political makeover abounds. Its unmistakable anticommunist platform could be found in an alarmist speech delivered onsite in late 1948 by the Chinese ambassador to the United States and the Institute's honorary president, Wellington Koo (Gu Weijun, 1888–1985), the twenty-fifth anniversary dinner program in May 1951, and its own fundraising materials in the 1950s.[106] Attention from the federal government seemed to confirm the trend. Meng appeared as an informant in the FBI investigation into whether a Chinese Christian social activist was a communist around the time of Luce's China House gift.[107] A congressional report on the China Lobby in mid-1951 also mentioned the Institute as the government's edu-

cational agent.[108] It is not surprising that reporters, whether for the *New York Times* or a local paper in York, Pennsylvania, considered the Institute among the "apologists" for the Nationalist government, and Luce a Nationalist agent.[109]

Tempting as it is to equate the China Institute's political posturing as a sure sign of its inherent ideological reorientation, piecing together its scattered activities across the 1949 divide helps make better sense of such posturing. A close reading of the nonsensationalist contemporary materials challenges the straightforward inference from the seemingly abundant evidence. The U.S. Department of Justice's annual registration record per the requirements of the 1938 Foreign Agents Registration Act listed the Institute as an agent of the China Foundation and various Chinese scholarship programs in the United States between 1942 and 1954, but never of the Nationalist government. The Institute even disappeared from such reporting from 1955 onward.[110] None of the widely circulated investigative reporting, biography, or academic monograph on the China Lobby from the time touched upon the Institute, either.[111]

Convinced of the broader value of his native culture, Meng managed to find common ground with Luce's political support of the Nationalist government *and* cultural appreciation of China. Unable to secure the commitment of the wary Rockefellers, he nevertheless piqued the Nationalist interest in the perceived political payoff of Luce. Neither a successful fundraiser nor a partisan operative, he was nevertheless willing to follow the money in order to continue promoting public understandings of Chinese culture during a time when the survival of the only organization capable of such endeavors was on the line.[112] For Meng, siding with Luce and the Nationalists was to protect the China Institute, "the granddaddy of all China exchange and educational institutions," from the political turbulence as much as possible, and to "revers[e] the flow of cultural information for teaching Americans about China."[113]

In a larger context, Meng's experience at the China Institute in this period was also part and parcel of the fraught collaboration between cosmopolitan Chinese intellectuals and the Nationalist government in the mid-twentieth century. What distinguished his connection to the government as compared to that of his better-known contemporaries is the catalytic role of Luce as a transnational actor. As China's survival under Japanese threats in the 1930s became the common denominator, famous Chinese scholars and artists started to canvass for the government in the United States, although they did not necessarily endorse the party state's illiberal politics. They included, among others, the dramatist and playwright

Zhang Pengchun, political theorist Qian Duansheng (1900–1990), jurist Zhou Gengsheng (1889–1971), dean of Chinese liberalism Hu Shi, and painter Zhang Shuqi as mentioned earlier in this chapter.[114] Some of them, including Hu, Zhang Pengchun, and Zhang Shuqi, followed or maintained contact with the Nationalists after 1949 and used that affiliation to shield their ongoing professional pursuit during the volatile Cold War.[115]

The collaboration between the China Institute and the National-ist government became imperative in the tumultuous middle-decades of the twentieth century when the capacity of the Chinese state languished even further amid incessant warfare. As the government gradually real-ized the critical importance of cultural outreach, it was however unable to support its own stable infrastructure of persuasion. Luce's high-profile patronage of the Institute gave the government a ready organization to latch onto, but the ensuing philanthropic Cold War was a marriage of con-venience instead of a preordained ideological agreement. The Institute as an ostensibly unofficial propaganda outlet of a battered government actu-ally reflected the evolving compromise between Meng and Luce when the Chinese state was too weak to institutionalize its own cultural diplomacy. Stood in its stead were transnational actors with different stakes in the intercultural encounters between China and the United States. Once the Nationalist government firmly reestablished itself in Taiwan under the U.S. military umbrella, it resumed in earnest planning its delayed spectacle of former imperial art collections in the United States. This would change the dynamic in the field of Chinese cultural diplomacy once again. It is to this topic the next chapter will turn.

Almost Solo Shows

1953–1965

"The show is by no means comprehensive—they do not in fact have a comprehensive representation of Chinese art in their collections—and we have tried to see that every one of the objects we selected is in its own way a masterpiece."

John Pope to John Walker, May 9, 1960

"The free Chinese are fighting to save their cultural heritage as much as to recover lost territories."

Wang Shijie, *Chinese Art Treasures* (1961)

"Tourism is of course, a good subject, and great native art is better . . . Then there is the possibility of selling more good native stuff. People love exotic things, bargains, souvenirs etc."

Robert Moses to Charles Poletti, September 29, 1964

As the previous chapter demonstrates, the 1949 divide did not sever the strategic partnership between the China Institute and the Nationalist government. With the tense standoff across the Taiwan Strait stabilizing under the U.S. military presence in the 1950s, the Nationalist government continued the official title of the Republic of China (ROC) on Taiwan and still enjoyed extensive diplomatic recognition through the mid-1960s. These positive factors allowed the government to relaunch its previously aborted grand spectacles of Chinese antiquities in the United States. After long

planning, it managed to stage two such events, the Chinese Art Treasures (CAT) exhibitions in five major museums between 1961 and 1962 and participation in the 1964 New York World's Fair. These events pushed the government to the forefront of Chinese cultural diplomacy and eclipsed the Institute's more humble operations. But as the fair wound down in 1964, the PRC's success in securing the diplomatic recognition of France, a permanent member of the UN Security Council, and fortuitously detonating its first atomic bomb two days before the fair's closing redoubled the challenges to the ROC's international standing.[1] This chapter focuses on the period between roughly the mid-1950s and mid-1960s when the two spectacles made the Nationalist government an increasingly prominent proponent of Chinese cultural diplomacy in the spotlight.

Both spectacles drew heavily on the former imperial art collections the government had evacuated from Beiping (Beijing) to the lower Yangzi area and further to the Chinese hinterland dating back to the 1930s. Back then, those objects already became symbols of endangered national treasures tied to the nation's survival. While such nationalist framing continued in the 1950s and 1960s, their high-profile exhibition in the United States in the 1960s also projected new meanings. By the end of the civil war in the late 1940s, the Nationalists further evacuated to Taiwan part of the imperial collections, mostly from the National Palace Museum (NPM), which had already endured multiple evacuations. These objects became even more potent legitimating symbols of an enduring civilization that escaped the would-be communist destruction under the painstaking Nationalist stewardship in the intensifying Cold War context.[2] They also became one of the few realistic options of showcasing the ROC's international legitimacy with a significantly shrunken territory and an increasingly hollow claim of reinvading the mainland controlled by the PRC. It bears an uncanny similarity to the situation in the Song dynasty (960–1279) when the Chinese confronted rival nomadic regimes in a divided realm. The quest for cultural legitimacy then led to the flourishing of literati antiquarianism and the beginning of the imperial collections.[3] To borrow the words of Clifford Geertz, the antiquarian spectacles sponsored by the Nationalist government were not "an echo of a politics taking place somewhere else" but "an intensification of a politics taking place everywhere else."[4]

Besides legitimation, these China-originated objects actually facilitated the local turn of the Nationalist cultural diplomacy, which would be increasingly rooted in territorial Taiwan. The great China framing of the two spectacles remained undoubtedly paramount. But especially by

the time of the New York fair in the mid-1960s, the Nationalist government's pragmatic need in developing Taiwan's economy also presented the venerable objects as revenue-generating tourist attractions among other local scenery with no apparent connections to China. This was broadly similar to and in tandem with the turn from "negative anti-communism" as emotional scare-mongering to "positive anti-communism" as reaffirming Western values in Europe.[5]

Despite the largely positive press coverage, the two spectacles did not give the Nationalist government the coveted sovereign definition and projection of Chinese culture. Nor did they generate or sustain the widespread political support it had hoped. As in the 1930s, the American audience continued to encounter different imageries of China propagated by actors beyond the government's control, and China's international branding remained fragmented. Due to increasing professionalization of Chinese studies in the post–World War II United States, American curators of Chinese art significantly influenced the contour of the CAT exhibitions. In Flushing Meadows, New York, the same location for world's fairs in 1939 and 1964, the ROC Pavilion competed for patronage against the services and products by entrepreneurs from Chinatown, America's heartland, and as far afield as Hong Kong. These alternative representations, such as the Orientalist allure of Hong Kong as a new Cold War frontier bordering China, and cheap American Chinese food, continued to dilute the intended Nationalist message of a unified China's longstanding cultural grandeur and hope for political support of the ROC as guardian of this great tradition. Such support would ideally be cultivated by long-term programming, but the evanescent spectacles were unlikely to generate enduring impact despite dramatic effects in the short run. Under the more pressing concerns of security and development, the Nationalist government in the early 1960s still did not have the resources nor time to develop a stable infrastructure of persuasion for its cultural diplomacy.

What follows is divided into two broad sections focusing respectively on the CAT exhibitions and Taiwan's participation in the 1964–65 New York World's Fair. Drawing upon Chinese and English language sources and reading them against each other, this chapter pays close attention to how the Nationalist government crafted its messaging and how the intended cultural diplomacy played out among competing representations of China. These two spectacles, almost solo shows of the government, reveal persisting structural challenges to institutionalized Chinese cultural diplomacy.

A Long-Delayed Spectacle

The Metropolitan Museum of Art (MMA) in New York indicated interests in holding loan exhibitions of the NPM objects in the late 1930s and late 1940s, but wartime chaos in China prevented further action.[6] In the early 1950s, the China Institute under the leadership of Henry Luce and Meng Zhi resumed the initial planning for the delayed U.S. debut of those objects. During his visit to Taiwan in 1952, Henry Luce inquired about the possibility of a loan exhibition of select NPM objects as Chinese art treasures in the United States. Upon knowing of Chiang Kai-shek's potential approval, Luce wrote to him directly in June 1953 to solicit his support and pledged the assistance of the Institute and *Life* magazine in staging a show in 1954 to commemorate the centennial celebration of the first Chinese graduate from American colleges. According to a handwritten note on the Presidential Office's internal memo that translated Luce's letter, it was actually Meng who had suggested Luce writing the letter and been in conversations with relevant Nationalist officials regarding the proposed exhibition.[7] Such joint efforts between Meng and Luce, overlooked in existing studies, reaffirm their genuine interest in promoting public understandings of Chinese culture through the Institute covered in the previous chapter. Their continuing contact with Taipei and other influential supporters in the United States, both Chinese and American, such as Hu Shi; Francis Henry Taylor (1903–1957), director of the MMA; and Arthur Sulzberger (1891–1968), publisher of the *New York Times*, generated enough momentum to keep the planning going.[8]

The China Institute's role in the early planning should not obscure the broad intellectual and political support within Taiwan. *Gonglun bao*, a newspaper catering to native-born Taiwanese intellectuals, published a commentary in 1950 that emphasized Taiwan's unique importance in "inheriting and glorifying the orthodoxy (*zhengtong*) of Chinese culture."[9] Some liberal intellectuals who had left mainland China in 1949 also emphasized the urgency of China's cultural rejuvenation, an important part of Chinese nationalism since the late nineteenth century, in the new Cold War environment. The famous magazine *Free China* (*Ziyou Zhongguo*), which would turn into a dissident publication in the late 1950s, published commentaries in 1952 that highlighted the urgent need to restore the Chinese cultural order in Taiwan after the communist victory on the mainland made intellectuals there increasingly subservient to the state.[10] In early 1958, four prominent intellectuals issued the "Manifesto for a Reappraisal of Chinese Culture" (*Wei Zhongguo wenhua jinggao shijie ren-*

shi xuanyan) in a magazine based in Hong Kong. The majority of the authors represented the neo-Confucian school, whose revival in Taiwan and Hong Kong after the founding of the PRC received tacit support from the ROC. The manifesto called for the revival of Chinese culture in the spirit of democracy and science, and affirmed the universalist values of such a continuous culture worthy of emulation in the West.[11] The proposed exhibition of the former imperial art collections in the United States agreed with such intellectual milieu.

If the New Life Movement in the 1930s was the Nationalist government's incomplete national cultural reconstruction project, the loss of mainland China in 1949 made the government redouble its commitment to this project and even expand its international reach. The debut of NPM objects in the United States thus became an important goal. Some of the key Nationalist officials in the early planning had already partaken in organizing the London exhibition in 1935 and were thus well informed of the potential of such spectacle before the China Institute's suggestions. Hang Liwu (1903–1991), for example, was in charge of all the national museums and libraries evacuated to Taiwan in the early 1950s. With a PhD in political science from University of London, Hang was one of the founders of the Sino-British Cultural Society in Nanjing in 1933 and served on the preparatory committee for the London exhibition.[12] Other early planners who had also been involved in the London show included Wang Yunwu (1888–1979), longtime publisher of the Commercial Press and former vice premier, and Li Ji (1896–1979), pioneer of modern archaeology in China.[13]

Far from a cosmopolitan intellectual, Chiang Kai-shek himself also increasingly resorted to Chinese cultural traditions in justifying his rule in Taiwan. An avid follower of neo-Confucianism since his youthful days, Chiang was attentive to the sociopolitical utility of Chinese culture in buttressing his political authority.[14] The New Life Movement reflected Chiang's hope for a moral rejuvenation of China under his party's authoritarian rule. The Nationalist defeat in the civil war and subsequent retreat to Taiwan made him even more determined in practicing such cultural politics. Just months after losing the mainland, Chiang accused the CCP of destroying "the five millennium legacy of the history and culture of our Chinese nation" (*wo Zhonghua minzu wuqiannian lishi wenhua de yichan*) following the Japanese surrender in an open letter to citizens on New Year's Day in 1950. He also exhorted readers to, among other things, "uphold ancient culture" (*weihu lishi wenhua*).[15] The cultural raison d'être of the ROC on Taiwan against the PRC thus had been percolating in Chiang's mind before suggestions from the United States.

A visual analysis of Chiang's photographs taken at various locations associated with the NPM in the 1940s and 1950s also demonstrates his shifting public persona from an awkward if not goofy supreme leader in front of the antiquities to a dedicated student of these objects. In December 1945, Chiang toured Beiping (Beijing), including the NPM ground in the former palace complex. One of his stops was the Hall of Martial Eminence (*Wu ying dian*), which used to house the Institute for Exhibiting Antiquities, a government museum founded in 1914 to hold imperial collections from Manchuria mentioned in chapter 2. In an unpublished photograph, a grinning Chiang in a black overcoat and a leather hat and gloves lifted the hem of the Qianlong Emperor's armor with his right hand. This befit an upbeat Chiang, who was fairly confident during an inspection tour of the former imperial capital about continuing as the national leader and eradicating the CCP threat not long after the Japanese surrender.[16] Chiang's playful pose, despite the physical proximity to a former imperial object, betrayed his mental distance. Yet such distancing disappeared in his photographs of the 1950s. The American-educated Madame Chiang started lessons of Chinese painting in the decade.[17] In late 1954, the Chiang couple visited the temporary exhibition room attached to the warehouse in central Taiwan for all the evacuated collections of the NPM and other cultural institutions from the mainland. Five years after the Nationalist defeat, the camera framed the Chiangs at a very close range. They appeared fully absorbed in appreciating a scroll painting without paying attention to the existence of the camera. As if learning from his past failures, Chiang now posed himself as a humble student of China's great cultural traditions in search of new directions for his government.

Blessed with Chiang's personal interest in the proposed exhibition, high-ranking officials often reported to Chiang directly and bypassed the regular bureaucratic process in the subsequent planning. In early September 1953, the Presidential Office installed a seven-member special panel of ranking officials and leading scholars. It included, among other people, Wang Yunwu, Hang Liwu, and Li Ji, all veteran planners from the NPM's international debut in London.[18] During his trip to attend the UN General Assembly meeting by the end of year, Hang already negotiated a draft contract with the MMA on behalf of four other participating museums, namely the National Gallery of Art (NGA) in Washington, DC, the Museum of Fine Arts in Boston, the Art Institute of Chicago, and the de Young Memorial Museum in San Francisco.[19] Even Madame Chiang took an interest and once suggested that her alma mater, Wellesley College, cohost the exhibition. She was joined by other disappointed advocates for

Fig. 3. Chiang Kai-shek at National Palace Museum, 1945. (Courtesy of Academia Historica, Taiwan.)

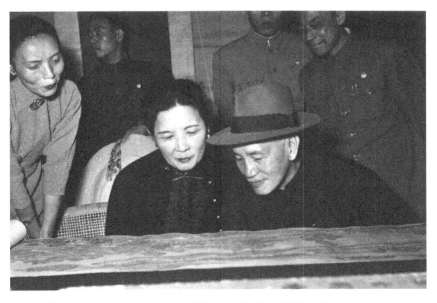

Fig. 4. Chiang Kai-shek and Madame Chiang at National Palace Museum's temporary exhibition room, 1954. (Courtesy of Academia Historica, Taiwan.)

about half a dozen other U.S. museums in cities from Richmond to Los Angeles to be included on the list.[20]

The symbolism of these five chosen museums deserves attention, particularly the NGA. The other four are located in major metropolitan centers that had long attracted Chinese immigration. New York and Boston already boasted considerable collections in Chinese and East Asian art. The Smithsonian Institution system in the nation's capital already had the Freer Gallery of Art as a dedicated Asian art museum. With no permanent Asian, not to mention Chinese, collections, the NGA was a counterintuitive choice. Established in 1937 with a congressional mandate and a generous donation of art and funding by the financial magnate Andrew W. Mellon (1855–1937), the NGA as a museum focused on the collecting and exhibitions of broadly defined Western art. Shortly after its founding, foreign governments started using the NGA to showcase their national culture and solidarity with the United States as the global leader of the Western world. During World War II, the NGA held national exhibitions of Australia (1941) and Chile (1942), and also showed stranded objects from Belgium (1943) and France (1942, 1943), exemplifying the nation's commitment to wartime allies on different continents. After World War II, the NGA continued to hold loan exhibitions from Cold War allies, and the expanding list marked the outreach of the U.S. global hegemony. Countries formerly under the Nazi occupation, such as France (1945) and the Netherlands (1946), used this venue to highlight their cultural treasures and the U.S. military assistance. Former enemies, such as West Germany (1948) and Austria (1949), staged national exhibitions to rehabilitate their image and solidify the new anticommunist alliance. Japan became the first non-Western country to open its national exhibition in this politically charged space in early 1953 shortly after the end of the Allied occupation in 1952. The Japanese government sent more than one hundred paintings and sculptures on a tour of five major museums, beginning at the NGA. This was followed by South Korea, which opened a similar touring exhibition of "Masterpieces of Korean Art" at the NGA in late 1957. In the same decade after the ROC, the NGA also hosted the opening of national exhibitions sponsored by the United Arab Republic (Egypt and Syria, 1961), Iran (1964), Peru (1965), and Turkey (1966).[21] It was the museum of choice where Cold War allies promoted their national culture and cemented relationship with the United States. A noteworthy exception was South Vietnam's "Art and Archaeology of Viet Nam" at the Smithsonian Institution's National Museum of Natural History in 1960, which did not get the same billing as a fine art show.[22]

Despite the smooth initial negotiations, a few sticking points began to surface in 1954 on both sides. Within Taiwan, the special panel attached to the Presidential Office expressed security concerns about the precious exhibits beyond mere insurance and transportation. Most worrisome to them was how to prevent the PRC's potential litigation in the United States regarding the legal ownership of these collections. Although the 1953 draft contract declared the exhibits the ROC's diplomatic assets (*waijiao caichan*), the panelists considered the lack of explicit support of this point from the U.S. government a significant flaw. They unanimously favored a firm commitment from the U.S. Department of State prior to the exhibitions to minimize the likelihood of the PRC's legal challenge.[23] As the constitutionally designated government agency in charge of cultural institutions, the Ministry of Education was marginalized in the planning process and did not get to review the draft contract until July 1954. Besides echoing the fear of legal disputes, the Ministry also cited logistic uncertainties under the tense international situation as another reason to rethink the proposal.[24] It was probably referring to the contemporary tension across the Taiwan Strait, which would result in the PRC's shelling of the offshore island Jinmen (Quemoy) in September, also known as the First Taiwan Strait Crisis. The U.S. museums became simultaneously hesitant about the proposed exhibitions for different reasons. Although Hang had repeatedly assured the Nationalist government's maximum cooperation, the MMA, on behalf of all the other participating museums, notified Taipei in mid-March that according to the precedent of the Austrian exhibition at the NGA in 1949, the contract needed to include a complete list of exhibits, which gave the participating museums no other option but to postpone the show. While Hang thought this was probably a technical necessity, he also reported Hu Shi's speculation of a personnel disaccord among the U.S. museums.[25]

Two previously unnoticed letters at the NGA archives offer a probable explanation for the U.S. museums' trepidation in the mid-1950s. Both were from John Foster Dulles, Secretary of State, to F. Lammot Belin (1881–1961), vice president of the NGA, in 1955. In his first letter in early May, Dulles curtly stated that he doubted "the desirability of such an exhibition at this time." He made an even more blunt observation in his second letter in mid-June that the proposed exhibition "may start up propaganda which will not be helpful to our policies."[26] It is unclear whether Dulles meant the NPM exhibition as Nationalist propaganda or the PRC counter-propaganda against the U.S. involvement in the proposed exhibition. Since the end of the Korean War in 1953, the U.S. government had sought to deescalate tensions with the PRC and started the ambas-

sadorial talks in Warsaw in August 1955 despite the open threat of nuclear attack on China during the First Taiwan Strait Crisis in 1954.[27] Dulles's concerns over unwelcome propaganda probably cut in both directions as the United States prepared to talk to the PRC. But whatever he meant, Dulles made his strong personal reservations very clear. Given the importance of the official U.S. recognition of the Nationalist government and the NGA's political significance, Dulles's wish not to "record any objection" should Taipei and the NGA plan to proceed did not really soften his tone. Although Dulles's letters were written in 1955, the underlying continuity of the Eisenhower administration's China policy in the mid-1950s means that his reservations probably dated further back and decelerated the U.S. museums' negotiations with Nationalist officials. In this sense, the Ministry of Foreign Affair's speculation in the late 1950s that the U.S. State Department in 1954 was not cooperative in planning the exhibition was not baseless.[28]

But a subsequent turn of events made the State Department much more receptive to the proposed exhibitions. Despite some progress on the mutual repatriation of imprisoned personnel, the halting ambassadorial talks between the United States and the PRC since 1955 did not resolve the fundamental differences between the two sides, particularly with regard to the status of Taiwan.[29] In order to prop up the ROC against the PRC without direct armed conflict, the U.S. government increasingly came to see the Nationalist representation of cultural China as a safer alternative. Through its embassy staff in Taipei, the State Department began to express its support and inquire into the concrete plans for the exhibitions. With regard to the feared litigations filed by the PRC, various U.S. officials affirmed that the likelihood of success was slim at best because of the U.S. recognition of the ROC.[30] In a 1957 letter to Minister of Foreign Affairs Ye Gongchao (1904–1981), U.S. ambassador to the ROC Karl Rankin (1898–1991) referenced the director of the State Department's Office of Chinese Affairs and argued that the exhibitions would be a golden opportunity for the Nationalist government to present itself "as the guardian of traditional Chinese culture."[31] Unlike the findings in existing research, the cultural turn in the U.S. support of the Nationalist government had started earlier than the PRC's shelling of the ROC-controlled offshore islands in 1958, also known as the Second Taiwan Strait Crisis.[32]

Moreover, the posting of Ye Gongchao as the ROC ambassador to the United States in 1958 helped clear the final hurdles. Descendant of a literati family, Ye enjoyed a distinguished career in academia and diplomacy. Growing up with his uncle, an art aficionado and member of the prepara-

tory committee for the NPM's London show, Ye was also a known connois-
seur of Chinese art and a calligrapher in his own right.[33] This set him apart
from his two immediate predecessors involved in the negotiations over the
proposed exhibitions in the early 1950s. Wellington Koo was a seasoned
career diplomat since the 1910s and a follower of realpolitik.[34] Hollington
Tong (Dong Xianguang, 1887–1971) was a journalist-turned-propagandist
in the 1930s before representing the ROC in Japan and the United States
in the 1950s.[35] With his understanding of both Chinese culture and diplo-
macy, Ye secured the preliminary U.S. confirmation of the ROC's sover-
eign immunity in case of legal disputes of the NPM collections, as well as
its agreement to arrange naval escort and enlist the U.S. president as an
honorary patron in mid-1959.[36] These much-desired commitments from
Washington finally eased Taipei's remaining concerns of the proposed
exhibitions.

The personal interest in the exhibitions from Chiang Kai-shek and to
a lesser extent Madame Chiang also left extra-bureaucratic marks on the
regular diplomatic correspondence in the closing negotiations. Besides
responding to Chiang's specific instructions for the contract, top National-
ist officials also reported to Madame Chiang about the latest progress.[37]
In both 1959 and 1960, Chiang dispatched Wang Shijie (1891–1981), one
of his top aides and former ministers of education and foreign affairs, to
negotiate the final terms on the side during Wang's trip to the UN Gen-
eral Assembly meeting. Wang also met with Luce several times during his
stay in the United States to discuss the arrangements for the exhibitions.[38]
This indicates Chiang's continuing preference for the personal envoy over
regular diplomatic representatives to handle what he considered the most
critical diplomatic tasks, like what he did in the early 1940s with regard to
U.S. military and economic aid to China mentioned in chapter 2. After the
signing of the formal contract in Washington in early 1960, the Execu-
tive Yuan set up a special committee headed by Wang Yunwu, then vice
premier, to coordinate the exhibitions. This committee, composed of top
government officials and leading scholars, would report directly to the
Presidential Office, and most likely Chiang himself.[39]

As the bilateral negotiations drew to a close, the Nationalist govern-
ment finally announced the forthcoming exhibitions to the world in late
1959. In both the preliminary and formal press releases, it downplayed
the significance of the long-delayed NPM debut in the United States as a
regular form of cultural exchange at the repeated request of the U.S. gov-
ernment and museums.[40] This, of course, obscured the Nationalist govern-
ment's ongoing ambitions in staging a spectacle of Chinese antiquities in

order to impress its most important ally dating back to the 1930s. It was the persistent sociopolitical upheavals in China that delayed the spectacle to 1961 partly to commemorate the fiftieth anniversary of the ROC. Besides the United States, there were requests for loan exhibitions of the NPM collections from countries such as Italy and Japan. Citing logistic difficulties, the Nationalist government never gave them serious considerations.[41] Two potential reasons account for the low-key publicity. On the one hand, as the apocalyptic Nationalist propaganda of reinvading mainland China and toppling the PRC in the 1950s made little inroad among Americans, a quieter message to tout the government's political legitimacy through traditional Chinese culture seemed more promising to engage this important audience. On the other hand, the announcement was probably trying not to provoke the PRC too much. Soon after the signing of the contract, the CCP's mouthpiece *Renmin ribao* printed the Ministry of Culture's accusation of the collusion between Chiang's regime and the United States in "hijacking (*jieyun*) . . . the cultural treasures created by the labor of the Chinese people through millennium."[42] Such a fairly formulaic statement from a government agency without top billing indicates the moderation of the PRC, which was in the throes of the disastrous consequences of the Great Leap Forward and an acrimonious split with the Soviet Union.

Sinological Expertise

Following the protracted negotiations among government officials and museum directors, curators from both sides selected and arranged the actual exhibits. The back and forth in this process underscores the differences between Chinese cultural diplomacy and art historical expertise in the United States. Concurring with the Nationalist officials, the NPM curators treated the chosen objects as a venerable whole and sought to use them to teach Americans a *comprehensive* lesson on China's enduring cultural refinement. This had been a consistent message in Chinese cultural diplomacy since the late Qing. On the other side, curators from U.S. museums armed with their *dissective* method, which privileged stylistic analysis, often underestimated and even dismissed such shared goals between different Chinese actors.

The methodological and epistemological dissonance underlined the planning process and often favored the U.S. side. Although the Nationalist government wanted to send around one thousand objects, a scale similar to the London show in 1935, the draft contract of 1953 whittled the number

down to roughly two hundred, the vast majority from the NPM. From the Chinese perspective, only a fair number of objects from various categories would give Americans a representative view of the elegant Chinese culture. Of the two hundred or so objects, one hundred to one hundred and fifty would be paintings.[43] While paintings had long been the pinnacle of Chinese aesthetics, their exodus out of war-torn China in the first half of the twentieth century gave them growing visibility in the international art market. Not incidentally, they also gained prominence in the professionalizing field of Chinese art history in the post–World War II United States, which had traditionally focused on porcelains and bronzes.[44] Curators in the United States were eager to get particular objects that appealed to them, but not so much the lesson the Chinese intended to impart.

Following the signing of the final contract in early 1960, curators from both sides began selecting the objects in earnest. This supposedly collaborative process was not short of conflicts between the dissective and comprehensive views of Chinese culture. Several U.S. curators had already visited the NPM warehouse in central Taiwan throughout the 1950s with an eye for potential exhibitions. In spring 1960, funds from the Luce Foundation enabled the five participating museums for the CAT exhibitions to send three representatives to Taiwan to select the objects. Among them, John Pope (1906–1982) from the Freer Gallery (on behalf of the NGA) was an expert on Chinese porcelains and bronzes, and Aschwin Lippe (1914–1988) from the MMA and Zeng Xianqi (1919–2000) from the Boston Museum of Fine Arts both specialized in Chinese paintings.[45] Together, they emphasized paintings and porcelain wares produced in particular official kilns not easily seen outside China. Pope also pressed Hu Shi, then president of Academia Sinica, for what in his opinion were the best five bronze objects, such as "the famous owl" and "the tiger" from the Institute of History and Philology, the pioneering institution of scientific archaeology in modern China since the late 1920s.[46] After this request was declined, Pope blamed the "politically involved" reasons and rejected outright what he considered "minor objects" from the Institute.[47] This kind of uncompromising attitude was even more evident in his letter to the NGA's director. While the selected paintings and ceramics were "of extraordinary quality and importance" in general, Pope dismissed other exhibits as nothing more than "the minor arts in purely Chinese taste."[48]

Such a dissective and sometimes condescending view of antiquities in Taiwan irritated both Chinese officials and curators. Wang Shijie, Chiang's personal envoy in the final negotiations and a collector and connoisseur himself, was also involved in the selection process. In his diary in 1959,

Wang was quite blunt in his mistrust of the American taste and asserted that no Chinese painting in the MMA collection had "significant values." Therefore, another entry in 1960 recording no major disagreement between the two sides in the selection process was most likely a courteous under-statement.[49] Similarly, the Chinese curators at the NPM also preferred a comprehensive presentation to educate Americans properly about Chinese culture. Immersed in traditional learning and equipped with unrivaled familiarity of the NPM collections after decades of working experience, these curators cherished these objects as a nationalist whole, which should not be randomly broken apart, especially by foreigners. While receptive to new insights from Western scholarship, they were not always impressed by its analytic framework or selective focus. Tan Danjiong (1906–1996), one of the curators who would escort the chosen objects to the United States, faulted the American experts for "scratching an itch from outside the boot" (*gexue saoyang*) with limited knowledge. Tan's colleague Li Lincan (1913–1999), although intrigued by findings from foreign scholars' "magnifying glass and measuring tape-ism" (*fangdajing midachi zhuyi*), was still "scorn-ful" of such method that could only give them partial insight from the "outside in."[50]

Despite such consensus in the comprehensive pedagogical values of the NPM objects against perceived foreign misunderstandings, the delibera-tion in Taiwan on the qualified printer of promotional materials revealed selective anxieties about foreign involvement in the planned CAT exhibi-tions. In 1959, the NPM published *Three Hundred Masterpieces of Chinese Painting in the Palace Museum* as part of its own cataloguing efforts. The six-volume set with high-quality photographs provided a detailed bibliog-raphy for the CAT exhibitions and would also be on sale at the participat-ing museums.[51] Due to the lack of suitable printing press in Taiwan, it was printed in Japan and carried such a stamp on the back cover. In the opinion of the NPM administration, this was not only "unsightly" but also "incon-venient." In planning for another catalogue series of porcelains also for sale at the CAT exhibitions, the NPM proposed to test print color plates in both Hong Kong and Japan. If the Japanese product was preferred, balk printing with the Japanese template would still take place in Hong Kong to "preserve the inherent traditional style of our nation instead of the Japa-nese one." In the end the Hong Kong printer got the order.[52] The NPM probably considered a predominantly Chinese society under British colo-nial rule a better choice than the former invader of China, colonizer of Tai-wan, and a strong international competitor in representing Eastern art. For small prints and postcards of famous paintings for sale in the United States,

the aforementioned special committee under the Executive Yuan directly mentioned the Japanese fine art printer Otsuka Kogeisha due to technological necessities.[53] Ironically, nobody voiced any misgivings about a Swiss press handling the English language catalogue amid all these discussions.

A serious disagreement on chosen exhibits in early 1961, just a few months before the opening exhibition at the NGA, nearly derailed the whole process. As the exhibits were being finalized, Pope, Lippe, and James Cahill (1926–2014), then associate curator of Chinese art at the Freer Gallery, drafted the English catalogue for the exhibitions. In late February Cahill informed Pope, then in Geneva supervising the catalogue's printing, that Ambassador Ye Gongchao had recently expressed serious concerns about various paintings' dates and attributions the American curators prepared.[54] Relying mainly on visual analysis and stylistic comparison, common scholarly approaches in art history in the United States, these curators did not agree with the traditional emphasis on seals and colophons in Chinese aesthetics. They pushed back against quite a few attributions to old masters codified in the imperial catalogue in the late eighteenth century and considered them later copies. The special committee in Taipei bristled at such changes and preferred to stick to the imperial catalogue. In Cahill's narrative, Ye was sympathetic to the American scholarly approaches, but as "the man caught in the middle" he requested the suspension of printing in Geneva before Taipei's final approval. While understanding of Ye's predicament, Cahill lashed out at the perceived Chinese bias of "presumptuous Occidentals . . . indulging in pedantic, individual judgements that will damage the reputations of these great paintings." Citing the agreement of the unidentified NPM staff with American curators, Cahill characterized the controversy as between "knowledgeable people on both sides" and powerful conservatives like Wang Shijie on the committee.[55] As an emerging international expert on Chinese paintings who published his first monograph in 1960 through the same Swiss press, the young and ambitious Cahill understandably had little patience with what he considered old school Chinese amateurs.[56] But he underestimated the extent to which Wang and the NPM curators shared their criticisms of the dissective American views. Wang did not leave any diary in 1961 for scholars to cross-examine Cahill's complaints. But even after the beginning of the exhibitions, Li Lincan recorded his lingering frustrations over what he considered arbitrary attribution and translation in the English language catalogue, and inadequate Chinese involvement therein in his diaries.[57] In other words, Cahill exaggerated the divide between the "conservative" officials and the "progressive" scholars in this cultural diplomacy initiative.

Existing documentation provides little clue as to how exactly this controversy was resolved. In his original letter, Cahill himself suggested the juxtaposition of traditional Chinese and contemporary American attributions as a compromise. But in his later recollection, Cahill attributed this suggestion to Ye.[58] Judging from the printed catalogue, the Nationalist government and U.S. museums reached a compromise that generally tilted toward a preference for the latter's opinions. For paintings of contested dates, the label heading still used "attributed to," a phrase the American curators insisted upon from the beginning. The body of such labels listed different opinions often with the passive voice and vague pronouns (we, some, etc.) to avoid pinpointing who exactly was in favor of which opinion.[59] In the case that individual Chinese curators might have agreed with the American dating, the label highlighted and possibly even exaggerated such consensus with the implied institutional endorsement by the NPM.[60] In general, stylistic analysis and comparison, the methods preferred by Americans, had more weight than the seals and colophons, the time-honored approach in China. On the other hand, the 112 paintings and the roughly equal number of calligraphy, bronze, porcelain, jade, and miscellaneous decorative pieces of different materials partly satisfied both the American emphasis on particular genres and the Chinese desire for a comprehensive demonstration. As to the title, Pope suggested "Selected Masterpieces of Chinese Art" in early May 1960 based on the reason that the NPM did not have "a comprehensive representation of Chinese art in their collections."[61] But Wang Shijie's suggestion for the "Chinese Art Treasures" ultimately prevailed, which implied the NPM's unrivalled position in representing the entirety of Chinese art and culture.[62]

Questionable Success

After almost the decade-long planning, the CAT exhibitions finally opened at the NGA in Washington with great fanfare in late May 1961 and subsequently toured New York, Boston, Chicago, and San Francisco until June 1962 with seemingly resounding success. Together, these exhibitions were a high point of the Nationalist cultural diplomacy at a time when the government's international legitimacy was still largely secure. Following the suggestion of Henry Luce, on October 10, 1961, the China Institute hosted a private showing for invited guests at the MMA to commemorate the fiftieth anniversary of the ROC and raise extra funds for itself. The estimated total visitors to the year-long exhibitions were close to half a mil-

lion.[63] Unlike the London show in 1935 in which multinational collections from museums and private collectors vied for attention, the Nationalist government in 1961 and 1962 was the content provider for the exhibitions in five prestigious museums across the United States, but still subject to the approval of the curatorial expertise. Thanks to the much smaller number of items in the U.S. exhibitions, the more generous space for individual objects also gave them an unprecedented air of grandeur compared to the London show. At the insistence of Chinese curators, most of the exhibits, especially the paintings and porcelains, were displayed according to dynastic chronologies and genres in order to underscore China's unbroken cultural orthodoxy through the Nationalist government.[64]

A closer examination of the exhibitions' effects, however, complicates such success. First of all, although the sheer number of visitors was impressive, it still paled in comparison to several other major exhibitions of national treasures. The ten-week Chinese exhibition at the NGA in the late spring and summer months of 1961 saw less than 150,000 visitors, and the Kennedys, despite being the honorary patrons, did not attend according to existing documentation. In comparison, the Japanese show of painting and sculpture in 1953 opened at the same venue for roughly one month between late January and late February. It attracted close to 190,000 people despite the wintry weather, including the Eisenhower couple on the opening day.[65] The Tutankhamun Treasures loaned by the United Arab Republic fetched almost a quarter million viewers in one month in late 1961, and the show was opened by Mrs. Kennedy together with United Arab officials at the NGA.[66] The iconic single painting exhibition of Mona Lisa in early 1963, lent by the French government, drew well over half a million people in four weeks at the NGA alone, and had a special preview for the Kennedys, ranking members of all branches of the federal government, plus the diplomatic corps.[67] The attendance number at these national exhibitions serves as an imperfect yet heuristic index of the ROC's more marginalized place among the Cold War allies of the United States in terms of their strategic and cultural significance.

Furthermore, the actual display of the NPM objects was not always conducive to the messages the Nationalist government or the Chinese curators intended to convey. Spatial limitations of some participating museums broke the preferred chronological display into anachronistic mixing of different kinds of objects. The labels in the exhibition rooms, according to the complaints of the Chinese curators, were often too brief to give the uninitiated visitors an informative introduction.[68] Instead of appreciating a linear progression that pointed to a teleological culmination

Fig. 5. Mixed installation at National Gallery of Art, 1961. (Courtesy of the National Gallery of Art Archives.)

in the Nationalist rule, viewers could easily take archaic bronzes and much more recent painting scrolls, sometimes two millennia apart, as a random combination of things that reinforced an Orientalist impression of exotic and unchanging Chinese culture.

Judging from the contemporary U.S. media coverage of the exhibitions, it was also doubtful whether the Nationalist government actually got its desired legitimacy message across. Major metropolitan dailies catering to the white middle-class readership, such as the *Washington Post*, *New York Times*, *Boston Globe*, and *Chicago Tribune*, all carried glowing reports of the exhibitions along every stop. Amazed by the artistic achievements of the exhibits, particularly the landscape paintings, reporters also highlighted the dramatic evacuations of the NPM collections from the Japanese invasion to the Nationalist retreat to Taiwan. But by focusing on the "subtlety" and "delicate refinement," the reports rarely, if at all, made the leap from the artistic to the political to support the Nationalist government as the sole legitimate government of China because of its preservation of Chinese art treasures. Only the *New York Times* specifically pointed out the owner-

ship of these collections by the ROC while other newspapers skipped the issue all together. Even Luce's *Time* only had one sentence referring to the NPM collection's rescue from the Japanese invasion and "Red conquest" and mainly focused on a brief history of Chinese art.[69] Also worth noting is that while the major metropolitan dailies kept a close eye on the exhibitions, African American newspapers showed far less enthusiasm. The *New York Amsterdam News*, for example, did not seem to report on the show at the MMA at all. The *Chicago Defender*'s brief report, calling the NPM collection "smuggled" out of the mainland by the Nationalists, did not appear until four days after the show's beginning in the city.[70] To the disappointment of Wang Shijie, who penned the preface of the catalogue, Americans did not seem to care much about what he wanted them to remember: "the free Chinese are fighting to save their cultural heritage as much as to recover lost territories."[71]

A photograph of three U.S. Navy sailors at the de Young Museum offers more suggestive evidence of ordinary Americans' receptions of the grand Nationalist spectacle. Clustered in a corner with what appeared to be a tall indoor plant, the three uniformed sailors were staring at and probably puzzling over *Shenyue qionglin tu* (Immortal mountains and luminous woods), the landscape painting by Fang Congyi (c. 1302–1393) mounted on the wall, and a tiny label to the left.[72] Given its size, the label was probably not informative enough to give the sailors, who probably had little background knowledge of Chinese art or culture in general, much guidance. Their intense gaze and one sailor's arms akimbo suggest some interest, but also lingering bewilderment. In the end, it is unlikely that these three sailors would leave the exhibition as the new converts to the Nationalist cultural diplomacy.

Within the specialized field of Chinese art history, the CAT exhibitions further solidified the canonical status of painting and inspired a few future American experts on the subject. This was not necessarily the intended message of Nationalist cultural diplomacy and reflected more of the capability of influential U.S. museum curators in shaping relevant scholarship. Richard M. Barnhart (1934–), emeritus professor of Chinese art at Yale University, reportedly abandoned his own painting career after seeing the landscape painting by Fan Kuan (c. 950–1032) at the CAT exhibition in San Francisco in 1962 and started studying Chinese art history.[73] James Cahill, the junior curator in the exhibitions, organized the "Chinese Art Treasures Post-mortem Conference" in New York in 1963 for specialists in the United States to appraise paintings seen at the exhibitions. This important convening helped

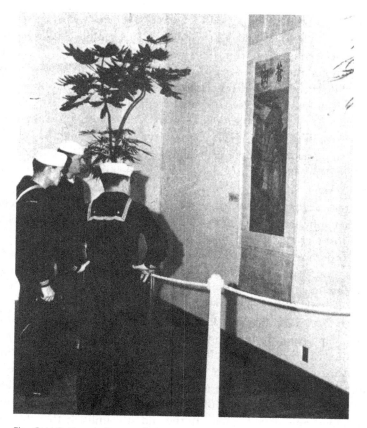

Fig. 6. U.S. Navy sailors at de Young Museum, 1962. (Courtesy of
Taiwan Shangwu yinshuguan.)

redefine the canon in Chinese art history, but it invited no scholars or
curators from Taiwan. Two years later he accepted a faculty position at
University of California Berkeley, where a three-decade career further
elevated his stature in the field.[74] The upper hand American curators
enjoyed in organizing the CAT exhibitions even motivated Tang Junyi
(1909–1978), a prominent neo-Confucian scholar then in exile in Hong
Kong and one of the authors of the "Manifesto for a Reappraisal of
Chinese Culture," to blame the Chinese "slave mentality" (*nuli yishi*)
in a 1964 essay.[75] A bit too harsh on the Nationalist government and
the NPM curators, Tang was nevertheless correct about the American
epistemological dominance in the infrastructure of persuasion laid bare
by the exhibitions.

Not only was the expected political payoff of such cultural diplomacy

dubious, it even became an economic liability. The Nationalist government received substantial assistance from various parties in the United States prior to and during the exhibitions. The Luce Foundation footed the bill for the trip of three curators to Taiwan in 1960 to select the final exhibits. The participating museums pooled funding for packaging, insurance, shipping outside Taiwan, and travel expenses of Chinese curators escorting the exhibits.[76] But on top of the elaborate catalogue printed in Switzerland, the government also organized costly publicity events in the United States, such as receptions, lectures, documentary screenings, and live demonstrations of Chinese calligraphy and painting.[77] For related expenses, the Executive Yuan ordered the Bank of Taiwan, the de facto central bank, to offer two three-year loans in 1960 at a token annual interest rate of 0.2 percent. To facilitate the payment in foreign exchange, the two loans were denominated separately in the local currency and U.S. dollars, valued at NT$ 1.2 million (roughly $30,000) and $40,000, respectively.[78] Despite the original expectation to use the receipts of catalogues and souvenirs to pay off the loans, the insufficient sales forced the government to extend the loans in 1963 and again in 1965.[79] The last recorded extension was in early 1967, when almost half of the NT$ loan was still outstanding, and it was quite probable that the government had to eventually write off the bad loan altogether.[80]

An Even Bigger Spectacle

Not long after the CAT exhibitions, the New York World's Fair in 1964 offered the Nationalist government the opportunity to execute its plan that was aborted at a similar fair in the same city twenty-five years before. Despite its participation in other U.S. exhibitions, such as the Century 21 Exposition in Seattle in 1962, the government definitely considered the New York one a much bigger prize.[81] It dispatched more antiquities to impress an even larger and more boisterous crowd, but also struggled to balance the antiquarian motif with the desire to attract foreign investment and tourism.[82] Other international participants at the same fair, such as Japan and Spain, also faced similar struggles.[83] The changing exhibitionary context gave these objects new pragmatic and localized meanings beyond the intended political legitimation of the Nationalist rule. It suggests the growing Taiwanization of the Nationalist government's Chinese cultural diplomacy.

Although the government did not face the intervention of knowledgeable American curators as in the CAT exhibitions, it still had to confront competing

representations of China in a more rowdy setting. Unlike the public fascination with the Central Asian edges of the former Qing Empire in the 1930s world's fairs in the United States, as mentioned in chapter 2, Hong Kong emerged as a new popular Cold War frontier in New York in 1964. Studying the Nationalist participation in the New York fair and the competing representations of China therein complicates the popular commemoration of the fair focusing on its modernist aspirations in the domestic context.[84]

The Nationalist government started deliberation on participation in early 1960, and formal planning followed suit in 1961. After the U.S. government started to invite foreign governments on behalf of the private fair corporation in early 1960, the Ministry of Foreign Affairs quickly indicated its acceptance in principle. In April, the ROC became the first foreign government to announce its participation, despite the fair's lack of endorsement by the Paris-based Bureau International des Expositions, the intergovernmental body regulating international exhibitions.[85] In early 1961, the fair dispatched Alan Kirk (1888–1963), former admiral and ambassador to Belgium and the Soviet Union, to tour U.S. allies in East Asia, the ROC included, to deliver personal invitations. Shortly before his departure from the United States, Kirk reassured You Jianwen, the ROC consul general in New York, that the fair had no formal plan to invite the PRC despite the suggestion by the fair corporation president Robert Moses (1888–1981), New York's imperious planner in the mid-twentieth century.[86] Even President Kennedy reportedly rejected this idea again later.[87] Chiang Kai-shek accepted Kirk's invitation at a formal dinner, and the Executive Yuan began concrete planning in mid-June. In September, the ROC became the second foreign government to sign the official contract after Indonesia, with the former president Dwight D. Eisenhower as a guest of honor.[88] Most of the Nationalist planning for the 1964 fair was through regular bureaucratic channels of an interdepartmental working group with representatives from relevant government agencies. Despite Chiang's formal acceptance of the invitation, he did not seem to show particular interest. Thus there was no ad-hoc committee of senior officials to report back to him directly.

Until the ROC Pavilion's official opening in 1964, diverse proponents of an antiquarian show had the upper hand, although their understandings of antiquities varied significantly. Consistent with Orientalist imaginations, American fair planners preferred exotic traditional art and culture to attract visitors to the fairground in Flushing Meadow Park.[89] In July 1962, Gates Davison at the fair corporation's international department made it quite clear to Consul General You that the fair did not want "a merchandise mart for Westinghouse fans built in Taiwan," allegedly what the ROC

Pavilion looked like in the 1962 Seattle fair. Given that Americans could see Westinghouse fans "whenever [and] wherever," Davison suggested "a picture of China, its problems, its rich past, of which the Republic's Government is custodian, and of its aspirations for the future," particularly Chinese art, from Taiwan as "treasury of Chinese culture." Writing to You one year later, Moses reiterated the ROC's significance as "the preserver of culture, beauty and tradition for all China, past and future."[90] But his remarks in the fair's internal correspondence revealed far less such respect for refined Chinese culture. What Moses really wanted was simply more "exotic things" as popular as Michelangelo's the *Pietà*, the famous Renaissance sculpture the Vatican had agreed to loan. Anything that could lead to "selling more good native *stuff* [emphasis added]" and thus the fair's commercial success, such as tourism and "great native art," should be encouraged among foreign exhibitors.[91]

These condescending remarks aside, the American endorsement of the nexus between cultural traditions and political legitimacy was nevertheless music to the ears of the Nationalist planners. Due to the regular bureaucratic planning, the proposed participation did not attract extra attention from the top, nor did it secure high-profile exhibits as in the CAT exhibitions. The working group adopted an eighty-foot-tall imperial palace structure for the ROC Pavilion, which was to break ground in November 1962 with the roof tiles and ceiling panels handmade in Taiwan.[92] The display of ancient objects within was left in the charge of the National Museum of History (NMH, *Guoli lishi bowuguan*), the first national museum reinstated in Taiwan in 1957 after the Nationalist retreat. Despite its national status, the NMH inherited part of the Henan Provincial Museum collections evacuated to Taiwan plus some objects returned by the Japanese government after World War II.[93] Such an institutional history made it much less prominent than the venerated NPM. Due to the limited budget, the NMH decided in September 1962 to send only various replicas, such as bronzes, porcelains, jade, coins, and silk brocade, but the list kept expanding. By the end of the year, the NMH was already contemplating replicas to present ancient Chinese music instrument, architecture, family life, handicraft, military defense, and communications technology.[94] The museum believed that even the replicas would "publicize China's long history and great traditional culture," which required "systematic demonstration" (*xitong biaoda*) beyond just "leisurely enjoyment" (*xiaoxian xinshang*).[95] Consistent with earlier endeavors since the late Qing, a comprehensive display of Chinese culture in order to educate the Americans remained the underlying rationale of Chinese cultural diplomacy at the 1964 New York Fair.

Transformation of the Antiquities

An unexpected intervention of Chiang Kai-shek, who had been largely absent in the bureaucratic planning process, significantly raised the stature of the antiquarian exhibits in 1963. At the latest in May, Chiang ordered select original objects from the NPM to be sent to the New York fair.[96] The reason for this decision was unclear, but given the apparent huge success of the CAT exhibitions, Chiang probably expected similar effects through more prominent objects at the fair. Eager to show their enthusiasm for the supreme leader's new directive, the Nationalist officials further upped the ante and tapped into more institutional collections not represented at the CAT exhibitions. In an early June advisory meeting, Wang Shijie, Li Ji, and Ye Gongchao, all senior planners for the CAT exhibitions, recommended an expansive list of antiquities beyond painting and porcelain.[97] Besides a small number of private collections, Academia Sinica's Institute of History and Philology was to send archaic bronzes and the marble tiger, items John Pope had been unable to secure a few years ago. The National Central Library, founded in Nanjing in 1933 and reinstated in Taipei in 1954, would contribute almost thirty rare books dating back to the tenth century. Other than porcelain, most of the NPM's fifty objects were jade, silk tapestry, lacquer, and carvings, genres Pope had dismissed as minor and in purely Chinese taste. The lion share would still come from the NMH, with more than three hundred objects ranging from bronzes to modern paintings.[98]

Compared to the CAT exhibitions, the Nationalist government did not have to deal with American experts on China much and had a lot more control over the curation of its national exhibition. In July 1963, Robert Moses did solicit the professional opinions of none other than Aschwin Lippe, the MMA's associate curator of Far Eastern art and expert of Chinese painting, and one of the American curators for the CAT exhibitions. Understanding Pope's failure to secure the Academia Sinica objects, Lippe composed a list that emphasized early bronzes and marbles as well as certain paintings not shown in the CAT exhibitions.[99] Unsurprisingly, Lippe's dissective view of Chinese culture still favored select objects based on professional interests of American experts. Judging from Taipei's final selection, his wish list did not quite resonate with the government's desire for a comprehensive display of the best of Chinese culture. Because no American museums paid for the exhibition of Chinese antiquities in 1964, the Nationalist government did not need to defer to Lippe this time.

The sudden influx of so many high-profile objects complicated the floor plan within the ROC Pavilion. Except for the top floor, which had always

Fig. 7. ROC Pavilion at New York World's Fair, 1964. (Photograph by Wilford Peloquin, courtesy of Wikimedia Commons.)

been reserved as office space, the four-story structure of almost 25,000 square feet went through several different designs. Based on existing documentation, one early plan would use the ground floor to showcase Taiwan's recent development, the second as a Chinese restaurant, and the third as a museum of replicas from the NMH. But a spatial division between Taiwan and China across different floors, warned Consul General You around 1962 and 1963, would carry unwelcome implications for the ROC's continuing claim to represent the whole China. He suggested displaying China's ancient civilization and Taiwan's contemporary development together on the first floor and staging live performance on the third floor.[100] Hardly did the planners in Taipei have time to consider You's suggestion when they also had to accommodate the arrival of high-profile original objects after Chiang's order. It was thus decided that most of the NMH objects would appear alongside the exhibits on Taiwan's contemporary development on the ground floor. The third floor would be dedicated to the collections from the NPM, National Central Library, Academia Sinica, and private collectors, as well as the overflow of the NMH objects.[101]

Specifically, the changing designs for the second floor underscore how the Nationalist government intended to use antiquarian objects to reorient the perceived Orientalist interests in the United States. As of late 1963, planners had to drop the original proposal for a Chinese restaurant because

the pavilion's design was not up to code for the operation of a working kitchen. Also, few Chinese restaurants in metropolitan New York showed interest in running the concession because they were not convinced of its profitability. Similar to Davison's suggestions a few years ago, the Nationalist officials thus reasoned that since Americans would not be interested in "the modern way of life in our country," it would make sense to "Orientalize" (*dongfanghua*) the second floor as traditional Chinese living quarters decorated with porcelain, antiques, screens, carved furniture, four treasures of a scholar's study (brush, ink, paper, and ink stone), and so on. Such self-Orientalization sought to present timeless Chinese literati leisure in order to raise the status of Chinese culture, and by extension the Nationalist government, in the United States.[102]

Despite the predominance of antiquarian themes in the Nationalist planning for the New York fair, the mix between the past and present gave the antiquities on display more pragmatic meanings. Taipei had certainly expected the CAT exhibitions to project political legitimation, but the exhibits seldom made explicit reference to their political meanings beyond art itself. In contrast, the antiquities at the 1964 fair were only meaningful in conjunction with the exhibits that highlighted the Nationalist achievements in Taiwan. In an overall developmentalist framing, the antiquities were no longer *objets d'art* in and of themselves but also tourist attractions within the ROC Pavilion.[103] Such a departure in the Nationalist cultural diplomacy also applied to the venerated NPM, as the construction of its new exhibition hall in suburban Taipei started right after the ending of the CAT exhibitions in mid-1962. The intended opening in 1964, unfortunately delayed to 1965, was to lure spectators of the Tokyo Olympic to visit Taiwan during their trip to East Asia.[104]

The Nationalist government's increasing reliance on tourist discourses in its cultural diplomacy in the 1960s carried significant political implications. The development of modern tourism in Taiwan began in the early twentieth century under the Japanese rule to showcase the tropical charm and colonial achievements.[105] Following the destruction during World War II, the Nationalist government revived the sector in the late 1950s thanks to the stabilizing conditions across the Taiwan Strait. In order to earn the badly needed foreign exchange and to redirect the local population's political and cultural allegiance, the recuperated government poured more resources into renovating the island's tourist infrastructure under a Sinocentric framework.[106] But an industry predicated on intimate local ties could not simply cast an extraterritorial gaze on mainland China as the lost homeland. Many of the tourist destinations in Taiwan, unlike the

antiquities, did not even have direct relations to the mainland. This actually compelled the government to be more territorially bound with Taiwan itself. Most of the existing studies pinpoint party politics in the 1980s as the beginning of the ROC's Taiwanization (*Taiwanhua*).[107] The cultural realm offers a different genealogy of this process, which would further develop, as will be seen in the following chapter, after the ROC's ouster from the UN dealt a fatal blow to its international legitimacy.

Despite the pragmatic framing, the antiquarian exhibits of the ROC Pavilion drew severe criticisms from those favoring the display of a modern Taiwan soon after the fair's opening in April 1964. In late May, Jiang Tingfu (T. F. Tsiang, 1895–1965), the former ROC ambassador to the UN and ambassador to the United States, visited the pavilion. Impressed with the palace style architecture, he nevertheless blasted the existing exhibits. In his opinion, they did not do justice to Taiwan's industrial development and were inadequate in comparison to how other U.S. allies in Asia, such as Japan, South Korea, the Philippines, and Thailand, showcased their contemporary achievements. A historian of Chinese foreign relations by training and known for his hot temper, Jiang did not seem to share the cultured appreciation of antiquities as his predecessor Ye Gongchao, a connoisseur and calligrapher. What Jiang probably did not know was that the Japanese exhibition, as mentioned before, was also the compromise between the traditionalist and modernist perspectives.[108] Since Chiang Kai-shek had personally ordered the display of high-profile antiquities, there would be no change to the third floor, where most of those objects were held. Instead Jiang suggested changing the second floor, a replica of a scholar's living quarters, to exhibits of industrial development. Jiang's modernist preference was echoed by some members of the Control Yuan, who opined that despite the differences between a world's fair and trade fair, it was still "very necessary" to showcase Taiwan's "economic progress."[109] These critiques from ranking officials coincided with the underwhelming number of visitors, which triggered negative comments from newspapers in Taiwan. Just more than one month into the fair, the interdepartmental working group in Taipei already decided to completely revamp the second-floor exhibition by replacing objects from a Chinese scholar's leisured life with modern manufactures in Taiwan. However, the proposed changes had to wait until the fair's second season in 1965.[110]

Internal communications in the Nationalist government also conceded the inadequate design of the exhibition space for antiquities. The total number of exhibits was more than four hundred, almost twice the size of that in the CAT exhibitions (around 230). These exhibits, coming from a

variety of institutions plus private collectors, were mostly crammed into the third floor of the pavilion, which only had narrow staircases but no elevators.[111] In a post-hoc report to the Ministry of Education, the New York consulate general admitted that the cluttered space, together with cursory exhibition labels, resulted in a perfunctory experience where visitors mostly just glanced at some eye-catching items and quickly moved on, if they climbed the stairs at all.[112] Despite all the Nationalist pedagogical urges to teach Americans refined China, it was doubtful whether fairgoers had significantly new impressions of Chinese art and culture beyond the stereotypical impressions of Oriental curios.

Persistence of Multiple Chinas

Despite its ambition to the contrary, the Nationalist government was far from the sole sovereign representative of China at the New York fair. To be sure, there were no American curators as in the CAT exhibitions, nor rugged Western explorers who showcased the Orientalist mystique of China's former imperial frontiers or their ambiguous connections to the country's Han majority as in the 1930s world's fairs. But a new crop of entrepreneurs, both ethnic Chinese and not, peddled different commodities and services with ambiguous connections to China to regular fairgoers. Competing representations of China by actors not under the Nationalist jurisdiction continued to complicate and challenge the effect of Chinese cultural diplomacy.

One such entrepreneur came from Hong Kong, the British crown colony that was undergoing rapid growth with refugee talents from mainland China and deeper economic connections to the United States.[113] During his East Asia tour in early 1961 to promote regional participation in the New York fair, Alan Kirk included Hong Kong on his itinerary. The colonial government declined due to high cost and the Bureau International des Expositions rule banning its member states from participating in any unsanctioned fair. The two large business associations, Federation of Hong Kong Industries and Hong Kong General Chamber of Commerce, also declined without a specific reason.[114] To the delight of the fair corporation, an obscure Chinese man Johnny Kao (Gao Zhenying) stepped forward in 1962 and promised to organize the exhibition on behalf of Hong Kong. A Shanghai native with some college education, Kao boasted a legendary barefoot escape to the colony from the advancing CCP troops in 1949. "Extremely intent on succeeding in whatever ventures he may undertake"

according to one background check, Kao served as a local guide for foreign businessmen after arriving in Hong Kong and built up his social network before starting his own garment export business. Kao also persuaded his former boss John P. Humes (1921–1985) at American Express, practicing corporate and estate lawyer in New York and future U.S. ambassador to Austria (1969–75), to join him. They set up a Hong Kong Trading Company in New York for this joint venture, with Humes as chairman of the board and Kao president.[115]

The dynamic duo soon began to pitch their ideas of representing the British colony's mixed heritage to the sympathetic fair corporation. Unlike the Nationalist government's cultural diplomacy, which had a strong urge to educate Americans with China's cultural refinement, Kao and Humes had few pedagogical pretensions and were mostly interested in profiting from Orientalist imaginations. Among their proposals were the Chinese rickshaw-pullers and the Hong Kong police of Sikh descent, in the hope that their "colorful" costumes would "lend an air of authenticity to the building." But neither materialized because of practicality and the potential opposition from those who had already contracted with the fair to provide similar services, such as Greyhound and the local police union.[116] Compared to its earlier correspondence with Taipei, the fair corporation suggested even more fantastic ideas of a generic Orient, such as an air-conditioned pagoda for "Chinese entertainment," filled with a dancing platform, exotic birds such as wandering peacocks, and a luminous glass tank of "Oriental fishes."[117] Judging from the press release, the Hong Kong Pavilion did cram the pagoda and dancing platform into the Crown Colony Club, which would provide "the haunting loveliness of this Chinese garden" with Chinese food and "American steaks and chops," and kept the rickshaw as an outdoor attraction.[118] As Kao summarized in the pavilion's official bulletin, the New York fair was the "greatest of trade fairs" so he would pull whatever gimmicks in order to boost his business.[119]

The Hong Kong Pavilion's Orientalist ambitions soon faced price competition from Jeno F. Paulucci (1918–2011), an entrepreneur of Italian descent from northeastern Minnesota. Although he probably never set foot in China, Paulucci had already developed in the 1940s a successful line of canned Chinese food products called Chun King (Chongqing, Nationalist China's wartime capital between 1938 and 1945), among other things.[120] With the endorsement of a Minnesota congressman, Paulucci got his fast food concession Chun King Inn in the New York fair's Lake Amusement area.[121] Its architectural mix would include a unique fifty-foot-tall pylon gateway and elements similar to those in the Hong Kong Pavilion, such

Fig. 8. Hong Kong Pavilion at New York World's Fair, 1964. (Photograph by Doug Coldwell, courtesy of Wikimedia Commons.)

as "pagoda-type teahouses," "an authentic Oriental garden," and "Ricksha Inn Restaurant."[122] Boasted as the "largest food sampling operation in history," the concession's "American-Oriental" fare would offer a multicourse "Chinese dinner" (fried rice, fried noodles, egg foo young, egg roll, fruit roll, fortune cookies, plus beverage) for 99 cents (slightly under $10 in 2023). Patrons could also enjoy a "Hong Kong Burger" with meat patties "specially prepared with mayonnaise, chili sauce, bean sprouts, soya sauce, American cheese, lettuce, and seasoning" plus "a generous serving of fried rice, fruit roll, and beverage" for another 99 cents.[123] This affordable option for American Chinese food undercut the bottom line of the Hong Kong Pavilion's Crown Colony Club. And Paulucci's appropriation of the name of Hong Kong gave the proprietors of the pavilion a perfect reason to file its complaints to the fair corporation.

Judging from the complaints filed by and against the Hong Kong Pavilion, neither the fair corporation nor the Kao-Humes team upheld the pavilion's exclusive representation of the colony. In fact, there were also

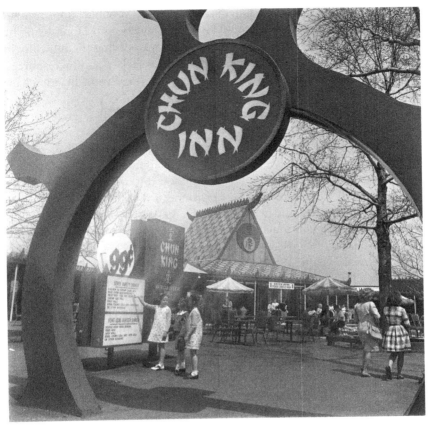

Fig. 9. Girls at Chun King Inn, New York World's Fair, 1965. (Courtesy of New York Public Library.)

other exhibitors attempting to sell products with the Hong Kong brand besides Chun King. In response to Humes's complaints about what he believed unlicensed use of the brand, the fair corporation did not consider the sale of food bearing the Hong Kong name or items made in Hong Kong a violation of the pavilion's right to represent the crown colony as stipulated in the contract.[124] Despite its disagreement with the fair's opinions, the Hong Kong Pavilion actually took a similar position in answering complaints about its sale of items made outside of the colony. Not long after the opening of the 1964 fair, a Brooklyn man complained to the fair that the souvenirs he bought from the pavilion were actually made in Japan. In his response, Kao explained that those items were "made in Japan but ordered from Hong Kong in Chinese taste." Unlike the Nationalist

concerns over the material Chineseness of the NPM publications printed in Japan, Kao defended the disputed items' connection to Hong Kong by differentiating representation and production. Conceding the difficulty in "100 percent produced in Hong Kong" due to its lack of natural resources, Kao nevertheless insisted on the amorphous prerogative of his merchandise in "represent[ing] Hong Kong and nothing else."[125]

Such disjunction between the physical and imagined geographies represented by diverse exhibitors contributed to further fragmentation of China-related imageries at the fair. A regular fairgoer with little background knowledge could be easily confused by the proliferation of such imageries of at least three different sites, not to mention the concurrent Chinatown guide probably distributed at the fairground. Edited by the same person who had prepared a similar guide for the 1939 New York fair, the slimmer 1964 volume continued the ethnographic expose of Chinatown and mentioned both the ROC and Hong Kong Pavilions. The lack of extensive advertisements in the 1964 volume suggested the dwindling interests of Chinatown businesses in the event.[126] To the dismay of the Nationalist government, what seemed to stick in popular memory regarding China during the sizzling summer of 1964 was the kitschy rickshaw replica at the Hong Kong Pavilion and cheap American Chinese food at the Chun King Inn.[127] Even Miss ROC, the selected beauty pageant representative of the titular state, had her picture taken sitting in the rickshaw with the official sash in late August 1964. In contrast, nothing is about antiquities in the scant photographic collection of the ROC Pavilion's interior in the fair corporation records.[128] As in the 1930s fairs, the audience was much less receptive to the educational messages to promote a refined cultural China than the familiar imageries that reinforced an exotic China and Orient. Whereas the Nationalist government finally exhibited cherished antiquities at the world's fair in 1964, its cultural diplomacy was still facing a tough crowd.

The Nationalist government records contain much less documentation on the New York fair's second season in 1965, a likely indicator of the ROC's waning interests under more grave challenges from the nuclear-powered PRC. Reports from the official newspaper emphasized new arrangements that supposedly increased attendance. The pavilion underwent the proposed reorganization to emphasize present achievements. Most of the first and second floors were dedicated to showcasing Taiwan's contemporary development, while the historical objects were concentrated on the third floor. But this probably resulted in an even more cluttered exhibition of antiquities, a complaint some visitors had already voiced in 1964. The pavilion also reportedly installed a Chinese restaurant on the second floor

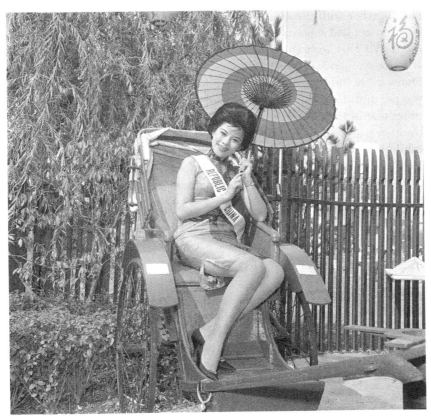

Fig. 10. Miss ROC visits Hong Kong Pavilion, 1964. (Courtesy of New York Public Library.)

operated by local Chinese businesses. Even some of the office space on the fourth floor was opened up for extra exhibitions of modern Chinese paintings. Live demonstrations of Chinese painting techniques were held during the summer months. Madame Chiang Kai-shek also graced the pavilion with her presence on October 4.[129]

But all these changes took place when the fair was facing deepening financial troubles and dwindling visitors, not to mention the escalating civil rights struggles and Vietnam-related tensions across the United States. Amid the financial and political troubles looming behind the 1965 fair, Academia Sinica decided to recall the marble tiger early because the pavilion's lack of climate-controlled space had eroded its delicate teeth.[130] Later that year all the antiquities loaned by various institutions for the New York

fair, together with the rare books and wooden strips that the Nationalist government had deposited at the Library of Congress for safekeeping since the early 1940s, were shipped back to Taiwan.[131] Hence ended the Nationalist government's mass exhibitions of Chinese antiquities in the United States in the mid-twentieth century, and the NPM's next big show there was not until 1996. The $2 million budget for the ROC Pavilion, over sixty times that of the CAT exhibitions, was still just a fraction of the expenses by other countries such as Spain.[132] Given the financial liability of the CAT exhibitions, it was unlikely that the pavilion generated much return either. With the world's fair soon fading as a platform of public entertainment, the Nationalist government's expensive but evanescent spectacle did not leave a lasting impression, let alone shore up its cultural and political legitimacy among ordinary Americans.

Conclusion

Well known is the ROC's seizure of the opportune moment of its security and international legitimacy between the mid-1950s and mid-1960s to develop the foundation of Taiwan's export-oriented economy.[133] This chapter focuses on the lesser-known story of the ROC's simultaneous efforts in sponsoring two major cultural diplomacy initiatives in the United States. The Chinese antiquities on display at the CAT exhibitions and the ROC Pavilion at the New York World's Fair traveled to no other country during the Cold War. A telling contrast is Southeast Asia, where a concentrated presence of Chinese diaspora and Beijing's significant diplomatic inroads since the 1950s prompted the ROC to fight pitched political battles with the PRC rather than practice cultural diplomacy.[134]

The expensive twin spectacles provided striking yet fleeting visuals of China's cultural refinement, which vied for resonance in museums and fairgrounds among competing voices and representations. A non-exclusive content provider, the Nationalist government had little control over the existing rules of engagement onsite. This was in line with the general Nationalist approach to propaganda in the United States around this time, where the government contracted Hamilton Wright Organization, Inc. and had to follow the rules of the commercial field of public relations.[135] It thus precluded the government from developing its own infrastructure of persuasion to sustain programming and outreach to Americans. In contrast, the China Institute's known activities around the same time were much less glamorous. The small loan exhibitions onsite from the mid-

1940s appeared to have continued at a less frequent pace, and the overall emphasis on antiquarianism still had an occasional twist such as contemporary landscape paintings in the "poetic tradition" of the twelfth-century old masters.[136] It also reportedly sponsored some free Chinese painting demonstrations by six Chinese artists at the ROC Pavilion in summer 1964.[137] Although the Nationalist cultural diplomacy appeared to have eclipsed that of the Institute by the mid-1960s, the values of an institutional platform would become more apparent again once the political fortunes of the ROC changed.

The building and maintenance of such an infrastructure required enormous commitment and resources, which the ROC even at the height of its cultural diplomacy in the United States was unable to afford. Despite periodic political disruptions and economic challenges, the PRC was more successful in implementing institutionalized cultural diplomacy especially in the Global South during the same period.[138] Since the 1950s, the PRC established several permanent semi-official institutions, including the Chinese People's Association for Friendship with Foreign Countries (*Zhongguo renmin duiwai youhao xiehui*) and China Performance Agency Company (*Zhongguo yanchu jingli gongsi*), to coordinate relevant activities. While unable to compete with the ROC in the United States yet, this formidable infrastructure of persuasion sponsored not just exhibitions but also live performances in the rest of the world across ideological camps.[139] Untethered to imperial pedigree or orthodoxy, the PRC adroitly extolled the folk and masses, and also cast itself as a humble and capable learner of the culture of fellow nations in the Global South.[140] As will be shown in the following chapter, the arrival of the PRC's cultural outreach in the mainstream American society in the early 1970s would unsettle the hitherto institutional dynamic of Chinese cultural diplomacy.

A Different Landscape

1966–1974

"Given that our [China] Institute has enjoyed a long and distinguished history among the academic and cultural circles in the United States, it might seem ordinary and receive no special attention when we control its daily operation. But the bad influence is bound to exploit it to the disadvantage of our country. Similar cautionary tales range from the Institute for Pacific Relations in the past and recently the Far Eastern Association [note: Association for Asian Studies]."

Cheng Qibao to ROC Embassy in the United States, June 28, 1966

"In order to maintain the friendly relationship with the [China] Institute and prevent its manipulation by the liberals associated with the [Rockefeller] Foundation or the leftists, we should agree to continue our subsidy."

Ministry of Foreign Affairs internal memo, September 17, 1972

The global reconfiguration of the Cold War order between the mid-1960s and mid-1970s significantly affected the dynamic of Chinese cultural diplomacy in the United States. Not long after the two major exhibitions in the first half of the 1960s, the Nationalist government had to recalibrate its relationship with the China Institute and its cultural diplomacy in general amid deepening geopolitical challenges. Since the PRC became a nuclear power in 1964, the support for its international recognition,

including the UN membership, grew even in the United States.[1] In October 1971, the PRC ultimately took over the China seat held by the ROC since the UN's founding in 1945 and became one of the five permanent members on the Security Council. As more countries, including some close U.S. allies, switched their diplomatic recognition from Taipei to Beijing as the sole legitimate government of China, the United States also leaned increasingly toward more realistic relations with the PRC, which resulted in President Nixon's 1972 visit. During the gradual rapprochement, the PRC also started to stage performances and exhibitions in the United States to present yet another distinctive representation of China's cultural achievements. The PRC's growing ambition as a new mainstream institutional actor of Chinese cultural diplomacy in the United States thus forced both the China Institute and the Nationalist government to reconsider their strategies.

Using the PRC's inroads as a foil, this chapter focuses on the gradual undoing of the bifurcated Chinese cultural diplomacy in the United States forged by the China Institute and the Nationalist government since the mid-1940s. The retirement of the Institute's longest serving director Meng Zhi and passing of its chief patron Henry Luce, both in 1967, injected uncertainties in the direction of this legacy institution. In the increasingly head-to-head competition between the two rival Chinese governments for mainstream support and legitimacy in the United States, the cash-strapped Institute started to hedge its humble yet longstanding institutional platform, a coveted asset neither Chinese government had achieved. In the meantime, the Nationalist government not only shepherded Taiwan's economic takeoff—a well-known success—but also innovated its recipe of cultural diplomacy.[2] Unlike the grand spectacles in the early 1960s that sought to comprehensively project China's cultural refinement, the government became nimbler in its targets and messaging. In response to the shifting popular opinion in the United States that favored engagement with the PRC, it reprioritized the patronage of front institutions, including the China Institute but not exclusively so, to avoid the liabilities of perceived direct propaganda. When such outsourcing failed to stem the UN debacle by the early 1970s, the government upgraded its own cultural diplomacy from exhibitions of still objects to live performances by the National Chinese Opera Theater (NCOT) in 1973 and 1974. As the first official Peking opera troupe to tour the United States, it made a pointed case about the genre's flourishing in the ROC in contrast to its alleged destruction during the Cultural Revolution in the PRC.

Legacy Collaboration in Transition

The leadership transition at the China Institute in the late 1960s coincided fortuitously with the deepening challenges facing the Nationalist cultural diplomacy in the United States, and offered a unique opportunity to reset their relationship. Meng Zhi, the Institute's long-term director since 1930, requested retirement in 1967. Henry Luce, the Institute's main benefactor who had kept it afloat since the mid-1940s, died in the same year. As mentioned in chapter 3, far from the dogmatic supporters of the Nationalist government's politics, they nevertheless maintained cordial relations with the government throughout their tenure. Once a key proxy in the Nationalist cultural diplomacy in the 1940s and 1950s, the Institute had become less central by the 1960s under the shadow of the government's grand spectacles and professionalizing field of Chinese studies in the United States. Yet trust between the two sides had never been a problem. The Institute's leadership transition in a volatile time gave Taipei more reasons to scrutinize the organization it used to take for granted.

William Henderson (1922–1983), the new director-apparent, indeed shocked the government with his proposal of distancing from Taipei. The ROC embassy first broke the news to the Ministry of Foreign Affairs in a telegram in July 1966. It was further circulated in the official *Central News Agency Reference* (*Zhongyang tongxunshe cankao xiaoxi*), which was only for the ranking officials. According to the report, Henderson was a former employee of the Council of Foreign Relations and recommended by Walter H. Mallory (1892–1980), the Council's former executive director and president of the China Institute in the early 1940s, to be Meng's potential successor.[3] The report also enclosed a March 1966 document titled "The Future of the China Institute in America," where Henderson presented to the board of trustees his strategies to strengthen the Institute's finance and programming, perennial problems Meng and Luce had been unable to resolve. He bluntly opined that "[w]hether rightly or wrongly, the Institute is too closely identified with the government of the Republic of China on Taiwan, and often dismissed as a dependency of that government." The solution was to bring the Institute into "the mainstream of American thought and discussion about China—not only about Taiwan, but also about the mainland and the overseas Chinese as well."[4] While Henderson's report reiterated the popular (mis)perception of a close relationship, it was an unmistakable anathema to a government that was fighting to safeguard its international legitimacy.

Henderson's vision temporarily revived the dwindling National-ist patronage of the China Institute, particularly financial contribution. Also enclosed in the embassy's telegram was a memo by Cheng Qibao in response to Henderson's plan. A former associate of Meng, Cheng led many of the Institute's initiatives in the 1950s and early 1960s mentioned in chapter 3. Already a trustee of the Institute by the late 1960s, Cheng urged the government to reverse the diminishing Chinese presence on the board by ramping up discreet donation.[5] In October 1966, the ROC ambassa-dor to the United States requested $40,000 from the Ministry of Foreign Affairs in the name of private donation, a method used before in the late 1940s, in order to curb Henderson's perceived pro-PRC tilt. But the slow bureaucratic procedures of appropriation forced him to take $20,000 from the embassy's reserve funds first. The $40,000 annual funding constituted almost half of the China Institute's yearly operating budget at the mid-1960s level and was not a small figure for the not-yet-wealthy Taiwan.[6]

As more information of Henderson trickled in, the Nationalist govern-ment's initial alarm gradually receded. One year after the news of Hender-son's potential appointment, head of the Government Information Office (*Xingzhengyuan xinwenju*) submitted a report in 1967 on Henderson's back-ground and his leadership at the China Institute. Henderson reportedly gave up his more lucrative job at the Mobil Oil Company for the non-profit sector to garner more cultural prestige, despite his lack of substan-tive knowledge of China. But he delayed the beginning of his tenure to early 1967 in order to claim a pension from Mobil.[7] With a keen interest in Southeast Asia, he had been instrumental in the American Friends of Viet-nam, a private organization that advocated more U.S. aid to the Republic of Vietnam as an anticommunist ally in Asia.[8] Despite his call for distancing the Institute from the Nationalist government, Henderson turned out to be more of an "opportunist" according to the report.[9]

On the other hand, Henderson's heavy-handed style during his short tenure created tensions for the Nationalist government to exploit. As the 1967 report noted, just a few months into his new job, Henderson had already ousted Meng Zhi, originally retained by the board of trust-ees to serve as a senior advisor.[10] He also antagonized some of the impor-tant trustees, including Elizabeth Luce Moore, Henry Luce's sister. This allowed the ROC ambassador to personally mediate between Henderson and the trustees and to renew friendship with Mrs. Moore. In anticipation of Henderson's departure in 1968, the government also worked behind the scenes to ensure a more friendly successor and indicated that it would set-tle for an American. Compared to some of the Chinese trustees who ada-

mantly opposed Henderson and openly preferred a Chinese successor, the government was more reticent lest it be seen as directly meddling in the business of an independent cultural organization.[11] But compared to their very loose relations just a few years ago, even such reticence highlights the unprecedented Nationalist involvement in the operations of an organization that remerged as the front and center of proxy cultural diplomacy in a changing Cold War order.

To what extent such intervention influenced the China Institute's choice of Henderson's successor was unknown. But the following two directors were certainly much more to the liking of the Nationalist government. Amid the uncertain prospect of the U.S. rapprochement with the PRC, it was also in the Institute's own interest to appoint a director who had the confidence of Taipei and, if possible, also Beijing. Ai Guoyan, Meng's long-term protégé at the Institute, served as interim director immediately following Henderson. He was the son of a prominent educational psychologist in China in the 1930s and 1940s, who later became a member of the Nationalist government's Examination Yuan in Taiwan.[12] F. Richard Hsu (Xu Fucheng, 1925–2019) directed the Institute on a more permanent basis from 1969 to 1981. Son of a famous international law professor at Yenching University in the 1930s who later represented the ROC as ambassador to Peru, Bolivia, and Canada in the 1950s and 1960s, Hsu had worked for the Voice of America and Encyclopedia Americana before assuming his position at the Institute.[13] Both Ai and Hsu came from families that followed the Nationalists to Taiwan after 1949 but nevertheless maintained high-profile connections on the mainland. In his recollection, Hsu emphasized that his candidacy hinged on friendly connections with Washington, Taipei, and Beijing. With his father's former students as top diplomats across the Taiwan Strait, Hsu believed that both camps were "trying to get on [his] good side."[14]

Compared to his predecessors, Hsu did rub shoulders more frequently with the top Nationalist leaders. But just as in the 1940s and 1950s, such political gestures stemmed more out of pragmatic needs than firm ideological commitment. As recognized by Hsu, Meng Zhi did not actively seek to curry political favor besides a cordial working relationship.[15] Guo Bingwen and Henderson were politically suspect because of their perceived sympathy toward the warlord government and the PRC respectively. During his tenure, Hsu met more frequently with the ROC ambassador to discuss the government's publicity in the United States.[16] He also took periodic trips to Taipei where he conferred with top leaders including Chiang Kai-shek and his son Chiang Ching-kuo (1910–1988) and briefed them on the develop-

ment at the Institute and in the United States in general.[17] However sym-
bolically important those meetings were, the Nationalist patronage ulti-
mately did not have the decisive leverage over the Institute's budget, given
the available data. The Luce Foundation, for example, had been making an
annual contribution between $2,500 and $20,000 to support the Institute's
general operations and building maintenance until the 1970s.[18] The C. T.
Loo Chinese Educational Fund, established in 1950 by the famous Chinese
art dealer and former trustee of the Institute, had been under the leader-
ship of Meng Zhi even after he retired from the Institute. The Fund subsi-
dized the Institute's student programming and general operations between
the late 1960s and mid-1970s in the range of $7,000 and $20,000. It even
made a one-time contribution of $150,000 in 1975 toward the Institute's
endowment.[19] Although the Institute did not do enough in diversifying its
fundraising, the Nationalist government was still not as significant a patron
as it would like to be and could only hope for a "balance" in the Institute's
programming on the two sides of the Taiwan Strait.[20]

Furthermore, Hsu did not hesitate to exploit Taipei's political vulner-
ability to extract funding, which the Nationalist government was obliged
to accept despite misgivings. Under Hsu's directorship, the China Institute
continued to host the Nationalist government's visiting dignitaries.[21] But
as the rapprochement between Washington and Beijing deepened in early
1972 after Nixon's visit, Hsu also reportedly invited Chinese scholars in
the United States to talk about their recent trips to the PRC, which was
not all negative.[22] This did not appear to be a pure coincidence as Hsu
was pressuring the Nationalist government around that time to send the
second half of the promised $40,000 annual contribution, which started in
1966 as mentioned above and continued through the early 1970s accord-
ing to existing documentation.[23] In January 1972, the government wired
$20,000 and planned to disperse the other half at an unspecified later date
depending on the Institute's political stance. Claiming that the Rockefeller
Foundation was making an offer of the same amount to the Institute, Hsu
effectively gave Taipei an ultimatum: either the full amount now or Rocke-
feller. Whether the Rockefeller offer was actually forthcoming was unclear;
there appears to be no documentation on such an offer in the Rockefeller
records. Just as an employee of the Ministry of Foreign Affairs wrote in
an internal memo, the government could not afford to lose the Institute
or have it "manipulated" by "liberals" or "leftists" at this time of political
uncertainties. By playing the card of fear, Hsu received the other $20,000
in April.[24]

Despite Hsu's hardball tactics in securing funding, a stable endowment

remained elusive for the China Institute, which had to temporarily scale back and even spin off longstanding programs. As mentioned in chapter 3, the Chinese Art Society of America had been affiliated with and housed at the Institute since its founding in 1945. Through the mid-1960s it organized almost annual loan exhibitions, prepared modest catalogues, and published its own journal, *Archives of the Chinese Art Society of America*, a pioneering publication dedicated to the study of Chinese art in the United States.[25] But these programs were drying up by the early 1960s with the passing of key early sponsors such as Loo and C. F. Yau, another prominent Chinese art dealer and also the Institute's long-term trustee and former vice president. Already in 1961, the Chinese Art Society had to stage an exhibition at the Asia Society, because of funding and space restrictions.[26] And signs of improvement were not forthcoming by the middle of the decade.[27] Starting from 1966, the Asia Society took over the journal and renamed it *Archives of Asian Art*. The name of Chinese Art Society of America was also dropped from the front page, an indication of its dissolution.[28] Seldom mentioned in the transition was the irony that the Asia Society was a cherished philanthropic project by John D. Rockefeller III, who had serious doubts about the Institute's politics and operation in the 1950s (as mentioned in chapter 3). But financial stress apparently called for drastic measures.

Thanks to the dedicated funding from the Luce Foundation and Louise Crane (1913–1997), another trustee, the China Institute was able to salvage and even expand some of its programming on refined Chinese culture. The Institute renovated its gallery and resumed regular biannual loan exhibitions around 1966.[29] More frequent than the shows in the 1940s and 1950s and accompanied by more elaborately printed catalogues, they remained the Institute's most well-publicized events.[30] Unlike the grand Nationalist exhibitions of antiquarian Chinese culture in the early 1960s, these eclectic undertakings were not bound by imperial tastes or immediate political goals. They were thus free to explore topics such as foreigners and tantric Buddhist art.

Beyond these onsite exhibitions, the China Institute also delved more into educational film, a medium that could reach a broader audience. Not long after Hsu's tenure began, the board approved Wango Weng, who had shot some of the Institute's earliest educational films in the 1940s as mentioned in chapter 3, to pilot another production on Buddhism in China. Additional funding from the Andrew Mellon Foundation in the early 1970s allowed Weng to eventually finish a thirteen-episode series on Chinese history from the beginning of Neolithic civilizations to the twentieth century, previewed at the Smithsonian Institution and Metropolitan Museum of

TABLE 7. Partial List of Exhibitions Held at the China Institute, Late 1960s
to Mid-1970s

Date	Catalogue
November 15, 1966–February 15, 1967	*Selections of Chinese Art from Private Collections in the Metropolitan Area*
April 5–June 11, 1967	*Art Styles of the Ancient Shang*
October 25, 1967–January 28, 1968	*Animals and Birds in Chinese Art*
March 21–May 26, 1968	*Gardens in Chinese Art*
October 24, 1968–January 26, 1969	*Chinese Jade through the Centuries*
March 27–May 25, 1969	*Foreigners in Ancient Chinese Art*
October 23, 1969–February 1, 1970	*Chinese Painted Enamels*
March 26–May 30, 1970	*Album Leaves from the Sung and Yuan Dynasties*
October 29, 1970–January 31, 1971	*Ming Porcelains*
March 24–May 27, 1971	*Chinese Silk Tapestry*
October 21, 1971–January 30, 1972	*Early Chinese Gold & Silver*
March 23–May 28, 1972	*Dragons in Chinese Art*
October 26, 1972–January 28, 1973	*Wintry Forests, Old Trees: Some Landscape Themes in Chinese Painting*
March 15–May28, 1973	*Ceramics in the Liao Dynasty*
October 25, 1973–January 27, 1974	*China Trade Porcelain*
March 14–May 24, 1974	*Tantric Buddhist Art*
October 24, 1974–January 26, 1975	*Friends of Wen Cheng-Ming: A View from the Crawford Collection*

Source: Data from *Selections of Chinese Art from Private Collections* (1986).

Art and later released on VHS tapes.[31] While various episodes addressed
the influence of nomadic polities from the Xianbei around 1,500 years ago
to the Manchu Qing between the mid-1600s and early 1900s, the largely
chronological series from "The Beginnings" to "The Enduring Heritage"
generally emphasized the message of Sinification and the result of a unified
Han-dominated multiethnic China.[32]

 In a time when the professionalization of Chinese studies in the United
States resulted in more university-based programs for teachers, the China
Institute also felt the pressure and started to branch out from its tradi-
tional genteel clientele.[33] A mainstay since the 1930s, the Institute's School
of Chinese Studies, where school teachers could earn in-service credits
and other interested middle-class adults—mostly women—learned about
China, saw its peak attendance in 1969.[34] Amid the shifting contemporary
national conversations on the compensative measures for the plight of
immigrant communities, the Institute also started to reach out to ordi-

nary Chinese Americans, whom they had kept at arm's length. Bilingual education first became federal law in 1967, reinforced by the landmark Supreme Court case of *Lau v. Nichols* and the Equal Educational Opportunities Act in 1974. These legislative and juridical mandates paved the way for a significant change in the Institute's programmatic orientation, which however garnered much less media attention than the Chinese art exhibitions. The Institute established a Chinese Community Research and Action Project in 1973 to document the Chinese American experience.[35] With a grant from the 1974 Act, it also launched a Bilingual Vocational Training Program in 1975 for recent Chinese immigrants aiming to enter the restaurant business.[36]

Worried about the prospect of the rapprochement between Beijing and Washington and aware of its inability to fully co-opt the China Institute, the Nationalist government started to subsidize other organizations as alternative fronts of publicity in the late 1960s and early 1970s. This further diluted its partnership with the Institute. One prominent example is the Institute of Chinese Culture (ICC) founded by Yu Bin (Paul Yu Pin, 1901–1978), a Catholic archbishop and later cardinal originally from Manchuria. Following the advice of Chiang Kai-shek, Yu founded the ICC in Washington, DC, in the early 1940s as an advocacy organization on behalf of China during World War II.[37] Through the 1960s, the ICC shared goals similar to those of the China Institute and sponsored Chinese art exhibitions, cultural performances, language lessons, and cooking demonstrations.[38] When Yu was otherwise preoccupied in the late 1960s, Cheng Qibao, the pro-Nationalist trustee of the China Institute, served as the ICC's interim president. Under his influence, the ICC moved to New York in 1967 to counter the China Institute under Henderson and received discreet Nationalist funding, for example $10,000 in 1970.[39] Additionally, Taipei wired undisclosed annual subsidies of around $10,000 to the ICC and organizations on the West Coast, including the Hoover Institution, to host conferences on Chinese culture for scholars and policymakers in New York and San Francisco through at least 1970.[40] Building upon the China Institute's conferences on Sino-U.S. cultural relations between 1955 and 1965 Cheng had coordinated, the ICC ones sought to further contrast the two competing Chinese governments and their cultural positions. They specifically drew on Taiwan's Chinese Cultural Renaissance Movement (*Zhonghua wenhua fuxing yundong*), launched in late 1966 as a celebration of the centennial of Sun Yat-sen, the founding father of the ROC. It was also intended as a direct response to the PRC's Cultural Revolution, which

started earlier in the same year. Ultimately the conferences touted Taiwan's dedication to preserving Chinese culture in the modern world as a rebuke to the PRC's reported destruction of Chinese traditions. But as conceded by Taipei, the conferences remained marginal compared to those convenings that advocated for engaging the PRC.[41]

The Nationalist government's influence operation also extended to academia, but similarly fell short of significantly redirecting the established discourses. The Institute for Asian Studies at St. John's University in New York was the main recipient of such support, thanks to its founding director Xue Guangqian (Paul K. T. Sih, 1910–1978). Similar to Cheng, Xue was also a mid-level government bureaucrat before 1949 and later settled in the United States. A devout Catholic and able administrator, Xue helped establish Asian studies at two Catholic universities in the metropolitan New York area: the Institute of Far Eastern Studies at Seton Hall University in New Jersey in 1951 and the Institute for Asian Studies at St. John's in 1959. Such efforts soon received Nationalist attention and Xue's regular visits to Taiwan also brought back considerable funds for his conference and publication series aiming at countering the perceived bias against the government in mainstream China studies in the United States.[42] Persuaded by Xue, Chiang Kai-shek himself donated $250,000— half of the estimated cost—as his purported personal contribution to construct Sun Yat-sen Memorial Hall, the new building for St. John's Institute for Asia Studies in 1970. Despite the continuing support from Taipei, which lasted through the early 2000s, this Institute did not develop into a major actor in the field, either.[43]

A probable sign of its desperation, the Nationalist government even secretly funded more fringe organizations, such as the Chinese Freemasons (*Hongmen zhigongdang*) with longstanding ties to the Chinatown secret societies and the far right John Birch Society, to stage disruptions at events that advocated U.S. engagement with the PRC.[44] All these efforts in propping up one proxy after another once again underscores the government's persistent lack of its own infrastructure of persuasion in cultural diplomacy. The proxy approach, beginning with the China Institute in the 1940s, seemed expedient when the government was fighting for its survival. But as the challenges to the government's international legitimacy mounted by the early 1970s, its shortcomings became increasingly apparent. Instead of asserting control over the projection of cultural messaging, Taipei once again resorted to staging spectacles, but a different kind from the museum exhibitions in the early 1960s.

New Political Economy of Peking Opera

The ROC's new arsenal to appeal to ordinary Americans was "national opera" (*guoju*), commonly known as Peking Opera (*jingju*). A syncretic genre whose popularity dated back to imperial patronage in the late eighteenth century, it had to be renamed due to the official nonrecognition of Beijing (Peking) as capital and shorthand of the rival PRC.[45] With the regular diplomatic space shrinking, the wealthier Nationalist government was able to upgrade its spectacle of cultural diplomacy from museum objects to live performances in order to convince Americans of its increasingly fictional proclamation of representing all China. In both 1973 and 1974, the government dispatched the National Chinese Opera Theater (NCOT), a troupe staffed by select members of existing Peking Opera troupes supported by the military, to the United States on such a mission. The NCOT's tours did not reverse the Nationalist government's political misfortune, but a hasty dismissal misses the significance of the Nationalist efforts in their timing, substance, and deployment. Despite the enormous international challenges, the early 1970s still presented the government a window of opportunity in making a targeted intervention in Chineseness and Chinese cultural diplomacy. The moderated yet ongoing Cultural Revolution still dictated some of the messaging in the PRC's cultural outreach. In particular, the radical remake of Peking Opera orchestrated by Mao Zedong's wife, Jiang Qing (1914–1991), and the ban on traditional repertoire provided opportune fodder in strengthening Taipei's claim of legitimacy through the stewardship of Chinese antiquity, discourses the PRC would later appropriate.[46] The NCOT's ultimate inability to deliver the intended political message hinged heavily on the government's subservience to American show business in commanding the infrastructure of persuasion in its cultural diplomacy.

While Peking Opera had appeared on high-profile stages in the United States as a means of promoting political goodwill and cultural understanding between the two countries, none of the earlier performances received direct sponsorship from the Nationalist government. As mentioned in chapter 1, Mei Lanfang, China's foremost male Peking Opera icon who played female roles, embarked on a critically acclaimed tour of major U.S. cities with mostly private funding as well as assistance from the China Institute in 1930. Only two years after the country's nominal unification then, the government's mouthpiece *Zhongyang ribao* even ran a few critical opinion pieces on Mei's tour. One commentator, for example, equated Mei's portrayal of melancholy Chinese women in the past as the unsavory

revelation of China's "ugly history of obscenity and debauchery" (*yinhui zongyu de choushi*). Such "decadent [and] effeminate" (*weimi rouruo*) drama was therefore unfit for a nascent party-state that was striving to "abrogate all the unequal treaties" (*feichu yiqie bu pingdeng tiaoyue*).[47]

Three decades later, performances given by fifty students from the private Fuxing Drama School (*Fuxing juxiao*) in Taiwan at the invitation of an American agent triggered another wave of popular interest in the genre in the Americas. Harold Shaw (1925–2014) was director of performing arts for the 1962 Seattle Century 21 Exposition and agent for Sol Hurok (1888–1974), a Russian-born American impresario who had brought the renowned Soviet Bolshoi Ballet to the United States in the 1950s. Shaw offered to subsidize the Fuxing troupe's yearlong tour during 1962 and 1963 with joint funding from both the Seattle fair and Hurok's agency. Starting in Seattle, the student troupe alternated between two repertoires of single-title performances in major cities and small towns such as Kohler, Wisconsin, and Laramie, Wyoming, as well as almost twenty Latin American countries, from Mexico to Chile. According to the government's final tally, the total audience reached 600,000, not including those tuning in to television or radio broadcasts.[48]

Shaw's representation contributed to the Fuxing troupe's "pure enchantment" of the critics.[49] After realizing that the Seattle fair's allotment of $15,000 was substantially lower than the promised sum, he secured extra funding from Hurok's agency to cover the troupe's living costs and stipends in the United States outside Seattle. Additional grants cobbled from different agencies of the ROC government, loans from the government-controlled Central Trust of China, and personal contributions from Fuxing's principal covered the rest of the expenses. Besides funding, Shaw rendered the Fuxing story palatable to the Cold War ethos. The school, the only one then in Taiwan to train future Peking Opera talents, recruited many refugee orphans from the mainland after the Chinese Civil War. As Shaw reassured the Nationalist officials in July 1961, Fuxing's history would "receive more publicity and attention in our American press and magazines, thus enabling the story of Free China to be told more dramatically than any physical exhibit that could ever be constructed on any ground."[50] The importance of a capable American impresario became even more obvious when another U.S. tour of the recently nationalized Fuxing School in 1969 turned into a debacle because of the hasty organization and poor funding by an obscure organization in San Francisco's Chinatown.[51]

No longer critical of staging Peking Opera in the United States as in 1930, the Nationalist government by the early 1960s was however not

fully committed to this cause on economic and political grounds. Cultural diplomacy had of course become much more central because of the yawning gap between its sovereignty claim and actual control. Although Taiwan's export-oriented economy had taken shape in the late 1950s, the island was not yet wealthy in the 1960s. Thus to support a yearlong tour of spectacular performances was still beyond the means of the government. Such financial restrictions dictated the concentration of limited resources in places of the most perceived importance. As it focused on preparing for the Chinese Art Treasures exhibitions and the New York World's Fair, the government—with generally solid U.S. recognition—saw no reason in overspending on a troupe for another fair in what was then a regional city.[52] In fact, its hitherto major overseas promotion of Peking Opera since retreating to Taiwan took place in Western Europe in the late 1950s, a region where the PRC had made diplomatic inroads since 1949.[53]

The shifting Cold War power alignment from the late 1960s brought the PRC's cultural outreach closer to mainstream American society. The National Committee on U.S.-China Relations (NCUSCR) was founded in New York in 1966. With secure funding and broad representation from policy, business, and cultural circles, it made normalizing relations with the PRC an increasingly prominent issue.[54] Following the unprecedented exchange of goodwill between the PRC and U.S. table tennis teams in Nagoya, Japan, and the U.S. team's subsequent visit to Beijing in 1971, President Richard Nixon's visit to the PRC in early 1972 ushered in more bilateral visits in the name of "people-to-people contacts" in areas such as "science, technology, culture, sports and journalism."[55] The NCUSCR helped arrange the historic U.S. visits of the PRC table tennis team and the Shenyang Acrobatic Troupe in 1972 alone. Drawing upon the physical culture that had burgeoned since the Republican period, the PRC used the athletic and agile body, both male and female, to showcase its nonmenacing strengths to the Cold War world. In particular, such focus eased the PRC's rapprochement with Washington when the strictures of the Cultural Revolution still limited its cultural messaging.[56]

These developments compelled the Nationalist government to reconsider cultural diplomacy strategies in engaging its most important ally, which still recognized Taipei as the sole legitimate government of China. Unmentioned in the existing scholarship on the "ping-pong diplomacy" is that Taiwan's Presbyterian Church, despite the concerns of the U.S. Table Tennis Association, dispatched a team to the United States and Canada in 1971 during the gap between the U.S. and PRC teams' meetings in Nagoya and Beijing. Carl McIntire (1906–2002), a famous right-wing

pastor and the team's U.S. organizer, touted its sportsmanship and Tai-wan's religious freedom.[57] A few months after the PRC team's U.S. visit in 1972, another ROC team toured the western United States and Canada.[58] Pleased with such disruptions to the momentum of the "ping-pong diplo-macy," the Nationalist government was also planning an official cultural counteroffensive that would "strike the Chinese Communists' cultural infiltration (*daji Zhonggong wenhua shentou*)."[59] In 1972, the Ministry of Education drafted an (overly) ambitious plan to send performing and visual arts groups to the United States, including painters, musicians, dancers, and folk artists, and the government ultimately settled on Peking Opera. In May 1973, Premier Chiang Ching-kuo approved the formation of an eighty-member national troupe, to be drawn from several troupes sup-ported by the Ministry of Defense. The total budget of the national troupe was close to NT$17,000,000 (a little over US$400,000).[60]

Such a decision came at the confluence of particular political and economic conditions. Peking Opera figured prominently in the larger competition for legitimate and authentic Chineseness across the Taiwan Strait. Since 1966, the Cultural Revolution in the PRC purged the estab-lished repertoire of many traditional art forms and introduced "model plays" in select genres in order to boost proletarian values. This allowed the ROC government in Taiwan to present the Chinese Cultural Renais-sance Movement as a countermeasure and reiterate its legitimacy through the stewardship of China's ancient cultural traditions. Peking Opera's popularity made it a high-profile target in both cultural campaigns.[61] Also by the early 1970s, Taiwan's steady economic growth enabled the govern-ment to fund the U.S. tour of a national troupe and carry the rhetoric of the Renaissance further overseas. As the Nationalist officials reasoned in an internal memo, Peking Opera as an internationally acclaimed and unique art form constituted the best *xuanchuan* at a time when the PRC was destroying it and the United States was ignoring Taiwan.[62] The NCOT would thus become the ROC's most spectacular counterattack on the PRC at a time when the two rival regimes' battle for international legitimacy was becoming even more fierce.

The ROC's antiquarian anchoring of Peking Opera vis-à-vis the PRC's proletarian one needs to be treated with caution. Rather than the epitome of millennia of Chinese civilization, the genre has only a relatively short history dating back to the late eighteenth century. While the PRC did not have the platform to appeal to ordinary Americans, it was a shrewd pro-moter of Peking Opera among major U.S. allies before the Cultural Revo-lution. The PRC art delegations toured Western Europe in 1955, 1958, and

1964 and Canada in 1960 with great fanfare.[63] The repertoire combining Peking Opera and folk songs and dances demonstrated the PRC emphasis on the former's mass artistic appeal instead of ancient pedigree as in the ROC rhetoric.[64] For example, official reporting from *Renmin ribao* on one such visit to France in early 1964—the one closest in time to the NCOT's U.S. tour, right after France had recognized the PRC—focused on Peking Opera's technical sophistication without referring to its history. It specifically highlighted the genre's emotional breadth through "gestures" (*zishi*), "eye contacts" (*yanshen*), "facial expressions" (*biaoqing*), and "dance moves" (*wudao dongzuo*) and the Parisian audience's captivation by the "humorous" (*huixie*) and "vivid [and] meticulous symbolic moves" (*bizhen xizhi de xiangzhengxing dongzuo*).[65] As will be seen, the Nationalist officials secretly studied the PRC techniques even though they never abandoned the antiquarian framing of Peking Opera.

The ROC government's preparations for the NCOT tours had started in earnest even before Chiang Ching-kuo's final approval of this major undertaking. The first task was to craft a repertoire both entertaining and educational. Drawing upon the Mei and Fuxing precedents, the officials continued with "tactical Orientalism" and preferred similar titles based on folktales and historical novels that featured colorful costumes or martial arts.[66] An uncanny similarity is evident in the emphasis on visual appeal in comparison with Japanese sushi chefs' early promotion of the dish in the United States in the late 1960s.[67] They also prepared two sets of repertoires: shorter excerpts in order to appeal to ordinary Americans with little background knowledge and longer ones for the ethnic Chinese audience. Among these were "The Heavenly Angel" (*Tiannü sanhua*), inspired by a Buddhist story and mythical flying figures in ancient Buddhist caves in northwestern China and famous for the performer's waving of a long stretch of silk; "The White Serpent" (*Jinshan si*), based on an old folktale involving the fateful romance between a white serpent and a cowherd; and "The Monkey King" (*Meihou wang*), featuring the rebellious monkey from *Journey to the West*, a sixteenth-century fantasy novel based on a seventh-century Chinese monk's pilgrimage to India.[68] An accompanying forty-page playbill in English, titled "Chinese Opera," elaborated on the history and techniques of a unique "total theatre" and a "great cultural heritage." Taiwan, declared the playbill, remained the place where people could view dress and makeup that was "the same as 200 years ago" and appreciate "the embodiment of China's 5,000 years of civilization."[69]

The government also strove to impart its political message through the repertoire. The officials particularly policed "ideological correctness"

(*zhuti yishi zhengquexing*) in order to imbue ancient stories with Cold War significance.[70] Originally on the list was "The Battle of Wancheng" (*Zhan Wancheng*), based on *Romance of the Three Kingdoms*, a sixteenth-century historical novel on China's political fragmentation in the second and third centuries. The excerpt featured a successful retreat of the warlord Cao Cao (155–220 CE), usurper of the weakening imperial rule and an illegitimate ruler in orthodox Chinese historiography. In the Cold War context, Cao became an allegory for the PRC, which in the official ROC parlance was also an illegitimate rebel regime. Since his successful retreat would thus send the wrong signal about the PRC's vitality, the officials replaced it with "At the River Ford" (*Hanjin kou*) upon deliberation. With a series of martial scenes adapted from the same novel, it instead featured a victorious repelling of Cao's attack by Liu Bei (161–223 CE), the celebrated legitimate heir to the crumbling ruling dynasty. Liu's victory, as a veiled affirmation of the Nationalist legitimacy, conveyed a message more in line with the ROC's political wishes.

A closer look at the ROC's repertoire again problematizes its emphasis on Peking Opera's antiquity. The playbill itself conceded that Peking Opera was a synthetic form that dated back only to the late eighteenth century.[71] Its presentation of Chinese opera as an encompassing category of all dramatic art in China with Peking Opera as a particular form muddled the claim of antiquity. Moreover, staging Peking Opera as visual spectacle had an even more recent origin at the turn of the twentieth century in China. Before Mei Lanfang dazzled Americans in 1930, more and more Chinese audience had already been craving visually stunning performances thanks to the new staging techniques in Chinese theaters and the proliferation of images of Peking Opera actors as popular cultural icons. Inspirations from ancient culture notwithstanding, *Tiannü sanhua* was developed by Mei in Beijing only in 1917 as part of the "ancient-costume new dramas" to cater to the nascent visually inclined Chinese audience.[72]

Despite the ROC government's questionable claims, there seemed to be no challenges to its definitions of the genre. Not only were there few, if any, dissenting voices within Taiwan still under the martial law, but Chinese theater as an underdeveloped academic field in the United States in the 1970s also had very few experts to provide second opinions of the repertoire. Among the earliest scholars of Chinese theater teaching in the United States in the early 1970s, A. C. Scott (1909–1985) from Britain was at the University of Wisconsin-Madison, Rulan Chao Pian (1922–2013), daughter of a prominent Chinese scholarly family, at Harvard, and Scott's student Daniel S. P. Yang from Taiwan at the University of Colo-

rado Boulder.[73] None of them appeared to be involved in the planning of the NCOT's visit. In a stark contrast, American collectors, curators, and scholars (not mutually exclusive careers) had been fueling the growth of sinological expertise in the object-focused field of art history since the late nineteenth century.[74] As mentioned in the previous chapter, influential curators decisively shaped the Chinese Art Treasures exhibitions often against the wishes of the Nationalist officials. The lack of such expertise in the performing arts together with the funding thus allowed the Nationalists to achieve almost sovereign control over the definition of Peking Opera.

Xuanchuan versus Business

Although the ROC government held a monopoly in *producing* the content for the NCOT's visit, it still lacked the means of *projecting* such content in the United States. From the beginning Taipei knew that it had to cede the infrastructure of persuasion to an American agent who understood the show business. By April 1973, the government settled on Harold Shaw, the same impresario who had represented the Fuxing tour and had since established his own independent agency. With Shaw's consent, the Government Information Office's representative in New York Lu Yizheng (Loh I-cheng, 1924–2016) also sought the sponsorship of the NCUSCR through its member William A. Rusher (1923–2011), publisher of the prominent conservative magazine *National Review*. The ROC government certainly had no illusion of the NCUSCR's position. But it believed that the organization would either accept, which would raise the NCOT's standing and even alienate the PRC, or decline, which would reveal its pro-PRC stance and tarnish its nonpartisan status. The NCUSCR unsurprisingly declined but suggested a few impresarios, Shaw among them.[75] As the NCOT's official impresario, Shaw was merely pursuing a business opportunity that was first and foremost a political project to the Nationalists. The disparate motivations behind this joint venture would eventually surface, yet the ROC government simply could not afford to forego Shaw's service.

The unexpected visit of a Hong Kong–based Peking Opera troupe to the U.S. West Coast soon tested the partnership. Nationalist officials learned of the troupe from press accounts just a few months before the NCOT's departure.[76] It was a thoroughly commercial undertaking under obscure U.S. representation and drew half of its performers from Taiwan, where the gradually declining market had triggered an exodus of actors.

The officials first tried in vain to dissuade the troupe from going.[77] They then anxiously monitored its itinerary and reception and incorporated criticisms of the excessive martial arts scenes and overly long performances as negative lessons into their final rehearsals in Taipei.[78] By early September, the Hong Kong troupe's abysmal box office performance forced it to fold its operation in Los Angeles. While this removed a competitor, it left the troupe's Taiwan members stranded in a foreign land and cast a shadow over the NCOT's debut in Honolulu one week later, to be followed by Los Angeles and San Francisco. Given the high stakes, the ROC government ordered its diplomats in the region not only to assist in the repatriation of actors to Taiwan but also to drum up publicity for the NCOT.[79] While ticket sales turned out to be fine in Honolulu, where the Hong Kong troupe had not visited, they were weak in the two major cities in California on the eve of the NCOT's arrival.[80]

The bleak commercial prospect exacerbated the divergent interests between the Nationalists and Shaw. To avoid the embarrassment of empty seats, the consulates requested more gift tickets. Claiming a weekly outlay of more than $25,000 on the NCOT, Shaw not only declined the request but also threatened to walk away from the deal should low ticket sales continue.[81] In a telegram in English to Taipei, Lu Yizheng speculated that Shaw was bluffing in order to minimize his losses, but the government must, warned Lu, be prepared to take over the tour should Shaw be determined to withdraw. To end the tour in just a few weeks would be "most humiliating and politically disastrous."[82] Lu's subtext, however, was that the government should not abandon Shaw. The ROC's predicament highlighted the tension between political and commercial goals and also the implications of its concession of the infrastructure of persuasion to the market.

The Nationalist efforts to further publicize the NCOT did eventually translate into improved ticket sales. As the ROC government's media coordinator in the United States, Lu pushed stories of the NCOT in high-profile outlets, such as articles in the *Los Angeles Times* and *Time*, and segments on NBC's *Today Show* and CBS's *Mike Douglas Show*.[83] The *Time* article on October 8, for example, opened with a sensational accusation of the PRC's "cultural crime" in destroying Peking Opera.[84] While not as bold as the count of five thousand years of history in the playbill, it still reaffirmed the genre as an "ancient" heritage dating back to the eighth century and the ROC's praiseworthy efforts in preserving an admirable tradition. The media campaign was too late to save the situation in Los Angeles, but subsequent ticket sales bounced back. The government's additional publicity spending thus averted its first standoff with Shaw.[85]

But this could not bridge the fundamental differences between the two sides nor prevent future problems. By mid-September, negotiations regarding arrangements for the NCOT's upcoming stop in Seattle in early October reached an impasse. The differing opinions within the ROC government reflected the lack of consensus about the intended audience. Lu, backed by the Ministry of Foreign Affairs, suggested the distribution of gift tickets mainly among influential Americans in media and politics.[86] The consulate general in Seattle on the other hand was considering using such tickets to maintain the local Chinese community's loyalty to Taipei. In consultation with community leaders, the consul general also proposed an additional free performance for the local Chinese to mark October 10, the ROC's national day in commemoration of the 1911 Revolution. Shaw, according to the consulate general's report to Taipei, was unsympathetic to any of these proposals. He was concerned with diminishing returns on the already scheduled regular performances and losing support from "the other side" (*qita fangmian*), probably a euphemism for Shaw's attempt to represent PRC groups. The frustrated local Chinese community blatantly called Shaw "a Jew knowing nothing other than making money" (*zhizhi zhuanqian zhi Youtairen*).[87] Probably due to the improved profit margin, it was Shaw who relented first this time. By early October he agreed to have ten members of the NCOT stay in Seattle for the requested free performance. Shaw was also reportedly open to similar future performances for Chinese communities in major urban centers, although he invoked the unsuccessful Fuxing tour in 1969 to reiterate the importance of a viable impresario like himself.[88] Shaw's compromise did not reconcile the inherent contradictions in what the consulate general lamented as "talking *xuanchuan* with [a] businessman" (*yu shengyiren tan xuanchuan*).[89] But just as in the first dispute, the ROC simply could not afford to lose Shaw as an agent.

Success and Challenges

Except for a failed attempt by unknown supporters of Taiwanese independence to put "Republic of Taiwan" on the playbill in Honolulu and minor heckling in Sacramento, California, and Madison, Wisconsin, by pro-PRC activists who accused the ROC of stifling Peking Opera in contrast to the genre's "dynamic" development for "ordinary people" in mainland China, the NCOT's tour was generally smooth, and its final box office performance satisfactory.[90] The three-month tour between September and December ended with additional performances in major centers of ethnic

Chinese population such as New York, San Francisco, and Los Angeles.[91] As the Fuxing tour in the early 1960s had done, the NCOT traveled from the West Coast to the East Coast via the Midwest, and covered both big and smaller cities. Ticket sales in the latter were sometimes even stronger, such as Omaha, Minneapolis, and Fort Wayne, Indiana.[92] After Shaw collected his share of ticket sales, the ROC government was expected to put its share of the receipts—more than $80,000—back into the state coffers, minus deductions for gift tickets and receptions. Since the original budget was about $400,000, the tour was unlikely to be a profitable one.[93]

At a time when the PRC's cultural diplomacy had started to make inroads in the United States, the ROC government could afford to care much more about publicity than expenditures. As mentioned earlier, unlike the ROC's insistence on the legitimate succession of antiquarian culture, the PRC's invocation of culture tended to emphasize not antiquity on its own but rather its popular and folk production. This approach was still in tune with the broad revolutionary aesthetics required by the Cultural Revolution but not menacingly so. In this sense, the PRC's cultural diplomacy in the United States in the early 1970s was yet to compete head-on with that of the ROC's and thus left open a niche the NCOT took advantage of. In the words of an American critic, "This [NCOT] is art. That [Shenyang Acrobatic Troupe] was athletics."[94]

The media coverage of the NCOT was generally positive. Reviewers were impressed with Peking Opera as an exotic and spectacular art form, something quite different from what they were used to. The lack of familiarity also made them generally accept the Nationalist claim of Peking Opera's long pedigree of antiquity. Few made reference to earlier Chinese efforts of promoting the genre in the United States, which testified to the fleeting effect of the spectacular performances. The *New York Times* review opened with "Chinese Opera is very, very, very, very old, old, old, old."[95] In line with the Nationalist officials' anticipation of Americans' preferences, many critics wrote glowingly about the visual appeal as "dazzling," "spectacular," and "a feast for the eyes" but found the arias "irritatingly grating and unfamiliar."[96] Compared to mainstream newspapers targeting a white majority readership, major African American newspapers' coverage was much more scant. The *New York Amsterdam News* carried none, while the *Chicago Defender* and the *New Pittsburgh Courier* each had one preshow announcement but no review afterward.[97] Similar to the Chinese Art Treasures exhibitions, most of the NCOT's American audience without Chinese heritage was most likely white middle class. The black radicals' focus

on the PRC probably exhausted the attention to Chinese affairs within a community battered by discrimination.[98]

Beneath the success, however, lay several intractable problems from limited outreach to commercial arrangement. As acknowledged in the government's final report on the 1973 tour, Peking Opera was still much more attractive to the audience of Chinese descent. Other attendees were likely to be curious middle-class white theatergoers, despite the government's conscientious goal of targeting ordinary Americans with little knowledge of the genre. Seat occupancy was close to 70 percent in performances for Chinese communities, while the average for all performances was only a little over 53 percent.[99] The last major Nationalist offensive in culture diplomacy in the United States on the eve of the PRC's consolidation of China's international representation appeared to have achieved a rather limited outreach. In addition to the numbers, the NCOT was yet to resolve the loss of its ultimate messaging through the acclaimed yet fleeting spectacles: it failed to generate further political support for the ROC government as Taipei had expected. The Nationalist officials believed that Peking Opera would not just entertain Americans but also educate them about the ROC's international legitimacy, which would serve as a counterweight to the rising influence of the PRC. But the reviewers' admiration of the spectacular performances seldom translated into political endorsement. This might have increased the NCOT's artistic appeal, but it also defeated the ROC's political purpose in staging the spectacles. Since the major exhibitions of museum antiquities in the United States in the early 1960s, the government had been wrestling with the gap between the artistic and the political in its messaging. But it still did not have a solution a decade later.

In the same report, the ROC government admitted another fundamental structural hurdle in the publicity of the NCOT in comparison to that of the PRC visiting groups.[100] Despite different phrasing, this pointed squarely at the inadequate infrastructure of persuasion. As mentioned before, the resourceful NCUSCR organized the U.S. visit of the Shenyang Acrobatic Troupe in 1972. It not only pushed that story to the front page of the *New York Times* but also arranged the attendance of Secretary of State William P. Rogers (1913–2001) at the inaugural performance in Washington, DC, and a welcome meeting with President Nixon at the White House. As the Nationalist report wryly noted, such arrangements practically gave the Shenyang troupe free publicity. In contrast, the ROC never had access to the NCUSCR's well-connected platform and instead relied on a private impresario whom it saw as indispensable though sometimes annoying. It

enjoyed far less publicity but paid a lot more. Unlike the front-page cover-
age of the PRC troupe, the *New York Times* reportedly charged $4,000 for a
quarter-page advertisement for the NCOT on November 18, 1973, which
was buried in thirty pages of the entertainment section and almost three
hundred pages of that day's newspaper. The quality of the NCOT's perfor-
mances aside, its ordinary commercial packaging gave the public, already
inundated with choices, no compelling reason to pay attention. The NCU-
SCR thus commanded a much more powerful infrastructure of persuasion
on behalf of the PRC troupe than did a private impresario for the NCOT.
This situation underscored the dilemmas of the ROC's commercialized
cultural diplomacy in a politically challenging time.

Second Act

By the end of the 1973 tour, the NCOT's spectacular performances
attracted invitations from different countries, such as the Dominican
Republic, Spain, and other unidentified European nations.[101] After assessing
the international situation, the Nationalist government still decided to dis-
patch the troupe to the United States in 1974, despite the thawing relations
between Washington and Beijing. Although the government had already
realized after the 1973 tour that *xuanchuan* and "commercial enterprise"
(*yingli shiye*) had "different points of departure" (*chufadian yibu xiangtong*),
it once again engaged the service of Harold Shaw.[102] Misgivings aside, the
government did not have an alternative infrastructure of persuasion for its
cherished cultural diplomacy project. The budget of NT$15,000,000 was
slightly less than that of the previous year, probably a reflection of the toll
of the worldwide oil crisis on the Taiwan economy. To bolster the ROC's
participation in the Spokane Expo '74, the government would arrange the
NCOT's debut there in early October. Shaw was to represent the NCOT's
subsequent cross-country tour until mid-December.[103]

The 1974 tour mostly followed the recipe from the previous year and
achieved similar effects. But there were also some notable differences.
First, the Nationalist officials sensed more scrutiny from the U.S. govern-
ment about the planning process, which hinted at the shrinking space for
the ROC in the triangular relationship among Washington, Beijing, and
Taipei.[104] The U.S. government had to perform a balancing act between
the two rival Chinese states, both of which craved access not just to offi-
cials but also to public opinion. But the balance was gradually tilting in the
PRC's favor. In bilateral meetings in Beijing and Paris prior to the PRC

table tennis team's U.S. visit in 1972, the PRC officials pressed their U.S. interlocutors on whether the U.S. government would prevent similar visits from the ROC groups. While the U.S. officials remained noncommittal, the PRC made its disapproval of the ROC's continuing cultural diplomacy very clear.[105] The 1973 tour, despite its political intentions, appeared to have received no official attention from the U.S. government. But in early May 1974, the counselor of the U.S. embassy in Taipei stopped by the Ministry of Foreign Affairs and reiterated that the ROC government had agreed in 1972 to negotiate with Washington about the U.S. tours of all government-sponsored troupes. He also asked for a copy of the tour's itinerary, which the Nationalist officials promised to deliver once it was finalized.[106] The U.S. diplomats did not appear to have followed these protocols in 1973. Although the unexpected visit did not interfere with the substantive planning in 1974, it was another reminder to the ROC government of the changing U.S. policy on China.

In anticipating the audiences' diminished curiosity in 1974, the Nationalist officials followed the opinions of a Western critic and secretly studied an earlier PRC troupe's overseas performance in a pirated film. As the NCOT was wrapping up its 1973 tour, Clive Barnes (1927–2008), the influential British-born dance and theater critic for the *New York Times*, wrote a short piece comparing the PRC and ROC Peking Opera troupes abroad.[107] While Barnes praised Taiwan's preservation of Chinese cultural traditions and the NCOT's performance, he was still more fond of the "gorgeous" PRC troupe he had experienced in Europe before the Cultural Revolution. As the PRC troupe visited Western Europe several times before the Cultural Revolution, it is not entirely clear to which tour Barnes was referring. In his opinion, even Taiwan was unable to replicate the lost glory. Barnes's comments motivated Lu Yizheng to hunt for relevant materials on the earlier PRC troupe. While information on the European tour mentioned by Barnes was not immediately available, Lu managed to find in the files of the New York branch of the Government Information Office a secretly pirated film of the PRC troupe's appearance in Canada in 1960. The hidden Nationalist emulation of the PRC cultural diplomacy once again belies its own facile dichotomy between the protector and the wrecker of Chinese cultural traditions.[108]

Lu's analysis of the PRC troupe's performance in Canada further muddled the ROC claim of its dutiful preservation of a timeless tradition. In a note to a Ministry of Defense official in charge of political warfare, Lu conceded the PRC superiority in the choreography of martial scenes in appealing to foreigners. In the meantime, however, Lu also argued that the

filming and costumes were far inferior to Taiwan's *contemporary* standards. In his opinion, the NCOT would do a much better job because the PRC troupe simply "clung to *outdated* [emphasis added] prewar conventions" (*moshou zhanqian chengui*). Contrary to the ROC's public proclamation of its own faithful replication of the genre as it had been two hundred years ago, Lu's celebration of Taiwan's innovation underscored Peking Opera's evolving historicity in order to stay relevant. But Lu did not abandon the discourse of antiquity, either. In the same note, he quickly returned to the time-honored traditions as the yardstick for the supposed authenticity of Peking Opera. The PRC troupe's arbitrary changes of the costumes and face paint of particular characters were thus, in Lu's opinion, symptomatic of the regime's general disrespect for Chinese cultural heritage. Despite such contradictory views in the same note, Lu maintained that Taiwan was still the legitimate guardian of Peking Opera as the essentialized "cultural heritage" (*wenhua yichan*) of China.[109]

The itinerary of the 1974 tour focused on the American South and the Sun Belt as the NCOT passed through major cities such as Atlanta, Miami, New Orleans, Houston, Memphis, Phoenix (Tempe), and smaller communities in several Southern states.[110] Despite discussions in 1973, this was the first time since Mei's U.S. visit in 1930 that a major Peking Opera troupe had actually set foot in the region. Existing records do not show the exact reason for this change. But it is nevertheless reasonable to speculate that the ROC government embraced the South as both an untapped market for the genre and a conservative bastion against the U.S. détente with the PRC.[111] The *Atlanta Constitution*, the major daily newspaper in one of the most populous Southern metropolitan areas, started advance coverage of the NCOT's first Southern tour a month before the scheduled performance.[112] Unlike the majority of news outlets, it did not merely reiterate statements about Peking Opera's artistry and antiquity. It further spelled out in great detail the PRC's alleged destruction of Peking Opera during the Cultural Revolution—claiming in one of the reports that it had been "put to death"—one of the ROC's favorite talking points on the subject, and named Jiang Qing the main culprit. As in 1973, the *Atlanta Daily World*, the major African American newspaper in the region, did not report on the NCOT. Outside the performance venue in Atlanta, some pro-PRC activists reportedly distributed an open letter from the US-China Peoples Friendship Association to the editor of the *Atlanta Constitution* that rebutted the newspaper's characterization of PRC policies on Peking Opera. But the ROC consulate general believed that the publicity campaigns ultimately contributed to decent ticket sales and a well-attended post-show

reception.[113] Even after the end of the 1974 tour, Barry Goldwater (1909–1998), former Republican presidential candidate, Arizona senator, and a staunch supporter of the ROC, still referenced "Chinese opera" in a Senate speech on February 18, 1975. It is unclear from existing records whether Goldwater attended any NCOT performance. Just as the Nationalist government had wanted, he used the genre to defend the legitimacy of "Free China" and to assail the "normalization of U.S. relations with the government of the Communist-occupied mainland."[114] Yet his opinion did not carry the day.

Conceptual Transformations

Despite or because of the shrinking diplomatic space, how the Nationalist government understood the fraught relationship between Taiwan and China in its self-positioning and diplomatic overtures continued to evolve. As the previous chapter indicates, the projection of Chinese antiquities as tourist attractions in territorial Taiwan at the 1964 New York World's Fair signaled Taiwanization of the Nationalist cultural diplomacy. Following the cascading losses in representing China in official diplomacy, the government did not abandon the China frame in its international narrative. But China in such framing was ever more firmly rooted in the increasingly prosperous Taiwan. This was evident in the case of NCOT, but it also applied to the museum objects mentioned in the previous chapter. The new exhibition hall of the National Palace Museum, originally scheduled to be complete in 1964 in order to attract the Japan-bound international spectators of the Olympic Games, finally opened in 1965 in suburban Taipei. The palatial style structure soon featured prominently in the ROC's various paid advertisement supplements in the *New York Times*, which touted Taiwan's resilience and vitality against all political odds.[115] Together with other local tourist attractions, Chinese antiquities became increasingly a supporting actor of Taiwan's economy, instead of a lead one in its international legitimacy.

By the 1970s, journalists and artists outside the government orbit pushed the subtle Taiwanization of Chinese heritage in cultural outreach to new territories. In 1971, a popular English-language monthly photo-magazine, *Echo of Things Chinese* (*Hansheng*), started publication. Among the founders were Wu Meiyun (1943–2016), descendant of a prominent Nationalist official born and raised in the United States, and Huang Yongsong (1943–), a Taiwanese artist.[116] Aiming to bring more capacious understandings of

Chinese culture to the wider world, this dynamic group went far beyond the well-known landscape and tourist attractions already promoted by the government. Moreover, they incorporated the vibrant folk culture in Taiwan, such as religious festivals, arts and crafts, and indigenous peoples.[117] The Nationalist government soon endorsed *Echo* as the in-flight magazine of its flag carrier China Airlines and replicated their eclectic approach to Chinese culture in its own bilingual monthly magazine *Sinorama* (*Guanghua*) starting in 1976.[118] This once again demonstrates the alternative genealogy of the Nationalist government's Taiwanization earlier than the commonly held 1980s from the perspective of high politics.

Amid these developments, *wenhua waijiao* (cultural diplomacy) became a more established neologism in the Nationalist discourse that carried the potential of compensating for the ongoing setbacks in official diplomacy. Such increasing conceptual self-awareness is reflected in the newspaper reporting in the 1970s, when the term suddenly became more frequent.[119] It also appeared in the internal government correspondence. In late 1973, the Planning Commission for the Recovery of the Mainland (*Guangfu dalu sheji yanjiu weiyuanhui*), a high-profile advisory body established in 1954, submitted a report specifically on cultural diplomacy to Chiang Kaishek.[120] One way or the other, these discussions exhorted the government to be more proactive in sponsoring more organized cultural exchange programs such as education, research, sports, and tourism. The striking irony is their apparent oblivion of the waves of Nationalist spectacles to impress Americans with Chinese culture, some of which, such as the NCOT, had just taken place recently at the time of discussion. This underscores once again the evanescent nature of these spectacles, which made few lasting impressions and seldom fed into sustainable future programming.

Conclusion

In early 1974, while the Nationalist government was preparing for the NCOT's return to the United States, a few villagers in northwest China accidentally discovered the First Emperor's terracotta warriors dating back to the third century BCE. Only revealed to the outside world later in the decade, those warriors would become one of the most recognized symbols of ancient China the PRC promoted in the world during the reform era. By the end of the same year, two days before the NCOT ended its second U.S. tour in suburban Los Angeles on December 15, the PRC's blockbuster exhibition of post-1949 archaeological finds, a multiyear world tour

that had begun the year before and already crisscrossed Europe, Japan, Mexico, and Canada, made its U.S. debut at the National Gallery of Art in Washington, DC, and later stopped in Kansas City and San Francisco.[121] At the National Gallery alone, the four hundred or so objects attracted a whopping number of more than 680,000 visitors in a little over three months, the venue's record-breaking show then. This even surpassed the total number of visitors (460,000) to the year-long Chinese Art Treasures touring exhibitions organized by the ROC in the early 1960s.[122] As the PRC's cultural diplomacy overshadowed that of the China Institute and of the ROC and unsettled their relationship as two longstanding institutional actors in the field, 1974 is a fitting end of this long story.

While the PRC would soon dominate the international representation of China, including its antiquities, a hasty dismissal of the hitherto efforts by the China Institute or the ROC on the eve of the PRC's full return to mainstream American society misses the historical contingencies in this period of Chinese cultural diplomacy.[123] Seen from the catalogue, the PRC exhibitions extolled the wisdom of the laboring masses over millennia and the state's scientific excavation.[124] The class framing made an apparent nod to the ongoing Cultural Revolution, but the scientific one even outlived the radical movement, as seen in an introductory article on the terracotta warriors by a Chinese archaeologist in the UNESCO flagship magazine in 1979.[125] It thus did not directly compete with the Institute's nor the ROC's presentation of Chinese cultural traditions.

Moreover, neither the China Institute nor the Nationalist government was a passive bystander as Beijing made inroads in cultural diplomacy. Despite its changing leadership, the Institute exploited the triangular relationship among Washington, Taipei, and Beijing to strengthen its finance and programming. It was able to do so largely because of its longstanding institutional platform. In a decade of diplomatic setbacks and economic strides, the Nationalist government recalibrated its patronage of the Institute and presented Peking Opera as an allegedly almost extinct ancient art that survived and thrived only under its care. Its cultural messaging also continued to redefine China in reference to territorial Taiwan. Such targeted messaging of legitimacy took advantage of a blind spot in the PRC publicity in the United States, which focused on athletic bodies and scientific excavations instead of ancient pedigree. The NCOT's ultimate failure in generating popular support for the ROC underlines the conflicts between a government initiative and the market platform. Taken together, the quest for a credible and robust infrastructure of persuasion in Chinese cultural diplomacy in the United States remained an unfinished task.

Epilogue

Elusive Infrastructure of Persuasion

"Culture includes politics, economy, literature, history, science, philosophy, religion, applied arts, fine arts, and craftsmanship (*zhizao*). How could it be exhausted in one piece of *xuanchuan* on paper or one social event (*chouying*)?"

Zhang Deliu, "On China's 'Cultural Diplomacy' in the Future," 1941

"For many years our *xuanchuan* in the United States only pays attention to the short-term issues, and ignores the long-term work of changing their impressions, which would lead to their changing policies toward us."

Zhou Shukai to Huang Shaogu, October 12, 1966

Broader Significance

As the PRC's accession to the UN started to consolidate China's international representation in the 1970s, the structure of Chinese cultural diplomacy in the United States saw drastic changes. The unstable partnership between two hitherto major institutional actors, namely the China Institute and the Chinese Nationalist government, crumbled amid the rise of the PRC as the new hegemonic spokesperson of China's cultural achievements. Fast forward to today, the PRC's Confucius Institute has become the synonym of Chinese cultural diplomacy among the American public,

or worse still an adversary's pernicious infiltration.[1] It is thus important to understand the history of Chinese cultural diplomacy in the age of fragmented China and articulate, rather than ignore or inflame, the contingent connections between the past and present.

During a time when foreign imperialism and domestic upheavals severely curtailed the Chinese state's capabilities in international projection, concerned Chinese intellectual and political elites saw in cultural diplomacy an avenue to affirm the country's right to self-representation. In response to predominant American views of China as an exotic diversion or racial and ideological threats, they sought to upend China's negative international image and assert their sovereign definition of China's cultural achievements. In this sense, cultural diplomacy is another example of China's restorative nation-building, similar to seemingly unrelated activities such as campaigns against coastal smuggling, in an even more transnational arena.[2] China's political fragmentation necessitated a largely bifurcated operation in the United States between the modest yet ongoing programming of the China Institute and the periodic but fleeting spectacles of the Nationalist government. Neither commanded a stable infrastructure of persuasion to project their messaging: the Institute's platform was underfunded, and the Nationalists bounced from one planning committee to another with little institutional continuity. But together they provided part of the script for the PRC's later efforts in cultural diplomacy in the United States.

As much as Chinese cultural diplomacy in the United States tried to publicize a uniformly positive image of China and shared sentiments of cultural nationalism, its messaging betrayed deep fractures. First, it was a project largely driven by select cultural and political elites that excluded the participation of their lower-class compatriots. The late Qing scholar-officials who took the lead in redefining Chinese culture for international appreciation were exasperated by what they considered indecent representations of China by misinformed foreigners, particularly missionaries, and poor Chinese in China and Chinatowns abroad. The China Institute and the Nationalist government inherited such elitism and continued to promote an idealized cultural China that was often beyond the reach or concerns of struggling Chinese immigrants, ironically most Americans' common entry to things Chinese. The elitist vision seldom had room for vernacular traditions.

It was also a deeply gendered project. Almost all the movers and shakers in Chinese cultural diplomacy were men. But the refined culture these men promoted emphasized sophistication and tranquility, feminine characteris-

tics in preexisting Orientalist imaginations. While there was an occasional painting of an eighth-century imperial steed in the museum exhibition or a martial scene in the Peking opera performance, neither the China Institute nor the Nationalist government highlighted China's military valor.[3] *The Art of War* by Sun Zi (c. 544–496 BCE), the revered ancient Chinese text on military strategy, never appeared in their messaging. Not coincidentally, it was foreigners who dominated its translation, now available in roughly forty foreign languages.[4] Throughout the period this book studies, but particularly when the United States saw the Chinese communists as a real danger to its allies in Asia, promoters of Chinese cultural diplomacy co-opted China's feminine Orientalist image to showcase the country's nonthreatening cultural achievements.

Centered on the country's Han majority, Chinese cultural diplomacy in the United States also obscured the deep-seated ethnic tension along the former imperial frontiers. In the early twentieth century, the virulent anti-Manchu Han nationalism and the collapse of the Qing Empire raised questions about the belonging of the multiethnic former imperial subjects in the new Chinese nation-state. Although the Republican government asserted claims over all the former imperial territories and adopted the platform of ethnic harmony, many ethnic minorities living in the borderland areas pursued de facto independence. It was unlikely that the Han Chinese leaders at the China Institute or the Nationalist government were unaware of such dynamics. But their invocation of Chinese culture emphasized the ideal of a Han-centered national whole and elided enormous ethnic differences.

The aspirations by the proponents of Chinese cultural diplomacy in restoring their prerogatives in the sovereign definition of China continued to confront competing representations of China. As mentioned throughout the book, Imperial Japan between the late nineteenth century and the end of World War II successfully used popular world's fairs in the West to stake its claims in embodying and leading the broader Asian and Eastern culture, of which China was just a subordinate part.[5] Also at these fairs, entrepreneurs of various stripes exploited the exotic appeals of China's various frontiers from Central Asia in the 1930s to Hong Kong in the 1960s. Such China-adjacent Orientalism propelled more consumption of the imageries and objects of purported China as exotic diversion without necessarily raising the country's cultural respectability. The post–World War II professionalization of China studies in American universities fostered a new form of hegemonic expertise. It eclipsed the hitherto public education on China by the China Institute and fundamentally reshaped the intended messaging by the Nationalist government.

Beyond the challenges in content, proponents of Chinese cultural diplomacy never commanded a stable infrastructure of persuasion to project their messages. The China Institute pioneered and maintained a more institutional platform. But its perennial financial woes reduced the continuity of its programming and limited the Institute's national ambition largely to the middle-class audience in the New York metropolitan area and those who could afford to travel for such programming. Even the patronage of Henry Luce was not enough to solve the problem. The Nationalist government, on the other hand, had few institutionalized solutions besides periodically assembled and disbanded committees, a problem the officials were not unaware of. Already in 1941 the official *Zhongyang ribao* published serial commentaries on Chinese cultural diplomacy that specifically warned the danger of different government agencies' "separate workings" (*gebie zuoye*). The author called for their "coordinated leadership" (*zonghe lianxi zhi lingdao*) in order to establish a single agency whose long-term work could rival that of its Western and Japanese counterparts.[6] But Nationalist officials still lamented a similar problem in the United States a quarter century later.[7] In lieu of its own infrastructure of persuasion, the government often had to defer to the Americans who set the ground rules for its preferred platforms, from organizers of fairs and exhibitions to commercial impresarios.

Reflections on the Present

Since the 1970s, the PRC has taken over the mantle as the most active promoter of Chinese language and culture overseas. First founded in 2004, the Confucius Institute formerly under the Ministry of Education's Office of Chinese Language Council International (colloquially known as *Hanban*) has spread around the world and become the PRC's signature cultural diplomacy program. Through mid-2020, the United States still hosted the largest number of such institutes in the world (81 out of 541, most affiliated with colleges and universities) according to the Chinese government's statistics.[8] Even the China Institute, the trailblazing institution in promoting Chinese culture in the United States and long perceived as the unofficial Nationalist propaganda outlet, has been quietly hosting an in-house Confucius Institute since 2006.[9]

The critical scrutiny of the Confucius Institute started around the mid-2010s, following reports of academic freedom violations through censorship of sensitive teaching materials and dismissal of dissident instructors.

This has prompted a wave of closures in not just the United States but also its Western allies.[10] Additional pressures from the U.S. federal government ensued. The Trump administration restricted the Department of Defense funding to higher education institutions hosting the Confucius Institute and declared the headquarters of the Confucius Institutes in the United States a foreign mission of the PRC in 2020. In response, the Chinese government nominally reorganized *Hanban* as a nonprofit Center for Language Education and Cooperation affiliated with the Ministry of Education. But this failed to satisfy the critics of the Confucius Institute. In 2022, the Biden administration further limited federal funding from agencies such as the National Science Foundation to higher education institutions hosting the Confucius Institute in the CHIPS and Science Act.[11] These restrictions caused more closure of not only individual Confucius Institutes but even their U.S. headquarters. As the remaining number of such institutes fell from more than one hundred at its peak to single digits by early 2023, a panel of experts convened by the National Academies of Sciences, Engineering, and Medicine recommended a set of waiver criteria to the Department of Defense for the existing funding ban.[12] But given the still tense relationship between China and the United States, a widespread return of the Confucius Institute is unlikely. In contrast, the Chinese Cultural Center, a low-key institution with similar programming supported by the PRC's Ministry of Culture (and Tourism, since 2018) since 1988, has generated much less attention. Unlike the Confucius Institute's extensive partnerships with foreign universities, the Center operates on its own in only thirty or so locations. Most of them are in Asia and Africa, and none in the United States.[13]

Compared to the institutional actors of Chinese cultural diplomacy in this book, which struggled to build their infrastructure of persuasion, the PRC certainly commands a far stronger and more extensive platform. Yet such control comes with its own problems. Compared to the China Institute and the Nationalist government, the PRC is certainly in a position of more power, but not necessarily more trust. Recent history shows that the U.S. distrust of foreign cultural overtures is by no means just targeting the PRC. In the 1980s, for example, Americans had similar concerns over the political agenda of Japanese philanthropy amid bilateral trade disputes.[14] In the 1990s, support of East Asian studies from Chiang Ching-kuo Foundation and Korea Foundation raised eyebrows in American academia because of their respectively close relations with the governments in Taiwan and South Korea. Both governments had had questionable human right records and only recently embarked on democratization.[15] Those institutions ulti-

mately achieved widespread recognition following their reorganizing in governance to avoid perceptions of foreign government control. The close political connections between the governments in question and the United States certainly also helped. Therefore a tight governmental grip over the Confucius Institute as the infrastructure of persuasion, even if just perceived, appears to have achieved efficiency at the cost of efficacy.

The growing backlash against the Confucius Institute indicates that effective cultural diplomacy is much more complicated than simply the grip of such infrastructure. Beyond the heated polemics, an insightful recent ethnographical study of the Institute reveals the deep misunderstandings between American students and Chinese teachers and officials about mutual expectations.[16] This calls into question the actual impact of the Institute's intended cultural diplomacy despite the alarmist rhetoric. My book underscores that such misunderstandings have deeper historical roots in the unequal intercultural encounters. As the Chinese strove for international recognition, Americans often took for granted the privileged position the United States occupied in such encounters. Ignoring such a history will continue to imperil genuine intercultural exchanges.

As much as the PRC aspires to be the hegemonic representative of Chinese culture on the international stage, the competing projections of Chineseness, a constant challenge for Chinese cultural diplomacy in this book, are not likely to disappear anytime soon. Long after abandoning the mantle to represent the whole China, the government of Taiwan proposed in 2011 during a Nationalist administration to open the Taiwan Academy (*Taiwan shuyuan*) affiliated with its representative offices in New York, Los Angeles, and Houston. The goal was to disseminate Chinese (read *Zhonghua* instead of *Zhongguo* because the latter is often a shorthand for the PRC) culture with characteristics of a democratic and multicultural Taiwan, including traditional scripts in contrast to the PRC's simplified scripts.[17] Among those currently operating, the one in Los Angeles, for example, aims to promote Taiwanese culture and "befriend the world with universal cultural values (*wenhua pushi jiazhi*)." The refrain from any mention of Chinese culture reflects the shifting priorities of the ruling pro-independence Democratic Progressive Party since 2016.[18] Even Falungong, the spiritual movement Beijing bans as a cult since 1999, has developed its own Shenyun performing arts brand to promote Chinese cultural traditions in the United States and elsewhere to the PRC's consternation.[19]

China's quest for admiration and respect is thus ongoing. As the current international order witnesses major shifts following the Covid pandemic and different regional conflicts, the PRC's global image also faces

serious challenges.[20] In a sense, President Xi Jinping's call to "better tell China's stories" (*jiang hao Zhongguo gushi*) and "make China's voice heard" (*chuanbo hao Zhongguo shengyin*), and to present a China that is "credible, appealing, and respectable" (*kexin ke'ai kejing*)—first with senior CCP officials in 2021 and reiterated in the Twentieth Party Congress work report in 2022—acknowledges such challenges.[21] In the meantime, however, the PRC also encourages a more strident assertion of "four matters of confidence" (*sige zixin*)—also reiterated in the 2022 work report—in the path, theory, system, and culture of socialism with Chinese characteristics. Party theoreticians often equate that with "ideological security" (*yishi xingtai anquan*).[22] China's growing wealth and power notwithstanding, credibility, appeal, and respect require *both* self-proclaimed confidence *and* external recognition, or such proclamation risks alienating and antagonizing other countries.[23] As the United States remains a key battleground of competing renditions of Chinese cultural traditions and a coveted target in intercultural exchange in general, how the PRC wields its infrastructure of persuasion efficiently and effectively when mutual political trust is on the wane is no less challenging than what the China Institute or the Nationalist government did. The earlier history of Chinese cultural diplomacy in the United States remains relevant today.

Notes

INTRODUCTION

1. Kiang Kang-hu, "A Chinese Scholar's View of Mrs. Buck's Novels," Pearl S. Buck, "Mrs. Buck Replies to Her Chinese Critic," *New York Times*, January 15, 1933. For more on the challenges to Buck's popular expertise on China, see Mari Yoshihara, *Embracing the East: White Women and American Orientalism* (New York: Oxford University Press, 2003), 149–70.

2. Richard Jean So, *Transpacific Community: The Rise and Fall of a Sino-American Cultural Network* (New York: Columbia University Press, 2016), chap. 2.

3. For more examples, see Da Zheng, *Chiang Yee: The Silent Traveller from the East, a Cultural Biography* (New Brunswick, NJ: Rutgers University Press, 2010), 72; Yong Z. Volz, "China's Image Management Abroad, 1920s-1940s: Origin, Justification, and Institutionalization," in *Soft Power in China: Public Diplomacy through Communication*, ed. Jian Wang (New York: Palgrave Macmillan, 2011), 157–79.

4. Sophia Chen Zen, "Review of *The Good Earth*," *Pacific Affairs* 4, no. 10 (1931): 915.

5. Hua Hsu, *A Floating Chinaman: Fantasy and Failure across the Pacific* (Cambridge, MA: Harvard University Press, 2016).

6. Li Songlin and Liu Wei, "Shixi Kongzi xueyuan wenhua ruanshili zuoyong," *Sixiang jiaoyu yanjiu*, no. 4 (2010): 45.

7. Li Shan, "Jiang Kanghu Beimei chuanbo Zhongguo wenhua shulun," *Shilin*, no. 2 (2011): 127–36.

8. Kang-hu Kiang, *On Chinese Studies* (Shanghai: Commercial Press, 1934), 5. This is a collection of Jiang's past essays on China written during his sojourns in the United States in the 1910s and Canada in the 1930s.

9. Joseph R. Levenson, *Revolution and Cosmopolitanism: The Western Stage and the Chinese Stages* (Berkeley: University of California Press, 1971), 24.

10. Qian Mu, *Bashi yi shuangqin shiyou zayi bekan* (Taipei: Dongda tushu, 1983), 304.

11. Ta-tuan Ch'en, "Investiture of Liu-ch'iu Kings in the Ch'ing Period," in *The Chinese World Order: Traditional China's Foreign Relations*, ed. John K. Fairbank (Cambridge, MA: Harvard University Press, 1968), 135–64.

12. Kathlene Baldanza, *Ming China and Vietnam* (New York: Cambridge University Press, 2016); Ji-Young Lee, *China's Hegemony: Four Hundred Years of East Asian Domination* (New York: Columbia University Press, 2016); Yuanchong Wang, *Remaking the Chinese Empire: Manchu-Korean Relations, 1616–1911* (Ithaca: Cornell University Press, 2018).

13. Suoqiao Qian, *Liberal Cosmopolitan: Lin Yutang and Middling Chinese Modernity* (Leiden: Brill, 2011), chap. 6; Zheng, *Chiang Yee*, chaps. 5–6.

14. Yuan Qing et al., *Liuxuesheng yu Zhongguo wenhua de haiwai chuanbo: yi 20 shiji shangbanqi wei zhongxin de kaocha* (Tianjin: Nankai daxue chubanshe, 2014), 33; Emily T. Metzgar, *The JET Program and the US–Japan Relationship: Goodwill Goldmine* (Lanham, MD: Lexington Books, 2018), 21.

15. Quote from Kiang, *On Chinese Studies*, 6–7. For existing scholarship on relevant foreign institutions, see Wang Yi, *Huangjia Yazhou wenhui bei Zhongguo zhihui yanjiu* (Shanghai: Shanghai shudian chubanshe, 2005); Sun Yimin, *Jindai Shanghai yingwen chuban yu Zhongguo gudian wenxue de kuawenhua chuanbo* (Shanghai: Shanghai guji chubanshe, 2014); Yiyou Wang, "C. T. Loo and the Formation of the Chinese Collection at the Freer Gallery of Art, 1915–1951," in *Collectors, Collections & Collecting the Arts of China: Histories and Challenges*, ed. Jason Steuber and Guolong Lai (Gainesville: University Press of Florida, 2014), 151–82; Shuhua Fan, *The Harvard-Yenching Institute and Cultural Engineering: Remaking the Humanities in China, 1924–1951* (Lanham, MD: Lexington Books, 2014).

16. Akira Iriye, *Cultural Internationalism and World Order* (Baltimore: Johns Hopkins University Press, 1997), chap. 2.

17. Luo Zhitian, "Guojia mubiao de waiqing: jindai minzu fuxing sichao de yige beijing," *Jindaishi yanjiu*, no. 4 (2014): 13–18.

18. Yuan, *Liuxuesheng*, 71–72.

19. Chiou-ling Yeh, *Making an American Festival: Chinese New Year in San Francisco's Chinatown* (Berkeley: University of California Press, 2008), chaps. 1–2.

20. For a similar assessment of other spectacles, see Henry Adams, *The Education of Henry Adams: An Autobiography* (Boston: Houghton Mifflin, 1918), 345; Karen Fiss, *Grand Illusion: The Third Reich, the Paris Exposition, and the Cultural Seduction of France* (Chicago: University of Chicago Press, 2009).

21. Nicholas J. Cull, "Public Diplomacy: Taxonomies and Histories," *Annals of the American Academy of Political and Social Science* 616 (2008): 31, 33.

22. Jessica C. E. Gienow-Hecht and Mark C. Donfried, eds., *Searching for a Cultural Diplomacy* (New York: Berghahn Books, 2010), 11; Joseph S. Nye Jr., "Public Diplomacy and Soft Power," *Annals of the American Academy of Political and Social Science* 616 (2008): 94–109.

23. Maria Repnikova, *Chinese Soft Power* (New York: Cambridge University Press, 2022).

24. Jessamyn R. Abel and Leo Coleman, "Dreams of Infrastructure in Global Asias," *Verge: Studies in Global Asia* 6, no. 2 (2020): xxiii.

25. Lydia He Liu, *Translingual Practice: Literature, National Culture, and Translated Modernity—China, 1900–1937* (Stanford: Stanford University Press, 1995).

26. Zhou Bin, "Qingmo minchu 'guomin waijiao' yici de xingcheng jiqi hanyi shulun," *Anhui shixue*, no. 5 (2008): 22–32.

27. Liu Hailong, *Xuanchuan: guanian, huayu jiqi zhengdanghua* (Beijing: Zhong-guo dabaike quanshu chubanshe, 2013).

28. Philip M. Taylor, *Munitions of the Mind: A History of Propaganda from the Ancient World to the Present Day* (Manchester: Manchester University Press, 2003).

29. Benjamin I. Schwartz, *In Search of Wealth and Power: Yen Fu and the West* (Cambridge, MA: Belknap Press of Harvard University Press, 1964); Stephen R. Halsey, *Quest for Power: European Imperialism and the Making of Chinese Statecraft* (Cambridge, MA: Harvard University Press, 2015); Shellen Wu, *Empires of Coal: Fueling China's Entry into the Modern World Order, 1860–1920* (Stanford: Stanford University Press, 2015); Anne Reinhardt, *Navigating Semi-Colonialism: Shipping, Sovereignty, and Nation-Building in China, 1860–1937* (Cambridge, MA: Harvard University Asia Center, 2018); Fei-Hsien Wang, *Pirates and Publishers: A Social History of Copyright in Modern China* (Princeton: Princeton University Press, 2019).

30. Joseph Esherick and Mary Backus Rankin, eds., *Chinese Local Elites and Patterns of Dominance* (Berkeley: University of California Press, 1990); David Strand, *An Unfinished Republic: Leading by Word and Deed in Modern China* (Berkeley: University of California Press, 2011).

31. Peter Zarrow, *After Empire: The Conceptual Transformation of the Chinese State, 1885–1924* (Stanford: Stanford University Press, 2012); Maggie Clinton, *Revolutionary Nativism: Fascism and Culture in China, 1925–1937* (Durham: Duke University Press, 2017); Brian Tsui, *China's Conservative Revolution: The Quest for a New Order, 1927–1949* (New York: Cambridge University Press, 2018).

32. For representative works, see Lloyd E. Eastman, *The Abortive Revolution: China under Nationalist Rule, 1927–1937* (Cambridge, MA: Harvard University Press, 1974); Lloyd E. Eastman, *Seeds of Destruction: Nationalist China in War and Revolution, 1937–1949* (Stanford: Stanford University Press, 1984); Zwia Lipkin, *Useless to the State: "Social Problems" and Social Engineering in Nationalist Nanjing, 1927–1937* (Cambridge, MA: Harvard University Asia Center, distributed by Harvard University Press, 2006); Xiaoqun Xu, *Trial of Modernity: Judicial Reform in Early Twentieth-Century China, 1901–1937* (Stanford: Stanford University Press, 2008). For the exception, see J. Megan Greene, *The Origins of the Developmental State in Taiwan: Science Policy and the Quest for Modernization* (Cambridge, MA: Harvard University Press, 2008).

33. Meredith Oyen, *The Diplomacy of Migration: Transnational Lives and the Making of U.S.-Chinese Relations in the Cold War* (Ithaca: Cornell University Press, 2015); James Lin, "Martyrs of Development: Taiwanese Agrarian Development and the Republic of Vietnam, 1959–1975," *Cross-Currents: East Asian History and Culture Review* 9, no. 1 (2020): 67–106; Chien-Wen Kung, *Diasporic Cold Warriors: Nationalist China, Anticommunism, and the Philippine Chinese, 1930s–1970s* (Ithaca: Cornell University Press, 2022).

34. Alexander C. Cook, ed., *Mao's Little Red Book: A Global History* (New York: Cambridge University Press, 2014); Julia Lovell, *Maoism: A Global History* (New York: Knopf, 2019).

35. William Glenn Gray, *Germany's Cold War: The Global Campaign to Isolate East Germany, 1949–1969* (Chapel Hill: University of North Carolina Press, 2003);

Gábor Sebő, "Different Cinematic Interpretations of Ch'unhyangjŏn: The Same Korean Identity," *European Journal of Korean Studies* 21, no. 1 (2021): 155–88.

36. Philip M. Taylor, *The Projection of Britain: British Overseas Publicity and Propaganda, 1919–1939* (New York: Cambridge University Press, 1981); Michael David-Fox, *Showcasing the Great Experiment: Cultural Diplomacy and Western Visitors to the Soviet Union, 1921–1941* (New York: Oxford University Press, 2012); Stephen G. Gross, *Export Empire: German Soft Power in Southeastern Europe, 1890–1945* (New York: Cambridge University Press, 2015); Jessamyn R. Abel, *The International Minimum: Creativity and Contradiction in Japan's Global Engagement, 1933–1964* (Honolulu: University of Hawai'i Press, 2015).

37. For the French case, see Herman Lebovics, *Mona Lisa's Escort: André Malraux and the Reinvention of French Culture* (Ithaca: Cornell University Press, 1999), chap. 2.

38. Sarah Van Beurden, *Authentically African: Arts and the Transnational Politics of Congolese Culture* (Athens: Ohio University Press, 2015); Andrew Bellisari, "The Art of Decolonization: The Battle for Algeria's French Art, 1962–70," *Journal of Contemporary History* 52, no. 3 (2017): 625–45; Cynthia Scott, *Cultural Diplomacy and the Heritage of Empire: Negotiating Post-Colonial Returns* (New York: Routledge, 2020).

39. Frederick Deknatel, "Reconstruction, Who Decides," in *Cultural Heritage and Mass Atrocities*, ed. James Cuno and Thomas G. Weiss (Los Angeles: Getty Publications, 2022), 220–37.

40. Dwayne R. Winseck and Robert M. Pike, *Communication and Empire: Media, Markets, and Globalization, 1860–1930* (Durham: Duke University Press, 2007), 2; Rita Zajácz, *Reluctant Power: Networks, Corporations, and the Struggle for Global Governance in the Early 20th Century* (Cambridge, MA: MIT Press, 2019), 2.

41. Sarah Nelson, "A Dream Deferred: UNESCO, American Expertise, and the Eclipse of Radical News Development in the Early Satellite Age," *Radical History Review*, no. 141 (2021): 30–59.

42. Frank A. Ninkovich, *The Diplomacy of Ideas: U.S. Foreign Policy and Cultural Relations, 1938–1950* (New York: Cambridge University Press, 1981); Nicholas J. Cull, *The Cold War and the United States Information Agency: American Propaganda and Public Diplomacy, 1945–1989* (New York: Cambridge University Press, 2008); Justin Hart, *Empire of Ideas: The Origins of Public Diplomacy and the Transformation of U.S. Foreign Policy* (New York: Oxford University Press, 2013); Jason C. Parker, *Hearts, Minds, Voices: US Cold War Public Diplomacy and the Formation of the Third World* (New York: Oxford University Press, 2016); Sam Lebovic, *A Righteous Smokescreen: Postwar America and the Politics of Cultural Globalization* (Chicago: University of Chicago Press, 2022).

43. Antoinette Burton, *The Postcolonial Careers of Santha Rama Rau* (Durham: Duke University Press, 2007); Dorothée Bouquet, "French Academic Propaganda in the United States, 1930–1939," in *Teaching America to the World and the World to America: Education and Foreign Relations since 1870*, ed. Richard Garlitz and Lisa Jarvinen (New York: Palgrave Macmillan, 2012), 155–72; Neal M. Rosendorf, *Franco Sells Spain to America: Hollywood, Tourism and Public Relations as Postwar Spanish Soft Power* (New York: Palgrave Macmillan, 2014); Nancy Lin, "5,000 Years of Korean Art: Exhibitions Abroad as Cultural Diplomacy," *Journal of the History of*

Collections 28, no. 3 (2016): 383–400; Rüstem Ertuğ Altınay, "'Carrying Our Country to the World': Cold War Diplomatic Tourism and the Gendered Performance of Turkish National Identity in the United States," *Radical History Review*, no. 129 (2017): 103–24; Shaul Mitelpunkt, *Israel in the American Mind: The Cultural Politics of US-Israeli Relations, 1958–1988* (New York: Cambridge University Press, 2018).

44. Edward W. Said, *Orientalism* (New York: Vintage Books, 1979).

45. Yoshihara, *Embracing the East*; Christina Klein, *Cold War Orientalism: Asia in the Middlebrow Imagination, 1945–1961* (Berkeley: University of California Press, 2003).

46. Arif Dirlik, "Chinese History and the Question of Orientalism," *History and Theory* 35, no. 4 (1996): 96–118; T. Christopher Jespersen, *American Images of China, 1931–1949* (Stanford: Stanford University Press, 1996); Gordon H. Chang, *Fateful Ties: A History of America's Preoccupation with China* (Cambridge, MA: Harvard University Press, 2015). For exceptions, see Guoqi Xu, *Chinese and Americans: A Shared History* (Cambridge, MA: Harvard University Press, 2014); Yunxiang Gao, *Arise Africa! Roar China! Black and Chinese Citizens of the World in the Twentieth Century* (Chapel Hill: University of North Carolina Press, 2021).

CHAPTER 1

1. Weili Ye, *Seeking Modernity in China's Name: Chinese Students in the United States, 1900–1927* (Stanford: Stanford University Press, 2001), chap. 1.

2. Zhou Bin, *Yulun, yundong yu waijiao: 20 shiji 20 niandai minjian waijiao yanjiu* (Beijing: Xueyuan chubanshe, 2010).

3. Nicolas Tackett, *The Origins of the Chinese Nation: Song China and the Forging of an East Asian World Order* (New York: Cambridge University Press, 2017).

4. David M. Robinson, *Martial Spectacles of the Ming Court* (Cambridge, MA: Harvard University Asia Center, 2013); Wang, *Remaking the Chinese Empire*, chap. 2.

5. Mary Clabaugh Wright, *The Last Stand of Chinese Conservatism: The T'ung-Chih Restoration, 1862–1874* (Stanford: Stanford University Press, 1957); Albert Feuerwerker, *China's Early Industrialization: Sheng Hsuan-Huai (1844–1916) and Mandarin Enterprise* (Cambridge, MA: Harvard University Press, 1958); Samuel C. Chu and Kwang-Ching Liu, *Li Hung-Chang and China's Early Modernization* (Armonk, NY: M. E. Sharpe, 1994).

6. Li Chen, *Chinese Law in Imperial Eyes: Sovereignty, Justice, and Transcultural Politics* (New York: Columbia University Press, 2015), chap. 4.

7. Arthur H. Smith, *Chinese Characteristics*, rev. ed. (New York: Revell, 1894).

8. Paul A. Cohen, *China and Christianity: The Missionary Movement and the Growth of Chinese Antiforeignism, 1860–1870* (Cambridge, MA: Harvard University Press, 1963).

9. Paul A. Cohen, *Between Tradition and Modernity: Wang T'ao and Reform in Late Ch'ing China* (Cambridge, MA: Harvard University Press, 1974), 57–61.

10. Jenny Huangfu Day, *Qing Travelers to the Far West: Diplomacy and the Information Order in Late Imperial China* (New York: Cambridge University Press, 2018), 37–45, 105–9.

11. Yin Dexiang, *Donghai xihai zhijian: wanqing shixi riji zhong de wenhua guan-*

cha, renzheng yu xuanze (Beijing: Beijing daxue chubanshe, 2009), 217; Day, *Qing Travelers*, 200–208.

12. Zeng Jize, *Chushi Ying Fa E guo riji* (Changsha: Yuelu shushe, 1985), 211; Yin, *Donghai xihai zhijian*, 235–36.

13. Ke Ren, "Chen Jitong, Les Parisiens Peints Par Un Chinois, and the Literary Self-Fashioning of a Chinese Boulevardier in Fin-de-Siècle Paris," *L'Esprit Créateur* 56, no. 3 (2016): 90–103; Ke Ren, "The Conférencier in the Purple Robe: Chen Jitong and Qing Cultural Diplomacy in Late Nineteenth-Century Paris," *Journal of Modern Chinese History* 12, no. 1 (2018): 1–21.

14. Ki-tong Tcheng, *The Chinese Painted by Themselves*, trans. James Millington (London: Field & Tuer, 1885), 1, 2, 5, 185.

15. Yu Yingshi, *Youji fengchui shuishang lin: Qian Mu yu xiandai Zhongguo xueshu* (Taipei: Sanmin shuju), 199–242.

16. Laurence A. Schneider, "National Essence and the New Intelligentsia," in *The Limits of Change: Essays on Conservative Alternatives in Republican China*, ed. Charlotte Furth (Cambridge, MA: Harvard University Press, 1976), 60; Martin Bernal, "Liu Shih-p'ei and National Essence," in *The Limits of Change: Essays on Conservative Alternatives in Republican China*, ed. Charlotte Furth (Cambridge, MA: Harvard University Press, 1976), 101–3.

17. Wang Rongzu, "Zhang Taiyan dui xiandaixing de yingju yu wenhua duoyuan sixiang de biaoshu," *Zhongyang yanjiuyuan jindaishi yanjiusuo jikan*, no. 41 (2003): 145–80.

18. Shi-chao Chang, "Missionaries in China," *Spectator*, August 13, 1910; Arthur H. Smith, "Missionaries in China," *Spectator*, August 20, 1910; Alex Walker and Herbert J. Allen, "Missionaries in China," *Spectator*, August 27, 1910; Shi-chao Chang, "Missionaries in China," *Spectator*, September 10, 1910; Clement F. R. Allen, "A Royal Heretic," *Spectator*, September 24, 1910; Herbert J. Allen, "Missionaries in China," *Spectator*, September 24, 1910. Arthur Smith's widely circulated book triggered a more sympathetic reading from Lu Xun, the future icon in modern Chinese literature. See Liu, *Translingual Practice*, chap. 1.

19. Ye Bin, "Yibai duo nian qian guanyu 'Zhongguoren qizhi' de yichang bianlun" [A debate on *Chinese Characteristics* one hundred years ago], *Wenhui bao*, June 19, 2015.

20. Tingfang Wu, *America through the Spectacles of an Oriental Diplomat* (New York: Frederick A. Stokes, 1914), 181.

21. Guy Alitto, *The Last Confucian: Liang Shu-Ming and the Chinese Dilemma of Modernity* (Berkeley: University of California Press, 1979), 116.

22. Geng Yunzhi, "Wusi yihou Liang Qichao guanyu Zhongguo wenhua jianshe de sikao: yi chongxin jiedu Ouyou xinying lu wei zhongxin," *Guangdong shehui kexue*, no. 1 (2004): 115.

23. Chunmei Du, *Gu Hongming's Eccentric Chinese Odyssey* (Philadelphia: University of Pennsylvania Press, 2019), 2–9.

24. Ku Hung-ming, *The Spirit of the Chinese People* (Peking: Peking Daily News, 1915).

25. Du, *Gu Hongming's Eccentric Chinese Odyssey*, chap. 1.

26. Tse-tsung Chow, *The May Fourth Movement: Intellectual Revolution in Modern China* (Cambridge, MA: Harvard University Press, 1960), 317–20.

27. Chen Yi'ai, "Zhengli guogu yundong de xingqi, fazhan yu liuyan" (PhD diss., National Chengchi University, 2002).

28. Li Xiaoqian, *Yuwai hanxue yu Zhongguo xiandai shixue* (Shanghai: Shanghai guji chubanshe, 2014), 1.

29. Iriye, *Cultural Internationalism and World Order*, chap. 2.

30. Sang Bing, *Guoxue yu hanxue* (Hangzhou: Zhejiang renmin chubanshe, 1999), 5; Li, *Yuwai hanxue*, 43–49.

31. Sang, *Guoxue yu hanxue*, 38.

32. Chen Yi'ai, *Zhongguo xiandai xueshu yanjiu jigou de xingqi: yi Beijing daxue yanjiusuo guoxuemen wei zhongxin de tantao, 1922–1927* (Tapei: Guoli zhengzhi daxue lishi xuexi, 1999).

33. Isabelle E. Williams to Henry R. Luce, April 10, 1957, folder 6, box 29, Henry R. Luce Papers, Library of Congress (hereafter HRL); Austin Seckersen, *The History of the China Society* (London: China Society, 1984); Chen Huaiyu, *Qinghua yu "Yizhan": Meiji jiaoshou de Zhongguo jingyan* (Hangzhou: Zhejiang guji chubanshe, 2021), 119–30.

34. Hongshan Li, *U.S.-China Educational Exchange: State, Society, and Intercultural Relations, 1905–1950* (New Brunswick, NJ: Rutgers University Press, 2008), chap. 3.

35. Yang Cuihua, *Zhongjihui dui kexue de zanzhu* (Taipei: Zhongyang yanjiuyuan jindaishi yanjiusuo, 1991), 2–18. For a more recent study on the Foundation, see Chengji Xing, "Pacific Crossings: The China Foundation and the Negotiated Translation of American Science to China, 1913–1949" (PhD diss., Columbia University, 2023).

36. Zhou Hongyu and Chen Jingrong, "Meng Lu zaihua huodong nianbiao," *Huadong shifan daxue xuebao* (jiaoyu kexue ban) 21, no. 3 (2003): 44–52.

37. Mao Rong, *Zhiping zhishan, hongsheng dongnan: Dongnan daxue xiaozhang Guo Bingwen* (Jinan: Shandong jiaoyu chubanshe, 2004), 238–62, 274–75.

38. P. W. Kuo, "Address Given before the Board of Trustees of the China Institute at Luncheon Given in His Honor," June 21, 1943, folder 6, box 27, HRL.

39. W. Reginald Wheeler, "Report of the Assistant Director: Fund Raising Plans for 1949–1950," folder 5, box 28, HRL.

40. Chih Meng, *Chinese American Understanding: A Sixty-Year Search* (New York: China Institute in America, 1981), 141–42; Andrew Charles Parmet, "Chih Meng and the China Institute in America: Pioneering Two-Way Chinese-American Cultural Exchange, 1926–1949" (Undergraduate honors thesis, Harvard University, 1993), 57–58; Yong Ho, "China Institute and Columbia University" (Columbia's China Connections Conference, Columbia University, 2004). More recent studies still mention Dewey but not Hu. See Ma Liangyu, "Hua Mei xiejinshe yu Zhong Mei wenhua jiaoliu yanjiu, 1926–1949" (PhD diss., Nankai University, 2016), 35–37; Li Gaofeng, *Hua Mei xiejinshe shi* (Chengdu: Xinan shifan daxue chubanshe, 2020), 28–30.

41. Jessica Ching-Sze Wang, *John Dewey in China: To Teach and to Learn* (Albany: State University of New York Press, 2007).

42. Cao Boyan and Ji Weilong, *Hu Shi nianpu* (Hefei: Anhui jiaoyu chubanshe, 1986), 315–26, 332; Yang, *Zhongjihui*, 34.

43. For more recent studies on Guo, see Ryan M. Allen and Ji Liu, eds., *Kuo Ping Wen: Scholar, Reformer, Statesman* (San Francisco: Long River, 2016).

44. Jiangxi sheng zhengxie Zhangshu shi zhengxie wenshi ziliao yanjiu weiyuanhui, "Yang Xingfo," *Jiangxi wenshi ziliao*, no. 38 (1991): 52–54.

45. Feng Xiaocai, "Counterfeiting Legitimacy: Reflections on the Usurpation of Popular Politics and the 'Political Culture' of China, 1912–1949," *Frontiers of History in China* 8, no. 2 (2013): 202–22.

46. Roger S. Greene, "Call on Dr. P. W. Kuo on the China Institute office," December 9, 1926, folder 848, Series CMB, Record Group (hereafter RG) 4, collection: Rockefeller Family China Medical Board Collection, Rockefeller Archives Center (hereafter RAC).

47. Seymour C. Y. Cheng to Roger S. Greene, April 7, 1927, Charles L. Wu to Roger Greene, April 9, 1927, Arthur K. Sun to Roger S. Greene, April 12, 1927, P. W. Kuo to Seymour C. Y. Cheng, April 16, 1927, folder 848, Series CMB, RG 4, collection: Rockefeller Family China Medical Board, RAC.

48. Weili Ye argues that Chinese students in the United States had become much less politically active by the 1920s, but her major focus is on the earlier decades. See Ye, *Seeking Modernity in China's Name*, 40–42.

49. Yang, *Zhongjihui*, 19–21; Roger S. Greene, "Dr. P. W. Kuo," April 12, 1927, "Dr. Sao-ke Alfred Sze," April 13, 1927, folder 848, Series CMB, RG 4, collection: Rockefeller Family China Medical Board, RAC.

50. "Dr. Sao-ke Alfred Sze," April 13, 1927.

51. Li Enhan, *Beifa qianhou de "geming waijiao," 1925–1931* (Taipei: Zhongyang yanjiuyuan jindaishi yanjiusuo, 1993).

52. Yang, *Zhongjihui*, 19–31.

53. Yang, *Zhongjihui*, 98–101.

54. Meng, *Chinese American Understanding*, 142–47.

55. Meng, pts. 1–3.

56. Wheeler, "Report of the Assistant Director," folder 5, box 28, HRL.

57. Erez Manela, *The Wilsonian Moment: Self-Determination and the International Origins of Anticolonial Nationalism* (New York: Oxford University Press, 2007), chap. 5.

58. Delia Davin, "Imperialism and the Diffusion of Liberal Thought: British Influences on Chinese Education," in *China's Education and the Industrialized World*, ed. Ruth Hayhoe and Marianne Bastid (Armonk, NY: M. E. Sharpe, 1987), 46–47; National Tsing Hua University Research Fellowship Fund and China Institute in America, *A Survey of Chinese Students in American Universities and Colleges in the Past One Hundred Years: A Preliminary Report* (New York: China Institute in America, 1954).

59. Volz, "China's Image Management Abroad," 157.

60. "China Institute in America," n.d. (c. 1926), folder 848, Series CMB, RG 4, collection: Rockefeller Family China Medical Board, RAC.

61. Edward J. M. Rhoads, *Stepping Forth into the World: The Chinese Educational Mission to the United States, 1872–81* (Hong Kong: Hong Kong University Press, 2011).

62. Li, *Hua Mei xiejinshe shi*, 148–49.

63. Meng, *Chinese American Understanding*, 169; Madeline Y. Hsu, *The Good*

Immigrants: How the Yellow Peril Became the Model Minority (Princeton: Princeton University Press, 2015), chap. 3.

64. Yang Weiming, "Zhonghua jiaoyu gaijinshe yu Oumei jiaoyu xueshu," *Jiaoyu pinglun*, no. 6 (2009): 132–135; Bernard W. Bell, "W.E.B. Du Bois' Search for Democracy in China: The Double Consciousness of a Black Radical Democrat," *Phylon* 51, no. 1 (2014): 121–23; Gao, *Arise Africa! Roar China!*, 23.

65. "China Institute in America," n.d. (c. 1926).

66. Robert W. Rydell, *All the World's a Fair: Visions of Empire at American International Expositions, 1876–1916* (Chicago: University of Chicago Press, 1984).

67. "China Institute Founded with Second Boxer Fund," *New York Times*, December 19, 1926; Zhou Fangmei, "1926 nian Feicheng shijie bolanhui Zhonghua minguo he Riben yipin zhi zhanshi," unpublished manuscript, no pagination; Li, *Hua Mei xiejinshe shi*, 142–48.

68. For earlier studies in English, see Nancy Guy, *Peking Opera and Politics in Taiwan* (Urbana: University of Illinois Press, 2005), 41–52; Joshua Goldstein, *Drama Kings: Players and Publics in the Re-Creation of Peking Opera, 1870–1937* (Berkeley: University of California Press, 2007), 264–80; Catherine Yeh, "China, a Man in the Guise of an Upright Female: Photography, the Art of the Hands, and Mei Lanfang's 1930 Visit to the United States," in *History in Images: Pictures and Public Space in Modern China*, ed. Christian Henriot and Wen-hsin Yeh (Berkeley: Institute of East Asian Studies, University of California, 2012), 81–110. For recent studies in Chinese, see Li Qingben and Li Tongwei, "Tan Hua Mei xiejinshe zai Mei Lanfang fang Mei yanchu zhong de zuoyong," *Xiju*, no. 5 (2018): 112–22; Chen Qian, "Hua Mei xiejinshe yu Zhongguo xiqu de kua wenhua chuanbo: zailun Mei Lanfang fang Mei zhi shimo," *Zhongguo wenhua yanjiu*, no. 2 (2021): 171–80.

69. Ernest K. Moy, ed., *The Pacific Coast Tour of Mei Lan-Fang: Under the Management of the Pacific Chinese Dramatic Club, San Francisco, California* (n.p., n.d.).

70. Qi Rushan, *Mei Lanfang you Mei ji* (Beiping: n.p., 1933); Ye, *Seeking Modernity in China's Name*, 208–10.

71. Meng, *Chinese American Understanding*, 150–54.

72. Nancy Guy, "Brokering Glory for the Chinese Nation: Peking Opera's 1930 American Tour," *Comparative Drama* 35, no. 3/4 (2001): 386; Goldstein, *Drama Kings*, 270.

73. Yunxiang Gao, "Soo Yong (1903–1984): Hollywood Celebrity and Cultural Interpreter," *Journal of American-East Asian Relations* 17, no. 4 (2010): 372–99.

74. Ernest K. Moy, ed., *The First American Tour of Mei Lan-Fang* (New York: China Institute in America, 1930).

75. Liu Lu, "Mei Lanfang yu Sitannisilafusiji fang Mei bijiao yanjiu," *Xiju yishu*, no. 5 (2012): 30–35.

76. Ernest K. Moy, ed., *Mei Lan-Fang: What New York Thinks of Him* (n.p., n.d.), 25, 28.

77. Hu Shih, "Mei Lan-Fang and the Chinese Drama," in *The First American Tour of Mei Lan-Fang*, ed. Ernest K. Moy (New York: China Institute in America, 1930), no pagination.

78. Charlotte Brooks, "#24: On Broadway," *Asian American History in NYC* (blog), 2016.

79. H. H., "Chinese Music Presented," *New York Times*, February 23, 1932; Meng, *Chinese American Understanding*, 154–56.

80. Recent Chinese scholarship needs to be more vigilant in this regard. See Chen, "Hua Mei xiejinshe," 175.

81. Meng, *Chinese American Understanding*, 247.

82. Chen Qian, "'Jingpai' wenxue huodong zai Meiguo de yanzhan: yi Hua Mei xiejinshe wei niudai," *Hebei shifan daxue xuebao* (zhexue shehui kexue ban) 44, no. 3 (2021): 92–98.

83. Timothy Tingfang Lew, *China in American School Text-Books: A Problem of Education in International Understanding and Worldwide Brotherhood* (Peking: Chinese Social and Political Science Association, 1923).

84. Meng, *Chinese American Understanding*, 157–59.

85. China Institute in America, *Theses and Dissertations by Chinese Students in America*, Bulletin 4 (New York, c. 1927); China Institute in America, *One Hundred Selected Books on China*, Bulletin 5 (New York, c. 1927); China Institute in America, *One Hundred Selected Books on China: Revised List*, Bulletin 6 (New York, c. 1928); China Institute in America, *Theses and Dissertations by Chinese Students in America: Supplementary List*, Bulletin 7 (New York, c. 1928); China Institute in America, *Theses and Dissertations by Chinese Students in America* (New York, 1934); Lai-han Loo, *China's Changing Civilization: A Selected Bibliography of Books in the English Language*, 3rd ed. (New York: China Institute in America, 1935); Virginia Irwin, *China in Some New York Secondary Schools* (New York: China Institute in America, 1936); Mousheng Lin, *A Guide to Chinese Learned Societies and Research Institutes* (New York: Chinese Institute in America, 1936); Mousheng Lin, *A Guide to Leading Chinese Periodicals* (New York: China Institute in America, 1936); Mousheng Lin, *Theses and Dissertations by Chinese Students in America, 1931–1936* (New York: China Institute in America, 1936); China Institute in America, "China: A Brief List of Introductory Readings Selected for Those Who Desire to Comprehend China's History and Culture, and Her Present Political, Economic and Social Re-Adjustments," 1939.

86. Robert A. Bickers, *Out of China: How the Chinese Ended the Era of Western Domination* (London: Allen Lane, 2017), 152–53.

87. Kang-hu Kiang, *Chinese Civilization: An Introduction to Sinology* (Shanghai: Chung Hwa, 1935), iii–iv.

88. L. C. Goodrich and H. C. Fenn, *A Syllabus of the History of Chinese Civilization and Culture* (New York: China Society of America, 1929); L. C. Goodrich and H. C. Fenn, *A Syllabus of the History of Chinese Civilization and Culture*, 2nd ed. (New York: China Society of America, 1934); L. C. Goodrich and H. C. Fenn, *A Syllabus of the History of Chinese Civilization and Culture*, 3rd ed. (New York: China Society of America, 1941).

89. Loo, *China's Changing Civilization*, 5.

90. Edgar Snow, ed., *Living China: Modern Chinese Short Stories* (London: George G. Harrap, 1936); Harold Acton and Shih-hsiang Chen, trans., *Modern Chinese Poetry* (London: Duckworth, 1936); China Institute in America, "China."

91. Mousheng Lin, "Recent Intellectual Movements in China," *China Institute Bulletin* 3, no. 1 (1938): 3–19.

92. Michael Denning, *The Cultural Front: The Laboring of American Culture in the Twentieth Century* (New York: Verso, 1996).

93. Harold R. Isaacs, *Scratches on Our Minds: American Images of China and India* (New York: John Day, 1958), 155–58.

94. Goldstein, *Drama Kings*, 279.

95. China Institute in America, *Some Pertinent Comments on the Manchurian Situation* (New York, 1931); China Institute in America, *The Manchurian Situation: Outline of Points to Be Considered* (New York, 1931); China Institute in America, *The Manchurian Crisis and World Peace* (New York, 1931); Ching-Chun Wang, *Extraterritoriality in China* (New York: China Institute in America, 1931); Chih Meng, *China Speaks on the Conflict between China and Japan* (New York: Macmillan, 1932); Mousheng Lin, *International Law and the Undeclared War* (New York: China Institute in America, 1937); Mousheng Lin, *Documents Concerning the Sino-Japanese Conflict* (New York: Trans-Pacific News Service, 1938); Mousheng Lin, *Facts and Figures Concerning the Far Eastern Situation* (New York: China Institute in America, 1940).

96. Meng, *China Speaks on the Conflict between China and Japan*; Kiyoshi Karl Kawakami, *Japan Speaks on the Sino-Japanese Crisis* (New York: Macmillan, 1932); Li Shan, "Jiuyiba shibian hou Zhongguo zhishijie dui Riben zhanzheng xuanchuan de fanji: yi yingwen zhuanshu wei zhongxin," *Kangri zhanzheng yanjiu*, no. 4 (2012): 65–66, 72–74; Michael E. Chapman, "Fidgeting Over Foreign Policy: Henry L. Stimson and the Shenyang Incident, 1931," *Diplomatic History* 37, no. 4 (2013): 727–48.

97. Xia Jinlin, "Haiwai xuanchuan gongzuo: 'wo wudu canjia waijiao gongzuo de huigu' fulu," *Zhuanji wenxue* 29, no. 6 (1976): 57–58; Shuge Wei, *News under Fire: China's Propaganda against Japan in the English-Language Press, 1928–1941* (Hong Kong: Hong Kong University Press, 2017), 198.

98. L. C. Goodrich, "Chinese Studies in the United States," *Chinese Social and Political Science Review* 15, no. 1 (1931): 75.

99. Kiang, *On Chinese Studies*, 7; Earl H. Pritchard, "The Foundations of the Association for Asian Studies, 1928–48," *Journal of Asian Studies* 22, no. 4 (1963): 518; Tsuen-hsuin Tsien, *Collected Writings on Chinese Culture* (Hong Kong: Chinese University Press, 2011), 195–99.

100. Pritchard, "The Foundations of the Association for Asian Studies," 518–22; Matthew D. Linton, "Any Enlightened Government: Mortimer Graves' Plan for a National Center for Far Eastern Studies, 1935–1946," *Journal of American-East Asian Relations* 24, no. 1 (2017): 7–26.

CHAPTER 2

1. Bouquet, "French Academic Propaganda."

2. Karen J. Leong, *The China Mystique: Pearl S. Buck, Anna May Wong, Mayling Soong, and the Transformation of American Orientalism* (Berkeley: University of California Press, 2005), 64–65, 75–76.

3. Timothy Mitchell, "Orientalism and the Exhibitionary Order," in *Colonialism and Culture*, ed. Nicholas B. Dirks (Ann Arbor: University of Michigan Press, 1992), 289–318.

4. Ma Jianbiao and Lin Xi, "Jindai waijiao de 'tongxin biange': qingmo minchu guoji xuanchuan zhengce xingcheng zhi kaocha," *Fudan xuebao* (shehui kexue ban), no. 5 (2013): 30–38.

5. Tsien, *Collected Writings on Chinese Culture*, 205–18.

6. Xu, *Chinese and Americans*, 105–35; Wm. Theodore de Bary, "East Asian Studies at Columbia: The Early Years," *Columbia Magazine* (Spring 2002).

7. Qiao Zhaohong, *Bainian yanyi: Zhongguo bolanhui shiye de shanbian* (Shanghai: Shanghai renmin chubanshe, 2009), 74–75, 85–96, 101–6, 465–70.

8. Wang Zhenghua, "Chengxian 'Zhongguo': wanqing canyu 1904 nian Meiguo Shengluyisi wanguo bolanhui zhi yanjiu," in *Hua zhong you hua: Jindai Zhongguo de shijue biaoshu yu wenhua goutu*, ed. Huang Kewu (Taipei: Zhongyang yanjiuyuan jindaishi yanjiusuo, 2003), 421–75.

9. Angus Lockyer, "Japan at the Exhibition, 1867–1877: From Representation to Practice," in *Japanese Civilization in the Modern World XVII: Collection and Representation*, ed. Tadao Umesao, Angus Lockyer, and Kenji Yoshida, vol. XVII (Osaka: National Museum of Ethnology, 2001), 67–76.

10. Carol Ann Christ, "'The Sole Guardians of the Art Inheritance of Asia': Japan at the 1904 St. Louis World's Fair," *Positions: East Asia Cultures Critique* 8, no. 3 (2000): 675–709; Miya Elise Mizuta Lippit, *Aesthetic Life: Beauty and Art in Modern Japan* (Cambridge, MA: Harvard University Asia Center, 2019), chap. 2.

11. Susan R. Fernsebner, "Material Modernities: China's Participation in World's Fairs and Expositions, 1876–1955" (PhD diss., University of California San Diego, 2002), 145–95; Hong Zhenqiang, *Minzu zhuyi yu jindai Zhongguo bolanhui shiye (1851–1937)* (Beijing: Shehui kexue wenxian chubanshe, 2017), chap. 4.

12. Zhou Fangmei, "Yijiuyiwu nian Zhonghua minguo he Riben canzhan Banama Taipingyang wanguo bolanhui meishugong zhi chutan," in *Shibian, xingxiang, liufeng: Zhongguo jindai huihua 1796–1949 guoji xueshu yantaohui lunwenji*, ed. Yang Dunyao (Taipei: Caituan faren hongxi yishu wenjiao jijinhui, 2008), 597–624.

13. Cao Bihong, "Minguo shiqi Zhongguo canjia shijie bolanhui jilüe," *Zhongguo dang'an*, no. 5 (2010): 28.

14. Zhou, "1926 nian Feicheng shijie bolanhui."

15. Ge Fuping, *Zhong Fa jiaoyu hezuo shiye yanjiu, 1912–1949* (Shanghai: Shanghai shudian chubanshe, 2011), 217–69.

16. Wei, *News under Fire*, chaps. 3, 5.

17. Corinne A. Pernet, "Twists, Turns, and Dead Alleys: The League of Nations and Intellectual Cooperation in Times of War," *Journal of Modern European History* 12, no. 3 (2014): 342–58.

18. Tang Qihua, *Beijing zhengfu yu Guoji lianmeng (1919–1928)* (Tapei: Dongda tushu, 1998), 344; Zhang Li, *Guoji hezuo zai Zhongguo: Guoji lianmeng juese de kaocha, 1919–1946* (Taipei: Zhongyang yanjiuyuan jindaishi yanjiusuo, 1999), 31–64.

19. "Wu Zhihui ren shijie wenhua hezuohui weiyuan" [Wu Zhihui to join the International Committee on Intellectual Cooperation], *Zhongyang ribao*, May 15, 1930; "Li Shizeng tan fu Ou jingguo, jieqia shijie wenhua hezuo shiye" [Li Shizeng talks about his European tour, discusses international intellectual cooperation], *Zhongyang ribao*, April 6, 1933; Chen Hexian, *Shijie wenhua hezuo: canjia Guolian shijie wenhua hezuo hui di shisi ci huiyi zhi jingguo* (Shanghai: Shijie bianyiguan, 1933), 46–49; Lin, *A Guide to Chinese Learned Societies and Research Institutes*, 10; Ye Jun, *Yi wenhua boyi: Zhongguo xiandai liu Ou xueren yu xixue dongjian* (Beijing: Beijing daxue chubanshe, 2009), 194–98. For a very recent study, see Kaiyi Li and Huimei Zhou, "The International Committee on Intellectual Cooperation and Chinese Cultural

Diplomacy during the Interwar Period," *International History Review* (online first, September 22, 2023), https://doi.org/10.1080/07075332.2023.2260386

20. Zhongguo di'er lishi dang'anguan, ed., *Zhonghua minguo lishi tupian dang'an*, vol. II (3) (Beijing: Tuanjie chubanshe, 2002), 1129–31.

21. Mao Qingxiang to Dong Xianguang, February 21, 1939, file 378: Ministry of Information 718 (4), Second Historical Archives of China (SHAC); Zhongguo di'er lishi dang'anguan, ed., *Zhonghua minguo shi dang'an ziliao huibian: di 5 ji di 2 bian wenhua (2)* (Nanjing: Jiangsu guji chubanshe, 1998), 489–539; Ye Meixia, "'Zhong Ri wenhua xiehui' shuping," *Minguo dang'an*, no. 3 (2000): 96–101; Zhang Xianwen, ed., *Zhonghua minguo shi da cidian* (Nanjing: Jiangsu guji chubanshe, 2001), 425, 434; Shi Yuanhua, *Zhong Han wenhua xiehui yanjiu* (Beijing: Shijie zhi-shi chubanshe, 2007), 17–19; Li Xiaoqian, *Yuwai hanxue yu Zhongguo xiandai shixue* (Shanghai: Shanghai guji chubanshe, 2014), 271; Tsui, *China's Conservative Revolution*, 213.

22. Wang Jinhui, "Zhong Su wenhua xiehui yanjiu" (PhD diss., Party School of the Central Committee of the Chinese Communist Party, 2010).

23. Shuang Shen, *Cosmopolitan Publics: Anglophone Print Culture in Semi-Colonial Shanghai* (New Brunswick, NJ: Rutgers University Press, 2009); Peng Fasheng, *Xiang xifang quanshi Zhongguo: Tianxia yuekan yanjiu* (Beijing: Qinghua daxue chu-banshe, 2016); Huang Fang, *Duoyuan wenhua rentong de jiangou: Zhongguo pinglun zhoubao yu Tianxia yuekan yanjiu* (Nanjing: Nanjing daxue chubanshe, 2018).

24. Academia Sinica to National Palace Museum and Sun Ke, February 25, 1941, National Palace Museum to Academia Sinica, September 10, 1942, file 393: Academia Sinica, 2259, SHAC; Xu Fengyuan, "Guomin zhengfu canjia Sulian 'Zhongguo yishu zhanlanhui' de quzhe (1939–1942)," *Dang'an bannian kan* 16, no. 1 (2017): 44–58.

25. Matthew W. Mosca, *From Frontier Policy to Foreign Policy: The Question of India and the Transformation of Geopolitics in Qing China* (Stanford: Stanford Univer-sity Press, 2013), 2.

26. Taylor, *The Projection of Britain*; Ninkovich, *The Diplomacy of Ideas*; See Heng Teow, *Japan's Cultural Policy toward China, 1918–1931: A Comparative Per-spective* (Cambridge, MA: Harvard University Asia Center, distributed by Harvard University Press, 1999); Mark I. Choate, *Emigrant Nation: The Making of Italy Abroad* (Cambridge, MA: Harvard University Press, 2008); David-Fox, *Showcasing the Great Experiment*; Rubén Domínguez Méndez, "Los Primeros Pasos Del Insti-tuto Italiano de Cultura En España (1934–1943)," *Cuadernos de Filología Italiana* 20 (2013): 277–90; Abel, *The International Minimum*; Gross, *Export Empire*; Janet Horne, "'To Spread the French Language Is to Extend the Patrie': The Colonial Mission of the Alliance Française," *French Historical Studies* 40, no. 1 (2017): 95–127.

27. Anikó Marcher, "Hungarian Cultural Diplomacy 1957–1963: Echoes of Western Cultures Activity in a Communist Country," in *Searching for a Cultural Diplomacy*, ed. Jessica C. E. Gienow-Hecht and Mark C. Donfried (New York: Berghahn Books, 2010), 75–108.

28. The famous collector John C. Ferguson (1866–1945) called this institution the Government Museum. See Duan Yong, "Guwu chenliesuo de xingshuai jiqi lishi diwei shuping," *Gugong bowuyuan yuankan*, no. 5 (2004): 14–39; Lara Jaishree Netting, *A Perpetual Fire: John C. Ferguson and His Quest for Chinese Art and Culture* (Hong Kong: Hong Kong University Press, 2013), 4.

29. Cheng-hua Wang, "The Qing Imperial Collection, circa 1905–25: National Humiliation, Heritage Preservation, and Exhibition Culture," in *Reinventing the Past: Archaism and Antiquarianism in Chinese Art and Visual Culture*, ed. Wu Hung (Chicago: Center for the Art of East Asia, University of Chicago, 2010), 320–41.

30. For a narrative of these evacuations in the 1930s and 1940s, see Jeannette Shambaugh Elliot and David Shambaugh, *The Odyssey of China's Imperial Art Treasures* (Seattle: University of Washington Press, 2007), chap. 4.

31. For existing studies, see Wu Shuying, "Zhanlan zhong de 'Zhongguo': yi 1961 nian Zhongguo gu yishupin fu Mei zhanlan weili" (Master's thesis, National Chengchi University, 2003), 19–62; Ellen Huang, "There and Back Again: Material Objects at the First International Exhibitions of Chinese Art in Shanghai, London, and Nanjing, 1935–1936," in *Collecting China: The World, China, and a History of Collecting*, ed. Vimalin Rujivacharakul (Newark: University of Delaware Press, 2011), 138–52.

32. See in particular Wu, "Zhanlan zhong de 'Zhongguo,'" 31, 41, 46–50.

33. Shanny Peer, *France on Display: Peasants, Provincials, and Folklore in the 1937 Paris World's Fair* (Albany: State University of New York Press, 1998).

34. Robert Joseph Culp, *Articulating Citizenship: Civic Education and Student Politics in Southeastern China, 1912–1940* (Cambridge, MA: Harvard University Asia Center, 2007), chap. 5.

35. He Aiguo, "'Quanpan xihua' vs 'Zhongguo benwei': shilun 1930 niandai Zhongguo guanyu wenhua jianshe luxiang de lunzhan," *Ershiyi shiji* (wangluo ban), no. 34 (2005).

36. Prasenjit Duara, "The Discourse of Civilization and Pan-Asianism," *Journal of World History* 12, no. 1 (2001): 116–17; Clinton, *Revolutionary Nativism*.

37. Tang Zhong, "Lun wenhua waijiao," *Waijiao pinglun* 2, no. 8 (1933): 11–16; Chang Renxia, "Wenhua shijie yu wenhua waijiao," *Waijiao jikan* 1, no. 2 (1940): 138–39.

38. James Boyd, "Japanese Cultural Diplomacy in Action: The Zenrin Kyōkai in Inner Mongolia, 1933–45," *Journal of Contemporary Asia* 41, no. 2 (2011): 266–88.

39. Abel, *The International Minimum*, chap. 3; John Gripentrog, "Power and Culture: Japan's Cultural Diplomacy in the United States, 1934–1940," *Pacific Historical Review* 84, no. 4 (2015): 478–516.

40. Liu Weikai et al., *Zhonghua minguo zhuanti shi: Guomin zhengfu zhizheng yu dui Mei guanxi* (Nanjing: Nanjing daxue chubanshe, 2015), 294–330.

41. Warren I. Cohen, *East Asian Art and American Culture: A Study in International Relations* (New York: Columbia University Press, 1992), 122–25.

42. Zhang Peide, "1933 nian Zhongguo canjia Zhijiage shibohui huigu," in *Shibohui yu Dongya de canyu*, ed. Tao Demin et al. (Shanghai: Shanghai renmin chubanshe, 2012), 235–51.

43. Neil Harris, "Old Wine in New Bottles: Masterpieces Come to the Fair," in *Designing Tomorrow: America's World's Fairs of the 1930s*, ed. Robert W. Rydell and Laura Burd Schiavo (New Haven: Yale University Press, 2010), 41–55; Robert Bennett, "Pop Goes to the Future: Cultural Representations of the 1939–1940 New York World's Fair," in *Designing Tomorrow: America's World's Fairs of the 1930s*, ed. Robert W. Rydell and Laura Burd Schiavo (New Haven: Yale University Press, 2010), 177–91; William Peterson, *Asian Self-Representation at World's Fairs* (Amsterdam: Amsterdam University Press, 2020), chap. 4.

44. Nicholas J. Cull, "Overture to an Alliance: British Propaganda at the New York World's Fair, 1939–1940," *Journal of British Studies* 36, no. 3 (1997): 337, 341.

45. Herbert S. Houston to George McAneny, April 2, 1936, H. F. Tung and K. Y. Tung to Leslie S. Baker, January 4, 193[7], folder 10, box 304, New York World's Fair 1939–1940 records, New York Public Library Manuscripts and Archives Division (hereafter NYWF 1939–40).

46. Wang Chonghui note, May 14, 1938, file: Canjia 1939 nian Niuyue shijie bolanhui, collection: Executive Yuan, 014000008978A, Academia Historica, Taipei (hereafter AH).

47. Wang Chonghui to Nelson Johnson, July 22, 1937, folder 10, box 304, NYWF 1939–40.

48. W. H. Standley to president of the fair, March 14, 1938, folder 10, box 304, NYWF 1939–40.

49. Mrs. W. Murray Crane to Madame Kung, May 2, 1938, folder 10, box 304, NYWF 1939–40; Mrs. Theodore Roosevelt Jr. to Madame Chiang Kai-shek, May 2, 1938, folder 11, box 1492, NYWF 1939–40.

50. Wang note, May 14, 1938.

51. Chen Lifu to Executive Yuan, July 5, 1938; "Zhonghua minguo canjia Meiguo shijie bolanhui choubei weiyuanhui zhengji chupin guize," n.d., file: Canjia 1939 nian Niuyue shijie bolanhui, collection: Executive Yuan, 014000008978A, AH.

52. Weng Wenhao to Executive Yuan, October 21, 1938, file: Canjia 1939 nian Niuyue shijie bolanhui, collection: Executive Yuan, 014000008978A, AH.

53. "Zhonghua minguo canjia Meiguo shijie bolanhui choubei weiyuanhui zhengji chupin ximu yilanbiao," n.d., file: Canjia 1939 nian Niuyue shijie bolanhui, collection: Executive Yuan, 014000008978A, AH.

54. Qiao Liang and Wang Lele, "Xiangguan zhidai 'wenwu' gainian cihui de chuxian yu bianhua shixi," *Wenwu chunqiu*, no. 2 (2011): 3–7, 10.

55. Cohen, *East Asian Art and American Culture*, 123–25; Stephen R. MacKinnon, *Wuhan, 1938: War, Refugees, and the Making of Modern China* (Berkeley: University of California Press, 2008).

56. Li Kuoching to Ministry of Foreign Affairs, n.d. (probably late October, 1938), Weng Wenhao to Secretariat of the Executive Yuan, November (no date), 1938, file: Canjia 1939 nian Niuyue shijie bolanhui, collection: Executive Yuan, 014000008978A, AH.

57. H. H. Kung to Ministry of Finance, June 8, 1939, file: Canjia Meiguo shijie bolanhui, collection: Ministry of Finance, 018000026306A, AH.

58. Chiang Kai-shek to Ministry of Finance, January 6, 1940, file: Canjia Meiguo shijie bolanhui, collection: Ministry of Finance, 018000026306A, AH.

59. Zhang Peide, "1933 nian Zhongguo canjia Zhijiage shibohui huigu," 247–49.

60. H. A. Flanigan to Vincent Bendix, May 21, 1937, folder 12, box 384, NYWF 1939–40.

61. Frank C. Reilly to H. M. Lammers, August 9, 1939, folder 13, box 1546, NYWF 1939–40.

62. Philippe Forêt, *Mapping Chengde: The Qing Landscape Enterprise* (Honolulu: University of Hawai'i Press, 2000); James A. Millward et al., eds., *New Qing Imperial*

History: The Making of Inner Asian Empire at Qing Chengde (New York: Routledge, 2004).

63. Reilly to Lammers, August 21, 1939, folder 13, box 1546, NYWF 1939–40.

64. G. V. Pach to Harvey D. Gibson, August 16, 1940, folder 7, box 541; A. A. Ricker to Lama Temple Sponsors, Ltd., June 12, 1940, folder 13, box 1546, NYWF 1939–40.

65. Frank Monaghan to E. E. Warner, October 25, 1938, folder 10, box 871, NYWF 1939–40; Henin Chin, ed., *Official Chinatown Guide Book for Visitors & New Yorkers* (New York: Henin & Company, 1938).

66. Chin, *Official Chinatown Guide Book*, 7; Him Mark Lai, "The Kuomintang in Chinese American Communities before World War II," in *Entry Denied: Exclusion and the Chinese Community in America, 1882–1943*, ed. Sucheng Chan (Philadelphia: Temple University Press, 1991), 170–212.

67. Chin, *Official Chinatown Guide Book*, 69–80.

68. Chinese Women's Relief Association and American Women's Sponsoring Committee, *A Loan Exhibition of Early Chinese Art Treasures for the Benefit of Chinese Civilian War Victims* (New York: Arden Gallery, 1938); Arden Gallery, *3000 Years of Chinese Jade* (New York, 1939).

69. Edward Poynter to Henry Luce, February 9, 1939, folder 5, box 25, HRL.

70. Poynter to Luce, February 9, 1939.

71. Eleanor B. Roosevelt to Henry Luce, November 29, 1939, folder 5, box 25, HRL. For the list of underwriters, see various reports in the same folder.

72. Arden Gallery, *Exhibition of Imperial Art Treasures from Peking's Forbidden City* (New York, 1939), 8–9, 12–13.

73. Arden Gallery, *Exhibition of Imperial Art Treasures*, 10–11.

74. Arden Gallery, *Exhibition of Imperial Art Treasures*, 8.

75. Arden Gallery, *Exhibition of Imperial Art Treasures*, 19.

76. Zhou Fangmei, "1933–34 nian Zhijiage shijie bolanhui Zhonghua minguo he Riben yipin zhi zhanshi," *Yishuxue yanjiu*, no. 6 (2010): 183–88.

77. Arden Gallery, *Exhibition of Imperial Art Treasures*, 2.

78. For a recent biography that goes beyond vilification of Loo's questionable business practices, see Luola, *Lu Qinzhai zhuan* (Hong Kong: Xinshiji, 2013).

79. James Louis Hevia, *English Lessons: The Pedagogy of Imperialism in Nineteenth-Century China* (Durham: Duke University Press, 2003), chaps. 4, 10.

80. Karen J. Kuo, *East Is West and West Is East: Gender, Culture, and Interwar Encounters Between Asia and America* (Philadelphia: Temple University Press, 2013), chap. 3.

81. Robert R. Hansen to George F. Smith Jr., June 2, 1938, folder 6, box 1546, NYWF 1939–40.

82. Robert R. Hansen to Grover Whalen, March 20, 1939, folder 6, box 1546, NYWF 1939–40.

83. George P. Smith Jr. to Paul Massman, March 27, 1939, Robert R. Hansen to Frank D. Shean, April 23, 1940, folder 6, box 1546, NYWF 1939–40.

84. George P. Smith Jr. to Chairman of the Board, March 8, 1940, August 10, 1940, folder 7, box 541, NYWF 1939–40.

85. Debra Craine and Judith Mackrell, eds., "Raqs Sharqi," in *Oxford Dictionary of Dance* (New York: Oxford University Press, 2016).

86. George P. Smith Jr. to Chairman of the Board, March 8, 1940, folder 7, box 541, NYWF 1939–40.

87. L. K. Wong to Harvey D. Gibson, May 30, 1940, folder 13, box 1546, NYWF 1939–40.

88. Frank D. Shean to Chairman of the Board, May 31, 1940, folder 7, box 541, NYWF 1939–40.

89. Frank D. Shean to Sandra Carlyle, August 8, 1940, George P. Smith Jr. and Frank D. Shean to Sandra Carlyle, August 18, 1940, George P. Smith Jr. to Harrison Forman, August 10, 1940, folder 7, box 541, NYWF 1939–40.

90. George P. Smith Jr. to Sandra Carlyle, July 15, 1940, folder 7, box 541, NYWF 1939–40.

91. George P. Smith Jr. to the Comptroller, July 17, 1940, folder 7, box 541, NYWF 1939–40.

92. Edward Rameizl to Sandra Carlyle, August 21, 1940, folder 7, box 541, NYWF 1939–40.

93. George P. Smith Jr. to Herbert Brownell Jr., October 5, 1940, folder 13, box 1546, NYWF 1939–40.

94. "China cannot sponsor an exhibit at the 1940 World's Fair but China's American friends can sponsor a Chinese exhibit for the American people," n.d., folder 12, box 1469, NYWF 1939–40.

95. Wei, *News under Fire*, 198.

96. Bruno Schwartz to Julius C. Holmes, December 12, 1939, folder 12, box 1469, NYWF 1939–40.

97. Schwartz to Holmes, December 12, 1939.

98. Karen Livingstone and Linda Parry, eds., *International Arts and Crafts* (London: Victorian and Albert Museum, 2005).

99. Wu Jingping and Guo Daijun, *Song Ziwen he tade shidai* (Shanghai: Fudan daxue chubanshe, 2008), 60–80.

100. American Bureau for Medical Aid to China press release, July 5, 1940, folder 12, box 1469, NYWF 1939–40.

CHAPTER 3

1. Parmet, "Chih Meng and the China Institute in America"; Hsu, *The Good Immigrants*, chap. 3; Ma Liangyu, "Hua Mei xiejinshe;" Li Gaofeng, *Hua Mei xiejinshe shi*. For a more nuanced treatment of Luce, see Alan Brinkley, *The Publisher: Henry Luce and His American Century* (New York: Alfred A. Knopf, 2010), chap. 12.

2. Treaty between the United States of America and the Republic of China for the Relinquishment of Extraterritorial Rights in China and the Regulation of Related Matters, January 11, 1943, 57 Stat. 767; Treaty Between His Majesty in Respect of the United Kingdom and India and His Excellency the President of the National Government of the Republic of China for the Relinquishment of Extra-Territorial Rights in China and the Regulation of Related Matters, January 11, 1943.

3. Federal Communications Commission Foreign Broadcast Intelligence Service, *Foreign Radio Broadcast Daily Report*, January 12–16, 1943.

4. Pär Kristoffer Cassel, *Grounds of Judgment: Extraterritoriality and Imperial*

Power in Nineteenth-Century China and Japan (New York: Oxford University Press, 2012).

5. Wesley R. Fishel, *The End of Extraterritoriality in China* (Berkeley: University of California Press, 1952), chap. 11.

6. Yang, *Zhongjihui*, 43–44.

7. Roger Greene to Wesley Bailey, December 30, 1943, p. 3, folder 6, box 27, HRL.

8. Chih Meng, "Report of the Director to the Board of Trustees for the Year of May 1942 to June 1943," 8–9, folder 6, box 27, HRL. Although this report is not dated as such, it should be submitted in June 1943, given its coverage.

9. Gertrude DonDero to Henry R. Luce, October 26, 1954, folder 4, box 30, HRL.

10. Meng, *Chinese American Understanding*, 191.

11. Mary Brown Bullock, *The Oil Prince's Legacy: Rockefeller Philanthropy in China* (Washington, DC and Stanford: Woodrow Wilson Center Press and Stanford University Press, 2011), chap. 2.

12. China Institute Finance Committee to Packard, August 6, 1931, Arthur W. Packard's memo, August 25, 1931, folder 558, box 57, Series E, RG 2, collection: Rockefeller Family Cultural Interests, RAC. On the Rockefeller patronage of the Council on Foreign Relations, see Peter Grose, *Continuing the Inquiry: The Council on Foreign Relations from 1921 to 1996* (New York: Council on Foreign Relations, 1996), 23. On the Institute of Pacific Relations, see Bullock, *The Oil Prince's Legacy*, 66.

13. Packard's memo, April 30, 1943, Packard's memo, June 22, 1943, folder 558, box 57, Series E, RG 2, collection: Rockefeller Family Cultural Interests, RAC; Liping Bu, *Making the World Like Us: Education, Cultural Expansion, and the American Century* (Westport, CT: Praeger, 2003), 66.

14. Meng, *Chinese American Understanding*, 83–85, 113, 132, 191–93.

15. Chih Meng to Henry R. Luce, November 18, 1943, Roger S. Greene to Charles L. Stillman, January 12, 1944, Walter H. Mallory to Charles L. Stillman, January 27, 1944, Roger S. Greene to Charles L. Stillman, July 31, 1944, folder 6, box 27, HRL.

16. Charles L. Stillman to president of board of trustees of the China Institute in America, January 13, 1944, folder 559, box 57, Series E, RG 2, collection: Rockefeller Family Cultural Interests, RAC; Josh Barbanel, "China Institute to Move to Lower Manhattan," *Wall Street Journal*, March 4, 2014.

17. Walter Guzzardi, *The Henry Luce Foundation: A History, 1936–1986* (Chapel Hill: University of North Carolina Press, 1988), 113, 115.

18. Brinkley, *The Publisher*, chap. 1.

19. David A. Hollinger, *Protestants Abroad: How Missionaries Tried to Change the World but Changed America* (Princeton: Princeton University Press, 2017), chap. 1.

20. Wes Bailey to Allen Grover, January 4, 1943, folder 5, box 27, HRL.

21. Chih Meng to Henry R. Luce, November 18, 1943, folder 6, box 27, HRL; Charles L. Stillman to president of board of trustees of the China Institute in America, January 13, 1944, folder 559, box 57, Series E, RG 2, collection: Rockefeller Family Cultural Interests, RAC.

22. Stillman to H. R. Luce, November 13, 1944, folder 6, box 27, HRL.

23. Stillman to Greene, November 27, 1944, Stillman to Edward R. Stettinius,

November 30, 1944, E. R. Stettinius, Jr. to Stillman, December 19, 1944, folder 6, box 27, HRL; "Attitude of the United States toward status of the China Foundation for the Promotion of Education and Culture after termination of the Boxer Protocol of 1901," *Foreign Relations of the United States: Diplomatic Papers* (hereafter *FRUS*), 1943, China (Washington, DC: Government Printing Office, 1957), 701–9; "Representations to the Chinese government protesting its order for the abolition of the China Foundation for the Promotion of Education and Culture," *FRUS*, 1944, China (Washington, DC: Government Printing Office, 1967), 1161–64.

24. Yang, *Zhongjihui*, 44–48.

25. Meng, *Chinese American Understanding*, 169, 186–89; Hsu, *The Good Immigrants*, 77–80.

26. Wang Chunnan, "Kangzhan qijian chuguo liuxue guanli," *Xuehai*, no. 2 (1997): 88–93; Wei Shanling, "Kangzhan qian Nanjing guomin zhengfu dui liuxue zhengce de tiaozheng yu guihua," *Xuzhou shifan daxue xuebao* (zhexue shehui kexue ban), no. 3 (2008): 1–8; Zhou Leiming, "Liu Mei Zhongguo xuesheng zhanshi xueshu jihua weiyuanhui jiqi huodong," in Tu Wenxue and Deng Zhengbing, eds., *Kangzhan shiqi de Zhongguo wenhua* (Beijing: Renmin chubanshe, 2006), 604–9.

27. Meng, *Chinese American Understanding*, 186–89.

28. "Meng Zhi," linshi dengji pian no. 14322, n.d., and Guomin zhengfu wenguanchu renshi dengji buchong pian no. 88975, n.d., file: Meng Zhi, collection: Junshi weiyuanhui weiyuanzhang shicongshi (XV), 129000070746A, AH.

29. H. H. Kung to Henry Luce, February 2, 1944, folder 6, box 27, HRL.

30. "Dr. Kung Accepts China House Here," *New York Times*, August 28, 1944; "Niuyue Zhongguo ting Lu Si zeng Hua Mei xiejinshe" [Luce gifts China House in New York to the China Institute in America], *Zhongyang ribao*, August 29, 1944.

31. *There Is Another China: Essays and Articles for Chang Poling of Nankai* (New York: King's Crown Press, 1948), photo page.

32. Robert E. Herzstein, *Henry R. Luce, Time, and the American Crusade in Asia* (New York: Cambridge University Press, 2005), 25–26, 36–37.

33. Isaacs, *Scratches on Our Minds*, 176–89.

34. Wu Jinqi, "'Dao Kong yundong': zhanshi de kangzheng zhengzhi," *Dongfang luntan*, no. 6 (2013): 34–41.

35. Zhang Xianwen, ed., *Zhonghua minguo shi da cidian*, 425.

36. Wheeler, "Report of the Assistant Director: Fund Raising Plans for 1949–1950," folder 5, box 28, HRL.

37. Henry R. Luce to Edward H. Hume, May 29, 1944, folder 6, box 27, HRL.

38. "China Institute in America," notecard with list of Luce's involvement affixed to Report of the Director to the Board of Trustees for the Year of May 1942 to June 1943, folder 6, box 27, HRL; Kip Finch to Henry Luce, February 19, 1951, folder 6, box 28, HRL.

39. Personal correspondence with Helena Kolenda of Luce Foundation, August 25, 2014; Guzzardi, *The Henry Luce Foundation*, 115.

40. Roger S. Greene to Walter H. Mallory, June 5, 1945, folder 4, box 30, HRL.

41. Stillman to H. R. Luce, November 13, 1944, folder 6, box 27, HRL; Charles Stillman to Beth, November 5, 1945, folder 4, box 27, HRL; personal interview with Wango Weng, March 30, 2013. For more on Moore, see Terrill E. Lautz, "Elisabeth Luce Moore: A Spoken History" (unpublished manuscript, 2008).

42. Arthur W. Packard to John D. Rockefeller III, January 21, 1944, folder 559, box 57, Series E, RG 2, collection: Rockefeller Family Cultural Interests, RAC.

43. Chih Meng to Arthur W. Packard, January 24, 1944, Arthur W. Packard to Chih Meng, January 26, 1944, folder 559, box 57, Series E, RG 2, collection: Rockefeller Family Cultural Interests, RAC.

44. Doris Goss to Arthur Packard, December 13, 1944, Arthur W. Packard to Rockefeller III, December 14, 1944, Arthur W. Packard to Rockefeller III, December 22, 1944, Stephen Duggan to Arthur W. Packard, December 22, 1944, Arthur W. Packard to Stephen Duggan, December 26, 1944, folder 559, box 57, Series E, RG 2, collection: Rockefeller Family Cultural Interests, RAC.

45. Rockefeller III to Walter H. Mallory, July 10, 1947, Walter H. Mallory to Rockefeller III, July 15, 1947, Dana S. Creel to Edwin N. Clark, December 5, 1950, Edgar B. Young to III, March 21, 1955, folder 559, box 57, Series E, RG 2, collection: Rockefeller Family Cultural Interests, RAC.

46. Yu Hongjun to Chiang Kai-shek, December 30, 1946, file: Jingji cuoshi (10), collection: Nationalist Government, 001000006647A, AH.

47. Kip Finch to Mr. Luce, October 21, 1947, folder 4, box 30, HRL; Wheeler, "Report of the Assistant Director: Fund Raising Plans for 1949–1950," folder 5, box 28, HRL.

48. Kip Finch to Mr. Luce, January 3, 1948, folder 4, box 30, HRL.

49. Thomas J. Christensen, *Useful Adversaries: Grand Strategy, Domestic Mobilization, and Sino-American Conflict, 1947–1958* (Princeton: Princeton University Press, 1996), 246–70.

50. For such deliberation, see file: Jingfei bofa (3), collection: Nationalist Government, 001000005980A, AH.

51. Virginia Runton to E. C. K. Finch, July 10, 1951, folder 1, box 8, HRL; memo by Arthur Packard, November 29, 1949, folder 559, box 57, Series E, RG 2, collection: Rockefeller Family Cultural Interests, RAC.

52. Yang, *Zhongjihui*, 61.

53. Hu Shih to Henry Luce and Edwin Clark, June 22, 1951, folder 6, box 28, HRL; Chiang Monlin to Henry R. Luce, March 16, 1950, folder 4, box 30, HRL; Charles Edison to Hu Shih, April 22, 1954, folder 1991.3.1, box 4, Meng Zhi papers, College of East Asian Studies, Wesleyan University, Middletown, CT.

54. Thomas J. Watson Jr. to Henry R. Luce, January 12, 1949, folder 4, box 30, HRL; Russell Bourne to Paul Geier, March 27, 1955, Secretary to Russell Bourne to Paul Geier, June 16, 1955, Russell Bourne to Mr. Luce, September 12, 1956, November 13, 1956, folder 5, box 30, HRL.

55. Kip Finch to Henry Luce, November 4, 1949, folder 3, box 28, HRL.

56. Weng interview, March 30, 2013.

57. Anonymous (probably by Luce given penmanship and content) handwritten outline, June 7, 1957, folder 1, box 30, HRL.

58. Bullock, *The Oil Prince's Legacy*, 72, 102, 112–13.

59. John Ensor Harr and Peter J. Johnson, *The Rockefeller Conscience: An American Family in Public and in Private* (New York: Scribner, 1991), chap. 7.

60. Robert C. Bates to Edgar B. Young, July 18, 1952, memo by Robert C. Bates, August 21, 1952, Robert C. Bates to John D. Rockefeller III, September 19, 1952, folder 559, box 57, Series E, RG 2, collection: Rockefeller Family Cultural Interests, RAC.

61. Dana S. Creel and Charles P. Noyes to John D. Rockefeller III, March 8, 1957, folder 559, box 57, Series E, RG 2, collection: Rockefeller Family Cultural Interests, RAC.

62. Russell Bourne to Henry Luce, January 27, 1958, folder 1, box 30, HRL.

63. Charles P. Noyes to John D. Rockefeller III, December 13, 1955, folder 559, box 57, Series E, RG 2, collection: Rockefeller Family Cultural Interests, RAC.

64. Bullock, *The Oil Prince's Legacy*, 83.

65. Michael R. Auslin, *Japan Society: Celebrating a Century 1907–2007* (New York: Japan Society, 2007), pt. II, III; Michael R. Auslin, *Pacific Cosmopolitans: A Cultural History of U.S.-Japan Relations* (Cambridge, MA: Harvard University Press, 2011), 197–200. For a more critical assessment, see Takeshi Matsuda, *Soft Power and Its Perils: U.S. Cultural Policy in Early Postwar Japan and Permanent Dependency* (Washington, DC and Stanford: Woodrow Wilson Center Press and Stanford University Press, 2007), chaps. 4–5.

66. Charles P. Noyes to John D. Rockefeller III, January 12, 1955, John D. Rockefeller III to Clark, January 18, 1955, John D. Rockefeller III to Mrs. Maurice T. Moore, December 21, 1955, Hu Shih to John D. Rockefeller III, December 14, 1956, John D. Rockefeller III to Hu Shih, March 20, 1957, folder 559, box 57, Series E, RG 2, collection: Rockefeller Family Cultural Interests, RAC.

67. John D. Rockefeller III to Dana S. Creel, May 7, 1958, Dana S. Creel to John D. Rockefeller III, May 9, 1958, folder 559, box 57, Series E, RG 2, collection: Rockefeller Family Cultural Interests, RAC. There is no documentation on Luce's attitudes toward the Japan and Asia Societies in his papers. And there are no direct commentaries on Rockefeller's philanthropic projects in *Time* in the late 1950s.

68. John D. Rockefeller III to Walter H. Mallory, June 16, 1958, folder 559, box 57, Series E, RG 2, collection: Rockefeller Family Cultural Interests, RAC.

69. Memo by Doris Goss, December 6, 1949, folder 559, box 57, Series E, RG 2, collection: Rockefeller Family Cultural Interests, RAC.

70. Dana S. Creel and James N. Hyde to John D. Rockefeller III, November 10, 1960, folder 559, box 57, Series E, RG 2, collection: Rockefeller Family Cultural Interests, RAC.

71. SW to John D. Rockefeller III, December 13, 1960, folder 559, box 57, Series E, RG 2, collection: Rockefeller Family Cultural Interests, RAC.

72. Telephone interview with F. Richard Hsu, April 11, 2016.

73. Gertrude DonDero to Henry R. Luce, October 26, 1954, folder 4, box 30, HRL.

74. Protocol Department to Minister and Vice Minister of Foreign Affairs, May 31, 1952, file: Meiguo renshi fang Hua, collection: Ministry of Foreign Affairs (hereafter MOFA), 020000005839A, AH.

75. Transcripts of Chiang's meetings with Clark, May 23, 24, 27, 1952, file: Dui Meiguo waijiao (11), collection: Jiang Zhongzheng zongtong wenwu, 002000001256A, AH.

76. ROC Embassy to MOFA, February 24, 1955, March 15, 1955, file: Jiaoyubu zai Mei wenjiao shiye guwen weiyuanhui, collection: MOFA, 020000011669A, AH.

77. ROC Embassy to MOFA, February 24, 1955, file: Jiaoyubu zai Mei wenjiao shiye guwen weiyuanhui, collection: MOFA, 020000011669A, AH.

78. Meng, *Chinese American Understanding*, 226.

79. *Cheng Qibao xiansheng shishi zhounian jinianji* (n.p., 1976), 31–37, 113–14.

80. Chi-pao Cheng, *Chinese American Cultural Relations* (New York: China Institute in America, 1965); Li, *Hua Mei xiejinshe shi*, 150–54.

81. For a similar dynamic between the Nationalist government and China Institute of Pacific Relations, see Zhang Jing, *Zhongguo Taipingyang guoji xuehui yanjiu (1925–1945)* (Beijing: Shehui kexue wenxian chubanshe, 2012), 116–23.

82. K. Ian Shin, "The Chinese Art 'Arms Race': Cosmopolitanism and Nationalism in Chinese Art Collecting and Scholarship between the United States and Europe, 1900–1920," *Journal of American-East Asian Relations* 23, no. 3 (2016): 229–56.

83. Meng, *Chinese American Understanding*, 149–50, 198–99, 221.

84. Wilma Prezzi to Albert Einstein, February 20, 1947, 11.2.22, Emergency Committee of Atomic Scientists Records, Oregon State University Special Collections & Archives, accessed May 26, 2023, http://scarc.library.oregonstate.edu/omeka/items/show/20826; Yiyou Wang, "The Loouvre from China: A Critical Study of C. T. Loo and the Framing of Chinese Art in the United States, 1915–1950" (PhD diss., Ohio University, 2007), 215–18; Anthony W. Lee, *Picturing Chinatown: Art and Orientalism in San Francisco* (Berkeley: University of California Press, 2001), chap. 5. The accuracy of the URL only reflects the time of access.

85. Meng, *Chinese American Understanding*, 177, 198. A copy of the film is at the U.S. National Archives and Records Administration (College Park, MD), accession number NN-368-14.

86. Weng Wange, "'Zhongguo dianying qiye' zai Mei yinian lu," *Yingyin* 7, no. 1 (1948): 2–3.

87. Mary Beattie Brady to Hu Shih, April 9, 1945, HS-JDSHSE-0136–004, Hu Shih Memorial Hall (HSMH), Academia Sinica; Weng interview, March 30, 2013; Meng, *Chinese American Understanding*, 198.

88. Weng, "Out of a Chinese Painting Brush: Professor Chang Shu-chi Shows His Master Skill," reel 1, Zhang Shuqi Papers, Hoover Institution Archives.

89. Ling Chengwei and Zhang Huailing, "Feiyue Taipingyang de xinshi: baigetu xiangguan shishi jikao he yanjiu," *Zhongguo meishuguan*, no. 9 (2012): 75–80.

90. Aida Yuen Wong, *Parting the Mists: Discovering Japan and the Rise of National-Style Painting in Modern China* (Honolulu: University of Hawai'i Press, 2006); Gordon H. Chang, "Trans-Pacific Composition: Zhang Shuqi Paints in America," in *Zhang Shuqi in California*, ed. Jianhua Shu (Santa Clara, CA: Silicon Valley Asian Art Center, 2012), 20–30.

91. Meng, *Chinese American Understanding*, 225–26.

92. Brochure of the China Institute, n.d. (probably early 1950s), folder 2, box 29, HRL; Meng, 193, 217–21; Li, *Hua Mei xiejinshe shi*, 103–12. For a complete list of the China Institute's Chinese culture courses in the late 1950s, see Chih Meng, "Report of the Director Given before the Board of Trustees," February 25, 1960, HS-NK05-277-010, HSMS.

93. Matthew D. Linton, "Understanding the Mighty Empire: Chinese Area Studies and the Construction of Liberal Consensus, 1928–1979" (PhD diss., Brandeis University, 2018), chap. 4.

94. Zheng, *Chiang Yee*, 171–72.

95. Li, *Hua Mei xiejinshe shi*, 105–6.

96. For important exceptions, see Heather Ruth Lee, *Gastrodiplomacy: Chinese Exclusion and the Ascent of Chinese Restaurants in New York* (Chicago: University of Chicago Press, under contract).

97. Yong Chen, *Chop Suey, USA: The Story of Chinese Food in America* (New York: Columbia University Press, 2014).

98. Charles W. Hayford, "Open Recipes, Openly Arrived At: *How to Cook and Eat in Chinese* (1945) and the Translation of Chinese Food," *Journal of Oriental Studies* 45, no. 1 & 2 (2012): 67–87.

99. Craig Claiborne, "Food: Chinese Cuisine, Fourteen Course Dinner Is Climax of Graduation from China Institute," *New York Times*, June 14, 1958.

100. Luo Yuanxu, *Dong cheng xi jiu: qige huaren jidujiao jiating yu zhongxi wenhua jiaoliu bainian* (Hong Kong: Sanlian shudian, 2012), 331–32; Shen Pengxia, "Cungu dao Meiguo pengren dashi." The Shen reference was from Folk History Archive at the Universities Service Centre for China Studies Collection at the Chinese University of Hong Kong. The university library removed this once open access collection from its website as of 2022.

101. See, for example, seq. 71, accessed May 28, 2023, https://iiif.lib.harvard.edu /manifests/view/drs:495102672$71i, and seq. 78, accessed May 28, 2023, https:// iiif.lib.harvard.edu/manifests/view/drs:495102672$78i, folder 1.7–1.10, Classes: China Institute in America, 1954–1967, Papers of Grace Zia Chu, 1941–1986, Schlesinger Library, Radcliffe Institute, Harvard University.

102. "Midwinter Madness," *New Yorker*, March 1, 1958, 25; Ellen Meade, "Get Some New People into Your Life," *Cosmopolitan*, November 1968, 109.

103. *Cheng Qibao xiansheng*, 114–16; Meng, *Chinese American Understanding*, 226; Cal Clark, "A Short History of the American Association for Chinese Studies," *American Journal of Chinese Studies* 25, no. 2 (2018): 603. What Clark refers to as the "China Center in America" is likely a misnomer for the China Institute.

104. China Institute in America, "An Analysis of Chinese Studies in American Colleges and Universities 1955–56: The Result of a Survey Undertaken Under the Sponsorship of the Chinese Advisory Committee on Cultural Relations in America," *Chinese Culture* 1, no. 1 (1957): 201–52; Thomas D. Snyder, *120 Years of American Education: A Statistical Portrait* (Washington, DC: U.S. Department of Education Office of Educational Research and Improvement, 1993), 80.

105. Han Tie, *Fute jijinhui yu Meiguo de Zhongguo xue, 1950–1979 nian* (Beijing: Zhongguo shehui kexue chubanshe, 2004), 78–89; Linton, "Understanding the Mighty Empire," 194–96; Chinese Advisory Committee on Cultural Relations in America and China Institute in America, *Basic Bibliography on China for Use of American School Teachers* (New York, 1956).

106. "Speech by H. E. Dr. V. K. Wellington Koo, Chinese Ambassador to the United States, at the China Institute in New York," December 1, 1948, Gu Weijun Papers, Koo_Box0128_014_0002, Chinese Academy of Social Sciences Institute of Modern History Archives (CASS); Program of the China Institute in America 25th anniversary dinner, May 18, 1951, folder 558, box 57, Series E, RG 2, collection: Rockefeller Family Cultural Interests, RAC; China Institute brochure, c. 1953, folder: China Institute (Bulletin & Correspondence), box 29, Alfred Kohlberg Papers, Hoover Institution; China Institute brochure, enclosed to C. F. Yau to

Mr. and Mrs. David Rockefeller, June 15, 1956, folder 558A, box 57, Series E, RG2, collection: Rockefeller Family Cultural Interests, RAC.

107. Gao, *Arise Africa! Roar China!*, 149.

108. "The China Lobby: A Case Study," *Congressional Quarterly Weekly Report Special Supplement*, June 29, 1951, 946–47.

109. "China Lectures Assailed: 500 Columbia Students Charge Talks Give Only Chiang Side," *New York Times*, April 8, 1948; Chih Meng to publisher and editor of *Gazette and Daily*, July 20, 1951, E. C. K. Finch to J. W. Gitt, July 20, 1951, Muriel Binder to E. C. K. Finch, July 25, 1951, folder 1, box 8, HRL.

110. Department of Justice, "Report of the Attorney General to the Congress of the United States on the Administration of the Foreign Agents Registration Act of 1938, as Amended for the Period from June 28, 1942 to December 31, 1944," 1945, 219–20; Department of Justice, "Report of the Attorney General to the Congress of the United States on the Administration of the Foreign Agents Registration Act of 1938, as Amended June 1950," 1950, 86; Department of Justice, "Report of the Attorney General to the Congress of the United States on the Administration of the Foreign Agents Registration Act of 1938, as Amended for the Period January 1, 1950 to December 31, 1954," 1955, 40.

111. Charles Wertenbaker, "The China Lobby," *The Reporter*, April 15, 1952; Philip Horton, Charles Wertenbaker, and Max Ascoli, "The China Lobby," *The Reporter*, April 29, 1952; Joseph Keeley, *The China Lobby Man: The Story of Alfred Kohlberg* (New Rochelle, NY: Arlington House, 1969); Ross Y. Koen, *The China Lobby in American Politics* (New York: Harper & Row, 1974).

112. Weng interview.

113. Guzzardi, *The Henry Luce Foundation*, 112; Warren I. Cohen, "While China Faced East: Chinese-American Cultural Relations, 1949–71," in *Educational Exchanges: Essays on the Sino-American Experience*, ed. Joyce K. Kallgren and Denis Fred Simon (Berkeley: University of California Institute of East Asian Studies, 1987), 48.

114. Wang Shijie to Chiang Kai-shek, October 1, 1939, file: Guofang qingbao yu xuanchuan (1), collection: Jiang Zhongzheng zongtong wenwu, 002000001231A, AH; Ministry of Foreign Affairs to Hu Shi, February 2, 1940, in collection: Hu Shi's telegrams as ambassador to the United States (January 3 to June 29, 1940), 2025–001, Hu Shi Papers, CASS; Akio Tsuchida, "China's 'Public Diplomacy' toward the United States before Pearl Harbor," *Journal of American-East Asian Relations* 17, no. 1 (2010): 41–43.

115. William C. Kirby, "The Chinese Party-State under Dictatorship and Democracy on the Mainland and on Taiwan," in *Realms of Freedom in Modern China*, ed. William C. Kirby (Stanford: Stanford University Press, 2004), 131.

CHAPTER 4

1. Lorenz M. Lüthi, "Rearranging International Relations? How Mao's China and de Gaulle's France Recognized Each Other in 1963–1964," *Journal of Cold War Studies* 16, no. 1 (2014): 111–45.

2. Wu Shuying, "Zhanlan zhong de 'Zhongguo': yi 1961 nian Zhongguo gu yishupin fu Mei zhanlan weili" (Master's thesis, National Chengchi University,

2003); Xu Fengyuan, "Zhanshi 'Zhongguo': Taiwan zai Niuyue shibohui (1964–1965)," in *Jindai Zhongguo de zhongwai chongtu yu siying*, ed. Tang Qihua (Taipei: Zhengda chubanshe, 2014), 203–26; Noelle Giuffrida, "The Right Stuff: Chinese Art Treasures' Landing in Early 1960s America," in *The Reception of Chinese Art across Cultures*, ed. Michele Huang (New Castle upon Tyne: Cambridge Scholars Publishing, 2014), 200–227.

3. Yunchiahn C. Sena, *Bronze and Stone: The Cult of Antiquity in Song Dynasty China* (Seattle: University of Washington Press, 2019), 22–23.

4. Clifford Geertz, *Negara: The Theatre State in Nineteenth-Century Bali* (Princeton: Princeton University Press, 1980), 120.

5. Giles Scott-Smith, *Western Anti-Communism and the Interdoc Network: Cold War Internationale* (New York: Palgrave Macmillan, 2012), 48.

6. Cohen, *East Asian Art and American Culture*, 144–45.

7. Internal memo with translation of Luce's letter to Chiang, n.d. (should be 1953), Han Lih-wu to Francis Taylor, June 16, 1953, Wu Guozhen to Ye Gongchao, July 7, 1953, file: Gugong wenwu yunsong guo nei wai zhanlan, 0042/33906/00/001/010~310, Presidential Office Archives (POA), Taiwan; Wu, "Zhanlan zhong de 'Zhongguo,'" 72–73; Meng, *Chinese American Understanding*, 229–31; Giuffrida, "The Right Stuff," 201.

8. "Minutes of the special meeting of the board of trustees of the China Institute in America, Inc.," May 11, 1953, HS-US01-104-020, HSMH.

9. You Mijian, "Zhankai Taiwan de wenhua gongzuo" [To promote cultural work in Taiwan], *Gonglun bao*, April 16, 1950.

10. Editorial, "Xueren mengnan wenhua zaoyang," *Ziyou Zhongguo* 6, no. 1 (1952): 4; Zhu Qibao, review of Tang Junyi, *Zhongguo zhi luan yu Zhongguo wenhua jingshen zhi qianli* (Taipei: Huaguo chubanshe, 1952), *Ziyou Zhongguo* 6, no. 9 (1952): 297–98.

11. For a reprint, see Mou Zongsan et al., "Zhongguo wenhua yu shijie: women dui Zhongguo xueshu yanjiu ji Zhongguo wenhua yu shijie wenhua qiantu zhi gongtong renshi," in Tang Junyi, *Shuo Zhonghua minzu zhi huaguo piaoling* (Taipei: Sanmin shuju, 1974), 125–92; Su Ruiqiang, "*Minzhu pinglun* de xin rujia yu *Ziyou Zhongguo* de ziyou zhuyi zhe guanxi bianhua chutan: yi Xu Fuguan yu Yin Haiguang wei zhongxin de tantao," *Si yu yan* 49, no. 1 (2011): 8.

12. Liu Sixiang, "Hang Liwu zhuanlüe," *Jianghuai wenshi*, no. 1 (2001): 142.

13. Wu, "Zhanlan zhong de 'Zhongguo,'" 26, 80.

14. Chen Tiejian and Huang Daoxuan, *Jiang Jieshi yu Zhongguo wenhua* (Hong Kong: Zhonghua shuju, 1992), 90.

15. Jiang Jieshi, "Zhonghua minguo sanshijiu nian yuandan gao quanguo junmin tongbao shu," *Zongtong Jianggong sixiang yanlun zongji*, vol. 32, 246–47.

16. Liu Weikai, "Jiang Jieshi de lüyou shenghuo," in *Jiang Jieshi de richang shenghuo*, ed. Lü Fangshang (Taipei: Zhengda chubanshe, 2012), 136.

17. Lin Jiahua, "Yingxiang zhong de jingshen chuandi: Jiang furen wenhua waijiao chutan" (paper presented at the international conference Yingxiang yu shiliao: yingxiang zhong de jindai Zhongguo, National Chengchi University, Taipei, October 2014).

18. Wu, "Zhanlan zhong de 'Zhongguo,'" 79–80.

19. Huang Shaogu to Zhang Qun, January 23, 1960, "Zai Mei juxing Zhong-

guo yishu zhanlan jihua," n.d., file: Gugong wenwu yunsong guo nei wai zhanlan, 0042/33906/00/001/010~310, POA.

20. "Xingzhengyuan Zhongguo gu yishupin fu Mei zhanlan weiyuanhui di san ci weiyuanhui huiyi jilu," June 20, 1960, file: Canjia Meiguo gexiang zhanlan, collection: Ministry of Education (MOE), 019000000435A, AH.

21. "Past Exhibitions," accessed August 24, 2015, https://www.nga.gov/content /ngaweb/exhibitions/past.html

22. Matthew Masur, "Exhibiting Signs of Resistance: South Vietnam's Struggle for Legitimacy, 1954–1960," *Diplomatic History* 33, no. 2 (2009): 293–313; Claire Wintle, "Decolonizing the Smithsonian: Museums as Microcosms of Political Encounter," *American Historical Review* 121, no. 5 (2016): 1505–6.

23. Wu, "Zhanlan zhong de 'Zhongguo,'" 82–86.

24. Zhang Qiyun to Ministry of the Interior, July 20, 1954, file: Canjia Meiguo gexiang zhanlan, collection: MOE, 019000000434A, AH; Yu Hongjun to Secretary General of the Presidential Office, December 6, 1954, file: Gugong wenwu yunsong guo nei wai zhanlan, 0042/33906/00/001/010~310, POA.

25. Wu, "Zhanlan zhong de 'Zhongguo,'" 82–83; Giuffrida, "The Right Stuff," 202.

26. John Foster Dulles to F. Lammot Belin, May 6, 1955, June 14, 1955, folder 54787, Central Files Record Group 7, National Gallery of Art Archives (NGAA).

27. Nancy Bernkopf Tucker, *The China Threat: Memories, Myths, and Realities in the 1950s* (New York: Columbia University Press, 2012).

28. Ministry of Foreign Affairs, "Guwu yun Mei zhanlan an shuotie," n.d., file: Gugong wenwu yunsong guo nei wai zhanlan, 0042/33906/00/001/010~310, POA.

29. Yafeng Xia, *Negotiating with the Enemy: U.S.-China Talks during the Cold War, 1949–1972* (Bloomington: Indiana University Press, 2006), chap. 4.

30. Wu, "Zhanlan zhong de 'Zhongguo,'" 88–90.

31. K. L. Rankin to George K. C. Yeh, May 3, 1957, file: Canjia Meiguo gexiang zhanlan, collection: MOE, 019000000434A, AH.

32. Zhang Shuya, "Taihai weiji yu Meiguo dui 'fangong dalu' zhengce de zhuanbian," *Zhongyang yanjiuyuan jindaishi yanjiusuo jikan*, no. 36 (2001): 231–90; Zhao Yina, "Meiguo zhengfu zai Taiwan de jiaoyu yu wenhua jiaoliu huodong (1951–1970)," *Oumei yanjiu* 31, no. 1 (2001): 79–127; Zhang Shuya, "'Zhuyi wei qianfeng, wuli wei houdun': Ba'ersan paozhan yu 'fangong dalu' xuanchuan de zhuanbian," *Zhongyang yanjiuyuan jindaishi yanjiusuo jikan*, no. 70 (2010): 1–49.

33. Wen-hsin Yeh, "Living with Art: The Yeh Family Collection and the Modern Practices of Chinese Collecting," in *Collecting China: The World, China, and a History of Collecting*, ed. Vimalin Rujivacharakul (Newark: University of Delaware Press, 2011), 176–83.

34. Jin Guangyao, *Gu Weijun zhuan* (Shijiazhuang: Hebei renmin chubanshe, 1999).

35. Dong Xianguang, *Dong Xianguang zizhuan: yige nongfu de zishu* (Taipei: Taiwan xinsheng baoshe, 1973).

36. Wu, "Zhanlan zhong de 'Zhongguo,'" 90.

37. Handwritten note by Chiang Kai-shek to Zhang Qun, January 28, 1958, Zhang Qun to Madame Chiang Kai-shek, July 23, 1959, file: Gugong wenwu yunsong guo nei wai zhanlan, 0042/33906/00/001/010~310, POA.

38. Wang Shijie to Huang Shaogu, December 4, 1959, file: Gugong wenwu yunsong guo nei wai zhanlan, 0042/33906/00/001/010~310, POA; Lin Meili, *Wang Shijie riji*, vol. 2 (Taipei: Zhongyang yanjiuyuan jindaishi yanjiusuo, 2012), entries on October 27, 1959, November 4, 1959, November 5, 1959, and November 13, 1959.

39. Wu, "Zhanlan zhong de 'Zhongguo,'" 94–97, 99.

40. Huang Shaogu to Zhang Qun, n.d. (c. mid-December, 1959), Xinwen gao, n.d., file: Gugong wenwu yunsong guo nei wai zhanlan, 0042/33906/00/001/010~310, POA; Wu, "Zhanlan zhong de 'Zhongguo,'" 91.

41. Cheng Tianfang to Ministry of Foreign Affairs, May 17, 1954, file: Guowai zhanlan, collection: MOE, 019000000333A; Zhang Qun to Zhang Qiyun, September 30, 1955, file: Guowai zhanlan ge sheng shi meishu yishu, collection: MOE, 01900000334A, AH.

42. "Zhonghua renmin gongheguo wenhuabu fabiao shengming" [The Ministry of Culture of the People's Republic of China issues a statement], *Renmin ribao*, February 22, 1960.

43. Wu, "Zhanlan zhong de 'Zhongguo,'" 74–78.

44. Cohen, *East Asian Art and American Culture*, 170, 181.

45. Henry Luce III to John Walker, February 25, 1960, folder 1, Chinese Art Treasures C-25, NGAA; Wu, "Zhanlan zhong de 'Zhongguo,'" 106, 111.

46. John A. Pope to Perry T. Rathbone, April 14, 1960, John A. Pope to Hu Shih, April 22, 1960, folder 11, box 3, John Pope Papers, Freer and Sackler Gallery Archives (FS). In neither letter did Pope list all the five objects.

47. Pope to Walker, May 9, 1960, folder 11, box 3, John Pope Papers, FS.

48. John A. Pope to John Walker, April 28, 1960, folder 11, box 3, John Pope Papers, FS.

49. Lin, ed., *Wang Shijie riji*, entries on October 26, 1959, April 21, 1960, and May 2, 1960.

50. Wu, "Zhanlan zhong de 'Zhongguo,'" 156–58.

51. Giuffrida, "The Right Stuff," 204.

52. Guoli gugong zhongyang bowuyuan gongtong lishihui tebie chuban xiaozu to Guoli gugong zhongyang bowuyuan lianhe guanli chu, n.d. (probably 1960), file: Canjia Meiguo gexiang zhanlan, collection: MOE, 019000000435A, AH; Guoli gugong zhongyang bowuyuan gongtong lishihui ed., *Gugong cangci* (Hong Kong: Cafa, 1961–1969).

53. Xingzhengyuan Zhongguo gu yishupin fu Mei zhanlan weiyuanhui disici weiyuan huiyi yicheng, December 6, 1960, file: Canjia Meiguo gexiang zhanlan, collection: MOE, 019000000436A, AH.

54. James Cahill to John A. Pope, February 28, 1961, folder 11, box 4, James Cahill Papers, FS.

55. James Cahill to John A. Pope, February 28, 1961.

56. James Cahill, *Chinese Painting* (Geneva: Albert Skira, 1960).

57. Li Lincan, *Guobao fu Mei zhanlan riji* (Taipei: Taiwan Shangwu yinshuguan, 1972), 95–96; Wu, "Zhanlan zhong de 'Zhongguo,'" 156–58.

58. James Cahill, "The Place of the National Palace Museum in My Scholarly Career," 2005; Giuffrida, "The Right Stuff," 206–7. Giuffrida's writing overlooks Cahill's original letter in 1961.

59. See, e.g., *Chinese Art Treasures* (Geneva: Skira, 1961), 34–35, 44–45, 55.

60. *Chinese Art Treasures*, 76.

61. Pope to Walker, May 9, 1960, folder 11, box 3, John Pope Papers, FS; James Cahill to John A. Pope, February 28, 1961, folder 11, box 4, James Cahill Papers, FS.

62. Lin, ed., *Wang Shijie riji*, entry on November 7, 1960.

63. Minute of the annual meeting of the board of trustees, China Institute in America, Inc., February 25, 1960, HS-NK05-168-023, HSMH; "Oct. 10 Showing of Chinese Art to Aid Institute," *New York Times*, September 17, 1961; Wu, "Zhanlan zhong de 'Zhongguo,'" 198.

64. Wu, "Zhanlan zhong de 'Zhongguo,'" 130, 135–36.

65. Wu, "Zhanlan zhong de 'Zhongguo,'" 198; "Japanese Painting and Sculpture from the Sixth Century A.D. to the Nineteenth Century," accessed January 24, 2016, http://www.nga.gov/content/ngaweb/exhibitions/1953/japanese_painting_sculpture.html

66. "Tutankhamun Treasures," accessed March 25, 2023, https://www.nga.gov/exhibitions/1961/tutankhamun.html

67. "Mona Lisa by Leonardo da Vinci," accessed March 25, 2023, https://www.nga.gov/exhibitions/1963/mona_lisa.html

68. Wu, "Zhanlan zhong de 'Zhongguo,'" 134–35.

69. Leslie Judd Ahlander, "Incomparable Rarities from China," *Washington Post*, May 28, 1961; Stuart Preston, "Museum Displays Art of Old China: 231 Objects from Imperial Collection in Loan Show at Metropolitan," *New York Times*, September 15, 1961; "From a Peking Palace," *Time* 78, no. 11 (September 15, 1961): 54; Edgar J. Driscoll Jr., "Heavily Guarded Art Here from Formosa," *Boston Globe*, November 14, 1961; Edith Weigle, "Treasures from Old China," *Chicago Tribune*, February 18, 1962.

70. "Art Institute Airs Chinese Works Feb. 26," *Chicago Defender*, February 20, 1962.

71. *Chinese Art Treasures*, 8.

72. Li, *Guobao fu Mei zhanlan riji*, fig. 11. For Fang's painting, see *Chinese Art Treasures*, 168–69.

73. Fang Wen, "Gannian Guoli gugong bowuyuan," *Gugong wenwu yuekan* (October 2005): 24.

74. Cahill, "The Place of the National Palace Museum in My Scholarly Career."

75. Tang, *Shuo Zhonghua minzu zhi huaguo piaoling*, 34.

76. Wu, "Zhanlan zhong de 'Zhongguo,'" 218.

77. Wu, "Zhanlan zhong de 'Zhongguo,'" 167–70.

78. Chen Cheng to Secretary General of the Presidential Office, March 4, 1960, 0042/33906/00/001/010~310, POA.

79. Yan Jiagan to Bank of Taiwan, February 15, 1963, file: Meiguo zhanlan gugong guwu, collection: MOE, 019000000430A; Yan Jiagan to Ministry of Education, February 20, 1965, file: Canjia Meiguo gexiang zhanlan, collection: Ministry of Foreign Affairs, 019000000438A, AH.

80. Chen Qingyu to Bank of Taiwan, February 7, 1967, file: Canjia Meiguo gexiang zhanlan, collection: MOE, 019000000439A, AH.

81. "Shangtao canjia mingnian Xiyatu 21 shiji bolanhui choubei shiyi huiyi jilu," November 8, 1961, file: Canjia Meiguo gexiang zhanlan, collection: MOE, 019000000437A, AH.

82. "Zhonghua minguo canjia 1964 nian Niuyue shijie bolanhui zhanchu jihua zonghe xiuzheng cao'an," July 1963, file: Canjia Meiguo gexiang zhanlan, collection: MOE, 019000000439A, AH.

83. Julie Nicoletta, "Art Out of Place: International Art Exhibits at the New York World's Fair of 1964–1965," *Journal of Social History* 44, no. 2 (2010): 499–519; Rosendorf, *Franco Sells Spain to America*, chap. 6; Jessamyn R. Abel, *Dream Super-Express: A Cultural History of the World's First Bullet Train* (Stanford: Stanford University Press, 2022), 195–207.

84. Lawrence R. Samuel, *The End of the Innocence: The 1964–1965 New York World's Fair* (Syracuse, NY: Syracuse University Press, 2010); Joseph Tirella, *Tomorrow-Land: The 1964–65 World's Fair and the Transformation of America* (Guilford, CT: Lyons, 2013).

85. "Woguo canjia 1964 nian Niuyue shijie bolanhui zhongyao jingguo jielüe," July 15, 1963, file: Canjia Meiguo gexiang zhanlan, collection: MOE, 019000000439A, AH; Xu, "Zhanshi 'Zhongguo,'" 208–9.

86. Allen E. Beach to General Potter, January 27, 1961, Allen E. Beach to staff and consultants, February 14, 1961, folder P0.3 China, Republic of 1961–1963, box 269, New York World's Fair 1964–1965 Records (hereafter NYWF 1964–65), New York Public Library; Robert A. Caro, *The Power Broker: Robert Moses and the Fall of New York* (New York: Knopf, 1974).

87. Emanuel Perlmutter, "World's Fair Bid to Peiping Barred," *New York Times*, June 3, 1962.

88. "J. Donoghue Corporation Press Release," September 21, 1961, folder P0.3 China, Republic of 1961–1963, box 269, NYWF 1964–65.

89. Nicoletta, "Art Out of Place," 504.

90. Gates Davison to Alan G. Kirk, July 20, 1962, Robert Moses to Kien Wen Yu, July 18, 1963, folder P0.3 China, Republic of 1961–1963, box 269, NYWF 1964–65.

91. Robert Moses to Gates Davison, July 11, 1963, Robert Moses to Governor Poletti, September 29, 1964, folder P0.3 China-Art Treasures, box 269, NYWF 1964–65.

92. Xu, "Zhanshi 'Zhongguo,'" 214; "Welcome to the China Pavilion," unidentified magazine clip, n.d., folder P0.3 China-Art Treasures, box 269, 1964 NYWF 1964–65.

93. "Yange" [Institutional history], accessed August 27, 2015, http://www.nmh.gov.tw/zh/about_9_2.htm

94. Bao Zunpeng to Ministry of Education, September 26, 1962, "Guoli lishi bowuguan chengban canjia 1964 nian Niuyue shijie bolanhui lishi wenwu zhanlan jihua," December 1962, file: Canjia Meiguo Niuyue bolanhui, collection: MOE, 019000000431A, AH.

95. "Guoli lishi bowuguan chengban canjia 1964 nian Niuyue shijie bolanhui lishi wenwu bumen zhanlan jihuashu," June 12, 1963, file: 1964 nian Niuyue shijie bolanhui, collection: Ministry of Communications Tourism Bureau, 047000000339A, AH.

96. "Woguo canjia 1964 nian Niuyue shijie bolanhui zhongyao jingguo jielüe," July 15, 1963, file: Canjia Meiguo gexiang zhanlan, collection: MOE, 019000000439A, AH.

97. Wang Shijie, Li Ji, and Ye Gongchao, "Guoli gugong zhongyang bowuyuan canjia Niuyue shijie bolanhui zhanlan sanren xiaozu taolun baogao," June 3, 1963, file: Canjia Meiguo gexiang zhanlan, collection: MOE, 019000000439A, AH.

98. Enclosure 3 to "Zhonghua minguo canjia 1964 nian Niuyue shijie bolanhui zhanchu jihua zonghe xiuzheng cao'an," July 1963, file: Canjia Meiguo gexiang zhanlan, collection: MOE, 019000000439A, AH; Xu, "Zhanshi 'Zhongguo,'" 212–13.

99. Aschwin Lippe to Gates Davison, July 16, 1963, folder P0.3 China-Art Treasures, box 269, NYWF 1964–65.

100. You Jianwen, "Duiyu woguo canjia 1964 nian Niuyue shijie bolanhui canzhan choubei xiaozu ge bumen gongzuo jihua zhi yijian ji jianyi," n.d., file: Canjia Meiguo gexiang zhanlan, collection: MOE, 019000000439A, AH.

101. "Zhonghua minguo canjia Niuyue shijie bolanhui gongzuo xiaozu di yi ci huiyi jilu," June 20, 1964(?), file: 1964 nian Niuyue shijie bolanhui, collection: Ministry of Communications Tourism Bureau, 047000000339A, AH.

102. "Zhongguo guan er lou buzhi jihua," enclosure to Zhonghua minguo canjia 1964 nian Niuyue shijie bolanhui zhuan'an xiaozu di wu ci huiyi yicheng, December 18, 1963, file: 1964 nian Niuyue shijie bolanhui, collection: Ministry of Communications Tourism Bureau, 047000000339A, AH.

103. "Zhonghua minguo canjia 1964 nian Niuyue shijie bolanhui zhanchu jihua zonghe xiuzheng an," n.d. (probably July 1963), file: Canjia Meiguo gexiang zhanlan, collection: MOE, 019000000439A, AH; "Canjia 1964 nian Niuyue shijie bolanhui guanguang bumen zhanchu jihua xiuzheng cao'an," May 22, 1963, file: 1964 nian Niuyue shijie bolanhui, collection: Ministry of Communications Tourism Bureau, 047000000339A, AH.

104. Yan Jiagan to Chiang Kai-shek, March 2, 1964, file: Gugong wenwu yunsong guo nei wai zhanlan, 0042/33906/00/001/010~310, POA.

105. Lü Shaoli, *Zhanshi Taiwan: quanli, kongjian yu zhimin tongzhi de xingxiang biaoshu* (Taipei: Maitian chuban, 2011), 341–90.

106. Ye Longyan, "Taiwan zhanhou chuqi lüyou ye de fusu," *Taibei wenxian*, no. 163 (2008): 21–54; Zheng Qiaojun, "Cong Jiang Jieshi dui zhanhou guanguang shiye de zhishi kan zhanhou guanguang shiye de fazhan," in *Jiang Jieshi de richang shenghuo*, ed. Lü Fangshang (Taipei: Zhengda chubanshe, 2012): 243–57; Zheng Qiaojun, "Cong *Guanguang yuekan* kan Zhonghua minguo de xingxiang (1966–1971)" (paper presented at the international conference Yingxiang yu shiliao: yingxiang zhong de jindai Zhongguo, National Chengchi University, Taipei, October 2014).

107. Shi Zhiyu, "Taiwan bentuhua lunshu de dangdai yuanqi," *Zhanwang yu tansuo* 1, no. 4 (2003): 73–84; Wakabayashi Masahiro, *Zhanhou Taiwan zhengzhishi: Zhonghua minguo Taiwanhua de licheng*, trans. Hong Yuru et al. (Taipei: Taida chuban zhongxin, 2014), 137–210; J. Bruce Jacobs, "'Taiwanization' in Taiwan's Politics," in *Cultural, Ethnic, and Political Nationalism in Contemporary Taiwan: Bentuhua*, ed. John Makeham and A-chin Hsiau (New York: Palgrave Macmillan, 2005), 17–34. For a different perspective focusing on currency design, see Man-hung Lin, "Money,

Images, and the State: The Taiwanization of the Republic of China, 1945–2000," *Twentieth-Century China* 42, no. 3 (2017): 274–96.

108. Telegram from Jiang Tingfu, May 22, 1964, enclosure 3 to "Woguo canjia 1964 nian Niuyue shijie bolanhui zhuan'an xiaozu di liu ci huiyi jilu," June 2, 1964, file: 1964 nian Niuyue shijie bolanhui, collection: Ministry of Communications Tourism Bureau, 047000000339A, AH; Abel, *Dream Super-Express*, 195–207.

109. "Jiancha yuan 53 niandu zheng zi di 7 hao jiuzheng an gaijin qingxing jian-bao: jiuzheng an yaodian," n.d., "Zhonghua minguo canjia Niuyue shijie bolanhui gongzuo xiaozu di er ci huiyi jilu," July 9, 1964, file: 1964 nian Niuyue shijie bolan-hui, collection: Ministry of Communications Tourism Bureau, 047000000339A, AH.

110. Xu, "Zhanshi 'Zhongguo,'" 216–21.

111. "Jiancha yuan."

112. ROC Consulate General in New York to MOE, December 24, 1964, file: Canjia Meiguo Niuyue bolanhui, collection: MOE, 019000000432A, AH.

113. Peter E. Hamilton, *Made in Hong Kong: Transpacific Networks and a New History of Globalization* (New York: Columbia University Press, 2021), chap. 5.

114. Charles Poletti to Sir Robert Black, April 10, 1961, G. Barnes to Charles Poletti, April 18, 1961, Sam P. Gilstrap to Robert Moses, April 25, 1961, folder P0.3 Hong Kong Exhibit 1960–1962, box 273, NYWF 1964–65.

115. Lynn Olson to New York World's Fair, May 23, 1962, folder P0.3 Hong Kong Exhibit 1960–1962, box 273, NYWF 1964–65; Sydney Fields, "Only Human Pavilion Partners," *New York Mirror*, September 16, 1963; Gates Davison to Robert Moses, January 16, 1964, folder P0.3 Hong Kong 1964 Foreign Participation, box 273, NYWF 1964–65; "John P. Humes Dies; Former Envoy Was 64," *New York Times*, October 3, 1985.

116. John P. Humes to Douglas K. Beaton, May 23, 1962, John V. Thornton to Charles Poletti, May 28, 1962, folder P0.3 Hong Kong Exhibit 1960–1962, box 273, NYWF 1964–65; John P. Humes to Douglas K. Beaton, August 23, 1963, Carol Lyttle to Mr. Constable, Gen. Meyers, and Judge Maguire, September 18, 1963, folder P0.3 Hong Kong 1963, box 273, NYWF 1964–65.

117. Douglass Beaton to John Humes, June 4, 1963, folder P0.3 Hong Kong 1963, box 273, NYWF 1964–65.

118. Hong Kong Pavilion press release, "General," n.d., folder P0.3 Hong Kong-1965 Foreign Participation, box 273, NYWF 1964–65.

119. Hong Kong Trading Co., Hong Kong Pavilion Official Bulletin: New York World's Fair 1964–1965, n.d., folder P0.3 Hong Kong-1965 Foreign Participation, box 273, NYWF 1964–65.

120. Daniel Slotnik, "Jeno Paulucci, a Pioneer of Ready-Made Ethnic Foods, Dies at 93," *New York Times*, November 25, 2011.

121. John A. Blatnik to Robert Moses, March 6, 1964, folder P1.680 Chun King (1960–1964), box 324, NYWF 1964–65.

122. Press release, February 20, 1963, folder P1.680 Chun King (1960–1964), box 324; photos in folder Chun King Inn, box 660, NYWF 1964–65.

123. Press release; Derus Media Service, "For the Budget-Conscious Ding How for Hungry Fairgoers," n.d., folder P1.680 Chun King (1960–1964), box 324, NYWF 1964–65.

124. John P. Humes to Douglas K. Beaton, March 3, 1964, John P. Humes to Douglas Beaton, April 20, 1964, Doug Beaton to John P. Humes, April 21, 1964, folder P0.3 Hong Kong 1964 Foreign Participation, box 273, NYWF 1964–65.

125. John C. Y. Kao to Douglas Beaton, May 27, 1964, folder P0.3 Hong Kong 1964 Foreign Participation, box 273, NYWF 1964–65.

126. Henin Chin, ed., *Official Chinatown Guide Book, New York 1964–65* (New York: Henin & Company, 1964).

127. Photo negatives D3264, D3265, D5555, D5851, D6850, D6853, NYWF 1964–65; Samuel, *The End of the Innocence*, xiv, 50, 66, 154.

128. See folder: China, Republic of Interior, box 660, NYWF 1964–65.

129. Xu, "Zhanshi 'Zhongguo,'" 221–23.

130. Wang Shijie to Ministry of Economic Affairs, July 8, 1965, file: Canjia Meiguo Niuyue bolanhui, collection: MOE, 019000000432A, AH.

131. Jiang Fucong to Ministry of Economic Affairs, November 10, 1965, Li Guoding to New York World's Fair ROC Pavilion, October 9, 1965, file: Canjia Meiguo Niuyue bolanhui, collection: MOE, 019000000432A, AH.

132. Xu, "Zhanshi 'Zhongguo,'" 226.

133. Kirby, "The Chinese Party-State," 133.

134. Taomo Zhou, *Migration in the Time of Revolution: China, Indonesia, and the Cold War* (Ithaca: Cornell University Press, 2019), chap. 3; Kung, *Diasporic Cold Warriors*, chap. 4. For an exception in Thailand, see Beiyu Zhang, *Chinese Theatre Troupes in Southeast Asia: Touring Diaspora, 1900s–1970s* (New York: Routledge, 2021), 139.

135. Chen Guanren, "1950–60 niandai Zhonghua minguo dui Mei xuanchuan zhengce de zhuanxing," *Zhengda shi cui*, no. 27 (2014): 91–120.

136. Chinese Art Society of America, *The Art of Eastern Chou, 772–221 B.C. (a Loan Exhibition)* (New York, 1962); "This Week around the Galleries," *New York Times*, February 16, 1964.

137. "Pavilion of the Republic of China," n.d., folder P0.3 China, Republic of 1964, box 269, NYWF 1964–65.

138. Cagdas Ungor, "Reaching the Distant Comrade: Chinese Communist Propaganda Abroad (1949–1976)" (PhD diss., State University of New York at Binghamton, 2009); Gregg A. Brazinsky, *Winning the Third World: Sino-American Rivalry during the Cold War* (Chapel Hill: University of North Carolina Press, 2017), chap. 5.

139. Xin Zhongguo duiwai wenhua jiaoliu shilüe bianweihui, ed., *Xin Zhongguo duiwai wenhua jiaoliu shilüe* (Beijing: Zhongguo youyi chuban gongsi, 1999), chap. 3–4; Yao Yao, *Xin Zhongguo duiwai xuanchuan shi: jiangou xiandai Zhongguo de guoji huayu quan* (Beijing: Qinghua daxue chubanshe, 2014), 44–47; China Arts and Entertainment Group Ltd., "Timeline," accessed March 24, 2020, http://en.caeg .cn/caeg/dsj/201802/b2931bf0b32b49609c11e51e018340bb.shtml

140. David G. Tompkins, "Red China in Central Europe: Creating and Deploying Representations of an Ally in Poland and the GDR," in *Socialist Internationalism in the Cold War: Exploring the Second World*, ed. Patryk Babiracki and Austin Jersild (Cham, Switzerland: Palgrave Macmillan, 2016), 273–301; Emily Wilcox, "Performing Bandung: China's Dance Diplomacy with India, Indonesia, and Burma, 1953–1962," *Inter-Asia Cultural Studies* 18, no. 4 (2017): 518–39; Austin Jersild,

"Socialist Exhibits and Sino-Soviet Relations, 1950–60," *Cold War History* 18, no. 3 (2018): 280; Yang Wang, "Envisioning the Third World: Modern Art and Diplomacy in Maoist China," *ARTMargins* 8, no. 2 (2019): 31–54; Yiqing Li, "Art Diplomacy: Drawing China-Indonesia Relations in the Early Cold War, 1949–1956," *Modern Asian Studies* 57, no. 6 (2023): 1707–42.

CHAPTER 5

1. Leonard A. Kusnitz, *Public Opinion and Foreign Policy: America's China Policy, 1949–1979* (Westport, CT: Greenwood, 1984), 162–64.

2. For more on Taiwan's economic takeoff, see Qu Wanwen, *Taiwan zhanhou jingji fazhan de yuanqi: houjin fazhan de weihe yu ruhe* (Taipei: Lianjing chuban gongsi, 2017).

3. ROC embassy in the United States to Ministry of Foreign Affairs, July 7, 1966, file: Minguo 56 niandu kuoda dui Mei xuanchuan gongzuo jinji jihua, collection: Ministry of Foreign Affairs (hereafter MOFA), 11-13-07-04-018, Academia Sinica Institute of Modern History Archives (hereafter IMH).

4. Enclosure to ROC embassy to Ministry of Foreign Affairs, William Henderson, "The Future of the China Institute in America," March 22, 1966.

5. Enclosure to ROC embassy to Ministry of Foreign Affairs, Cheng Qibao memo, June 28, 1966.

6. Ministry of Foreign Affairs Intelligence Division, "Dui '56 niandu kuoda dui Mei xuanchuan gongzuo jinji jihua' cao'an zhi jianyi," October 4, 1966, file: Jiaqiang dui Mei xuanchuan, collection: MOFA, 11-07-02-03-02-003, IMH.

7. Wei Jingmeng, "Guanyu Hua Mei xiejinshe xianzhuang baogao," July 25, 1967, file: Zongtongfu xuanwai zonghe yanjiuzu, collection: MOFA, 11-13-07-02-065, IMH.

8. William Henderson, *Pacific Settlement of Disputes: The Indonesian Question, 1946–1949* (New York: Woodrow Wilson Foundation, 1954); Joseph G. Morgan, *The Vietnam Lobby: The American Friends of Vietnam, 1955–1975* (Chapel Hill: University of North Carolina Press, 1997).

9. Wei, "Guanyu Hua Mei xiejinshe."

10. Wei, "Guanyu Hua Mei xiejinshe."

11. Lu Yizheng to Zhou Shukai, April 26, 1968, MOFA notes, May 9, 1968, May 23, 1968, file: Zongtongfu xuanwai Meizhou xiaozu, collection: MOFA, 11-07-02-03-02-013, IMH.

12. "Yan fuzongtong jiejian Ai Guoyan, Wang Rong'an," *Zhongyang ribao*, September 1, 1968; Cheng Qibao, "Liushi nian jiaoyu shengya (er): huiyi sanji zhi er," *Zhuanji wenxue* 23, no. 4 (1973): 22; Meng, *Chinese American Understanding*, 156–57.

13. "Director Named by China Institute," *New York Times*, March 30, 1969; telephone interview with Hsu, April 4, 2016.

14. Telephone interview with Hsu, April 11, 2016.

15. Hsu interview, April 4, 2016.

16. ROC embassy in the United States, "60 nian 5 yuefen guang'an gongzuo baogao," file: Zhu Mei dashiguan guang'an, collection: MOFA, 11-13-07-04-095, IMH; ROC embassy in the United States, "61 nian 5 yuefen guang'an gongzuo baogao," "61 nian 6 yuefen guang'an gongzuo baogao," file: Zhu Mei dashiguan

guang'an, collection: MOFA, 11-13-07-04-096, IMH; ROC embassy in the United States to MOFA, May 19, 1971, file: Jiaqiang dui Mei xuanchuan, collection: MOFA, 11-07-02-03-02-005, IMH.

17. "Yan fu zongtong 8 yue 31 ri jiejian Hua Mei xiejinshe shezhang Ai Guoyan," *Zhongyang ribao*, August 31, 1968; Chen Yuqing, note, n.d. (around 1970), file: Zongtongfu xuanwai xiaozu ziliao, collection: MOFA, 11-13-07-05-014, IMH; MOFA to secretary general of the Presidential Office, July 13, 1977, file: Jinjian (zongtong fu zongtong yuanzhang), collection: MOFA, 020000013997A, AH.

18. Personal correspondence with Helena Kolenda, August 25, 2014.

19. Chih Meng to F. Richard Hsu, June 10, 1975, folder: C. T. Loo Agenda+Minutes, C. Martin Wilbur Papers, Columbia University Rare Book & Manuscript Library.

20. Wei, "Guanyu Hua Mei xiejinshe."

21. F. Richard Hsu to K. T. Li, July 14, 1969, K. T. Li to F. Richard Hsu, October 24, 1969, folder: K. T. Li correspondence, 1969–70, no box information, China Institute records.

22. Wei Jingmeng to Zongtongfu xuanchuan waijiao zonghe yanjiuzu, March 17, 1972, file: Zongtongfu xuanwai zonghe yanjiuzu, collection: MOFA, 11-13-07-02-065, IMH.

23. MOFA to Executive Yuan, August 23, 1971, file: 1971 nian kuo'an, collection: MOFA, 11-13-04-04-006, IMH.

24. Zhang Jinjun to MOFA, September 17, 1972, file: Buzhu Hua Mei xiejinshe, collection: MOFA, 11-11-26-03-058, IMH.

25. "Front Matter," *Archives of the Chinese Art Society of America* 1 (1945/1946): 4.

26. Chinese Art Society of America and Asia House, *Arts of the Han Dynasty* (New York, 1961), 5.

27. Mrs. Edwin Stanton and Myron S. Falk Jr. to Lois Katz, June 25, 1965, folder: China Institute in America, 2 of 2, Brooklyn Museum Archives.

28. "Front Matter," *Archives of Asian Art* 20 (1966/1967): 3.

29. Wei Jingmeng, "Guanyu Hua Mei xiejinshe."

30. See, for example, Marvin D. Schwartz, "Antiques: Jade, Early and Late, at the China Institute," *New York Times*, October 26, 1968; Schwartz, "Antiques: A Ming Must, Fascinating Display of Fine Porcelains Is Shown at the China Institute," *New York Times*, October 31, 1970.

31. Marked copy, "The First Cycle: A Brief History of China Institute in America, 1926–1986," 16–18, folder: 60th Anniversary, Wango Weng personal papers.

32. More information can be found at the partially digitized Weng film collection at Columbia University, accessed February 17, 2023, https://findingaids.library.columbia.edu/ead/nnc-ea/ldpd_11018656/dsc/4

33. Huang Renyu, *Huanghe qingshan: Huang Renyu huiyi lu* (Beijing: Sanlian shudian, 2015), 96.

34. "The First Cycle," 17.

35. "The First Cycle," 17–18.

36. Hsu interview, April 11, 2016.

37. *Cheng Qibao xiansheng* (n.p.: 1976), 46; Chen Fangzhong, *Yu Bin shuji zhuan* (Taipei: Taiwan Shangwu yinshuguan, 2001), 67–68. There is some discrepancy as to the time of the ICC's founding and its Chinese name.

38. For the *Washington Post* reports, see, for example, "Chinese Art on Exhibit," January 6, 1946; "Fashion Show to Aid Chinese Student Fund," March 21, 1948; Peggy Preston, "Show Stars Exotic Chinese Fashions," April 1, 1948; "Chinese Fashions to Be Modeled at Benefit Tonight," April 12, 1956; "Chinese Ships Art Here for Passage to Join It," November 4, 1958; "Satisfy Yen for Chinese Type Cooking," February 18, 1960; Mary Ann Seawell, "Fourth Graders Learn to Speak Mandarin," September 20, 1966.

39. Cheng Qibao memo, n.d., file: Zongtongfu xuanwai zonghe yanjiuzu, collection: MOFA, 11-13-07-02-065, IMH; Yan Jiagan to MOFA, December 10, 1970, file: 1971 nian kuo'an, collection: MOFA, 11-13-07-04-006, IMH.

40. Zhou Shukai to MOFA, November 15, 1967, ROC embassy in the United States, "57 niandu qiang'an jingfei shouzhi mingxi biao," July 15, 1968, "58 niandu qiang'an jingfei 1 zhi 6 yuefen shouzhi mingxi biao," June 30, 1969, "59 niandu qiang'an jingfei shouzhi mingxi biao," July 31, 1970, file: 1969 nian qiang'an, collection: MOFA, 11-13-07-04-005, IMH.

41. Xingzhengyuan xinwenju zhu Niuyue xinwenchu, "Niuyue 'Zhongguo wenhua huiyi' juban jingguo," March 15, 1968, file: 1969 nian qiang'an, collection: MOFA, 11-13-07-04-005, IMH; Yu Guobin to MOFA, May 1?, 1970, file: Jiaqiang dui Mei xuanchuan, collection: MOFA, 11-07-02-03-02-005, IMH; Lin Guoxian, *"Zhonghua wenhua fuxing yundong tuixing weiyuanhui" zhi yanjiu* (Taipei: Daoxiang chubanshe, 2005).

42. Xue Guangqian, *Kunxing yiwang: Xue Guangqian boshi zhongyao jingli biannian zishu* (Taipei: Zhuanji wenxue chubanshe, 1984), particularly chaps. 10–12.

43. Yang Guang, "Zhongshantang zai Niuyue: Meiguo daxue nei weiyi zhongshi gudian jianzhu de lishi bianqian," unpublished manuscript (2015); Chen Yongfa et al., *Jiashi, guoshi, tianxiashi: Xu Zhuoyun yuanshi yisheng huigu* (Taipei: Zhongyang yanjiuyuan jindaishi yanjiusuo, 2010), 315.

44. ROC embassy in the United States to Minister and Vice Minister of Foreign Affairs, July 16, 1966, file: Jiaqiang dui Mei xuanchuan, collection: MOFA, 11-07-02-03-02-003, IMH; Shen Jianhong to Minister and Vice Minister of Foreign Affairs, July 23, 1971, file: 1971 nian kuo'an, collection: MOFA, 11-13-07-04-006, IMH. For existing scholarship on these organizations, see Him Mark Lai, "Developments in Chinese Community Organizations in the U.S. since World War II," in *The Chinese Diaspora: Selected Essays*, ed. Ling-chi Wang and Wang Gungwu, vol. 1 (Singapore: Times Academic Press, 1998), 235–36; Joyce Mao, *Asia First: China and the Making of Modern American Conservatism* (Chicago: University of Chicago Press, 2015), 105–34; Terry Lautz, *John Birch: A Life* (New York: Oxford University Press, 2016), chaps. 14–15.

45. For the genre's early history, see Andrea S. Goldman, *Opera and the City: The Politics of Culture in Beijing, 1770–1900* (Stanford: Stanford University Press, 2012).

46. Hsiao-t'i Li, *Opera, Society, and Politics in Modern China* (Cambridge, MA: Harvard University Asia Center, 2019), chap. 6.

47. Zeng Juemi, "Mei Lanfang fu Mei" [Mei Lanfang visits the US], *Zhongyang ribao*, January 14, 1930.

48. Xingzhengyuan xinwenju, "Fuxing jutuan fu Meizhou yanchu baogao," October 1963, file: Xiyatu bolanhui fuxing juxiao fu Mei, collection: MOFA, 020000016450A, AH; Guy, *Peking Opera*, 194n10.

49. Allen Hughes, "Theater: Young Visitors from Taiwan," *New York Times*, November 13, 1962.

50. Harold Shaw to Shen Chang-huan, July 13, 1961, file: Xiyatu nianyi shiji bolanhui yao fuxing juxiao fu Mei gongyan, collection: MOFA, 020000017145A, AH; "Fuxing jutuan fu Meizhou yanchu baogao."

51. Wei Jingmeng to Ministry of Education (MOE), February 24, 1970, file: Fuxing jutuan fu Mei gongyan, collection: MOFA, 020000017177A, AH.

52. "Shangtao mingniandu canjia Xiyatu nianyi shiji bolanhui shiyi huiyi jilu," June 9, 1961, file: Xiyatu nianyi shiji bolanhui yao fuxing juxiao fu Mei gongyan, collection: MOFA, 020000017145A, AH; Yin Zhongrong, "Xingzhengyuan waihui maoyi shenyi weiyuanhui di 329 ci huiyi taolun di (3) an jueyi tongzhi," September 8, 1961, file: Xiyatu nianyi shiji bolanhui yao fuxing juxiao fu Mei gongyan, collection: MOFA, 020000017145A, AH; Noam Kochavi, *A Conflict Perpetuated: China Policy During the Kennedy Years* (Westport, CT: Praeger, 2002), chap. 3.

53. Guy, *Peking Opera*, 55–57.

54. Norton Wheeler, *The Role of American NGOs in China's Modernization: Invited Influence* (New York: Routledge, 2012), chap. 2.

55. Joint Communiqué of the United States of America and the People's Republic of China, February 28, 1972, article 12.

56. Guanhua Wang, "'Friendship First': China's Sports Diplomacy during the Cold War," *Journal of American-East Asian Relations* 12, no. 3/4 (2003): 133–53; Guoqi Xu, *Olympic Dreams: China and Sports, 1895–2008* (Cambridge, MA: Harvard University Press, 2008), chaps. 3, 5; Pete Millwood, *Improbable Diplomats: How Ping-Pong Players, Musicians, and Scientists Remade US-China Relations* (New York: Cambridge University Press, 2022), chap. 2. For a gendered analysis of such physical appeals, see Kazushi Minami, "'How Could I Not Love You?': Transnational Feminism and US-Chinese Relations during the Cold War," *Journal of Women's History* 31, no. 4 (2019): 18–27.

57. The phrasing of the newspaper reporting does not make clear which Presbyterian establishment in Taiwan was involved. "Maijiantai jiji anpai wo zhuoqiudui fang Huafu" [McIntire actively arranges the Washington visit of our table tennis team], *Zhongyang ribao*, September 3, 1971; Markku Ruotsila, *Fighting Fundamentalist: Carl McIntire and the Politicization of American Fundamentalism* (New York: Oxford University Press, 2015).

58. "Fang Mei zhuodui xiangji fanguo" [Table tennis teams touring the US successively return], *Lianhe bao*, November 26, 1972.

59. "Zuzhi fudao Zhonghua minguo wenhua yishu tuanti fangwen Meiguo jihua dagang (cao'an)," n.d. [probably 1972], file: Zhonghua minguo guojutuan fu Mei Jia biaoyan: 1973 nian, collection: MOFA, 11-11-25-04-003, IMH.

60. MOFA to MOE Bureau of Culture, n.d. [probably late 1972], Chiang Ching-kuo to MOE, Ministry of Defense, Directorate General of Budget, Government Information Office, May 4, 1973, file: Zhonghua minguo guojutuan fu Mei Jia biaoyan: 1973 nian, collection: MOFA, 11-11-25-04-003, IMH.

61. Guy, *Peking Opera*, 67–68.

62. "Zupai Zhonghua minguo qingshaonian guojutuan jihua shuoming," n.d., file: Zhonghua minguo guojutuan fu Mei Jia biaoyan: 1973 nian, collection: MOFA, 11-11-25-04-003, IMH.

63. *Xin Zhongguo duiwai wenhua jiaoliu shilüe*, 200, 206.

64. This differs from Nancy Guy's interpretation that the PRC before the Cultural Revolution viewed "the upkeep of traditional culture" as key to its international legitimacy. Guy, *Peking Opera*, 57.

65. "Wo yishutuan zai Bali juxing zhaodaihui" [Our artistic troupe holds reception in Paris], February 21, 1964; "Zhongguo yishutuan shouci yanchu qingdao Bali guanzhong" [The debut of the Chinese artistic troupe dazzles the Parisian audience], February 23, 1964.

66. Goldstein, *Drama Kings*, 270.

67. Andrew C. McKevitt, *Consuming Japan: Popular Culture and the Globalizing of 1980s America* (Chapel Hill: University of North Carolina Press, 2017), 163.

68. "Shihe waiguoren guanshang de jumu," enclosure to Guojutuan fu Mei diyici huiyi, March 13, 1973, file: Zhonghua minguo guojutuan fu Mei Jia biaoyan: 1973 nian, collection: MOFA, 11-11-25-04-003, IMH.

69. "Chinese Opera," n.d., 1, 6, file: Zhonghua minguo guojutuan fu Mei Jia biaoyan: 1973 nian, collection: MOFA, 11-11-25-04-003, IMH.

70. "Zhonghua minguo guojutuan fu Mei fangwen zhidao weiyuanhui huiyi jilu," June 26, 1973, file: Zhonghua minguo guojutuan fu Mei Jia biaoyan: 1973 nian, collection: MOFA, 11-11-25-04-003, IMH.

71. "Chinese Opera," 6.

72. Goldstein, *Drama Kings*, 122–24, 156–57.

73. Siyuan Liu, "A. C. Scott," *Asian Theatre Journal* 28, no. 2 (2011): 414–25; Emily E. Wilcox, "Rulan Chao Pian 卞赵如兰 (1922–2013)," *Asian Theatre Journal* 32, no. 2 (2015): 636–47.

74. Cohen, *East Asian Art and American Culture*.

75. Lu Yizheng to Government Information Office, April 1973 [probably beginning of the month], April 27, 1973, file: Zhonghua minguo guojutuan fu Mei Jia biaoyan: 1973 nian, collection: MOFA, 11-11-25-04-003, IMH.

76. Lu Yizheng to MOE, June 7, 1973, file Zhonghua minguo guojutuan fu Mei Jia biaoyan: 1973 nian, collection: MOFA, 11-11-25-04-003, IMH.

77. Consulate general in San Francisco to MOFA, July 11, 1973, file: Zhonghua minguo guojutuan fu Mei Jia biaoyan: 1973 nian, collection: MOFA, 11-11-25-04-004, IMH.

78. "Yanshang Zhonghua minguo guojutuan di yi ci shiyan hou youguan gaijin shixiang huiyi jilu," July 30, 1973, file: Zhonghua minguo guojutuan fu Mei Jia biaoyan: 1973 nian, collection: MOFA, 11-11-25-04-004, IMH.

79. Lu Yizheng to MOFA, September 13, 1973, file: Zhonghua minguo guojutuan fu Mei Jia biaoyan: 1973 nian, collection: MOFA, 11-11-25-04-004, IMH.

80. Sylvie Drake, "Another Look at Peking Opera Genre," *Los Angeles Times*, September 5, 1973.

81. Lu Yizheng to MOFA, September 13, 1973, file: Zhonghua minguo guojutuan fu Mei Jia biaoyan: 1973 nian, collection: MOFA, 11-11-25-04-004, IMH.

82. I-Cheng Loh to MOFA and MOE, n.d. [probably mid-September 1973], file: Zhonghua minguo guojutuan fu Mei Jia biaoyan: 1973 nian, collection: MOFA, 11-11-25-04-005, IMH.

83. I-Cheng Loh to MOFA and MOE.

84. "Chinese Opera: Gongs and Whiteface," *Time*, October 8, 1973.

85. Sylvie Drake, "Chinese Opera Visits L.A.," *Los Angeles Times*, September 20, 1973.

86. Lu Yizheng to Consulate general in Seattle, September 14, 1973, file: Zhonghua minguo guojutuan fu Mei Jia biaoyan: 1973 nian, collection: MOFA, 11-11-25-04-005, IMH.

87. Consulate general in Seattle to MOFA, September 14, 1973, file: Zhonghua minguo guojutuan fu Mei Jia biaoyan: 1973 nian, collection: MOFA, 11-11-25-04-005, IMH.

88. "Guojutuan fanhui xi'an gongyan beiwanglu," October 22, 1973, file: Zhonghua minguo guojutuan fu Mei Jia biaoyan: 1973 nian, collection: MOFA, 11-11-25-04-005, IMH.

89. Consultate general in Seattle to MOFA, October 23, 1973, file: Zhonghua minguo guojutuan fu Mei Jia biaoyan: 1973 nian, collection: MOFA, 11-11-25-04-005, IMH.

90. Consulate general in Honolulu to MOFA, September 19, 1973, Lu Yizheng to ROC embassy in the United States, October 5, 1973, US-China Peoples Friendship Association at Madison, "The Old and New Peking Opera," n.d. [probably distributed on October 31, 1973], file: Zhonghua minguo guojutuan fu Mei Jia biaoyan: 1973 nian, collection: MOFA, 11-11-25-04-005, IMH. For a history of the US-China Peoples Friendship Association, see Paul B. Trescott, *From Frenzy to Friendship: The History of the US-China Peoples Friendship Association* (Morrisville, NC: Lulu, 2015).

91. Xingzhengyuan xinwenju zhu Niuyue xinwenchu, "Guojutuan fang Mei zong jiantao baogao," February 12, 1974, file: Zhonghua minguo guojutuan fu Mei Jia biaoyan: 1973 nian, collection: MOFA, 11-11-25-04-006, IMH.

92. Ouyang Huang to MOFA, October 30, 1973, file: Zhonghua minguo guojutuan fu Mei Jia biaoyan: 1973 nian, collection: MOFA, 11-11-25-04-005, IMH.

93. Lu Yizheng to Jiang Yanshi, November 26, 1973, file: Zhonghua minguo guojutuan fu Mei Jia biaoyan: 1973 nian, collection: MOFA, 11-11-25-04-005, IMH.

94. Charles Staff, "Chinese Opera Opens Door to Past," *Indianapolis News*, October 23, 1973.

95. Harold Schonberg, "Opera: Taiwan Style," *New York Times*, November 21, 1973.

96. Charles Faber, "Chinese Opera Displays Art," *Los Angeles Herald-Examiner*, September 20, 1973; Cynthia Kirk, "National Chinese Opera Theatre," *Oakland Tribune*, September 20, 1973, cited in *Express News*, September 28, 1973, and October 1, 1973; Staff, "Chinese Opera Opens Door to Past."

97. "Chinese Opera Premieres at Auditorium," *Chicago Defender*, October 17, 1973; "National Chinese Theatre Brings Kung Fu to Heinz," *New Pittsburgh Courier*, December 1, 1973.

98. Robeson Taj Frazier, *The East Is Black: Cold War China in the Black Radical Imagination* (Durham: Duke University Press, 2014).

99. Xingzhengyuan xinwenju zhu Niuyue xinwenchu, "Guojutuan fang Mei zong jiantao baogao."

100. "Guojutuan fang Mei zong jiantao baogao."

101. Wang Fei to MOFA, November 14, 1973, Sun Banghua to MOFA, November 22, 1973, and Lu Yizheng to Jiang Yanshi, November 26, 1973, file:

Zhonghua minguo guojutuan fu Mei Jia biaoyan: 1973 nian, collection: MOFA, 11-11-25-04-005, IMH.

102. Xingzhengyuan xinwenju zhu Niuyue xinwenchu, "Guojutuan fang Mei zong jiantao baogao."

103. Lu Yizheng to MOE, March 21, 1974, "Zhonghua mingguo guojutuan zaidu fu Mei Jia gongyan yusuan," n.d., file: Zhonghua minguo guojutuan fu Mei Jia biaoyan: 1974 nian, collection: MOFA, 11-11-25-04-007, IMH.

104. Nancy Bernkopf Tucker, *Strait Talk: United States-Taiwan Relations and the Crisis with China* (Cambridge, MA: Harvard University Press, 2009), chaps. 2–3.

105. *FRUS, 1969–1976*, vol. E–13, *Documents on China, 1969–1972*, documents 43 and 115.

106. MOFA to MOE, May 14, 1974, file: Zhonghua minguo guojutuan fu Mei Jia biaoyan: 1974 nian, collection: MOFA, 11-11-25-04-007, IMH.

107. Clive Barnes, "Chinese Opera: It Used to Be Great," *New York Times*, December 2, 1973.

108. Lu Yizheng to Wu Baohua, June 6, 1974, file: Zhonghua minguo guojutuan fu Mei Jia biaoyan: 1974 nian, collection: MOFA, 11-11-25-04-007, IMH.

109. Lu Yizheng to Wu Baohua, June 6, 1974.

110. Itinerary for 1974, n.d., file: Zhonghua minguo guojutuan fu Mei Jia biaoyan: 1974 nian, collection: MOFA, 11-11-25-04-007, IMH.

111. Mao, *Asia First*, 154–57.

112. Helen C. Smith, "Chinese Opera Theatre to Play Here in October," September 21, 1974; Smith, "Chinese Opera Theatre 'Elegant Variety Show,'" October 17, 1974.

113. Consulate general in Atlanta to MOFA, November 6, 1974, file: Zhonghua minguo guojutuan fu Mei Jia biaoyan: 1974 nian, collection: MOFA, 11-11-25-04-007, IMH.

114. Statement of Sen. Goldwater, 94 Cong. Rec. 3310–15 (1975).

115. See, for example, "Taiwan: Beautiful Isle of the Orient," "World's Greatest Collection of China Art," June 19, 1966; "Free China is Alive and Well," October 8, 1972.

116. Li Hongyuan, *Ji naxie boguang yu yingxiang: Li Hongyuan rensheng suibiji* (Taipei: Shibao chuban, 2015), 143–44.

117. "Index 1971–74," *Echo*, October (1974): 49–52.

118. Personal Correspondence with Chang Li; Lin Xiufen, "Haiwai xuanchuan kanwu zhong Taiwan de wenhua tuxiang: yi *Guanghua* zazhi wei zhongxin (1976–2005)" (Master's thesis, National Taiwan Normal University, 2011).

119. See, for example, "Wang Lan zai jinianzhou baogao woguo jidai kaituo wenhua waijiao gongzuo" [Wang Lan reports during the memorial week, our country is in urgent need of cultural diplomacy], *Zhongyang ribao*, July 14, 1970; "Zhengfu ying yu xiezhu peihe zi haiwai fanguo yishujia dui wenhua ju tigong yijian" [The government should provide support, artists returning from abroad give suggestions to the Bureau of Culture], *Zhongguo shibao*, November 7, 1971; "Tuixing 'wenhua waijiao zhan' jiang wenxue yishu xiang guowai shuchu yiwenjie yu shehui renshi zhichi" [Conduct the 'war of cultural diplomacy,' the artistic and literary circles urge more societal support of the international dissemination of arts and culture], *Lianhe bao*, November 7, 1971.

120. Guangfu dalu sheji yanjiu weiyuanhui, "Jiaqiang jidi jianshe, ji(ji) cejin

guangfu dalu chongjian sanmin zhuyi xin Zhongguo an: kaituo wenhua waijiao chuangzao duiwai guanxi xin jumian zhi yanjiu an," December 1973, file: Benhui yanni wancheng fang'an cheng zongtong jianhe juan-kaituo wenhua waijiao, collection: Guangfu dalu sheji yanjiu weiyuanhui, 120000001410A, AH.

121. For more on the history of blockbuster exhibitions, see Lin, "5,000 Years of Korean Art," 384–85.

122. Wu Shu-ying, "Zhanlan zhong de 'Zhongguo,'" 198; "The Exhibition of Archaeological Finds of the People's Republic of China," accessed February 1, 2017, https://www.nga.gov/content/ngaweb/exhibitions/1974/china_archaeology.html

123. For a list of the PRC art exhibitions overseas in the 1970s, see "Zhongguo wenwu jiaoliu zhongxin 1973–2009 nian juban wenwu zhanlan mulu," accessed May 22, 2017, http://www.aec1971.org.cn/art/2016/7/4/art_418_34657.html

124. Zhonghua renmin gongheguo chutu wenwu zhanlan gongzuo weiyuanhui, *The Exhibition of Archaeological Finds of the People's Republic of China* (Washington, DC: National Gallery of Art, 1974). For more on science in the PRC's Cold War international engagement, see E. Elena Songster, *Panda Nation: The Construction and Conservation of China's Modern Icon* (New York: Oxford University Press, 2018), chap. 4; Gordon Barrett, *China's Cold War Science Diplomacy* (New York: Cambridge University Press, 2022).

125. Gu Wenjie, "A Chinese Emperor's Clay Army," *Unesco Courier* (December 1979): 5–8.

EPILOGUE

1. Marshall Sahlins, *Confucius Institutes: Academic Malware* (Chicago: Prickly Paradigm Press, 2015).

2. Philip Thai, *China's War on Smuggling: Law, Economic Life, and the Making of the Modern State, 1842–1965* (New York: Columbia University Press, 2018), 275.

3. *Chinese Art Treasures*, 38.

4. Zheng Jianning, "Sunzi bingfa yi shi gouchen," *Xibei minzu daxue xuebao* (zhexue shehui kexue ban), no. 5 (2019): 178–88.

5. Elizabeth Lillehoj, "Making Asia Out of China: Okakura Kakuzō's Notions of Classicism," in *Collecting China: The World, China, and a History of Collecting*, ed. Vimalin Rujivacharakul (Newark: University of Delaware Press, 2011), 73–85.

6. Zhang Deliu, "Lun jinhou Zhongguo zhi 'wenhua waijiao'" [On China's "cultural diplomacy" in the future], *Zhongyang ribao*, October 24 and 25, 1941.

7. Zhou Shukai to Huang Shaogu, October 12, 1966, file: Dui Mei xuanchuan jimifei, collection: MOFA, 11-17-06-01-106, IMH.

8. "Guanyu Kongzi xueyuan/ketang," accessed June 18, 2020, http://www.hanban.org/confuciousinstitutes/node_10961.htm. The Institute's website has since migrated to an entirely different domain, "Quanqiu kongyuan," accessed December 15, 2023, https://ci.cn/qqwl

9. "Confucius Institute at China Institute," accessed January 29, 2023, https://www.chinainstitute.org/about-us/confucius-institute-at-china-institute-cici/ (no longer accessible, but see https://chinainstitute.org/about-us/ [accessed December 15, 2023]).

10. Pratik Jakhar, "Confucius Institutes: The Growth of China's Controversial Cultural Branch," BBC (website), September 7, 2019, accessed June 18, 2020, https://www.bbc.com/news/world-asia-china-49511231

11. Thomas Lum and Hannah Fischer, "Confucius Institutes in the United States: Selected Issues," Congressional Research Service, May 20, 2022.

12. Katherine Knott, "Could Confucius Institutes Return to U.S. Colleges?" *Inside Higher Ed*, January 26, 2023, accessed January 29, 2023, https://www.insidehighered.com/news/2023/01/26/report-proposes-waiver-criteria-confucius-institutes

13. Guo Zhenzhi et al., "Yong wenhua de liliang yingxiang shijie: shilun Zhongguo wenhua zhongxin de haiwai chuanbo," *Xinwen yu chuanbo yanjiu*, no. 2 (2016): 41–50.

14. Kathleen Teltsch, "Foundation Hopes to Strengthen U.S.-Japan Ties: Series of Good-Will Projects No Direct Lobbying Planned," *New York Times*, March 29, 1981; Kathleen Teltsch, "Hitachi Setting up U.S. Philanthropy: Joins Other Japanese Concerns Establishing Such Bodies in Show of Good Will," *New York Times*, November 17, 1983.

15. Tim Golden, "Donations to Universities Sometimes Carry a Price: Foreign-Studies Aid Can Have Political Pitfalls," *New York Times*, December 9, 1996.

16. Jennifer Hubbert, *China in the World: An Anthropology of Confucius Institutes, Soft Power, and Globalization* (Honolulu: University of Hawai'i Press, 2019).

17. Liao Zhen, "Liang'an haiwai hanxue tuiguang de jing yu he: yi 'Kongzi xueyuan' ji 'Taiwan shuyuan' weili," *Guojia tushuguan guankan*, no. 2 (2012): 113–38.

18. "Guanyu women," accessed February 1, 2023, https://la.us.taiwan.culture.tw/ch/content_109.html

19. Lik Sam Chan, "Emotional Duplex in the Nation (de-)Branding: A Case Study of China and Shen Yun Performing Arts," *Critical Studies in Media Communication* 33, no. 2 (2016): 139–53.

20. Joshua Kurlantzick, "China's Collapsing Global Image: How Beijing's Unpopularity Is Undermining Its Strategic, Economic, and Diplomatic Goals," Discussion Paper (Council on Foreign Relations, July 2022).

21. "Xi Jinping Calls for More 'Loveable' Image for China in Bid to Make Friends," BBC (website), June 2, 2021, accessed February 3, 2023, https://www.bbc.com/news/world-asia-china-57327177; Xinhua, "Full Text of the Report to the 20th National Congress of the Communist Party of China," October 25, 2022, accessed February 3, 2023, https://www.chinadaily.com.cn/a/202210/25/WS6357e484a310fd2b29e7e7de.html. Note the different translations of *ke'ai* between the BBC's "loveable" and its less sentimental Chinese version of "appealing."

22. Wang Mingsheng, "Lun 'sige zixin' yu yishi xingtai anquan: jianding 'sige zixin' yu xin shidai yishi xingtai jianshe de neizai luoji guanxi yanjiu," *Renmin luntan xueshu qianyan*, no. 2 (2019): 70–77.

23. Xiaoyu Pu, *Rebranding China: Contested Status Signaling in the Changing Global Order* (Stanford: Stanford University Press, 2019), 18; Bates Gill, *Daring to Struggle: China's Global Ambitions under Xi Jinping* (New York: Oxford University Press, 2022).

Glossary

biaoqing 表情
Bin Chun 斌椿
bizhen xizhi de xiangzhengxing dongzuo 逼真细致的象征性动作
buchong 補充
Cao Cao 曹操
Chang Renxia 常任俠
Chen Hengzhe 陳衡哲
Chen Jitong 陳季同
Chen Tian'en 陳天恩
Cheng Qibao 程其保
chouying 酬應
chuanbo hao Zhongguo shengyin 传播好中国声音
chufadian yibu xiangtong 出發點已不相同
Cixi 慈禧
daji Zhonggong wenhua shentou 打擊中共文化滲透
dan 旦
dao yi feng tong 道一風同
Daxue yuan 大學院
Dong Xianguang 董顯光
dongfanghua 東方化
Dongxi wenhua jiqi zhexue 東西文化及其哲學
dongyang 東洋
Fan Kuan 范寬
Fang Congyi 方從義

205

fangdajing midachi zhuyi 放大鏡米達尺主義
feichu yiqie bu pingdeng tiaoyue 廢除一切不平等條約
Fuxing juxiao 復興劇校
Gao Zhenying 高振英
gebie zuoye 各別作業
gexue saoyang 隔靴搔癢
Gonglun bao 公論報
Gu Hongming 辜鴻銘
Gu Weijun 顧維鈞
Guangfu dalu sheji yanjiu weiyuanhui 光復大陸設計研究委員會
Guo Bingwen 郭秉文
Guo Moruo 郭沫若
guocui 國粹
guojia mubiao de waiqing 国家目标的外倾
guoju 國劇
Guoli gugong bowuyuan 國立故宮博物院
Guoli lishi bowuguan 國立歷史博物館
guomin waijiao 國民外交
guoxue 國學
Guwu chenliesuo 古物陳列所
Hanjin kou 漢津口
Hansheng 漢聲
Hongmen zhigongdang 洪門致公黨
Hu Shi 胡適
Hua Mei xiejinshe 華美協進社
huixie 诙谐
jiang hao Zhongguo gushi 讲好中国故事
Jiang Kanghu 江亢虎
Jiang Tingfu 蔣廷黻
Jiang Yi 蔣彝
Jiaoyubu zai Mei jiaoyu wenhua shiye guwen weiyuanhui 教育部在美教育文化事業顧問委員會
jieyun 劫运
jingju 京劇
Jinshan si 金山寺
kexin ke'ai kejing 可信可爱可敬
kongyan 空言
Kongzi xueyuan 孔子学院
Li Shizeng 李石曾
Liang Qichao 梁啟超

Liang Shuming 梁漱溟
Lin Yutang 林語堂
linshi 臨時
Liu Bei 劉備
Liu Mei Zhongguo xuesheng zhanshi xueshu jihua weiyuanhui 留美中國
學生戰時學術計劃委員會
Liu Tingfang 劉廷芳
Lu Qinzhai 盧芹齋
Lu Xun 魯迅
Lu Yizheng 陸以正
Mei Lanfang 梅蘭芳
Meihou wang 美猴王
Meng Zhi 孟治
moshou zhanqian chengui 墨守戰前陳規
nuli yishi 奴隸意識
Ouyou xinying lu 歐遊心影錄
Qi Rushan 齊如山
Qian Cunxun 錢存訓
qita fangmiang 其他方面
quanpan xihua 全盤西化
Renmin ribao 人民日报
Shen Congwen 沈從文
Shen Pengxia 沈鵬俠
Shenyue qionglin tu 神岳瓊林圖
shi yi chang ji yi zhi yi 師夷長技以制夷
sige zixin 四个自信
Tai he dian 太和殿
Taiwan shuyuan 臺灣書院
Taiwanhua 臺灣化
Tang Junyi 唐君毅
Tiannü sanhua 天女散花
waijiao caichan 外交財產
Wang Shijie 王世杰
Wang Tao 王韜
Wei Zhongguo wenhua jinggao shijie renshi xuanyan 為中國文化敬告世
界人士宣言
weihu lishi wenhua 維護歷史文化
weimi rouruo 萎靡柔弱
Weng Wange 翁萬戈
wenhua pushi jiazhi 文化普世價值

wenhua waijiao 文化外交
wenhua xuanchuan 文化宣傳
wenhua yichan 文化遺產
wo Zhonghua minzu wuqiannian lishi wenhua de yichan 我中華民族五千年歷史文化的遺產
Wu Tingfang 伍廷芳
wudao dongzuo 舞蹈动作
xiangwai kuochong 向外擴充
xiaoxian xinshang 消閒欣賞
Xie Wenqiu 謝文秋
xifang huayu quan 西方话语权
Xingzhengyuan xinwenju 行政院新聞局
xitong biaoda 系統表達
xuanchuan 宣傳
Xue Fucheng 薛福成
Xue Guangqian 薛光前
Yan Huiqing 顏惠慶
Yan Jiagan 嚴家淦
Yang Xingfo 楊杏佛
Yang Xiu 楊秀
yanshen 眼神
Yao Shulai 姚叔來
Ye Gongchao 葉公超
yingli shiye 營利事業
yinhui zongyu de choushi 淫穢縱慾的醜史
yishi xingtai anquan 意识形态安全
yongjiu wenhua shiye 永久文化事業
You Jianwen 游建文
you lai xue wu wang jiao 有來學無往教
Yu Bin 于斌
yu shengyiren tan xuanchuan 與生意人談宣傳
Zeng Guofan 曾國藩
Zeng Jize 曾紀澤
Zeng Xianqi 曾憲七
Zhan Wancheng 戰宛城
Zhang Deyi 張德彝
Zhang Pengchun 張彭春
Zhang Shizhao 章士釗
Zhang Shuqi 張書旂
Zhang Taiyan 章太炎

zhengli guogu 整理國故

zhengtong 正統

zhizao 製造

zhizhi zhuanqian zhi Youtairen 只知賺錢之猶太人

Zhongguo benwei de wenhua jianshe xuanyan 中國本位的文化建設宣言

Zhongguo renmin duiwai youhao xiehui 中国人民对外友好协会

Zhongguo shibao 中國時報

Zhongguo wenhua xiehui 中國文化協會

Zhongguo xiehui 中國協會

Zhongguo yanchu jingli gongsi 中国演出经理公司

Zhonghua jiaoyu gaijin she 中華教育改進社

Zhonghua minzu 中華民族

Zhonghua wenhua fuxing yudong 中華文化復興運動

zhongxue wei ti xixue wei yong 中學為體西學為用

Zhongyang ribao 中央日報

Zhongyang tongxun she cankao xiaoxi 中央通訊社參考消息

Zhu Yuanzhi 朱沅芷

zhuti yishi zhengquexing 主題意識正確性

zishi 姿势

Ziyou Zhongguo 自由中國

zonghe 綜合

zonghe lianxi zhi lingdao 綜合聯繫之領導

Selected Bibliography

ARCHIVAL SOURCES

Academia Historica (Taipei)
Academia Sinica Institute of Modern History Archives (Taipei)
Brooklyn Museum Library and Archives (Brooklyn, NY)
Chinese Academy of Social Sciences Institute of Modern History Archives (Beijing)
Columbia University Rare Book & Manuscript Library (New York, NY)
Freer and Sackler Gallery Archives (Washington, DC)
Harvard University Radcliffe Institute Schlesinger Library (Cambridge, MA)
Hoover Institution Archives (Stanford, CA)
Hu Shih Memorial Hall Hu Shih Archives (Taipei)
Library of Congress Manuscript Division (Washington, DC)
National Gallery of Art Archives (Washington, DC)
New York Public Library Manuscripts and Archives Division (New York, NY)
Presidential Office Archives (Taipei)
Rockefeller Archives Center (Sleepy Hollow, NY)
Second Historical Archives of China (Nanjing)
Wango Weng Personal Papers (Lyme, NH)
Wesleyan University Mansfield Freeman Center for East Asian Studies
 (Middletown, CT)

NEWS SOURCES

Atlanta Constitution
Atlanta Daily World
Boston Globe
Chicago Defender
Chicago Tribune

Gonglun bao
Lianhe bao
Los Angeles Times
New Pittsburgh Courier
New York Times
Renmin ribao
Time
Wall Street Journal
Washington Post
Zhongguo shibao
Zhongyang ribao

PUBLISHED SOURCES

Note: The accuracy of the URLs only reflects the time of access.

Abel, Jessamyn R. *Dream Super-Express: A Cultural History of the World's First Bullet Train*. Stanford: Stanford University Press, 2022.

Abel, Jessamyn R. *The International Minimum: Creativity and Contradiction in Japan's Global Engagement, 1933–1964*. Honolulu: University of Hawai'i Press, 2015.

Abel, Jessamyn R., and Leo Coleman. "Dreams of Infrastructure in Global Asias." *Verge: Studies in Global Asia* 6, no. 2 (2020): vi–xxix.

Acton, Harold, and Shih-hsiang Chen, trans. *Modern Chinese Poetry*. London: Duckworth, 1936.

Adams, Henry. *The Education of Henry Adams: An Autobiography*. Boston: Houghton Mifflin, 1918.

Alitto, Guy. *The Last Confucian: Liang Shu-Ming and the Chinese Dilemma of Modernity*. Berkeley: University of California Press, 1979.

Allen, Clement F. R. "A Royal Heretic." *Spectator*, September 24, 1910.

Allen, Herbert J. "Missionaries in China." *Spectator*, September 24, 1910.

Allen, Ryan M., and Ji Liu, eds. *Kuo Ping Wen: Scholar, Reformer, Statesman*. San Francisco: Long River, 2016.

Altınay, Rüstem Ertuğ. "'Carrying Our Country to the World': Cold War Diplomatic Tourism and the Gendered Performance of Turkish National Identity in the United States." *Radical History Review*, no. 129 (2017): 103–24.

Arden Gallery. *3000 Years of Chinese Jade*. New York, 1939.

Arden Gallery. *Exhibition of Imperial Art Treasures from Peking's Forbidden City*. New York, 1939.

Auslin, Michael R. *Japan Society: Celebrating a Century 1907–2007*. New York: Japan Society, 2007.

Auslin, Michael R. *Pacific Cosmopolitans: A Cultural History of U.S.-Japan Relations*. Cambridge, MA: Harvard University Press, 2011.

Baldanza, Kathlene. *Ming China and Vietnam*. New York: Cambridge University Press, 2016.

Barrett, Gordon. *China's Cold War Science Diplomacy*. New York: Cambridge University Press, 2022.

Bell, Bernard W. "W.E.B. Du Bois' Search for Democracy in China: The Double Consciousness of a Black Radical Democrat." *Phylon* 51, no. 1 (2014): 115–27.

Bellisari, Andrew. "The Art of Decolonization: The Battle for Algeria's French Art, 1962–70." *Journal of Contemporary History* 52, no. 3 (2017): 625–45.

Bennett, Robert. "Pop Goes to the Future: Cultural Representations of the 1939–1940 New York World's Fair." In *Designing Tomorrow: America's World's Fairs of the 1930s*, edited by Robert W. Rydell and Laura Burd Schiavo, 177–91. New Haven: Yale University Press, 2010.

Bernal, Martin. "Liu Shih-p'ei and National Essence." In *The Limits of Change: Essays on Conservative Alternatives in Republican China*, edited by Charlotte Furth, 90–112. Cambridge, MA: Harvard University Press, 1976.

Beurden, Sarah Van. *Authentically African: Arts and the Transnational Politics of Congolese Culture*. Athens: Ohio University Press, 2015.

Bickers, Robert A. *Out of China: How the Chinese Ended the Era of Western Domination*. London: Allen Lane, 2017.

Bouquet, Dorothée. "French Academic Propaganda in the United States, 1930–1939." In *Teaching America to the World and the World to America: Education and Foreign Relations since 1870*, edited by Richard Garlitz and Lisa Jarvinen, 155–72. New York: Palgrave Macmillan, 2012.

Boyd, James. "Japanese Cultural Diplomacy in Action: The Zenrin Kyōkai in Inner Mongolia, 1933–45." *Journal of Contemporary Asia* 41, no. 2 (2011): 266–88.

Brazinsky, Gregg A. *Winning the Third World: Sino-American Rivalry during the Cold War*. Chapel Hill: University of North Carolina Press, 2017.

Brinkley, Alan. *The Publisher: Henry Luce and His American Century*. New York: Alfred A. Knopf, 2010.

Brooks, Charlotte. "#24: On Broadway." *Asian American History in NYC* (blog), 2016. Accessed March 8, 2017. https://blogs.baruch.cuny.edu/asianamericanhistorynyc/

Bu, Liping. *Making the World Like Us: Education, Cultural Expansion, and the American Century*. Westport, CT: Praeger, 2003.

Bullock, Mary Brown. *The Oil Prince's Legacy: Rockefeller Philanthropy in China*. Washington, DC, and Stanford: Woodrow Wilson Center Press and Stanford University Press, 2011.

Burton, Antoinette. *The Postcolonial Careers of Santha Rama Rau*. Durham: Duke University Press, 2007.

Cahill, James. *Chinese Painting*. Geneva: Albert Skira, 1960.

Cahill, James. "The Place of the National Palace Museum in My Scholarly Career," 2005. Accessed August 18, 2015. http://jamescahill.info/the-writings-of-james-cahill/cahill-lectures-and-papers/81-clp-117-2005

Cao Bihong. "Minguo shiqi Zhongguo canjia shijie bolanhui jilüe" [A brief account of China's participation in the international expositions during the Republican period]. *Zhongguo dang'an*, no. 5 (2010): 27–29.

Cao Boyan and Ji Weilong. *Hu Shi nianpu* [The chronicle of Hu Shi]. Hefei: Anhui jiaoyu chubanshe, 1986.

Caro, Robert A. *The Power Broker: Robert Moses and the Fall of New York*. New York: Knopf, 1974.

Cassel, Pär Kristoffer. *Grounds of Judgment: Extraterritoriality and Imperial Power in Nineteenth-Century China and Japan*. New York: Oxford University Press, 2012.

Chan, Lik Sam. "Emotional Duplex in the Nation (de-)Branding: A Case Study of

China and Shen Yun Performing Arts." *Critical Studies in Media Communication* 33, no. 2 (2016): 139–53.

Chang, Gordon H. *Fateful Ties: A History of America's Preoccupation with China*. Cambridge, MA: Harvard University Press, 2015.

Chang, Gordon H. "Trans-Pacific Composition: Zhang Shuqi Paints in America." In *Zhang Shuqi in California*, edited by Jianhua Shu, 20–30. Santa Clara, CA: Silicon Valley Asian Art Center, 2012.

Chang Renxia. "Wenhua shijie yu wenhua waijiao" [Cultural diplomats and cultural diplomacy]. *Waijiao jikan* 1, no. 2 (1940): 138–39.

Chang, Shi-chao. "Missionaries in China." *Spectator*, August 13, 1910.

Chang, Shi-chao. "Missionaries in China." *Spectator*, September 10, 1910.

Chapman, Michael E. "Fidgeting Over Foreign Policy: Henry L. Stimson and the Shenyang Incident, 1931." *Diplomatic History* 37, no. 4 (2013): 727–48.

Chen Fangzhong. *Yu Bin shuji zhuan* [A biography of Cardinal Yu Bin]. Taipei: Taiwan Shangwu yinshuguan, 2001.

Chen Guanren (Chen Kuan-jen). "1950–60 niandai Zhonghua minguo dui Mei xuanchuan zhengce de zhuanxing" [The transformation of the propaganda policy of the Republic of China toward the United States between the 1950s and 1960s]. *Zhengda shi cui*, no. 27 (2014): 91–120.

Chen Hexian. *Shijie wenhua hezuo: canjia Guolian shijie wenhua hezuo hui di shisi ci huiyi zhi jingguo* [International intellectual cooperation: attending the fourteenth meeting of the League of Nation's International Committee on Intellectual Cooperation]. Shanghai: Shijie bianyiguan, 1933.

Chen Huaiyu. *Qinghua yu "Yizhan": Meiji jiaoshou de Zhongguo jingyan* [Tsinghua University and the First World War: American professors in China]. Hangzhou: Zhejiang guji chubanshe, 2021.

Chen, Li. *Chinese Law in Imperial Eyes: Sovereignty, Justice, and Transcultural Politics*. New York: Columbia University Press, 2015.

Chen Qian. "Hua Mei xiejinshe yu Zhongguo xiqu de kuawenhua chuanbo: zailun Mei Lanfang fang Mei zhi shimo" [China Institute in America and the cross-cultural spread of Chinese opera: on the neglected details of Mei Lanfang's American tour]. *Zhongguo wenhua yanjiu*, no. 2 (2021): 171–80.

Chen Qian. "'Jingpai' wenxue huodong zai Meiguo de yanzhan: yi Hua Mei xiejinshe wei niudai" [Extension of "Beijing literary group" activities in the United States: focus on China Institute in America]. *Hebei shifan daxue xuebao* (zhexue shehui kexue ban) 44, no. 3 (2021): 92–98.

Ch'en, Ta-tuan. "Investiture of Liu-ch'iu Kings in the Ch'ing Period." In *The Chinese World Order: Traditional China's Foreign Relations*, edited by John K. Fairbank, 135–64. Cambridge, MA: Harvard University Press, 1968.

Chen Tiejian and Huang Daoxuan. *Jiang Jieshi yu Zhongguo wenhua* [Chiang Kai-shek and Chinese culture]. Hong Kong: Zhonghua shuju, 1992.

Chen Yi'ai. "Zhengli guogu yundong de xingqi, fazhan yu liuyan" [The rise, development, and decline of the movement for rearranging the national heritage]. PhD diss., National Chengchi University, 2002.

Chen Yi'ai. *Zhongguo xiandai xueshu jigou de xingqi: yi Beijing daxue yanjiusuo guoxuemen wei zhongxin de tantao* [The rise of modern academic institutions in China: a focus on Peking University Graduate School's Department of National Studies]. Taipei: Guoli zhengzhi daxue lishi xuexi, 1999.

Chen, Yong. *Chop Suey, USA: The Story of Chinese Food in America*. New York: Columbia University Press, 2014.

Chen Yongfa (Chen Yung-fa) et al. *Jiashi, guoshi, tianxiashi: Xu Zhuoyun yuanshi yisheng huigu* [Family affairs, national affairs, and affairs under heaven: a reminiscence by Academician Xu Zhuoyun]. Taipei: Zhongyang yanjiuyuan jindaishi yanjiuisuo, 2010.

Chen Zhengshu. "Wang Xiaolai." In *Haishang shi wenren* [Ten famous figures of old Shanghai], edited by Chen Zu'en and Wang Jinhai, 272–300. Shanghai: Shanghai renmin chubanshe, 1990.

Cheng, Chi-pao. *Chinese American Cultural Relations*. New York: China Institute in America, 1965.

Cheng Qibao (Cheng Chi-pao). "Liushi nian jiaoyu shengya (er): huiyi sanji zhi er" [My educational career in six decades (II): a reminiscence (2)]. *Zhuanji wenxue* 23, no. 3 (1973): 17–22.

Cheng Qibao xiansheng shishi zhounian jinianji [A collection of commemorative essays for the one year anniversary of Mr. Cheng Qibao's passing]. N.p., 1976.

Chin, Henin, ed. *Official Chinatown Guide Book for Visitors & New Yorkers*. New York: Henin & Company, 1938.

Chin, Henin, ed. *Official Chinatown Guide Book, New York 1964–65*. New York: Henin & Company, 1964.

China Institute in America. "An Analysis of Chinese Studies in American Colleges and Universities 1955–56: The Result of a Survey Undertaken Under the Sponsorship of the Chinese Advisory Committee on Cultural Relations in America." *Chinese Culture* 1, no. 1 (1957): 201–52.

China Institute in America. "China: A Brief List of Introductory Readings Selected for Those Who Desire to Comprehend China's History and Culture, and Her Present Political, Economic and Social Re-Adjustments." 1939.

China Institute in America. *The Manchurian Crisis and World Peace*. New York, 1931.

China Institute in America. *The Manchurian Situation: Outline of Points to Be Considered*. New York, 1931.

China Institute in America. *One Hundred Selected Books on China*. Bulletin 5. New York, c. 1927.

China Institute in America. *One Hundred Selected Books on China: Revised List*. Bulletin 6. New York, c. 1928.

China Institute in America. *Some Pertinent Comments on the Manchurian Situation*. New York, 1931.

China Institute in America. *Theses and Dissertations by Chinese Students in America*. Bulletin 4. New York, c. 1927.

China Institute in America. *Theses and Dissertations by Chinese Students in America*. New York, 1934.

China Institute in America. *Theses and Dissertations by Chinese Students in America: Supplementary List*. Bulletin 7. New York, c. 1928.

"The China Lobby: A Case Study." *Congressional Quarterly Weekly Report Special Supplement* 9, no. 25 (June 29, 1951): 939–58.

Chinese Advisory Committee on Cultural Relations in America and China Institute in America. *Basic Bibliography on China for Use of American School Teachers*. New York, 1956.

Chinese Art Society of America. *The Art of Eastern Chou, 772–221 B.C. (a Loan Exhibition)*. New York, 1962.

Chinese Art Society of America and Asia House. *Arts of the Han Dynasty*. New York, 1961.

Chinese Art Treasures. Geneva: Skira, 1961.

Chinese Women's Relief Association and American Women's Sponsoring Committee. *A Loan Exhibition of Early Chinese Art Treasures for the Benefit of Chinese Civilian War Victims*. New York: Arden Gallery, 1938.

Choate, Mark I. *Emigrant Nation: The Making of Italy Abroad*. Cambridge, MA: Harvard University Press, 2008.

Chow, Tse-tsung. *The May Fourth Movement: Intellectual Revolution in Modern China*. Cambridge, MA: Harvard University Press, 1960.

Christ, Carol Ann. "'The Sole Guardians of the Art Inheritance of Asia': Japan at the 1904 St. Louis World's Fair." *Positions: East Asia Cultures Critique* 8, no. 3 (2000): 675–709.

Christensen, Thomas J. *Useful Adversaries: Grand Strategy, Domestic Mobilization, and Sino-American Conflict, 1947–1958*. Princeton: Princeton University Press, 1996.

Chu, Samuel C., and Kwang-Ching Liu. *Li Hung-Chang and China's Early Modernization*. Armonk, NY: M. E. Sharpe, 1994.

Clark, Cal. "A Short History of the American Association for Chinese Studies." *American Journal of Chinese Studies* 25, no. 2 (2018): 133–45.

Clinton, Maggie. *Revolutionary Nativism: Fascism and Culture in China, 1925–1937*. Durham: Duke University Press, 2017.

Cohen, Paul A. *Between Tradition and Modernity: Wang T'ao and Reform in Late Ch'ing China*. Cambridge, MA: Harvard University Press, 1974.

Cohen, Paul A. *China and Christianity: The Missionary Movement and the Growth of Chinese Antiforeignism, 1860–1870*. Cambridge, MA: Harvard University Press, 1963.

Cohen, Warren I. *East Asian Art and American Culture: A Study in International Relations*. New York: Columbia University Press, 1992.

Cohen, Warren I. "While China Faced East: Chinese-American Cultural Relations, 1949–71." In *Educational Exchanges: Essays on the Sino-American Experience*, edited by Joyce K. Kallgren and Denis Fred Simon, 44–57. Berkeley: University of California Institute of East Asian Studies, 1987.

Cook, Alexander C., ed. *Mao's Little Red Book: A Global History*. New York: Cambridge University Press, 2014.

Craine, Debra, and Judith Mackrell, eds. "Raqs Sharqi." In *Oxford Dictionary of Dance*, 367. New York: Oxford University Press, 2016.

Cull, Nicholas J. *The Cold War and the United States Information Agency: American Propaganda and Public Diplomacy, 1945–1989*. New York: Cambridge University Press, 2008.

Cull, Nicholas J. "Overture to an Alliance: British Propaganda at the New York World's Fair, 1939–1940." *Journal of British Studies* 36, no. 3 (1997): 325–54.

Cull, Nicholas J. "Public Diplomacy: Taxonomies and Histories." *Annals of the American Academy of Political and Social Science* 616 (2008): 31–54.

Culp, Robert Joseph. *Articulating Citizenship: Civic Education and Student Politics in*

Southeastern China, 1912–1940. Cambridge, MA: Harvard University Asia Center, 2007.

David-Fox, Michael. *Showcasing the Great Experiment: Cultural Diplomacy and Western Visitors to the Soviet Union, 1921–1941*. New York: Oxford University Press, 2012.

Davin, Delia. "Imperialism and the Diffusion of Liberal Thought: British Influences on Chinese Education." In *China's Education and the Industrialized World*, edited by Ruth Hayhoe and Marianne Bastid, 33–56. Armonk, NY: M. E. Sharpe, 1987.

Day, Jenny Huangfu. *Qing Travelers to the Far West: Diplomacy and the Information Order in Late Imperial China*. New York: Cambridge University Press, 2018.

De Bary, Wm. Theodore. "East Asian Studies at Columbia: The Early Years." *Columbia Magazine*, Spring (2002). Accessed March 10, 2017. http://www.columbia.edu/cu/alumni/Magazine/Spring2002/AsianStudies.html

Deknatel, Frederick. "Reconstruction, Who Decides." In *Cultural Heritage and Mass Atrocities*, edited by James Cuno and Thomas G. Weiss, 220–37. Los Angeles: Getty Publications, 2022.

Denning, Michael. *The Cultural Front: The Laboring of American Culture in the Twentieth Century*. New York: Verso, 1996.

Department of Justice. "Report of the Attorney General to the Congress of the United States on the Administration of the Foreign Agents Registration Act of 1938, as Amended for the Period from June 28, 1942 to December 31, 1944," 1945.

Department of Justice. "Report of the Attorney General to the Congress of the United States on the Administration of the Foreign Agents Registration Act of 1938, as Amended June 1950," 1950.

Department of Justice. "Report of the Attorney General to the Congress of the United States on the Administration of the Foreign Agents Registration Act of 1938, as Amended for the Period January 1, 1950 to December 31, 1954," 1955.

Dirlik, Arif. "Chinese History and the Question of Orientalism." *History and Theory* 35, no. 4 (1996): 96–118.

Domínguez Méndez, Rubén. "Los Primeros Pasos Del Instituto Italiano de Cultura En España (1934–1943)." *Cuadernos de Filología Italiana* 20 (2013): 277–90.

Dong Xianguang (Tong, Hollington). *Dong Xianguang zizhuan: yige nongfu de zishu* [The autobiography of Hollington Tong: the self-narrative of a Chinese peasant]. Taipei: Taiwan xinsheng baoshe, 1973.

Du, Chunmei. *Gu Hongming's Eccentric Chinese Odyssey*. Philadelphia: University of Pennsylvania Press, 2019.

Duan Yong. "Guwu chenliesuo de xingshuai jiqi lishi diwei shuping" [The rise and fall of the Institute for Exhibiting Antiquities and its historical legacy]. *Gugong bowuyuan yuankan*, no. 5 (2004): 14–39.

Duara, Prasenjit. "The Discourse of Civilization and Pan-Asianism." *Journal of World History* 12, no. 1 (2001): 99–130.

Eastman, Lloyd E. *The Abortive Revolution: China under Nationalist Rule, 1927–1937*. Cambridge, MA: Harvard University Press, 1974.

Eastman, Lloyd E. *Seeds of Destruction: Nationalist China in War and Revolution, 1937–1949*. Stanford: Stanford University Press, 1984.

Elliot, Jeannette Shambaugh, and David Shambaugh. *The Odyssey of China's Imperial Art Treasures*. Seattle: University of Washington Press, 2007.

Esherick, Joseph, and Mary Backus Rankin, eds. *Chinese Local Elites and Patterns of Dominance*. Berkeley: University of California Press, 1990.

Fan, Shuhua. *The Harvard-Yenching Institute and Cultural Engineering: Remaking the Humanities in China, 1924–1951*. Lanham, MD: Lexington Books, 2014.

Fang Wen (Fong, Wen C.). "Gannian Guoli gugong bowuyuan" [Appreciating the National Palace Museum]. *Gugong wenwu yuekan*, October (2005): 23–30.

Feng Xiaocai. "Counterfeiting Legitimacy: Reflections on the Usurpation of Popular Politics and the 'Political Culture' of China, 1912–1949." *Frontiers of History in China* 8, no. 2 (2013): 202–22.

Fernsebner, Susan R. "Material Modernities: China's Participation in World's Fairs and Expositions, 1876–1955." PhD diss., University of California San Diego, 2002.

Feuerwerker, Albert. *China's Early Industrialization: Sheng Hsuan-Huai (1844–1916) and Mandarin Enterprise*. Cambridge, MA: Harvard University Press, 1958.

Fishel, Wesley R. *The End of Extraterritoriality in China*. Berkeley: University of California Press, 1952.

Fiss, Karen. *Grand Illusion: The Third Reich, the Paris Exposition, and the Cultural Seduction of France*. Chicago: University of Chicago Press, 2009.

Forêt, Philippe. *Mapping Chengde: The Qing Landscape Enterprise*. Honolulu: University of Hawai'i Press, 2000.

Frazier, Robeson Taj. *The East Is Black: Cold War China in the Black Radical Imagination*. Durham: Duke University Press, 2014.

"Front Matter." *Archives of Asian Art* 20 (1966/1967): 3.

"Front Matter." *Archives of the Chinese Art Society of America* 1 (1945/1946): 4.

Gao, Yunxiang. *Arise Africa! Roar China! Black and Chinese Citizens of the World in the Twentieth Century*. Chapel Hill: University of North Carolina Press, 2021.

Gao, Yunxiang. "Soo Yong (1903–1984): Hollywood Celebrity and Cultural Interpreter." *Journal of American-East Asian Relations* 17, no. 4 (2010): 372–99.

Ge Fuping. *Zhong Fa jiaoyu hezuo shiye yanjiu, 1912–1949* [A study of the Sino-French educational cooperation, 1912–1949]. Shanghai: Shanghai shudian chubanshe, 2011.

Geertz, Clifford. *Negara: The Theatre State in Nineteenth-Century Bali*. Princeton: Princeton University Press, 1980.

Geng Yunzhi. "Wusi yihou Liang Qichao guanyu Zhongguo wenhua jianshe de sikao: yi chongxin jiedu Ouyou xinying lu wei zhongxin" [Liang Qichao's post-May Fourth thoughts on Chinese culture: revisiting the *Impressions of the European Tour*]. *Guangdong shehui kexue*, no. 1 (2004): 112–19.

Gienow-Hecht, Jessica C. E., and Mark C. Donfried, eds. *Searching for a Cultural Diplomacy*. New York: Berghahn Books, 2010.

Gill, Bates. *Daring to Struggle: China's Global Ambitions under Xi Jinping*. New York: Oxford University Press, 2022.

Giuffrida, Noelle. "The Right Stuff: Chinese Art Treasures' Landing in Early 1960s America." In *The Reception of Chinese Art across Cultures*, edited by Michele Huang, 200–27. New Castle upon Tyne: Cambridge Scholars Publishing, 2014.

Goldman, Andrea S. *Opera and the City: The Politics of Culture in Beijing, 1770–1900*. Stanford: Stanford University Press, 2012.

Goldstein, Joshua. *Drama Kings: Players and Publics in the Re-Creation of Peking Opera, 1870–1937*. Berkeley: University of California Press, 2007.

Goodrich, L. C. "Chinese Studies in the United States." *Chinese Social and Political Science Review* 15, no. 1 (1931): 62–77.

Goodrich, L. C., and H. C. Fenn. *A Syllabus of the History of Chinese Civilization and Culture*. New York: China Society of America, 1929.

Goodrich, L. C., and H. C. Fenn. *A Syllabus of the History of Chinese Civilization and Culture*. 2nd ed. New York: China Society of America, 1934.

Goodrich, L. C., and H. C. Fenn. *A Syllabus of the History of Chinese Civilization and Culture*. 3rd ed. New York: China Society of America, 1941.

Gray, William Glenn. *Germany's Cold War: The Global Campaign to Isolate East Germany, 1949–1969*. Chapel Hill: University of North Carolina Press, 2003.

Greene, J. Megan. *The Origins of the Developmental State in Taiwan: Science Policy and the Quest for Modernization*. Cambridge, MA: Harvard University Press, 2008.

Gripentrog, John. "Power and Culture: Japan's Cultural Diplomacy in the United States, 1934–1940." *Pacific Historical Review* 84, no. 4 (2015): 478–516.

Grose, Peter. *Continuing the Inquiry: The Council on Foreign Relations from 1921 to 1996*. New York: Council on Foreign Relations, 1996.

Gross, Stephen G. *Export Empire: German Soft Power in Southeastern Europe, 1890–1945*. New York: Cambridge University Press, 2015.

Gu Wenjie. "A Chinese Emperor's Clay Army." *The Unesco Courier*, December (1979): 5–8.

Guo Zhenzhi, Zhang Xiaoling, and Wang Jue. "Yong wenhua de liliang yingxiang shijie: Shilun Zhongguo wenhua zhongxin de haiwai chuanbo" [Influencing the world with cultural efforts: the international communications of the China Culture Centres]. *Xinwen yu chuanbo yanjiu*, no. 2 (2016): 41–50.

Guoli gugong zhongyang bowuyuan gongtong lishihui, ed. *Gugong cangci* [The porcelain collections of the National Palace Museum]. Hong Kong: Cafa, 1961–1969.

Guy, Nancy. "Brokering Glory for the Chinese Nation: Peking Opera's 1930 American Tour." *Comparative Drama* 35, no. 3/4 (2001): 377–92.

Guy, Nancy. *Peking Opera and Politics in Taiwan*. Urbana: University of Illinois Press, 2005.

Guzzardi, Walter. *The Henry Luce Foundation: A History, 1936–1986*. Chapel Hill: University of North Carolina Press, 1988.

Halsey, Stephen R. *Quest for Power: European Imperialism and the Making of Chinese Statecraft*. Cambridge, MA: Harvard University Press, 2015.

Hamilton, Peter E. *Made in Hong Kong: Transpacific Networks and a New History of Globalization*. New York: Columbia University Press, 2021.

Han Tie. *Fute jijinhui yu Meiguo de Zhongguo xue, 1950–1979 nian* [The Ford Foundation and Chinese studies in the United States, 1950–1979]. Beijing: Zhongguo shehui kexue chubanshe, 2004.

Harr, John Ensor, and Peter J. Johnson. *The Rockefeller Conscience: An American Family in Public and in Private*. New York: Scribner, 1991.

Harris, Neil. "Old Wine in New Bottles: Masterpieces Come to the Fair." In *Designing Tomorrow: America's World's Fairs of the 1930s*, edited by Robert W. Rydell and Laura Burd Schiavo, 41–55. New Haven: Yale University Press, 2010.

Hart, Justin. *Empire of Ideas: The Origins of Public Diplomacy and the Transformation of U.S. Foreign Policy*. New York: Oxford University Press, 2013.

Hayford, Charles W. "Open Recipes, Openly Arrived At: *How to Cook and Eat in Chinese* (1945) and the Translation of Chinese Food." *Journal of Oriental Studies* 45, no. 1 & 2 (2012): 67–87.

He Aiguo. "'Quanpan xihua' vs 'Zhongguo benwei': shilun 1930 niandai Zhongguo guanyu wenhua jianshe luxiang de lunzhan" [Total Westernization vs. China-centered approach: on the debates of cultural paths in the 1930s China]. *Ershiyi shiji* (wangluo ban), no. 34 (2005). Accessed August 6, 2017. http://www.cuhk.edu.hk/ics/21c/media/online/0410015.pdf

Henderson, William. *Pacific Settlement of Disputes: The Indonesian Question, 1946–1949*. New York: Woodrow Wilson Foundation, 1954.

Herzstein, Robert E. *Henry R. Luce, Time, and the American Crusade in Asia*. New York: Cambridge University Press, 2005.

Hevia, James Louis. *English Lessons: The Pedagogy of Imperialism in Nineteenth-Century China*. Durham: Duke University Press, 2003.

Ho, Yong. "China Institute and Columbia University." Columbia University, 2004. Accessed July 4, 2014. http://chineselectures.org/cicu.htm

Hollinger, David A. *Protestants Abroad: How Missionaries Tried to Change the World but Changed America*. Princeton: Princeton University Press, 2017.

Hong Zhenqiang. *Minzu zhuyi yu jindai Zhongguo bolanhui shiye (1851–1937)* [Nationalism and the exhibitions in modern China, 1851–1937]. Beijing: Shehui kexue wenxian chubanshe, 2017.

Horne, Janet. "'To Spread the French Language Is to Extend the Patrie': The Colonial Mission of the Alliance Française." *French Historical Studies* 40, no. 1 (2017): 95–127.

Horton, Philip, Charles Wertenbaker, and Max Ascoli. "The China Lobby." *The Reporter*, April 29, 1952.

Hsu, Hua. *A Floating Chinaman: Fantasy and Failure across the Pacific*. Cambridge, MA: Harvard University Press, 2016.

Hsu, Madeline Y. *The Good Immigrants: How the Yellow Peril Became the Model Minority*. Princeton: Princeton University Press, 2015.

Hu, Shih. "Mei Lan-Fang and the Chinese Drama." In *The First American Tour of Mei Lan-Fang*, edited by Ernest K. Moy, no pagination. New York: China Institute in America, 1930.

Huang, Ellen. "There and Back Again: Material Objects at the First International Exhibitions of Chinese Art in Shanghai, London, and Nanjing, 1935–1936." In *Collecting China: The World, China, and a History of Collecting*, edited by Vimalin Rujivacharakul, 138–52. Newark: University of Delaware Press, 2011.

Huang Fang. *Duoyuan wenhua rentong de jiangou: Zhongguo pinglun zhoubao yu Tianxia yuekan yanjiu* [The construction of a multicultural identity: a study of *China Critic* and *T'ien Hsia Monthly*]. Nanjing: Nanjing daxue chubanshe, 2018.

Huang Renyu (Huang, Ray). *Huanghe qingshan: Huang Renyu huiyi lu* [The yellow river and the green mountain: the memoir of Huang Renyu]. Beijing: Sanlian shudian, 2015.

Huang Xiangyu (Huang Hsiang-yu). "Guwu baocunfa de zhiding jiqi shixing kunjing (1930–1949)" [The drafting of the Antiquities Conservation Law and the

difficulties in implementation, 1930–1949]. *Guoshiguan guankan*, no. 32 (2012): 41–83.

Hubbert, Jennifer. *China in the World: An Anthropology of Confucius Institutes, Soft Power, and Globalization*. Honolulu: University of Hawai'i Press, 2019.

"Index 1971–74." *Echo*, October (1974): 49–52.

Iriye, Akira. *Cultural Internationalism and World Order*. Baltimore: Johns Hopkins University Press, 1997.

Irwin, Virginia. *China in Some New York Secondary Schools*. New York: China Institute in America, 1936.

Isaacs, Harold R. *Scratches on Our Minds: American Images of China and India*. New York: John Day, 1958.

Jacobs, J. Bruce. "'Taiwanization' in Taiwan's Politics." In *Cultural, Ethnic, and Political Nationalism in Contemporary Taiwan: Bentuhua*, edited by John Makeham and A-chin Hsiau, 17–34. New York: Palgrave Macmillan, 2005.

Jersild, Austin. "Socialist Exhibits and Sino-Soviet Relations, 1950–60." *Cold War History* 18, no. 3 (2018): 275–89.

Jespersen, T. Christopher. *American Images of China, 1931–1949*. Stanford: Stanford University Press, 1996.

Jiang Jieshi (Chiang Kai-shek). "Zhonghua minguo sanshijiu nian yuandan gao quanguo junmin tongbao shu" [A letter to the military personnel and civilians all over the nation on the New Year's Day of 1950]. *Zongtong Jianggong sixiang yanlun zongji* [A general collection of President Chiang Kai-shek's thoughts and remarks], vol. 32, 246–47. Accessed August 5, 2015. http://www.ccfd.org.tw/cc ef001/index.php?option=com_content&view=article&id=370:0001-83&catid= 228&Itemid=256

Jiangxi sheng zhengxie zhangshu shi zhengxie wenshi ziliao yanjiu weiyuanhui. "Yang Xingfo." *Jiangxi wenshi ziliao*, no. 38 (1991): 52–54.

Jin Guangyao. *Gu Weijun zhuan* [A biography of Gu Weijun]. Shijiazhuang: Hebei renmin chubanshe, 1999.

Kawakami, Kiyoshi Karl. *Japan Speaks on the Sino-Japanese Crisis*. New York: Macmillan, 1932.

Keeley, Joseph. *The China Lobby Man: The Story of Alfred Kohlberg*. New Rochelle, NY: Arlington House, 1969.

Kiang, Kang-hu. *Chinese Civilization: An Introduction to Sinology*. Shanghai: Chung Hwa, 1935.

Kiang, Kang-hu. *On Chinese Studies*. Shanghai: Commercial Press, 1934.

Kirby, William C. "The Chinese Party-State under Dictatorship and Democracy on the Mainland and on Taiwan." In *Realms of Freedom in Modern China*, edited by William C. Kirby, 113–38. Stanford: Stanford University Press, 2004.

Klein, Christina. *Cold War Orientalism: Asia in the Middlebrow Imagination, 1945–1961*. Berkeley: University of California Press, 2003.

Kochavi, Noam. *A Conflict Perpetuated: China Policy During the Kennedy Years*. Westport, CT: Praeger, 2002.

Koen, Ross Y. *The China Lobby in American Politics*. New York: Harper & Row, 1974.

Ku Hung-ming. *The Spirit of the Chinese People*. Peking: Peking Daily News, 1915.

Kung, Chien-Wen. *Diasporic Cold Warriors: Nationalist China, Anticommunism, and the Philippine Chinese, 1930s–1970s*. Ithaca: Cornell University Press, 2022.

Kuo, Karen J. *East Is West and West Is East: Gender, Culture, and Interwar Encounters Between Asia and America*. Philadelphia: Temple University Press, 2013.

Kurlantzick, Joshua. "China's Collapsing Global Image: How Beijing's Unpopularity Is Undermining Its Strategic, Economic, and Diplomatic Goals." Discussion Paper. Council on Foreign Relations, July 2022. Accessed February 3, 2023. https://cdn.cfr.org/sites/default/files/report_pdf/Kurlantzick_DP_ChinasColl apsingGlobalImage.pdf

Kusnitz, Leonard A. *Public Opinion and Foreign Policy: America's China Policy, 1949–1979*. Westport, CT: Greenwood, 1984.

Lai, Him Mark. "Developments in Chinese Community Organizations in the U.S. since World War II." In *The Chinese Diaspora: Selected Essays*, vol. 1, edited by Ling-chi Wang and Wang Gungwu, 196–267. Singapore: Times Academic Press, 1998.

Lai, Him Mark. "The Kuomintang in Chinese American Communities before World War II." In *Entry Denied: Exclusion and the Chinese Community in America, 1882–1943*, edited by Sucheng Chan, 170–212. Philadelphia: Temple University Press, 1991.

Lautz, Terrill. "Elisabeth Luce Moore: A Spoken History." Unpublished manuscript, 2008.

Lautz, Terry (Terrill). *John Birch: A Life*. New York: Oxford University Press, 2016.

Lebovic, Sam. *A Righteous Smokescreen: Postwar America and the Politics of Cultural Globalization*. Chicago: University of Chicago Press, 2022.

Lebovics, Herman. *Mona Lisa's Escort: André Malraux and the Reinvention of French Culture*. Ithaca: Cornell University Press, 1999.

Lee, Anthony W. *Picturing Chinatown: Art and Orientalism in San Francisco*. Berkeley: University of California Press, 2001.

Lee, Heather Ruth. *Gastrodiplomacy: Chinese Exclusion and the Ascent of Chinese Restaurants in New York*. Chicago: University of Chicago Press, under contract.

Lee, Ji-Young. *China's Hegemony: Four Hundred Years of East Asian Domination*. New York: Columbia University Press, 2016.

Leong, Karen J. *The China Mystique: Pearl S. Buck, Anna May Wong, Mayling Soong, and the Transformation of American Orientalism*. Berkeley: University of California Press, 2005.

Levenson, Joseph R. *Revolution and Cosmopolitanism: The Western Stage and the Chinese Stages*. Berkeley: University of California Press, 1971.

Lew, Timothy Tingfang. *China in American School Text-Books: A Problem of Education in International Understanding and Worldwide Brotherhood*. Peking: Chinese Social and Political Science Association, 1923.

Li Enhan (Lee En-han). *Beifa qianhou de "geming waijiao," 1925–1931* ["Revolutionary diplomacy" around the time of the Northern Expedition, 1925–1931]. Taipei: Zhongyang yanjiuyuan jindaishi yanjiusuo, 1993.

Li Gaofeng. *Hua Mei xiejinshe shi* [A history of the China Institute in America]. Chongqing: Xinan shifan daxue chubanshe, 2020.

Li, Hongshan. *U.S.-China Educational Exchange: State, Society, and Intercultural Relations, 1905–1950*. New Brunswick, NJ: Rutgers University Press, 2008.

Li Hongyuan. *Ji naxie boguang yu yingxiang: Li Hongyuan rensheng suibiji* [Remembering those lights and images: Li Hongyuan's collection of essays on life]. Taipei: Shibao chuban, 2015.

Li, Hsiao-t'i. *Opera, Society, and Politics in Modern China*. Cambridge, MA: Harvard University Asia Center, 2019.

Li, Kaiyi, and Huimei Zhou. "The International Committee on Intellectual Cooperation and Chinese Cultural Diplomacy during the Interwar Period." *International History Review* (online first, September 22, 2023). https://doi.org/10.1080 /07075332.2023.2260386

Li Lincan. *Guobao fu Mei zhanlan riji* [The diary during the U.S. tour of national treasures]. Taipei: Taiwan Shangwu yinshuguan, 1972.

Li Qingben and Li Tongwei. "Tan Hua Mei xiejinshe zai Mei Lanfang fang Mei yanchu zhong de zuoyong" [The role of the China Institute in America in the U.S. tour of Mei Lanfang]. *Xiju*, no. 5 (2018): 112–22.

Li Shan. "Jiang Kanghu Beimei chuanbo Zhongguo wenhua shulun" [A discussion of Jiang Kanghu's dissemination of Chinese culture in North America]. *Shilin*, no. 2 (2011): 127–36.

Li Shan. "Jiuyiba shibian hou Zhongguo zhishijie dui Riben zhanzheng xuanchuan de fanji: yi yingwen zhuanshu wei zhongxin" [The Chinese intellectuals' pushback against Japanese war propaganda after the Mukden Incident: a focus on the English writings]. *Kangri zhanzheng yanjiu*, no. 4 (2012): 64–75.

Li Songlin and Liu Wei. "Shixi Kongzi xueyuan wenhua ruanshili zuoyong" [A discussion of the cultural soft power of the Confucius Institute]. *Sixiang jiaoyu yanjiu*, no. 4 (2010): 43–47.

Li Xiaoqian. *Yuwai hanxue yu Zhongguo xiandai shixue* [International sinology and modern historiography in China]. Shanghai: Shanghai guji chubanshe, 2014.

Li, Yiqing. "Art Diplomacy: Drawing China-Indonesia Relations in the Early Cold War, 1949–1956." *Modern Asian Studies* 57, no. 6 (2023): 1707–42.

Liao Zhen (Liau Jane). "Liang'an haiwai hanxue tuiguang de jing yu he: yi 'Kongzi xueyuan' ji 'Taiwan shuyuan' weili" [Competition and cooperation of cross-Strait sinology promotion: the "Confucius Institute" and the "Taiwan Academy"]. *Guojia tushuguan guankan*, no. 2 (2012): 113–38.

Lillehoj, Elizabeth. "Making Asia Out of China: Okakura Kakuzō's Notions of Classicism." In *Collecting China: The World, China, and a History of Collecting*, edited by Vimalin Rujivacharakul, 73–85. Newark: University of Delaware Press, 2011.

Lin Guoxian (Lin Guo-sian). "*Zhonghua wenhua fuxing yundong tuixing weiyuanhui*" *zhi yanjiu* [A study of the Committee on Promoting the Chinese Cultural Renaissance]. Taipei: Daoxiang chubanshe, 2005.

Lin, James. "Martyrs of Development: Taiwanese Agrarian Development and the Republic of Vietnam, 1959–1975." *Cross-Currents: East Asian History and Culture Review* 9, no. 1 (2020): 67–106.

Lin Jiahua (Lin Chia-hua). "Yingxiang zhong de jingshen chuandi: Jiang furen wenhua waijiao chutan" [Communication through images: a preliminary discussion of Madame Chiang Kai-shek's cultural diplomacy]. Paper presented at the international conference Yingxiang yu shiliao: yingxiang zhong de jindai Zhongguo [Images and historical sources: modern China in images], National Chengchi University, Taipei, October 2014.

Lin, Man-houng. "Money, Images, and the State: The Taiwanization of the Republic of China, 1945–2000." *Twentieth-Century China* 42, no. 3 (2017): 274–96.

Lin Meili (Lin May-li), ed. *Wang Shijie riji* [The diary of Wang Shijie], vol. 2. Taipei: Zhongyang yanjiuyuan jindaishi yanjiusuo, 2012.

Lin, Mousheng. *Documents Concerning the Sino-Japanese Conflict*. New York: Trans-Pacific News Service, 1938.

Lin, Mousheng. *Facts and Figures Concerning the Far Eastern Situation*. New York: China Institute in America, 1940.

Lin, Mousheng. *A Guide to Chinese Learned Societies and Research Institutes*. New York: Chinese Institute in America, 1936.

Lin, Mousheng. *A Guide to Leading Chinese Periodicals*. New York: China Institute in America, 1936.

Lin, Mousheng. *International Law and the Undeclared War*. New York: China Institute in America, 1937.

Lin, Mousheng. "Recent Intellectual Movements in China." *China Institute Bulletin* 3, no. 1 (1938): 3–19.

Lin, Mousheng. *Theses and Dissertations by Chinese Students in America, 1931–1936*. New York: China Institute in America, 1936.

Lin, Nancy. "5,000 Years of Korean Art: Exhibitions Abroad as Cultural Diplomacy." *Journal of the History of Collections* 28, no. 3 (2016): 383–400.

Lin Xiufen (Lin Hsiu-fen). "Haiwai xuanchuan kanwu zhong Taiwan de wenhua tuxiang: yi *Guanghua* zazhi wei zhongxin (1976–2005)" [The cultural image of Taiwan in international propaganda publications: a focus on the *Sinorama* magazine]. Master's thesis, National Taiwan Normal University, 2011.

Ling Chengwei and Zhang Huailing. "Feiyue Taipingyang de 'xinshi': Baigetu xiangguan shishi jikao he yanjiu" [The "messenger" across the Pacific: a study of the painting One Hundred Doves]. *Zhongguo meishuguan*, no. 9 (2012): 75–80.

Linton, Matthew D. "Any Enlightened Government: Mortimer Graves' Plan for a National Center for Far Eastern Studies, 1935–1946." *Journal of American-East Asian Relations* 24, no. 1 (2017): 7–26.

Linton, Matthew D. "Understanding the Mighty Empire: Chinese Area Studies and the Construction of Liberal Consensus, 1928–1979." PhD diss., Brandeis University, 2018.

Lipkin, Zwia. *Useless to the State: "Social Problems" and Social Engineering in Nationalist Nanjing, 1927–1937*. Cambridge, MA: Harvard University Asia Center, distributed by Harvard University Press, 2006.

Lippit, Miya Elise Mizuta. *Aesthetic Life: Beauty and Art in Modern Japan*. Cambridge, MA: Harvard University Asia Center, 2019.

Liu Hailong. *Xuanchuan: guanian, huayu jiqi zhengdanghua* [Propaganda: ideas, discourses, and legitimation]. Beijing: Zhongguo dabaike quanshu chubanshe, 2013.

Liu Lu. "Mei Lanfang yu Sitannisilafusiji fang Mei bijiao yanjiu" [A comparative study of the U.S. tour of Mei Lanfang and of Stanislavski]. *Xiju yishu*, no. 5 (2012): 30–35.

Liu, Lydia He. *Translingual Practice: Literature, National Culture, and Translated Modernity—China, 1900–1937*. Stanford: Stanford University Press, 1995.

Liu Sixiang. "Hang Liwu zhuanlüe" [A biographical sketch of Hang Liwu]. *Jianghuai wenshi*, no. 1 (2001): 139–53.

Liu, Siyuan. "A. C. Scott." *Asian Theatre Journal* 28, no. 2 (2011): 414–25.

Liu Weikai (Liu Wei-kai). "Jiang Jieshi de lüyou shenghuo" [The travels of Chiang Kai-shek]. In *Jiang Jieshi de richang shenghuo* [The everyday life of Chiang Kai-shek], edited by Lü Fangshang (Lu Fang-shang), 125–54. Taipei: Zhengda chubanshe, 2012.

Liu Weikai (Liu Wei-kai) et al. *Zhonghua minguo zhuanti shi: Guomin zhengfu zhizheng yu dui Mei guanxi* [Topics in the history of Republican China: the rule of the Nationalist government and its relationship with the United States]. Nanjing: Nanjing daxue chubanshe, 2015.

Livingstone, Karen, and Linda Parry, eds. *International Arts and Crafts*. London: Victorian and Albert Museum, 2005.

Lockyer, Angus. "Japan at the Exhibition, 1867–1877: From Representation to Practice." In *Japanese Civilization in the Modern World XVII: Collection and Representation*, edited by Tadao Umesao, Angus Lockyer, and Kenji Yoshida, XVII: 67–76. Osaka: National Museum of Ethnology, 2001.

Loo, Lai-han. *China's Changing Civilization: A Selected Bibliography of Books in the English Language*. 3rd ed. New York: China Institute in America, 1935.

Lovell, Julia. *Maoism: A Global History*. New York: Knopf, 2019.

Lü Shaoli (Lu Shao-li). *Zhanshi Taiwan: quanli, kongjian yu zhimin tongzhi de xingxiang biaoshu* [Showcasing Taiwan: power, space, and the imagery of the colonial rule]. Taipei: Maitian chuban, 2011.

Lum, Thomas, and Hannah Fischer. "Confucius Institutes in the United States: Selected Issues." Congressional Research Service, May 20, 2022. Accessed January 29, 2023. https://crsreports.congress.gov/product/pdf/IF/IF11180

Luo Yuanxu (Lo, York). *Dong cheng xi jiu: qige huaren jidujiao jiating yu zhongxi wenhua jiaoliu bainian* [Achievements between the East and West: seven Chinese Christian families and one hundred years of Sino-Western cultural exchange]. Hong Kong: Sanlian shudian, 2012.

Luo Zhitian. "Guojia mubiao de waiqing: jindai minzu fuxing sichao de yige beijing" [The externalization of the goal of the state: some context of the modern thought on national rejuvenation]. *Jindaishi yanjiu*, no. 4 (2014): 13–18.

Luola (Lenain, Géraldine). *Lu Qinzhai zhuan* [C. T. Loo: a biography]. Chinese translation of *Monsieur Loo: Le roman d'un marchand d'art asiatique*. Hong Kong: Xinshiji, 2013.

Lüthi, Lorenz M. "Rearranging International Relations? How Mao's China and de Gaulle's France Recognized Each Other in 1963–1964." *Journal of Cold War Studies* 16, no. 1 (2014): 111–45.

Ma Jianbiao and Lin Xi. "Jindai waijiao de 'tongxin biange': qingmo minchu guoji xuanchuan zhengce xingcheng zhi kaocha" [Transformation in communications in modern Chinese diplomacy: an examination of the international propaganda policy in the late Qing and early Republic]. *Fudan xuebao* (shehui kexue ban), no. 5 (2013): 30–38.

Ma Liangyu. "Hua Mei xiejinshe yu Zhong Mei wenhua jiaoliu yanjiu (1926–1949)" [The China Institute in America and Sino-U.S. cultural exchange (1926–1949)]. PhD diss., Nankai University, 2016.

MacKinnon, Stephen R. *Wuhan, 1938: War, Refugees, and the Making of Modern China*. Berkeley: University of California Press, 2008.

Manela, Erez. *The Wilsonian Moment: Self-Determination and the International Origins of Anticolonial Nationalism.* New York: Oxford University Press, 2007.

Mao, Joyce. *Asia First: China and the Making of Modern American Conservatism.* Chicago: University of Chicago Press, 2015.

Mao Rong. *Zhiping zhishan, hongsheng dongnan: Dongnan daxue xiaozhang Guo Bingwen* [Striving for goodness, achieving fame in the southeast: President Guo Bingwen of the National Southeastern University]. Jinan: Shandong jiaoyu chubanshe, 2004.

Marcher, Anikó. "Hungarian Cultural Diplomacy 1957–1963: Echoes of Western Cultures Activity in a Communist Country." In *Searching for a Cultural Diplomacy,* edited by Jessica C. E. Gienow-Hecht and Mark C. Donfried, 75–108. New York: Berghahn Books, 2010.

Masur, Matthew. "Exhibiting Signs of Resistance: South Vietnam's Struggle for Legitimacy, 1954–1960." *Diplomatic History* 33, no. 2 (2009): 293–313.

Matsuda, Takeshi. *Soft Power and Its Perils: U.S. Cultural Policy in Early Postwar Japan and Permanent Dependency.* Washington, DC, and Stanford: Woodrow Wilson Center Press and Stanford University Press, 2007.

McKevitt, Andrew C. *Consuming Japan: Popular Culture and the Globalizing of 1980s America.* Chapel Hill: University of North Carolina Press, 2017.

Meng, Chih. *China Speaks on the Conflict between China and Japan.* New York: Macmillan, 1932.

Meng, Chih. *Chinese American Understanding: A Sixty-Year Search.* New York: China Institute in America, 1981.

Metzgar, Emily T. *The JET Program and the US–Japan Relationship: Goodwill Goldmine.* Lanham, MD: Lexington Books, 2018.

Millward, James A., Ruth W. Dunnell, Mark C. Elliott, and Philippe Forêt, eds. *New Qing Imperial History: The Making of Inner Asian Empire at Qing Chengde.* New York: Routledge, 2004.

Millwood, Pete. *Improbable Diplomats: How Ping-Pong Players, Musicians, and Scientists Remade US-China Relations.* New York: Cambridge University Press, 2022.

Minami, Kazushi. "'How Could I Not Love You?': Transnational Feminism and US-Chinese Relations during the Cold War." *Journal of Women's History* 31, no. 4 (2019): 12–36.

Mitchell, Timothy. "Orientalism and the Exhibitionary Order." In *Colonialism and Culture,* edited by Nicholas B. Dirks, 289–318. Ann Arbor: University of Michigan Press, 1992.

Mitelpunkt, Shaul. *Israel in the American Mind: The Cultural Politics of US-Israeli Relations, 1958–1988.* New York: Cambridge University Press, 2018.

Morgan, Joseph G. *The Vietnam Lobby: The American Friends of Vietnam, 1955–1975.* Chapel Hill: University of North Carolina Press, 1997.

Mosca, Matthew W. *From Frontier Policy to Foreign Policy: The Question of India and the Transformation of Geopolitics in Qing China.* Stanford: Stanford University Press, 2013.

Moy, Ernest K., ed. *The First American Tour of Mei Lan-Fang.* New York: China Institute in America, 1930.

Moy, Ernest K., ed. *Mei Lan-Fang: What New York Thinks of Him.* N.p., n.d.

Moy, Ernest K., ed. *The Pacific Coast Tour of Mei Lan-Fang: Under the Management of the Pacific Chinese Dramatic Club, San Francisco, California.* N.p., n.d.

National Tsing Hua University Research Fellowship Fund and China Institute in America. *A Survey of Chinese Students in American Universities and Colleges in the Past One Hundred Years: A Preliminary Report.* New York, 1954.

Nelson, Sarah. "A Dream Deferred: UNESCO, American Expertise, and the Eclipse of Radical News Development in the Early Satellite Age." *Radical History Review*, no. 141 (2021): 30–59.

Netting, Lara Jaishree. *A Perpetual Fire: John C. Ferguson and His Quest for Chinese Art and Culture.* Hong Kong: Hong Kong University Press, 2013.

Nicoletta, Julie. "Art Out of Place: International Art Exhibits at the New York World's Fair of 1964–1965." *Journal of Social History* 44, no. 2 (2010): 499–519.

Ninkovich, Frank A. *The Diplomacy of Ideas: U.S. Foreign Policy and Cultural Relations, 1938–1950.* New York: Cambridge University Press, 1981.

Nye, Joseph S., Jr. "Public Diplomacy and Soft Power." *Annals of the American Academy of Political and Social Science* 616 (2008): 94–109.

Oyen, Meredith. *The Diplomacy of Migration: Transnational Lives and the Making of U.S.-Chinese Relations in the Cold War.* Ithaca: Cornell University Press, 2015.

Parker, Jason C. *Hearts, Minds, Voices: US Cold War Public Diplomacy and the Formation of the Third World.* New York: Oxford University Press, 2016.

Parmet, Andrew Charles. "Chih Meng and the China Institute in America: Pioneering Two-Way Chinese-American Cultural Exchange, 1926–1949." Undergraduate honors thesis, Harvard University, 1993.

Peer, Shanny. *France on Display: Peasants, Provincials, and Folklore in the 1937 Paris World's Fair.* Albany: State University of New York Press, 1998.

Peng Fasheng. *Xiang xifang quanshi Zhongguo: Tianxia yuekan yanjiu* [Interpreting China to the West: a study of the *T'ien Hsia Monthly*]. Beijing: Qinghua daxue chubanshe, 2016.

Pernet, Corinne A. "Twists, Turns, and Dead Alleys: The League of Nations and Intellectual Cooperation in Times of War." *Journal of Modern European History* 12, no. 3 (2014): 342–58.

Peterson, William. *Asian Self-Representation at World's Fairs.* Amsterdam: Amsterdam University Press, 2020.

Pritchard, Earl H. "The Foundations of the Association for Asian Studies, 1928–48." *Journal of Asian Studies* 22, no. 4 (1963): 513–47.

Pu, Xiaoyu. *Rebranding China: Contested Status Signaling in the Changing Global Order.* Stanford: Stanford University Press, 2019.

Qi Rushan. *Mei Lanfang you Mei ji* [A chronicle of Mei Lanfang's U.S. tour]. Beiping: n.p., 1933.

Qian Mu. *Bashi yi shuangqin shiyou zayi hekan* [Joint printing of *Recollection of parents at eighty* and *Reminiscing teachers and friends*]. Taipei: Dongda tushu, 1983.

Qian, Suoqiao. *Liberal Cosmopolitan: Lin Yutang and Middling Chinese Modernity.* Leiden: Brill, 2011.

Qiao Liang and Wang Lele. "Xiangguan zhidai 'wenwu' gainian cihui de chuxian yu bianhua shixi" [An analysis of the emergence and changes of concepts related to "antiquities"]. *Wenwu chunqiu*, no. 2 (2011): 3–7, 10.

Qiao Zhaohong. *Bainian yanyi: Zhongguo bolanhui shiye de shanbian* [A story of one hundred years: the changes to exhibitions in China]. Shanghai: Shanghai renmin chubanshe, 2009.

Qu Wanwen (Chu Wan-wen). *Taiwan zhanhou jingji fazhan de yuanqi: houjin fazhan*

de weihe yu ruhe [The origins of economic development in postwar Taiwan: why and how late development was possible]. Taipei: Lianjing chuban gongsi, 2017.

Reinhardt, Anne. *Navigating Semi-Colonialism: Shipping, Sovereignty, and Nation-Building in China, 1860–1937.* Cambridge, MA: Harvard University Asia Center, 2018.

Ren, Ke. "Chen Jitong, Les Parisiens Peints Par Un Chinois, and the Literary Self-Fashioning of a Chinese Boulevardier in Fin-de-Siècle Paris." *L'Esprit Créateur* 56, no. 3 (2016): 90–103.

Ren, Ke. "The Conférencier in the Purple Robe: Chen Jitong and Qing Cultural Diplomacy in Late Nineteenth-Century Paris." *Journal of Modern Chinese History* 12, no. 1 (2018): 1–21.

Repnikova, Maria. *Chinese Soft Power.* New York: Cambridge University Press, 2022.

Rhoads, Edward J. M. *Stepping Forth into the World: The Chinese Educational Mission to the United States, 1872–81.* Hong Kong: Hong Kong University Press, 2011.

Robinson, David M. *Martial Spectacles of the Ming Court.* Cambridge, MA: Harvard University Asia Center, 2013.

Rosendorf, Neal M. *Franco Sells Spain to America: Hollywood, Tourism and Public Relations as Postwar Spanish Soft Power.* New York: Palgrave Macmillan, 2014.

Ruotsila, Markku. *Fighting Fundamentalist: Carl McIntire and the Politicization of American Fundamentalism.* New York: Oxford University Press, 2015.

Rydell, Robert W. *All the World's a Fair: Visions of Empire at American International Expositions, 1876–1916.* Chicago: University of Chicago Press, 1984.

Sahlins, Marshall. *Confucius Institutes: Academic Malware.* Chicago: Prickly Paradigm Press, 2015.

Said, Edward W. *Orientalism.* New York: Vintage Books, 1979.

Samuel, Lawrence R. *The End of the Innocence: The 1964–1965 New York World's Fair.* Syracuse: Syracuse University Press, 2010.

Sang Bing. *Guoxue yu hanxue* [National learning and sinology]. Hangzhou: Zhejiang renmin chubanshe, 1999.

Schneider, Laurence A. "National Essence and the New Intelligentsia." In *The Limits of Change: Essays on Conservative Alternatives in Republican China*, edited by Charlotte Furth, 57–89. Cambridge, MA: Harvard University Press, 1976.

Schwartz, Benjamin I. *In Search of Wealth and Power: Yen Fu and the West.* Cambridge, MA: Belknap Press of Harvard University Press, 1964.

Scott, Cynthia. *Cultural Diplomacy and the Heritage of Empire: Negotiating Post-Colonial Returns.* New York: Routledge, 2020.

Scott-Smith, Giles. *Western Anti-Communism and the Interdoc Network: Cold War Internationale.* New York: Palgrave Macmillan, 2012.

Sebő, Gábor. "Different Cinematic Interpretations of Ch'unhyangjŏn: The Same Korean Identity." *European Journal of Korean Studies* 21, no. 1 (2021): 155–88.

Seckersen, Austin. *The History of the China Society.* London: China Society, 1984.

Sena, Yunchiahn C. *Bronze and Stone: The Cult of Antiquity in Song Dynasty China.* Seattle: University of Washington Press, 2019.

Shen Pengxia. "Cong cungu dao Meiguo pengren dashi" [From a peasant woman to a culinary master in the United States]. Accessed August 6, 2020. http://mjlsh.usc.cuhk.edu.hk/Book.aspx?cid=4&tid=5650

Shen, Shuang. *Cosmopolitan Publics: Anglophone Print Culture in Semi-Colonial Shanghai*. New Brunswick, NJ: Rutgers University Press, 2009.

Shi Yuanhua. *Zhong Han wenhua xiehui yanjiu* [A study of the Sino-Korean Cultural Association]. Beijing: Shijie zhishi chubanshe, 2007.

Shi Zhiyu (Shih Chih-yu). "Taiwan bentuhua lunshu de dangdai yuanqi" [The contemporary origins of Taiwan's localization discourses]. *Zhanwang yu tansuo* 1, no. 4 (2003): 73–84.

Shin, K. Ian. "The Chinese Art 'Arms Race': Cosmopolitanism and Nationalism in Chinese Art Collecting and Scholarship between the United States and Europe, 1900–1920." *Journal of American-East Asian Relations* 23, no. 3 (2016): 229–56.

Smith, Arthur H. *Chinese Characteristics*. Rev. ed. New York: Revell, 1894.

Smith, Arthur H. "Missionaries in China." *Spectator*, August 20, 1910.

Snow, Edgar, ed. *Living China: Modern Chinese Short Stories*. London: George G. Harrap, 1936.

Snyder, Thomas D. *120 Years of American Education: A Statistical Portrait*. Washington, DC: U.S. Department of Education Office of Educational Research and Improvement, 1993.

So, Richard Jean. *Transpacific Community: The Rise and Fall of a Sino-American Cultural Network*. New York: Columbia University Press, 2016.

Songster, E. Elena. *Panda Nation: The Construction and Conservation of China's Modern Icon*. New York: Oxford University Press, 2018.

Strand, David. *An Unfinished Republic: Leading by Word and Deed in Modern China*. Berkeley: University of California Press, 2011.

Su Ruiqiang (Su Jui-chiang). "*Minzhu pinglun* de xin rujia yu *Ziyou Zhongguo* de ziyou zhuyi zhe guanxi bianhua chutan: yi Xu Fuguan yu Yin Haiguang wei zhongxin de tantao" [A preliminary analysis of the relationship change between the Neo-Confucianists of *Democratic Review* and Liberals of *Free China*: a focus on Xu Fuguan and Yin Haiguang]. *Si yu yan* 49, no. 1 (2011): 7–44.

Sun Yimin. *Jindai Shanghai yingwen chuban yu Zhongguo gudian wenxue de kuawenhua chuanbo (1867–1941)* [Shanghai's modern publishing in English and the cross-cultural dissemination of Chinese classical literature (1867–1941)]. Shanghai: Shanghai guji chubanshe, 2014.

Tackett, Nicolas. *The Origins of the Chinese Nation: Song China and the Forging of an East Asian World Order*. New York: Cambridge University Press, 2017.

Tang Junyi. *Shuo Zhonghua minzu zhi huaguo piaoling* [On the dispersing of the Chinese nation]. Taipei: Sanmin shuju, 1974.

Tang Qihua (Tang Chi-hua). *Beijing zhengfu yu Guoji lianmeng (1919–1928)* [The Beijing government and the League of Nations (1919–1928)]. Tapei: Dongda tushu, 1998.

Tang Zhong. "Lun wenhua waijiao" [On cultural diplomacy]. *Waijiao pinglun* 2, no. 8 (1933): 11–16.

Taylor, Philip M. *Munitions of the Mind: A History of Propaganda from the Ancient World to the Present Day*. Manchester: Manchester University Press, 2003.

Taylor, Philip M. *The Projection of Britain: British Overseas Publicity and Propaganda, 1919–1939*. New York: Cambridge University Press, 1981.

Tcheng, Ki-tong. *The Chinese Painted by Themselves*. Translated by James Millington. London: Field & Tuer, 1885.

Teow, See Heng. *Japan's Cultural Policy toward China, 1918–1931: A Comparative Perspective*. Cambridge, MA: Harvard University Asia Center, distributed by Harvard University Press, 1999.

Thai, Philip. *China's War on Smuggling: Law, Economic Life, and the Making of the Modern State, 1842–1965*. New York: Columbia University Press, 2018.

There Is Another China: Essays and Articles for Chang Poling of Nankai. New York: King's Crown Press, 1948.

Tirella, Joseph. *Tomorrow-Land: The 1964–65 World's Fair and the Transformation of America*. Guilford, CT: Lyons, 2013.

Tompkins, David G. "Red China in Central Europe: Creating and Deploying Representations of an Ally in Poland and the GDR." In *Socialist Internationalism in the Cold War: Exploring the Second World*, edited by Patryk Babiracki and Austin Jersild, 273–301. Cham, Switzerland: Palgrave Macmillan, 2016.

Trescott, Paul B. *From Frenzy to Friendship: The History of the US-China Peoples Friendship Association*. Morrisville, NC: Lulu, 2015.

Tsien, Tsuen-hsuin. *Collected Writings on Chinese Culture*. Hong Kong: Chinese University Press, 2011.

Tsuchida, Akio. "China's 'Public Diplomacy' toward the United States before Pearl Harbor." *Journal of American-East Asian Relations* 17, no. 1 (2010): 35–55.

Tsui, Brian. *China's Conservative Revolution: The Quest for a New Order, 1927–1949*. New York: Cambridge University Press, 2018.

Tucker, Nancy Bernkopf. *The China Threat: Memories, Myths, and Realities in the 1950s*. New York: Columbia University Press, 2012.

Tucker, Nancy Bernkopf. *Strait Talk: United States-Taiwan Relations and the Crisis with China*. Cambridge, MA: Harvard University Press, 2009.

Ungor, Cagdas. "Reaching the Distant Comrade: Chinese Communist Propaganda Abroad (1949–1976)." PhD diss., State University of New York at Binghamton, 2009.

Volz, Yong Z. "China's Image Management Abroad, 1920s–1940s: Origin, Justification, and Institutionalization." In *Soft Power in China: Public Diplomacy through Communication*, edited by Jian Wang, 157–79. New York: Palgrave Macmillan, 2011.

Wakabayashi Masahiro. *Zhanhou Taiwan zhengzhishi: Zhonghua minguo Taiwanhua de licheng* [A political history of postwar Taiwan: The Taiwanization of the Republic of China]. Trans. Hong Yuru et al. Taipei: Taida chuban zhongxin, 2014.

Walker, Alex, and Herbert J. Allen. "Missionaries in China." *Spectator*, August 27, 1910.

Wang, Cheng-hua (Wang Zhenghua). "The Qing Imperial Collection, circa 1905–25: National Humiliation, Heritage Preservation, and Exhibition Culture." In *Reinventing the Past: Archaism and Antiquarianism in Chinese Art and Visual Culture*, edited by Wu Hung, 320–41. Chicago: Center for the Art of East Asia, University of Chicago, 2010.

Wang, Ching-Chun. *Extraterritoriality in China*. New York: China Institute in America, 1931.

Wang Chunnan. "Kangzhan qijian chuguo liuxue guanli" [The study abroad policy during the Sino-Japanese War]. *Xuehai*, no. 2 (1997): 88–93.

Wang, Fei-Hsien. *Pirates and Publishers: A Social History of Copyright in Modern China*. Princeton: Princeton University Press, 2019.

Wang, Guanhua. "'Friendship First': China's Sports Diplomacy during the Cold War." *Journal of American-East Asian Relations* 12, no. 3/4 (2003): 133–53.

Wang, Jessica Ching-Sze. *John Dewey in China: To Teach and to Learn*. Albany: State University of New York Press, 2007.

Wang Jinhui. "Zhong Su wenhua xiehui yanjiu" [A study of the Sino-Soviet Cultural Association]. PhD diss., Party School of the Central Committee of the Chinese Communist Party, 2010.

Wang Mingsheng. "Lun 'sige zixin' yu yishi xingtai anquan: jianding 'sige zixin' yu xin shidai yishi xingtai jianshe de neizai luoji guanxi yanjiu" [On the "four matters of confidence" and ideological security: a study of the internal logical connections of maintaining the four matters of confidence and ideological construction in the new era]. *Renmin luntan xueshu qianyan*, no. 2 (2019): 70–77.

Wang Rongzu (Wong Young-tsu). "Zhang Taiyan dui xiandaixing de yingju yu wenhua duoyuan sixiang de biaoshu" [A case for cultural pluralism: Zhang Taiyan's critique of Western modernity]. *Zhongyang yanjiuyuan jindaishi yanjiusuo jikan*, no. 41 (2003): 145–80.

Wang, Yang. "Envisioning the Third World: Modern Art and Diplomacy in Maoist China." *ARTMargins* 8, no. 2 (2019): 31–54.

Wang Yi. *Huangjia Yazhou wenhui bei Zhongguo zhihui yanjiu* [A study of the North-China branch of the Royal Asiatic Society]. Shanghai: Shanghai shudian chubanshe, 2005.

Wang, Yiyou. "C. T. Loo and the Formation of the Chinese Collection at the Freer Gallery of Art, 1915–1951." In *Collectors, Collections & Collecting the Arts of China: Histories and Challenges*, edited by Jason Steuber and Guolong Lai, 151–82. Gainesville: University Press of Florida, 2014.

Wang, Yiyou. "The Loouvre from China: A Critical Study of C. T. Loo and the Framing of Chinese Art in the United States, 1915–1950." PhD diss., Ohio University, 2007.

Wang, Yuanchong. *Remaking the Chinese Empire: Manchu-Korean Relations, 1616–1911*. Ithaca: Cornell University Press, 2018.

Wang Zhenghua (Wang Cheng-hua). "Chengxian 'Zhongguo': wanqing canyu 1904 nian Meiguo Shengluyisi wanguo bolanhui zhi yanjiu" [Displaying "China": a study of the late Qing government's participation in the 1904 St. Louis World's Fair]. In *Hua zhong you hua: jindai Zhongguo de shijue biaoshu yu wenhua goutu* [Behind the images: the visual narratives and cultural construction in modern China], edited by Huang Kewu, 421–75. Taipei: Zhongyang yanjiuyuan jindaishi yanjiusuo, 2003.

Wei Shanling. "Kangzhan qian Nanjing guomin zhengfu dui liuxue zhengce de tiaozheng yu guihua" [The Nanjing Nationalist government's adjustment and planning of the study abroad policy before the Sino-Japanese War]. *Xuzhou shifan daxue xuebao* (zhexue shehui kexue ban), no. 3 (2008): 1–8.

Wei, Shuge. *News under Fire: China's Propaganda against Japan in the English-Language Press, 1928–1941*. Hong Kong: Hong Kong University Press, 2017.

Weng Wange. "'Zhongguo dianying qiye' zai Mei yinian lu" [The one-year anniversary of China Film Enterprises in America]. *Yingyin* 7, no. 1 (1948): 2–3.

Wertenbaker, Charles. "The China Lobby." *The Reporter*, April 15, 1952.

Wheeler, Norton. *The Role of American NGOs in China's Modernization: Invited Influence*. New York: Routledge, 2012.

Wilcox, Emily. "Performing Bandung: China's Dance Diplomacy with India, Indonesia, and Burma, 1953–1962." *Inter-Asia Cultural Studies* 18, no. 4 (2017): 518–39.

Wilcox, Emily. "Rulan Chao Pian 卞赵如兰 (1922–2013)." *Asian Theatre Journal* 32, no. 2 (2015): 636–47.

Winseck, Dwayne R., and Robert M. Pike. *Communication and Empire: Media, Markets, and Globalization, 1860–1930*. Durham: Duke University Press, 2007.

Wintle, Claire. "Decolonizing the Smithsonian: Museums as Microcosms of Political Encounter." *American Historical Review* 121, no. 5 (2016): 1492–1520.

Wong, Aida Yuen. *Parting the Mists: Discovering Japan and the Rise of National-Style Painting in Modern China*. Honolulu: University of Hawai'i Press, 2006.

Wright, Mary Clabaugh. *The Last Stand of Chinese Conservatism: The T'ung-Chih Restoration, 1862–1874*. Stanford: Stanford University Press, 1957.

Wu Jingping and Guo Daijun (Kuo Tai-chun). *Song Ziwen he tade shidai* [T. V. Soong and his time]. Shanghai: Fudan daxue chubanshe, 2008.

Wu Jinqi. "'Dao Kong yundong': zhanshi de kangzheng zhengzhi" ["The anti-Kong movement": wartime protests and politics]. *Dongfang luntan*, no. 6 (2013): 34–41.

Wu, Shellen. *Empires of Coal: Fueling China's Entry into the Modern World Order, 1860–1920*. Stanford: Stanford University Press, 2015.

Wu Shuying (Wu Shu-ying). "Zhanlan zhong de 'Zhongguo': yi 1961 nian Zhongguo gu yishupin fu Mei zhanlan weili" [China on display: a focus on the loan exhibitions of Chinese antiquities in the United States in 1961]. Master's thesis, National Chengchi University, 2003.

Wu, Tingfang. *America through the Spectacles of an Oriental Diplomat*. New York: Frederick A. Stokes, 1914.

Xia Jinlin (Hsia Chin-lin). "Haiwai xuanchuan gongzuo: 'wo wudu canjia waijiao gongzuo de huigu' fulu" [Overseas propaganda work: recollections of the my five-time diplomatic work, appendix]. *Zhuanji wenxue* 29, no. 6 (1976): 57–58.

Xia, Yafeng. *Negotiating with the Enemy: U.S.-China Talks during the Cold War, 1949–1972*. Bloomington: Indiana University Press, 2006.

Xin Zhongguo duiwai wenhua jiaoliu shilüe bianweihui, ed. *Xin Zhongguo duiwai wenhua jiaoliu shilüe* [A historical sketch of international cultural communications of the People's Republic of China]. Beijing: Zhongguo youyi chuban gongsi, 1999.

Xing, Chengji. "Pacific Crossings: The China Foundation and the Negotiated Translation of American Science to China, 1913–1949." PhD diss., Columbia University, 2023.

Xing Yitian (Hsing I-tien). "Fu Sinian, Hu Shi yu Juyan hanjian de yun Mei ji fan Tai" [Fu Ssu-nien and Hu Shih's roles in the shipment of Chü-yen wooden strips to the United States and their return to Taiwan]. *Zhongyang yanjiuyuan lishi yuyan yanjiusuo jikan* 66, no. 3 (1995): 921–52.

Xu Fengyuan (Hsu Feng-yuan). "Guomin zhengfu canjia Sulian 'Zhongguo yishu zhanlanhui' de quzhe (1939–1942)" [The Nationalist government's participa-

tion in the Chinese art exhibition in the Soviet Union, 1939–1942]. *Dang'an bannian kan* 16, no. 1 (2017): 44–58.

Xu Fengyuan (Hsu Feng-yuan). "Zhanshi 'Zhongguo': Taiwan zai Niuyue shibohui (1964–1965)" [To display "China": Taiwan at the New York World's Fair, 1964–1965]. In *Jindai Zhongguo de zhongwai chongtu yu siying* [Sino-foreign conflicts and responses in modern China], edited by Tang Qihua (Tang Chi-hua), 203–26. Taipei: Zhengda chubanshe, 2014.

Xu, Guoqi. *Chinese and Americans: A Shared History*. Cambridge, MA: Harvard University Press, 2014.

Xu, Guoqi. *Olympic Dreams: China and Sports, 1895–2008*. Cambridge, MA: Harvard University Press, 2008.

Xu, Xiaoqun. *Trial of Modernity: Judicial Reform in Early Twentieth-Century China, 1901–1937*. Stanford: Stanford University Press, 2008.

Xue Guangqian (Sih, Paul K. T.). *Kunxing yiwang: Xue Guangqian boshi zhongyao jingli biannian zishu* [Reminiscing the past while striving forward: the autobiography of Dr. Xue Guangqian's milestone experiences]. Taipei: Zhuanji wenxue chubanshe, 1984.

"Xueren mengnan wenhua zaoyang" [Scholars suffer, culture destroyed]. *Ziyou Zhongguo* 6, no. 1 (1952): 4.

Yang Cuihua (Yang Tsui-hua). *Zhongjihui dui kexue de zanzhu* [The support of science by the China Foundation for the Promotion of Education and Culture]. Taipei: Zhongyang yanjiuyuan jindaishi yanjiusuo, 1991.

Yang Guang. "Zhongshantang zai Niuyue: Meiguo daxue nei weiyi zhongshi gudian jianzhu de lishi bianqian" [The Sun Yat-sen Memorial Hall in New York: the history of the only Chinese classical architecture in American universities]. Unpublished manuscript, 2015.

Yang Weiming. "Zhonghua jiaoyu gaijinshe yu Oumei jiaoyu xueshu" [The National Association for the Advancement of Education and the educational studies in Euro-America]. *Jiaoyu pinglun*, no. 6 (2009): 132–35.

Yao Yao. *Xin Zhongguo duiwai xuanchuan shi: jiangou xiandai Zhongguo de guoji huayu quan* [A history of international propaganda of the People's Republic of China: constructing modern China's international discourses]. Beijing: Qinghua daxue chubanshe, 2014.

Ye Jun. *Yi wenhua boyi: Zhongguo xiandai liu Ou xueren yu xixue dongjian* [Negotiations among different cultures: the European-educated modern Chinese intellectuals and the influence of Western learning on China]. Beijing: Beijing daxue chubanshe, 2009.

Ye Longyan (Yeh Lung-yen). "Taiwan zhanhou chuqi lüyouye de fusu" [The revival of tourism in the immediate postwar Taiwan]. *Taibei wenxian*, no. 163 (2008): 21–54.

Ye Meixia. "'Zhong Ri wenhua xiehui' shuping" [A review of the "Sino-Japanese Cultural Association"]. *Minguo dang'an*, no. 3 (2000): 96–101.

Ye, Weili. *Seeking Modernity in China's Name: Chinese Students in the United States, 1900–1927*. Stanford: Stanford University Press, 2001.

Yeh, Catherine. "China, a Man in the Guise of an Upright Female: Photography, the Art of the Hands, and Mei Lanfang's 1930 Visit to the United States." In *History in Images: Pictures and Public Space in Modern China*, edited by Christian

Henriot and Wen-hsin Yeh, 81–110. Berkeley: Institute of East Asian Studies, University of California, 2012.

Yeh, Chiou-ling. *Making an American Festival: Chinese New Year in San Francisco's Chinatown*. Berkeley: University of California Press, 2008.

Yeh, Wen-hsin. "Living with Art: The Yeh Family Collection and the Modern Practices of Chinese Collecting." In *Collecting China: The World, China, and a History of Collecting*, edited by Vimalin Rujivacharakul, 176–83. Newark: University of Delaware Press, 2011.

Yin Dexiang. *Donghai xihai zhijian: wanqing shixi riji zhong de wenhua guancha, renzheng yu xuanze* [Between the East and West: cultural commentaries, confirmations, and choices in the diaries of the late Qing diplomats to the West]. Beijing: Beijing daxue chubanshe, 2009.

Yoshihara, Mari. *Embracing the East: White Women and American Orientalism*. New York: Oxford University Press, 2003.

Yu Yingshi (Yü Ying-shih). *Youji fengchui shuishang lin: Qian Mu yu xiandai Zhongguo xueshu* [Remembering the wind over the surface ripples of the water: Qian Mu and modern Chinese academe]. Taipei: Sanmin shuju, 1991.

Yuan Qing et al. *Liuxuesheng yu Zhongguo wenhua de haiwai chuanbo: yi 20 shiji shangbanqi wei zhongxin de kaocha* [Foreign-educated students and the international dissemination of Chinese culture: a focus on the first half of the twentieth century]. Tianjin: Nankai daxue chubanshe, 2014.

Zajácz, Rita. *Reluctant Power: Networks, Corporations, and the Struggle for Global Governance in the Early 20th Century*. Cambridge, MA: MIT Press, 2019.

Zarrow, Peter. *After Empire: The Conceptual Transformation of the Chinese State, 1885–1924*. Stanford: Stanford University Press, 2012.

Zen, Sophia Chen. "Review of *The Good Earth*." *Pacific Affairs* 4, no. 10 (1931): 914–15.

Zeng Jize. *Chushi Ying Fa E guo riji* [Diaries during diplomatic postings in Britain, France, and Russia]. Changsha: Yuelu shushe, 1985.

Zhang, Beiyu. *Chinese Theatre Troupes in Southeast Asia: Touring Diaspora, 1900s–1970s*. New York: Routledge, 2021.

Zhang Jing. *Zhongguo Taipingyang guoji xuehui yanjiu (1925–1945)* [A study of the China Institute of Pacific Relations (1925–1945)]. Beijing: Shehui kexue wenxian chubanshe, 2012.

Zhang Li (Chang Li). *Guoji hezuo zai Zhongguo: Guoji lianmeng juese de kaocha, 1919–1946* [International cooperation in China: a study of the role of the League of Nations, 1919–1946]. Taipei: Zhongyang yanjiuyuan jindaishi yanjiusuo, 1999.

Zhang Peide. "1933 nian Zhongguo canjia Zhijiage shibohui huigu" [A review of China's participation in the 1933 Chicago World's Fair]. In *Shibohui yu Dongya de canyu* [East Asia's participation in the international exhibitions], edited by Tao Demin et al., 235–51. Shanghai: Shanghai renmin chubanshe, 2012.

Zhang Shuya (Chang Su-ya). "Taihai weiji yu Meiguo dui 'fangong dalu' zhengce de zhuanbian" [The Taiwan Strait Crises and U.S. Attitude toward the "reinvade the mainland" policy in the 1950s]. *Zhongyang yanjiuyuan jindaishi yanjiusuo jikan*, no. 36 (2001): 231–90.

Zhang Shuya (Chang Su-ya). "'Zhuyi wei qianfeng, wuli wei houdun': ba'ersan paozhan yu 'fangong dalu' xuanchuan de zhuanbian" ["Ideology as the fore-

front, force as the backup": the Second Taiwan Strait Crisis and the evolution of "reinvade the mainland" propaganda]. *Zhongyang yanjiuyuan jindaishi yanjiusuo jikan*, no. 70 (2010): 1–49.

Zhang Xianwen, ed. *Zhonghua minguo shi da cidian* [An encyclopedia of the history of the Republic of China]. Nanjing: Jiangsu guji chubanshe, 2001.

Zhao Yina (Chao E-na). "Meiguo zhengfu zai Taiwan de jiaoyu yu wenhua jiaoliu huodong (1951–1970)" [U.S. government programs in educational and cultural exchange in Taiwan (1951–1970)]. *Oumei yanjiu* 31, no. 1 (2001): 79–127.

Zheng, Da. *Chiang Yee: The Silent Traveller from the East, a Cultural Biography*. New Brunswick, NJ: Rutgers University Press, 2010.

Zheng Jianning. "Sunzi bingfa yi shi gouchen" [A sketch of the history of the translation of Sun Tzu's *The Art of War*]. *Xibei minzu daxue xuebao* (zhexue shehui kexue ban), no. 5 (2019): 178–88.

Zheng Qiaojun (Cheng Chiao-chun). "Cong *Guanguang yuekan* kan Zhonghua minguo de xingxiang (1966–1971)" [The image of the Republic of China in the Tourism Monthly (1966–1971)]. Paper presented at the international conference Yingxiang yu shiliao: yingxiang zhong de jindai Zhongguo [Images and historical sources: modern China in images], National Chengchi University, Taipei, October 2014.

Zheng Qiaojun (Cheng Chiao-chun). "Cong Jiang Jieshi dui zhanhou guanguang shiye de zhishi kan zhanhou guanguang shiye de fazhan" [The development of tourism in postwar Taiwan from the perspective of Chiang Kai-she's directives]. In *Jiang Jieshi de richang shenghuo* [The everyday life of Chiang Kai-shek], edited by Lü Fangshang (Lu Fang-shang), 243–57. Taipei: Zhengda chubanshe, 2012.

Zhongguo di'er lishi dang'anguan, ed. *Zhonghua minguo lishi tupian dang'an* [Collection of historical photographs of the Republic of China], vol. II (3). Beijing: Tuanjie chubanshe, 2002.

Zhongguo di'er lishi dang'anguan, ed. *Zhonghua minguo shi dang'an ziliao huibian: di 5 ji di 2 bian wenhua (2)* [Compendium of archival materials on the history of the Republic of China: series IV issue II culture vol. II]. Nanjing: Jiangsu guji chubanshe, 1998.

Zhonghua renmin gongheguo chutu wenwu zhanlan gongzuo weiyuanhui. *The Exhibition of Archaeological Finds of the People's Republic of China*. Washington, DC: National Gallery of Art, 1974.

Zhou Bin. "Qingmo minchu 'guomin waijiao' yici de xingcheng jiqi hanyi shulun" [The emergence of "public diplomacy" and its meanings in the late Qing and early Republic]. *Anhui shixue*, no. 5 (2008): 22–32.

Zhou Bin. *Yulun, yundong yu waijiao: 20 shiji 20 niandai minjian waijiao yanjiu* [Public opinions, popular movements, and diplomacy: a study of public diplomacy in the 1920s]. Beijing: Xueyuan chubanshe, 2010.

Zhou Fangmei (Chou Fang-mei). "1926 nian Feicheng shijie bolanhui Zhonghua minguo he Riben yipin zhi zhanshi" [The display of Chinese and Japanese art at the 1926 Sesqui-Centennial International Exposition in Philadelphia]. Unpublished manuscript, no pagination.

Zhou Fangmei (Chou Fang-mei). "1933–34 nian Zhijiage shijie bolanhui Zhonghua minguo he Riben yipin zhi zhanshi" [The display of Chinese and Japanese

art at the 1933–34 Chicago World's Fair]. *Yishuxue yanjiu*, no. 6 (2010): 161–230.

Zhou Fangmei (Chou Fang-mei). "Yijiuyiwu nian Zhonghua minguo he Riben canzhan Banama Taipingyang wanguo bolanhui meishugong zhi chutan" [A preliminary essay on the participation by the Republic of China and Japan in the 1915 Panama-Pacific International Exposition's Palace of Fine Arts]. In *Shibian, xingxiang, liufeng: Zhongguo jindai huihua 1796–1949 guoji xueshu yantaohui lunwenji* [Turmoil, representation, and trends: modern Chinese painting, 1796–1949 international conference papers], edited by Yang Dunyao, 597–624. Taipei: Caituan faren hongxi yishu wenjiao jijinhui, 2008.

Zhou Hongyu and Chen Jingrong. "Meng Lu zaihua huodong nianbiao" [A chronology of Paul Monroe's activities in China]. *Huadong shifan daxue xuebao* (jiaoyu kexue ban) 21, no. 3 (2003): 44–52.

Zhou Leiming. "Liu Mei Zhongguo xuesheng zhanshi xueshu jihua weiyuanhui jiqi huodong" [The activities of the Committee on Wartime Planning for Chinese Students in the United States]. In *Kangzhan shiqi de Zhongguo wenhua* [Chinese culture during the Sino-Japanese War], edited by Tu Wenxue and Deng Zhengbing, 604–9. Beijing: Renmin chubanshe, 2006.

Zhou, Taomo. *Migration in the Time of Revolution: China, Indonesia, and the Cold War*. Ithaca: Cornell University Press, 2019.

Zhu Qibao. Review of Tang Junyi, *Zhongguo zhi luan yu Zhongguo wenhua jingshen zhi qianli* [The chaos in China and the spiritual potential of Chinese culture] (Taipei: Huaguo chubanshe, 1952). *Ziyou Zhongguo* 6, no. 9 (1952): 297–98.

Index

Studies of the Weatherhead East Asian Institute

Columbia University

Selected Titles

(Complete list at: weai.columbia.edu/content/publications)

In Search of Admiration and Respect: Chinese Cultural Diplomacy in the United States, 1875–1974, by Yanqiu Zheng. University of Michigan Press, 2024.

Perilous Wagers: Gambling, Dignity, and Day Laborers in Post-Fukushima Tokyo, by Klaus K. Y. Hammering. Cornell University Press, 2024.

The Chinese Computer: A Global History of the Information Age, by Thomas S. Mullaney. The MIT Press, 2024.

Beauty Matters: Modern Japanese Literature and the Question of Aesthetics, 1890–1930, by Anri Yasuda. Columbia University Press, 2024.

Revolutionary Becomings: Documentary Media in Twentieth-Century China, by Ying Qian. Columbia University Press, 2024.

Waiting for the Cool Moon: Anti-imperialist Struggles in the Heart of Japan's Empire, by Wendy Matsumura. Duke University Press, 2024.

Beauty Regimes: A History of Power and Modern Empire in the Philippines, 1898–1941, by Genevieve Clutario. Duke University Press, 2023.

Afterlives of Letters: The Transnational Origins of Modern Literature in China, Japan, and Korea, by Satoru Hashimoto. Columbia University Press, 2023.

Republican Vietnam, 1963–1975: War, Society, Diaspora, edited by Trinh M. Luu and Tuong Vu. University of Hawai'i Press, 2023.

Territorializing Manchuria: The Transnational Frontier and Literatures of East Asia, by Miya Xie. Harvard East Asian Monographs, 2023.

Takamure Itsue, Japanese Antiquity, and Matricultural Paradigms that Address the Crisis of Modernity: A Woman from the Land of Fire, by Yasuko Sato. Palgrave Macmillan, 2023.

Rejuvenating Communism: Youth Organizations and Elite Renewal in Post-Mao China, by Jérôme Doyon. University of Michigan Press, 2023.

From Japanese Empire to American Hegemony: Koreans and Okinawans in the Resettlement of Northeast Asia, by Matthew R. Augustine. University of Hawai'i Press, 2023.

Made in United States
North Haven, CT
05 November 2024

59898907R00148